Dashkova

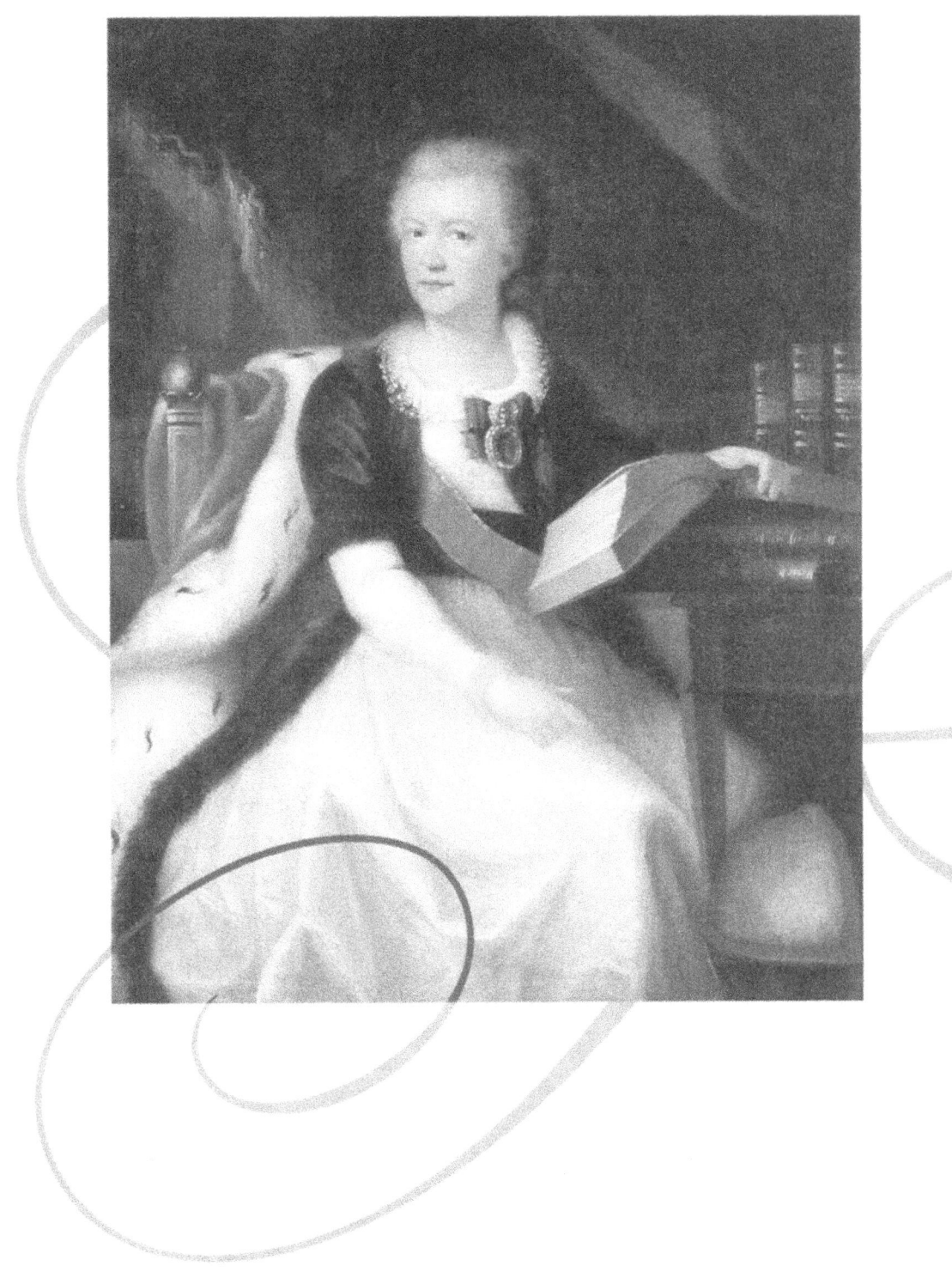

Dashkova
A Life of Influence and Exile

A. Woronzoff-Dashkoff

AMERICAN PHILOSOPHICAL SOCIETY

Transactions of the American Philosophical Society
Held at Philadelphia For Promoting Useful Knowledge
Volume 97, Part 3

Copyright © 2008 by the American Philosophical Society for its *Transactions* series, volume 97, part 3.
All rights reserved.

Set in Monotype Baskerville with Bickham Script display by
Graphic Composition, Inc., Bogart, Georgia
Text and cover design by Ellen Graben
Printed and bound in the United States of America

ISBN-13: 978-0-87169-973-2
US ISSN: 0065-9738

Library of Congress Cataloging-in-Publication Data

Woronzoff-Dashkoff, A. (Alexander)
 Dashkova : a life of influence and exile / A. Woronzoff-Dashkoff. —1st ed.
 p. cm. — (Transactions of the American Philosophical Society held at Philadelphia for promoting useful knowledge)
 Includes bibliographical references and index.
 ISBN 978-0-87169-973-2 (pbk.)
 1. Dashkova, E. R. (Ekaterina Romanovna), kniaginia, 1743–1810. 2. Princesses—Russia—Biography. 3. Intellectuals—Russia—Biography. 4. Russia—Court and courtiers—Biography. 5. Russia—Civilization—18th century. I. Title.
DK169.D3W67 2007
947'.06092—dc22
[B]

2007041650

FRONTISPIECE: Dashkova as president of the Russian Academy, by an unknown artist

For my family

Contents

Abbreviations	viii
List of Illustrations	x
Genealogies	xii
Introductory Note—MARY MAPLES DUNN	xv
Author's Note	xvii
Chronology of Events	xviii
Introduction	xxiii

PART I *Early years, 1743–1763*
 Chapter One: Education and Enlightenment 3
 Chapter Two: Conspiracy 27
 Chapter Three: The Coup 49

PART II *European Travel, 1763–1782*
 Chapter Four: Banishment 73
 Chapter Five: First Journey Abroad 97
 Chapter Six: Second Journey Abroad 124

 ILLUSTRATIONS *following page* 150

PART III *Influence and Intellectual Pursuits, 1782–1794*
 Chapter Seven: The Academy of Sciences 153
 Chapter Eight: The Russian Academy 179
 Chapter Nine: A Woman of Letters 197

PART IV *Exile, 1794–1810*
 Chapter Ten: Estrangement 221
 Chapter Eleven: Troitskoe and Korotovo 240
 Chapter Twelve: The Final Years 261

 Epilogue 281

 Notes 287
 Selected Bibliography 311
 Index 323

Abbreviations

AAE	Archives des Affaires Etrangères, "Russie"
AKK	Arkhiv kn. F. A. Kurakina (Archive of Prince F. A. Kurakin)
AKV	Arkhiv kniazia Vorontsova (Archive of Prince Vorontsov)
BERD	"Bumagi E. R. Dashkovoi" (Papers of E. R. Dashkova)
BFP	Brook Family Papers
ch.	chast' (part)
ChOIDR	Chtenie v Obshchestve istorii i drevnostei rossiiskikh (Readings of the Society of Russian History and Antiquities at Moscow University)
Companion	Companion to those who love the Russian word (Sobesednik liubitelei rossiiskogo slova)
d., dd.	delo, dela (file, files)
ed. khr.	edinitsa khraneniia (storage unit)
ERD	Ekaterina Romanovna Dashkova: Issledovaniia i materialy (Ekaterina Romanovna Dashkova: Research and Materials)
f.	fond (collection)
GIM OPI	Gosoudarstvennyi istoricheskii muzei, otdel pis'mennykh istochnikov (State Historical Museum. Department of Written Sources)
l., ll.	list, listy (folio, folios)
MDB	Materialy dlia biografii kniagini E. R. Dashkovoi (Materials for a biography of E. R. Dashkova)
Nova	Nova Acta Academiae Scientiarum Imperialis Petropolitanae
ob.	oborot (reverse side)

op	opis' (inventory)
OR RGB	Otdel rukopisei Rossiiskaia Gos. bib (Manuscript Division, Russian State Library)
otd.	otdelenie (section)
Protokoly	Protokoly zasedanii Konferentsii Imperatorskoi Adademii Nauk
PSZ	Polnoe sobranie zakonov Rossiiskoi imperii (Complete Collection of Laws of the Russian Empire)
RA	Russikii arkhiv (Russian Archive)
RGADA	Rossiiskii gosudarstvennyi arkhiv drevnikh aktov (Russian State Archive of Ancient Acts)
RGIA	Rossiiskii gosoudarstvennyi istoricheskii arkhiv (Russian State Historical Archive)
RIA	Royal Irish Academy
RS	Russkaia starina (Russian Past)
SIRIO	Sbornik imperatorskogo russkogo istoricheskogo obshchestva, St. Petersburg, 1867-1916 (Collection of the Imperial Russian Historical Society)
Sobesednik	Sobesdnik liubitelei rossiiskogo slova (Companion to those who love the Russian word)
SPFA RAN	Sankt-Peterburgskii filial Arkhiva RAN (St. Petersburg Branch of the Archive of the Russian Academy of Sciences)
SPFIRI RAN	Sankt-Peterburgskii filial Instituta rossiiskoi istorii RAN (St. Petersburg Branch of the Institute of Russian History of the Russian Academy of Sciences)
t.	tom (volume)

Illustrations

Illustrations are reproduced here by kind permission of the American Philosophical Society (frontispiece), the Alupka Museum in the Crimea (3, 7, 8, 12, 13, 20, 21), and the State Historical Museum in Moscow (15). All others are from a private collection.

FRONTISPIECE: Dashkova as president of the Russian Academy, by an unknown artist

1. Print of Dashkova from the original portrait by Dmitrii Levitskii
2. Portrait of Dashkova in exile, after Salvatore Tonci
3. Thought to be Marfa Vorontsova, Dashkova's mother, by an unknown artist
4. Print of Roman Vorontsov, Dashkova's father, by A. Kolpachnikov
5. Print of Catherine II by C. Guttenberg, from a portrait by P. Rotari
6. Print of Peter III
7. Mikhail Vorontsov, Dashkova's uncle, by Iakov Ulianov after a portrait by L. Tocqué
8. Anna Vorontsova, Dashkova's aunt, by Iakov Ulianov after a portrait by P. Rotari
9. Print of Mikhail Vorontsov's palace, St. Petersburg
10. Print of church in the Vorontsov palace
11. Print of Dashkova by Johann Conrad Mayr, from the original portrait by Dmitrii Levitskii
12. Print of Elizaveta Vorontsova, Dashkova's sister, from the original portrait by L. Tocqué
13. Portrait of Aleksandr Vorontsov, Dashkova's brother, by an unknown artist
14. Print of Simon Vorontsov, Dashkova's brother, by T. Hodgett, from the original portrait by R. Evans

15. Portrait of Dashkova in military uniform by an unknown artist
16. The Academy of Sciences in St. Petersburg photographed from the English Embankment
17. Photograph of Kirianovo
18. Photograph of Mikhail Mikeshin's monument to Catherine II on Ostrovskii Square, St. Petersburg, with Dashkova seated to the left
19. Print of Paul I
20. Print of Dashkova in exile by A. Osipov, from the original portrait by Salvatore Tonci
21. Dashkova in later life by an unknown artist
22. Photograph of the gates to Troitskoe
23. Photograph of Andreevskoe, Aleksandr Vorontsov's estate
24. Photograph of Dashkova's monument to Catherine in Troitskoe

Genealogies

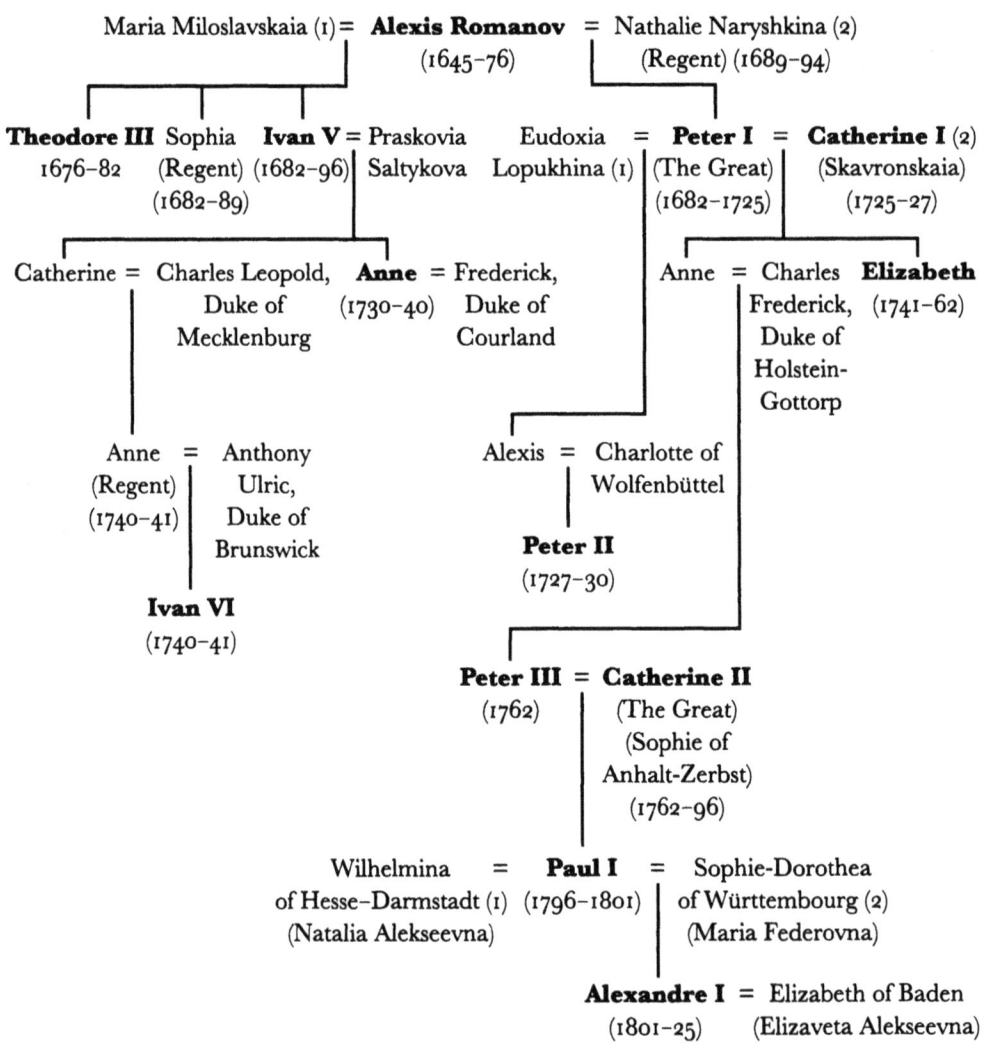

Introductory Note

THE AMERICAN PHILOSOPHICAL SOCIETY is particularly pleased to publish *Dashkova* because Princess Ekaterina Dashkova was admired by our founder, Benjamin Franklin, and because on his nomination she became the first female member of the Society. Publication of this volume follows a very successful exhibition, mounted by the Society, in celebration of Benjamin Franklin's Tercentenary. That exhibition, called *The Princess and the Patriot: Ekaterina Dashkova, Benjamin Franklin, and the Age of the Enlightenment,* explored the lives of Dashkova and Franklin and the Enlightenment ideals they espoused. They had a special affinity through their mutual devotion to the pursuit of knowledge, which prompted Franklin to found the Philosophical Society, and led to Dashkova's appointment, exceedingly unusual for a woman, as Director of both the Russian Imperial Academy of Sciences and the Imperial Russian Academy, to which she gave distinguished and vigorous leadership. Franklin's story is well-known, but Dashkova has had much less attention than she deserves. In this splendid study the author, her descendent, rescues her from the obscurity that has been her lot in the English-speaking world.

Mary Maples Dunn
Co-Executive Officer, 2002–2007
The American Philosophical Society

Author's Note

I WOULD LIKE TO THANK the numerous specialists, archivists, and librarians in Russia, the Ukraine, France, England, Ireland, and the United States who have, over the years, aided me in my research. No one took greater interest in this work, nor followed its progress more closely than my wife, Catherine, who read early drafts several times. A graduate of Smith College and a senior lecturer there, she is devoted to the education of women. She was able to illuminate and clarify many of my blind spots, while my children and grandchildren listened patiently to my endless stories about Dashkova. Professors Gitta Hammarberg, Hilde Hoogenboom, and Mikhail Mikeshin also read the manuscript, and their corrections and recommendations were invaluable. My thanks go to the Vorontsov Society in Russia, particularly Viacheslav Udovik and Vladimir Alekseev, for their tireless research into the history of my family. Many others have also contributed to this project, and I owe a special debt of gratitude to Professors Mary and Richard Dunn, Executive Directors of the American Philosophical Society, for their interest in the life and works of Dashkova, and to Mary McDonald, Susan Dodson, and David Marck, for their expert editing of this book.

All dates are cited as in the original document. Therefore, old-style dates of the Julian calendar, which in the eighteenth century lagged eleven days behind the new style, have not been converted to the Gregorian calendar. In certain cases, especially diplomatic correspondences, both dates are cited. The modified Library of Congress system is used throughout in the transliteration of Russian. Feminine surnames are given in the Russian form (Dashkova, rather than Dashkov) and English equivalents of Russian names are preferred when they are the most familiar; for example, in the case of emperors and empresses (Catherine II, rather than Ekaterina II). For clarity, and to distinguish her from other Vorontsov family members, Dashkova is always Dashkova, even prior to her marriage.

A. Woronzoff-Dashkoff
Cornwall, Vermont

Chronology of Events

1743　Dashkova is born on March 17 in St. Petersburg.

1744　Princess Sophie of Anhalt-Zerbst (the future Empress Catherine II) arrives in Russia to join her prospective husband, the Grand Duke Peter.

1745　Catherine and Peter marry in Moscow.

1754　Catherine gives birth to Paul.

1756　Beginning of the Seven Years War.

1758　Dashkova meets her future husband Mikhail Dashkov.

1759　Dashkova and Mikhail marry in February.

1759　Dashkova lives in Moscow and Troitskoe for the next two years.

1760　On February 21 Dashkova gives birth to a daughter, Anastasia.

1761　In January Dashkova gives birth to a son, Mikhail.
She returns to St. Petersburg in June.
Empress Elizabeth dies on December 25 and is succeeded by Peter III.

1762　Palace revolution and the ascension of Catherine to the throne.

1762　Dashkova's son Mikhail dies in the fall.

1763　In May Dashkova gives birth to a son, Pavel, in Moscow.
Grigorii Orlov accuses her of participation in the Khitrovo plot.
Dashkova travels to Riga, Latvia.

1764　In August her husband dies in Poland.
Mirovich is executed and Dashkova leaves St. Petersburg for Moscow.

1765　Dashkova resides in Moscow and on her estate in Troitskoe.

1767　The Legislative Commission convenes to codify the laws of Russia on the basis of Catherine's Nakaz, or Instruction.

1768　Dashkova travels to Kiev.
The First Russo-Turkish War (1768–1774).

1769	In December Dashkova departs for a tour of Europe.
1771	At the end of the year Dashkova returns to St. Petersburg. Plague in Moscow.
1772	Dashkova lives in Moscow and on her estate. First of three partitions of Poland.
1773	Pugachev rebellion.
1775	Dashkova travels to Europe for the education of her son.
1776	Continental Congress carries the Declaration of Independence.
1777	Birth of Catherine's grandson, the future Emperor Alexander I.
1779	Pavel completes his course of studies at Edinburgh University.
1781	Dashkova meets Benjamin Franklin in Paris. The British capitulate at Yorktown.
1782	Meeting with the Grand Duke Paul in Rome and return to St. Petersburg.
1783	Dashkova heads two academies. During the summer Catherine Hamilton visits her.
1784	Death of Diderot.
1787	Catherine travels to the south of Russia and the Crimea. Dashkova does not accompany her. The Second Russo-Turkish War.
1788	In January Pavel marries Anna Alferova. Storming of the Bastille. War with Sweden.
1789	Dashkova publishes the six-volume Russian Academy Dictionary.
1790	Publication of Radishchev's *Journey from St. Petersburg to Moscow*.

1793	Executions of Louis XVI and Marie Antoinette. Falling out with Catherine over the publication of Kniazhnin's play *Vadim of Novgorod*. Second Partition of Poland.
1794	Dashkova leaves the academies. Terror and the Directorate in France.
1795	Third Partition of Poland.
1796	Catherine dies and Paul ascends the throne. Paul I exiles Dashkova to northern Russia.
1797	In March Dashkova returns from exile.
1801	Paul I is murdered in a palace coup and is succeeded by his son. Dashkova attends the coronation of Alexander I in Moscow.
1802	In July Dashkova travels to St. Petersburg for the last time.
1803	Martha Wilmot arrives in Troitskoe, later to be joined by her sister Catherine.
1805	Dashkova writes her *Memoirs*. Napoleon defeats Austro-Russian forces at Austerlitz.
1807	Death of Dashkova's son, Pavel.
1808	In October Martha Wilmot leaves Russia.
1810	On January 4 Dashkova dies in Moscow.

Dashkova

Introduction

ON JANUARY 26, 1781, Benjamin Franklin left the Hôtel de Valentinois, his stately residence overlooking the river Seine in the village of Passy. He rode in his carriage through Paris to the Hôtel de la Chine in the Marais district of the city where the Russian princess Ekaterina Dashkova was staying. As a representative of the rebellious Colonies, he hoped to meet the woman who had played such an important role in bringing down the legitimate heir to the Russian throne and who, according to contemporary accounts, had caused such a stir in the Blue Stocking gatherings of London. Years earlier Elizabeth Carter, the English poet and translator, had written to Elizabeth Montagu, the "Queen of the Blues" and champion of women's education:

> I suppose you know that Princess Daschan [sic], who at nineteen harangued the troops, and was the principal instrument of bringing about the Revolution, is now in England. She seems to be a most extraordinary genius. She rides in boots, and all the other habiliments of a man, and in all the manners and attitudes belonging to that dress ... She likewise dances in a masculine habit and I believe appears as often in it as in her proper dress.[1]

For the aging Franklin, who suffered from boils and gout, travel over the uneven cobblestone streets of Paris was difficult and in the end disappointing, since Dashkova was not at home and he was obliged to return a week later.

As a result of their subsequent meeting on the evening of Saturday, February 3, 1781, Dashkova was elected the first female member of the Philadelphia (later American) Philosophical Society, of which Franklin

was president. Equally, Franklin was elected the first American member of the Imperial Academy of Sciences in St. Petersburg (later Russian), of which Dashkova was director.² Dashkova, who rarely praised men, admired Franklin greatly; his brilliant mind, unassuming manner, and straightforward appearance attracted her immediately. At first glance, she noticed his disdain for the fashion of the day, his smoothly combed, unpowdered hair, the spectacles precariously poised at the end of his nose, and the loose-fitting plain coat—a garment she too favored. Dashkova considered Franklin to be "a very superior man who combined profound erudition with simplicity of dress and manner, whose modesty was unaffected, and who had a great deal of indulgence for other people."³ For his part, Franklin, known to enjoy the company of educated women, wrote Georgiana Shipley that he had received the "very kind Letter by Made. Sherbinin with whom and the Princess [Dashkova] her Mother I am much pleased."⁴

Franklin's restrained and serious assessment of Dashkova was unusual at a time when the judgments of her contemporaries mostly lacked objectivity.⁵ Her achievements were both highly praised as well as roundly condemned, and such disparate evaluations of her life set in relief some of the constraints and biases of the age. Many would elevate her to the heights of Mount Parnassus through hyperbole and elaborate panegyrics. In particular, those who sought to gain favor with her extolled her inventive mind, brilliant education, unusual energy, and generosity toward her friends. Others would pillory her unfairly and cast her into the dust stressing her miserliness, vanity, pride, irascibility, ambitiousness, and fondness for intrigue. Like Franklin, Horace Walpole was also "eager to see this Amazon who had so great a share in a revolution when she was not above nineteen," and when they met, his insulting description was perhaps typical. "Well! I have seen Princess Daschioff [*sic*], and she is well worth seeing—not for her person, though for an absolute Tartar she is not ugly; her smile is pleasing, but her eyes have a very Cataline fierceness."⁶

More often than not, Dashkova's contemporaries considered her eccentric and incongruous because her actions corresponded more closely to eighteenth-century notions of male behavior. The Count de Ségur recorded rumors at court that Dashkova aspired to the top positions in the state and hoped to gain a seat in the senate, or at least to command a regiment of the guards. He wrote that in certain ways she was like a man. She dressed, as depicted in her portraits, in something resembling a man's suit, which harmonized with her rough masculine features, and that "it only by a chance, capricious mistake of nature that she was born a woman."⁷ In his

memoirs, the French adventurer Charles-François Masson agreed that she was "masculine in her tastes, her gait, and her exploits."[8] Like Ségur, Masson claimed that Dashkova requested promotion to the rank of colonel, while the great poet of the age Gavriil Derzhavin asserted that she sought appointment to the senate and characterized Dashkova as an overambitious woman always seeking the highest position in government.[9] In fact, the cruelest and most demeaning portrayal of Dashkova belongs to Derzhavin, who owed much to Dashkova's patronage, yet considered her to be irascible, or better yet, simply mad.[10] To commemorate her appointment to the presidency of the Russian Academy he composed a congratulatory poem, "To the Portrait of Princess Ekaterina Romanovna Dashkova during Her Presidency." In the portrait Dashkova is seated on a chair, her academic garb is thrown over its back, and a globe of the world is standing at her feet. She is looking over volumes of her *Russian Academic Dictionary*. The short poem describes her support of Catherine and ironically alludes to what Derzhavin perceived to be Dashkova's masculinity:

They rode together,
When Astraea descended from heaven
To ascend the throne;
But now — she is Apollo.

Even more revealing of attitudes never openly expressed is the offensive doggerel on the same painting found among Derzhavin's papers and ascribed to his quill. Undoubtedly circulated among his friends to the great delight of all, it is entitled "On the Portrait of a Hermaphrodite":

Her looks:
Are both a wench's and a bloke's.[11]

Derzhavin's allusions to Dashkova's masculinity, whether tacit or explicit, as well as the views of his contemporaries, reflect her uniqueness and distinctiveness. Precisely because she was so atypical of her time, Dashkova's life provides an early example of a woman's attempt to be successful and gain acceptance in a world dominated almost entirely by men. As an eminent woman of letters in eighteenth-century Russia, she was exceptional and different, mostly because the choices available to her were more representative of a man's life. Aleksandr Herzen, the nineteenth-century liberal author, critic of Catherine the Great's reign, and publisher of Dashkova's autobiography in Russian, was perhaps the first to evaluate

her achievements in light of Russian women and their history. He wrote that "with Dashkova, the *Russian woman,* awakened by Peter's reforms, emerges from her captivity, states her abilities and demands participation in governmental affairs, in science, in the transformation of Russia."[12] Following his lead, V. V. Ogarkov proclaimed her a pioneer in the struggle for the equality of women and a captive spirit who strove to clear new paths for women in Russia.[13] Nikolai Dobroliubov, the radical civic critic, would also emphasize Dashkova's singularity: "More serious-minded than her surroundings, imbued with enlightened ideas, skilled at adapting them to her life, toiling not to make a show of her own achievements but to be of actual use to others, she stood head and shoulders above contemporary Russian society."[14]

Indeed, as a public figure, writer, musician, patron of the arts, and administrator of the sciences, Ekaterina Romanovna Dashkova (née Vorontsova) was the first modern stateswoman in Russia and one of the first women in Europe to hold governmental office. With Dashkova, a Russian woman who was not born into a ruling royal family had stepped forward to play an active role in the political arena and became for a time the head of science and learning in her native land. In 1783, Catherine II appointed her director of the Academy of Sciences and the same year Dashkova founded and became president of the Russian Academy. For close to twelve years, she headed these two prestigious academic institutions of Russia. Because of her education, travel abroad, and writings, she was a leading figure in the introduction of eighteenth-century Russian culture to the West, while passing on French Enlightenment to Russia. She actively strove to institute reforms in Russia, to adapt and apply the ideas of the Enlightenment, and to establish new approaches to the education of Russia's youth. Dashkova considered education and the dissemination of enlightened ideas to be her life's work and she is associated with a number of leading institutes of higher learning. In addition to the American Philosophical Society, she was a member of the St. Petersburg Economic and the Berlin Natural History Societies, as well as the Royal Irish and Royal Stockholm Academies.

Personally, Dashkova stressed action, self-sufficiency, and the acquisition of knowledge in a wide variety of fields. She was a prominent woman of letters publishing translations of Helvétius, Hume, and Voltaire, and articles on education, agriculture, travel, and the pernicious influence of French culture. Her other writings included occasional papers, speeches, and an extensive epistolary output, a portion of which appeared posthumously in the *Archive of Prince Vorontsov*.[15] Additionally, she wrote aphorisms,

sketches, verse, travelogues, plays, and an autobiography. Her works appeared in various journals, often under the pseudonym "The Russian Woman" (*Rossiianka*), and since she published anonymously, many still require positive attribution. At the Academy she produced the *Russian Academic Dictionary* and participated in its compilation and writing. She was also one of the first women in Russia to work professionally as an editor, supervising the publication of several literary and scholarly journals, while attracting contributions from some of the leading intellectual figures of the time. Moreover, she was an accomplished naturalist interested in horticulture, landscaping, and gardening, and over the years she collected an extensive cabinet of minerals. She loved to compose and perform her music, and as an accomplished musician and avid ethnomusicologist, she collected and transcribed the folk music of Russia.

Dashkova is best known for her own story, *Mon histoire* (often translated as *Memoirs*), which is her most significant literary achievement and to this day remains a valuable source for the study of the political intrigues, social conditions, cultural life, and gender roles in Russia during the second half of the eighteenth century. Focusing on the palace revolution of 1762, her travels abroad, and her work as head of the two Academies, she completed the *Memoirs* in 1805, or five years before her death at the age of sixty-two. They present an older woman's final assessment of her career and family life, while allowing, perhaps for the first time, a glimpse through her many masks and disguises. Although Dashkova promised to hide nothing, in the dedicatory letter to Martha Wilmot, dated October 27, 1805, she confided to her friend deep-seated feelings that she was unwilling to explore or admit to openly elsewhere. She described her past as

> a life of sorrow, aggravated, indeed, by the efforts, which I have made to conceal from the world those distresses of the heart, of which neither pride nor fortitude could blunt the poignancy. In this respect, I may be said to have lived a martyr to constraint: I say a martyr, for to disguise my sentiments and to appear otherwise than I am, has ever been most repugnant and hateful to my nature.[16]

The sense of concealment, frustration, and confinement pervades Dashkova's *Memoirs*, but nowhere is it voiced with such clarity and force than in this letter.

Thus, Dashkova disguised her voice in the *Memoirs*, so that the autobiography became a kind of masquerade both revealing and concealing a narrating presence masked by a series of past and present identities. When

she came to write her life, she imagined it as a series of disguises based on sexual differentiation: from the daring and adventurous to the ordinary and expected, from dreams of escape and deliverance to the reality of alienation and isolation. In the end, despite Dashkova's many achievements, her eventual exile to the north of Russia added immediacy and a physical presence to the sense of disaffection that pervaded her life. A major source of the depressions from which she suffered from childhood, she was beset by feelings of inner loss and dispossession when, for example, she was repeatedly banished from St. Petersburg or during the years she lived abroad.

Existing biographical studies of Dashkova's life are not sufficiently critical and adhere too closely to the often-unreliable biographical and historical evidence Dashkova presented in the *Memoirs*. Mostly, they fail to consider her struggle for independence in a man's world as the defining feature of her life and art, her dreams and aspirations, her successes and failures. Above all, Dashkova revealed her life through her many masks, the narrative design of her story, and her individual, subjective vision. Therefore, if the *Memoirs* are an account of self-representation and self-affirmation rather than historical truth exclusively, gender becomes a central determining factor in her attempt to create and give written expression to her life.[17]

In her private and public lives, her prepossessions, impetuosity, the decisiveness of her pronouncements, and the strength of her character define Dashkova. As a result, the *Memoirs* are primarily polemical in nature and fundamentally reconsider and dramatize the events of 1762. She often wrote in direct response to contemporary accounts of Catherine's life, such as the histories of Rulhière, Castéra, and others. More than forty years had passed since the events she depicts in the *Memoirs*, and her decision to formulate and set forth a defense of her past was a strong, forceful act, and represented a desire to be correctly, according to her recollection, included in the historical record. She was presenting a justification for her support of Catherine and for her actions that brought down the legitimate heir to the throne. She disputed any falling out with Catherine, since toward the end of her life she idolized the former empress and challenged those who would disparage her memory. What she described is an elaborate staging of actual historical facts, and her literary performance was less a history and more a personal elucidation of her actions, with Dashkova forever at center stage. Dashkova disclosed her life through the integrated patterns of her subjective vision, as she selected and organized those materials that clarify and authenticate her identity.

She strove to present a cohesive, unified portrait of herself notwithstanding the dichotomies and incongruities she faced at home and on the stage of public events.

Yet the great value of her narrative is precisely its subjectivity. As Hyde would have it,

> Dashkova's *Memoirs* possess all the faults of the mass of autobiographical writings. They are incomplete, partial, and inaccurate; they exaggerate the significance of many incidents, while minimizing that of many others; they lack proportion; and many most important statements of fact which they contain require to be tested by reference to external authorities. They must therefore be read with caution; but they are well worth reading all the same.[18]

In fact, Hyde's warning concerning omission and inexactness in the *Memoirs* is very much to the point. Dashkova's life story cannot be properly assessed without reference to archival material informing her career and personal life, including domestic details, family difficulties, and the judgments of both her enemies and close friends.

In the first decade of the nineteenth century, her friend Catherine Wilmot was a keen, perceptive, and often critical observer of Russian life and of Dashkova's declining years. Having spent several years in her house, she concluded that it was almost impossible to give an accurate description of Dashkova. She seemed to be so complex and so unique for her time that in the end one only succeeded in describing a mass of human contradiction. Instances of her individuality immediately challenged any single generalization:

> Such are her peculiarities & inextricable varieties that the result would only appear like a Wisp of Human Contradictions. 'Tis the stuff we are all made of to be sure, but nevertheless nothing is more foreign from the thing itself than the raw materials of which it is made! And woe betide individuality the moment one begins to generalize . . . But she has as many Climates to her mind, as many Splinters of insulation, as many Oceans of agitated uncertainty, as many Etnas of destructive fire and as many Wild Wastes of blighted Cultivation as Exists in any quarter of the Globe![19]

The climates to Dashkova's mind were largely the result of her influence at court, subsequent banishment, and personal tragedies. They were a prod-

uct of her education, family, class, rank, position in society, court politics, and many other factors.

However, the perceived contradictions in her self-representation, the need to mask her opinions, and the disparity between her *Memoirs* and her actual life are primarily illuminated by her consciousness of gender and ability to appropriate it to her advantage as she took on various roles. Two oil portraits define the varieties and extremes of her actions and experiences—her dreams of public success and the reality of her exile.[20] The first is the work of Dmitrii Levitskii, academician and favorite portraitist at Catherine's court; he was a religiously minded man who eventually embraced Freemasonry. In Levitskii's idealized representation Dashkova stands straight and strong, meeting the viewers eyes directly and unflinchingly. Her characteristic features include heavy eyelids, a fixed, penetrating glance, and firmly, decisively pursed lips. She wears little powder in her hair, but her cheeks are well rouged and her hair is piled high, though not excessively, emphasizing a high forehead and hairline as was then fashionable. Elegantly attired in ruffled sleeves, fine lace, and rich, imported fabrics, as befitting a woman honored as a cavalier of the court and Catherine's lady-in-waiting, she is wearing the red ribbon and Order of St. Catherine and a miniature portrait of the empress with a blue ribbon. This is the official Dashkova, the woman of power and influence, about whom Catherine Wilmot wrote,

> For my part I think she would be most in her element at the *Helm of the State,* or Generalissimo of the army, or Farmer General of the Empire. In fact she was born for business on a large scale which is not irreconcilable with the life of a woman who at eighteen headed a revolution and who for twelve years afterwards govern'd an Academy of Arts & Sciences.[21]

The author of the second portrait is Salvatore Tonci, the Italian poet and artist, who advocated agnosticism and Descartes' method of Cartesian doubt, claiming that the only knowable reality is that he exists. In Tonci's representation, she is dressed in the garments of exile and opposition, the clothes she preferred at the end of her life. She now seems smaller, hunched, with her body hidden beneath her favorite man's dark greatcoat buttoned left to right. Her face is drawn and tired, without cosmetics, and her stare is no longer bold and challenging. Rather, it is pensive, preoccupied, and directed inward. Around her neck, as a token of friendship, she is wearing the silk handkerchief Catherine Hamilton gave her decades earlier. The stylish hairstyle is gone and something resembling a nightcap

(*kolpak*) covers her head. No longer a lady-in-waiting, she has removed all decorative ribbons. Only the medal of the Order of St. Catherine remains, the lone keepsake of the most important event of her public life, the coup d'état of 1762, and an enduring reminder of her feelings for Catherine II.

Dashkova sought to reconcile her actions with her sense of self. In a manner reminiscent of the two oil paintings, in her *Memoirs* she brought together a classical design of reason and restraint in her public life, with its motifs of power and influence, and a sentimental emphasis on feelings and emotions in her private life, with its motifs of depression, ill health, and exile. She was determined to formulate and give voice to her own history despite its many contradictions, to realize her personality in its entirety, and to discover her destiny outside established roles. Her tragedy, as expressed in her *Memoirs*, letters, and other writings, was that she could not realize her dreams and expectations within the accepted norms of eighteenth-century female behavior. But just as the donning of an officer's uniform empowered Dashkova and lent authority to her actions during the coup d'état of 1762, so too her autobiography was an assertive step back into the public arena—a type of rhetorical cross-dressing.[22] Despite the existing social conditions constraining Dashkova during her lifetime, she strove to open up new avenues for her suppressed energies. As a result of her efforts in her life and works, she isolated, clarified, and defined patterns of action, identity, and gender for herself as well as for other women.

PART I

Early Years
1743–1763

Chapter One

Education and Enlightenment

ASHKOVA WAS BORN MARCH 17, 1743, in St. Petersburg, the new capital of Russia, during an unprecedented age of women's rule.[1] Peter the Great founded the city only forty years earlier as a symbol of his determination to break with Russia's past and to improve links with the West. His imposition of reform and westernization on the institutions of Russia was to have a marked impact on the lives of all Russians, including noblewomen who abandoned the *kokoshnik*—a high-standing, colorful headdress—along with other forms of traditional clothing, donned European, décolleté dresses, and began to mingle in society. The Count de Ségur enthusiastically described the transformation and Europeanization of Russian women, writing that as opposed to their fathers, husbands, and brothers, they "spoke four or five languages, played various musical instruments, and were acquainted with the works of the most celebrated novelists of France, Italy, and England."[2] Not the least of Peter's reforms was the revision in 1722 of the law of succession, which undoubtedly was intended to pave the way for the elevation of his wife Catherine I to the throne. In the edict, he stated that the succession would be dependent on the reigning monarch's personal choice, not on primogeniture in the male line, and thereby ushered in a unique time in Russian history when women governed the country.

The latter part of the eighteenth century (from Peter's death in 1725 to Paul's assassination in 1801) saw eight occupants on the Russian throne. Five were women, with Catherine II reigning for thirty-four years. During Dashkova's lifetime Russia was primarliy ruled by women, and indisputably, her remarkable achievements in the public sphere would not have been possible at any other time of Russian history. Her education and childhood intellectual experiences defined her potential and directed her

into the area of public service. Precocious and gifted, her early reading exposed her to the ideas of the French Enlightenment with their emphasis on a life of the mind, science, progress, and social justice. She dreamed of eminence and achievement, of personal change through education and the transformation of society. Still, as a woman, she was confronted by the discrepancies between her gender and her social goals, between her longing for self-affirmation and the requirements of a socially acceptable self-effacement, between a private and public life, and between a desire for public recognition and the more culturally appropriate roles for female behavior.

Mystery surrounds Dashkova's birth. Her assertions that she was born in 1744 on the English Embankment, a fashionable row of houses in St. Petersburg on the Neva River, seem to be slips of the quill.[3] Archival records show that the Vorontsov family did not own a house on the English Embankment in the middle of the eighteenth century. In the reigns of Elizabeth and Catherine II, St. Petersburg experienced a great building boom as marshes were transformed into squares and everywhere, on the islands and along the canals, palaces and churches appeared. Yet St. Petersburg was still a city in progress: Many of the streets were narrow and covered with boards and only those around the Admiralty were paved with stones. In the best areas, such as the embankment of the Neva near the Admiralty, the luxurious two- and three-story houses stood side by side, but in other locations such as the Vasil'evskii Island, brick buildings were interspersed with lowly wooden shacks. Dashkova's older sister Maria was born in 1738 in their father's house on the Fifth Line of the Vasil'evskii Island and was baptized nearby in the Church of St. Andrew the First-Called—but Dashkova's certificate of baptism has not been found.

Dashkova's years span a period of wars, shifting alliances, and Russian expansion through conquest and annexations in Europe, the Baltic, and the Ottoman Empire. A marked rise in the family fortune prepared and facilitated her active role in the historical events of her time. According to the family genealogy, the Vorontsovs trace their origins back to Simon Afrikaner (*Afrikan*), a Viking who conducted raids along the coast of Africa. The youngest son of King Haakon I of Norway, he came to Russia in 1027 when his sister married Iaroslav the Wise, grand prince of Kiev. Later, he escorted his niece Anne to France for her marriage to King Henry I. Anne of Russia was the mother of Philippe I and reigned as regent during the minority of her second son, Baudoin V, Count of Flanders.[4] The Vorontsov family's direct ancestor was Fedor Vasil'evich Voronetz (circa 1400), from whom their surname is derived. From the fifteenth to the seventeenth cen-

turies, members of the family played a distinguished role in Russian history as commanders in the army, officers of the tsar's household, courtiers, and boyars. But there were also setbacks to their rise to prominence, and Ivan the Terrible executed six of twelve adult male Vorontsovs during his reign of terror. While questions remain concerning the historical accuracy of the lineage, it is clear that Dashkova never doubted the ancient roots of her family's past.[5] From her earliest years, she witnessed and participated in the family's elevation to unprecedented power and its influence on the development of Russian culture and history. After the palace revolution of 1741 and with the ascension of Empress Elizabeth to the throne on April 25, 1742, Dashkova and members of her family were to hold the highest offices of chancellors, viceroys, field marshals, senators, and ambassadors, among many other duties.

Her life began propitiously when the most august royal couple in the land held her at the font: Grand Duke Peter, the future Emperor Peter III, whom she would dethrone, and the newly crowned Empress Elizabeth, who on December 20, 1742, returned from her coronation at the Uspenskii Cathedral in Moscow. Dashkova stressed in the *Memoirs* that Elizabeth consented to serve as her godmother because of her close friendship with her mother and not because her uncle Mikhail Vorontsov had recently married the empress's first cousin Anna Skavronskaia, a commanding presence at court and member of the empress's inner circle, the so-called Elizaveta Petrovna's Cabinet. Dashkova thereby distanced herself from the most influential member of her family, head of the Vorontsov faction at court. A year after Dashkova's birth, Mikhail Vorontsov was the first in the family to be titled, when on March 27, 1744, Emperor Charles VII conferred on him the title of Count of the Holy Roman Empire. He had been a page in Elizabeth's court and stood on the footboard of her sledge as it sped in the night toward the barracks of the Preobrazhenskii Guards during the coup of November 25, 1741, that brought Elizabeth to the throne. Accompanied by Dr. Armand Lestocq, her German music master Schwartz, the brothers Petr and Aleksandr Shuvalov, and two young Guards' officers, he helped Elizabeth seize the throne. Thereupon, Elizabeth would remain dependent primarily on the support of Mikhail Vorontsov, the three Shuvalovs (Petr, Aleksandr, and Ivan), Kirill Razumovskii, and Mikhail Bestuzhev.

His subsequent service as vice chancellor (1744–1758) and grand chancellor (1758–63) corresponded closely to the period of the Seven Years War and the years of Dashkova's childhood and adolescence. During Elizabeth's reign, the most difficult time for Mikhail Vorontsov, in particular,

and for the Vorontsov family, in general, occurred in the mid-1740s, when Elizabeth discovered that Lestocq was in the pay of Britain, Prussia, and Sweden. Although she learned that Mikhail Vorontsov too accepted gifts from foreign powers, he was able to escape punishment. Nevertheless, his reputation was tarnished, and Catherine II would describe Mikhail Vorontsov as "a hypocrite if ever there was one" who was "in the pocket" of foreign ambassadors.[6] Removed from his duties at court in the fall of 1745, he and his family traveled for a year in Europe visiting Germany, Italy, France, and the Netherlands. While abroad, he furthered his political and cultural ties with the West; in Italy, for instance, he visited the Academy of Sciences of the Institute of Bologna and donated books and presents. For a number of years Mikhail Vorontsov remained in the shadow of the Chancellor Bestuzhev-Riumin, but as Europe headed steadily toward the Seven Years War, his fortunes began to improve. When Frederick II invaded Saxony in 1756, Bestuzhev lost power to Vice Chancellor Vorontsov and Ivan Shuvalov. With Bestuzhev's arrest, the empress herself came to Mikhail Vorontsov's house to announce his appointment as grand chancellor and on October 23, 1758, she promoted him to the most powerful civilian position in the Russian Empire.

Born into wealth and privilege, Dashkova grew up at the center of eighteenth-century political and cultural life in Russia. Mikhail Vorontsov's career predicted her own involvement in the politics of Catherine's reign, for like her uncle, Dashkova would play a major role in a successful coup, fall victim to the vicissitudes of court intrigue, and find it necessary to travel abroad. Nevertheless, rather than present her uncle as a model and antecedent to her own life story, and there were indeed many parallels, she chose to stress the personal relationship that developed between her mother and Empress Elizabeth. Elizabeth felt that she possessed few resources after Alexander Menshikov, Peter the Great's close friend and collaborator, had deprived both her and her sister of the greater part of their mother's bequest. She complained bitterly and never forgave the poverty that she, the daughter of Peter the Great, had endured after her mother's death. Her penury, as she saw it, became even more acute in the reign of Empress Anne, and Dashkova's mother, Marfa Vorontsova, came to Elizabeth's rescue, assisting her and supplying her with money. To a great extent, Mikhail Vorontsov and Dashkova's father, Roman, owed their advancement at court to Marfa's friendship with Elizabeth. In Dashkova's mind, the mother's story created a justification for her own actions, as well as a sense of continuity — an alternative genealogy based on the friendship of women, in lieu of the traditional family tree passing on a surname from

father to son. She therefore highlighted the solidarity that existed between Elizabeth and her mother as a legacy of mutual support among women, which mirrored and predicted her own relationship with Catherine II.

Dashkova lost her mother, Marfa, to typhoid fever when she was two years old and would always recall her fondly and with great veneration, if somewhat sentimentally. Marfa Vorontsova, née Surmina, was sole heir to a considerable fortune. She married Iurii Dolgorukii, a captain in the Guards, but the powerful Dolgorukii family fell into disfavor. Charged with undermining the health of the young tsar, Peter II, who had died of smallpox in 1730, Empress Anne found them guilty and exiled them to Siberia on the advice of her lover, Count Biron, who ushered in a reign of terror in Russia. Marfa petitioned Empress Anne and had her marriage to Iurii Dolgorukii annulled.[7] In 1735, when she was seventeen and he was eighteen, she married Roman Vorontsov and in ten years bore him seven children: Maria, Elizaveta, Aleksandr, Ekaterina (Dashkova), and Simon (Vladimir and Anna died in infancy). When her mother died, Dashkova was living in the country on a family estate where a peasant nanny and her maternal grandmother, Fedos'ia Surmina, cared for her.[8] At four, the warmth and security she had taken for granted came to an end, and she was sent to live in the cold and regimented splendor of St. Petersburg to receive a proper education. Her uncle, the vice chancellor, had agreed to take her in and a new and very different life awaited her.[9]

The court nobility was then constructing for themselves enormous palaces in St. Petersburg, and one of the grandest was Mikhail Vorontsov's. Dashkova first lived in her uncle's old house, which he soon replaced with a magnificent palace the architect Bartolomeo Rastrelli was building in the Russian baroque style.[10] The Vorontsov palace faces the Sadovaia Street, opposite the Gostinnyi Dvor, and at that time, its gardens extended down to the Fontanka Canal. Begun in 1746, its main features are the beautifully incorporated columns and the graceful railings at the front of the palace, one of the earliest examples of Russian artistic wrought iron, which is also Rastrelli's creation. For the young Dashkova the palace was a cheerless, official residence of gold and ivory, lacquer and luster, furnished in the French style: escritoires ornamented in gilded bronze, consoles with marble tops, and chairs of inlaid wood covered in silk and velvet. She felt lost and alone in the vast and uninviting rooms. Everywhere she looked, there was expensive artwork and statuary, parquet floors, crystal chandeliers, tapestries, walls decorated in the elaborate designs of imported damask, and oversize mirrors endlessly reflecting the splendor and extravagance of her new home. Catherine II would write inaccurately that Mikhail Vorontsov

had decorated his rooms with the furniture of Madame Pompadour, Louis XV's highly refined mistress. It was a gift presented to him in gratitude for his pro-French policies. Actually, the consignment consisted of a fine assortment of wall tapestries and chairs, possibly once belonging to Pompadour, but it was lost at sea during transportation to Russia. The generous French king replaced the lost items with new tapestries depicting scenes from Don Quixote as well as a series of engravings, books, and a cabinet containing a fine collection of medals.[11] Dashkova grew up in this luxurious palace and in Novoznamenka, situated just over ten miles outside of St. Petersburg on the Peterhof Road, the country house her uncle purchased in 1750 and then hired the architect A. Rinaldi to rebuild.

Despite this luxury, Dashkova's childhood was lonely and unhappy. Deprived of the care, tenderness, and concern of loving parents, her upbringing combined indulgence and neglect. Her uncle was embroiled in affairs of state and his consolidation of power, while political struggles and petty intrigues at court consumed her aunt, a social lioness. Most of all, they were perpetually concerned with their own elevation in society. Even worse, her father, Roman Vorontsov, did not play an important role in the rearing and nurturing of his daughter and took little interest in her well-being. Although it "was not unusual at least during the first years of . . . life, for the youngster to grow up without direct parental supervision," Dashkova's father did not understand her need for guidance or the effect its absence might have on her development.[12] She would never live with her father and was never close to him, as he was too involved in the social and political activities of the capital. More concerned with his personal affairs and pleasures, he chose to ignore her obvious sensitivity and intelligence. Dashkova tried to explain and rationalize his behavior toward her: "My father . . . was young and liked to enjoy life. He therefore paid scant attention to his children" (32). In his autobiography, her brother Aleksandr corroborated Dashkova's assessment that at the death of their mother their father was a young man leading a dissipated lifestyle at court and in high society. Others would be more forthright, writing that Roman Vorontsov had female acquaintances that he preferred to his daughters and that his mistresses embezzled him. Catherine bluntly stated that the father had "no fondness for Princess Dashkova."[13]

Roman Vorontsov was a general, senator, and eventually became viceroy of the Vladimir, Tambov, Penza, and Kostroma Provinces. Biographers frequently cite 1707 as the year of his birth, but Dashkova is correct and much more to the point when she writes that he was Mikhail's younger brother, born in 1717.[14] Already a major landowner, he came into vast ad-

ditional estates through his marriage to Marfa Surmina. A Freemason and determined politician, he considered himself to be an enlightened and cultivated man. For eight years of his life, Roman Vorontsov was involved in the writing of new laws and in the introduction of many needed reforms. In 1760, he persuaded the senate to appoint a committee to provide a new legal code under the presidency of three elected noblemen and three elected merchants, but the project came to a halt with Elizabeth's death. Then, on October 29, 1760, he was appointed chair of the legislative committee whose work would lead eventually in 1762, during the reign of Peter III, to the abolition of compulsory state service for the gentry. Thus, he participated in drafting the Manifesto on the Freedom of the Nobility, which was an important step forward in the modernization of Russia.

He was also a member of the Free Economic Society (*Vol'noe ekonomicheskoe obshchestvo*), a group consisting of nobles who furthered the study of agronomics and the applied arts. The Society's mandate included the study and dissemination of scientific information and to this purpose, it published the journal *Transactions* (*Trudy*). In its second and fifth issues, Roman Vorontsov published his articles on the establishment of grain reserves and ways to improve village house construction. The latter piece stressed the need to limit the power of stewards on the estate, a theme repeated by his daughter, Dashkova, who would also become a member of the Society in 1783. Although her father was unresponsive to his daughter's emotional and psychological needs, and they were mostly on opposite sides politically, when it came to questions concerning her estates, Dashkova maintained her father's views. In many ways, she continued and supported his work in her own writings and publications on economic issues. In 1775, Catherine made public the first part of the "Statute for the Administration of the Provinces of the Russian Empire." As a result of the newly created territorial divisions, Roman Vorontsov's duties as viceroy were expanded to include the administration of additional provinces. Interestingly, his son Aleksandr was deeply involved in the formulation and writing of these reforms, and Dashkova produced the maps reflecting these changes. Eventually, Roman Vorontsov would became a member of the Russian Academy, whose founder and president was his daughter, Dashkova.

According to the French envoy, Baron de Breteuil, "Roman Vorontsov was ambitious and vain and aspired to the chancellorship."[15] Historians too have not been kind to the memory of Dashkova's father. Following Mikhail Shcherbatov's lead, they have pointed to charges of corruption while repeating the anecdote of how Catherine presented him with a large purse on his name day, thereby poking fun at his dishonesty and

involvement in bribery.[16] Since there is no evidence to support such allegations, recent studies are reconsidering Roman's life and whether the accepted moniker of "Roman the large pocket" (*Roman bol'shoi karman*) is justified.[17] Catherine, who disliked and feared the powerful Vorontsov clan as a whole, characterized Roman Vorontsov as "the father of two young maidens at the court, and who I should say in passing was the bête noire of the Grand Duke [Peter III] and also of his own five children."[18] Over the years, Dashkova wrote repeatedly to her father, signing her letters as his "humble and obedient daughter" and expressing her sincere bewilderment at his silence. "Have I innocently given you cause to be angry with me," she pleaded. "If this is the case, I ask you dear father, to forgive me any transgression unwittingly committed."[19] Her father responded rarely. He produced a second family with his mistress Elizabeth Brockett, who bore him four children, Anna, Maria, Aleksandra, and Ivan, who acquired the surname Rontsov.[20]

Dashkova's siblings were also absent from her life and she saw them infrequently. Maria and Elizaveta, her sisters, were maids of honor at court—the oldest, Maria, served the empress, and Elizaveta, the Grand Duchess Catherine. Since Catherine and Elizaveta would become mortal enemies competing for the throne of Russia and the heart of the emperor, Catherine's subsequent description is hardly objective and highly uncomplimentary:

> The Empress had engaged the two Countesses Vorontsova, nieces of the Vice Chancellor and daughters of Count Roman, his younger brother. The elder girl, Maria, may have been fourteen; she was placed among the Empress's maids of honor. The younger, Elizabeth, was only eleven, she was given to me. She was a very ugly child with a sallow complexion and she was extremely dirty. They both started out in Petersburg by catching smallpox at court, and the younger one became even uglier as a result because her facial features were totally deformed and her face was covered not with pockmarks but with scars.[21]

Of all her brothers and sisters, Dashkova received the least amount of attention. Simon and Aleksandr lived with their grandfather, Illarion Vorontsov, and father respectively. On occasion, the brothers would visit their uncle's house, especially when Simon fell in love with his cousin Anna Vorontsova. But Dashkova never got on with Simon and was closest to her brother Aleksandr, who would remain a trusted friend for the rest of her

life. Despite some difficulties, the events of 1762 and her complete falling out with her family could not destroy their relationship.

She grew up with her cousin, Anna—Mikhail and Anna Vorontsov's only child—who was her exact contemporary, yet the two girls had very little in common. "The same room, the same masters, even dresses cut from the same cloth, all, in fact, should have made us into two perfectly similar individuals; and yet never have two people been so different at all the various periods of their lives" (32). Anna lived her life fashionably, in a world of coquetry, balls, and court functions, spending hours on her appearance and gaining full proficiency in the art of dancing, singing, and talking to fashionable and influential persons. Along with her mother, she was completely at home in the artificial and mannered setting of the court. Much of the girls' early instruction was centered on the need to be engaging and to perform with poise at social events. A great deal of time was devoted to the cultivation of proper manners and ladylike deportment, and to becoming self-possessed and accomplished young women who could conduct themselves properly at home and at court.

Dashkova and her cousin were constantly on stage, and great emphasis was placed on theatricality with its sense of the dramatic. The grace of their bearing, the distinguished carriage of their movements, the elegance of the slightest turn of the head, were all watched and evaluated. Even at home, all eyes were on them. The palace was abuzz with family and friends, officials attached to the vice chancellor, domestic servants, butlers, valets, barbers, cooks, bakers, stewards, housekeepers, yardmen, coachmen, grooms, gardeners, tutors, governesses, nannies, musicians, and others. As Lotman has pointed out in his study of masquerade and theatricality in eighteenth-century Russia, "To behave properly was to behave . . . in a somewhat artificial manner, according to the norms of somebody else's way of life."[22] Life itself was a theatrical production, and they were expected to maintain a stage presence through perfect mastery of etiquette and demeanor. They were taught to dress properly at a time when both men and women of the *haute noblesse* wore colorful French clothing made of satin, moiré, and velvet, often sewn with silk and embroidered in gold. Silk stockings and shoes with red heels were the rage.

At official functions, full court dress (*grand habit de cour*), with tightly strung bodices (instruments of torture for young women), wide-hoop skirts, and powdered hair were *de rigueur*. Although their every movement was constrained, they were instructed on how to be graceful, lightly dance the minuet in their cumbersome dresses, and glide effortlessly on the parquet

floor in their satin slippers. Physical beauty was stressed, yet the young, clever, and impressionable Dashkova always felt that she lacked the requisite elegance, attractiveness, and social graces. She was not beautiful, or even pretty; rather, she was intelligent with a lively inquisitive mind and a forceful personality. For Dashkova the fashion of the day and the wearing of corsets and the paniers, literally cages composed of plaited cord, strips of metal, osier, or whalebone, strangled her body as well as her mind. Every attempt was made to train her to be docile, submissive, and never to put on airs, but Dashkova was straightforward, blunt, and decisive, and even as a child she could be impatient and brusque in her dealings with others. The strong-minded and willful girl did not fit in a society that prized female modesty and obedience.

Although she felt unappreciated and unloved, Dashkova received an excellent, even if thoroughly conventional education, with major emphasis placed on social skills and the fine arts. Mikhail Vorontsov spared no amount of money on the education of his daughter, and as a result, his niece benefited greatly. He appointed as their tutor Fedor Bekhteev, a diplomat and his protégé. Mikhail Vorontsov must have been pleased with his work, and recommended him for promotion; when Dashkova was thirteen, Bekhteev was named tutor to the four-year-old Grand Duke Paul. Two years later Nikita Panin, second cousin of Dashkova's future husband and her most influential political mentor, replaced Bekhteev as tutor to Paul. In many ways, Dashkova's upbringing and education were hardly different from that of many of her fellow noblewomen, and her home schooling was far more superficial than that of her brothers.[23] The goal was to create an accomplished, polished, and educated—but not too educated—young woman. She acquired certain practical knowledge such as fluency in a number of foreign languages: German, Italian, French— which was stressed—and Russian, which was an afterthought and never emphasized. (Dashkova acquired English later in life.) Drawing masters taught her art and music masters gave her lessons in voice and harpsichord. She also studied history, geography, arithmetic, and catechism. Instruction in the history and observances of the Russian Orthodox Church played an important role in her early development. She attended services in the palace chapel and stood there for what seemed to be hours as her legs ached and her mind wandered. She would stare at the crucifix high above the altar and the bas-relief of the two Marys represented as kneeling angels. As a child she could not imagine then that twice in her life she too would know a mother's inconsolable grief at the death of a son.[24]

Dashkova felt that her education had not prepared her either intellectu-

ally or emotionally for her life in the future, nor had it addressed her interests and talents. In a description of her childhood education, Dashkova does not mention music or voice lessons. Yet the enjoyment of music was central to her life and she must have had extensive instruction, since she was expected to sing and dance to a certain level of elegance and to achieve a high level of musical expertise. Music, especially her harpsichord, Italian songs, and favorite operas, would always remain an important area of interest. When she requested advanced, professional instruction in voice and performance, it was denied her, presumably because it was not considered appropriate training for an accomplished young noblewoman. It was thereby assured that she would remain a gifted amateur, but Dashkova would never be satisfied with mere dilettantism. Later in life, and with a note of bitterness and sarcasm, she commented on the inadequacy of her education: "Everybody had to agree that our education left nothing to be desired. And yet, what was done for the improvement of our hearts and minds? Nothing at all" (32). For most young women education ended with their entry into society and marriage, but Dashkova was an exception. She remained a committed autodidact, since she felt that her upbringing was defective and incomplete with regard to the acquisition of knowledge and virtue, and the formation of a moral character. She could attain her educational goals in life only through a long and demanding process, and she was determined to transcend the limitations of her inadequate instruction through self-sufficiency and the firmness of her resolve.

Unquestionably, her lifelong studiousness and the seriousness of her reading distinguished Dashkova from most of her peers. Because of her inquisitive mind, she became a voracious reader, and E. Likhacheva concluded,

> While still young, [Dashkova] began to read serious books. In this respect Princess Dashkova was an exception not only among the women, but also among the men of the Elizabethan period. In general, she was the first, and throughout many long years remained the sole, Russian woman who was educated in the European sense.[25]

In the second half of the eighteenth century a typical woman's library consisted of innocuous or scabrous French romances and works dealing with the domestic sphere—the world of children and the household. Dashkova seems to have completely disregarded the light, popular, and often mildly risqué romances, the so-called *livres du boudoir*, which were in favor with many women. It was her choice of subject matter that led to her emancipa-

tion from conventional and routine views and habits, so that her reading developed a yearning for higher ideals, philosophical contemplation, and a satirical and critical attitude toward contemporary society. In this, she differed greatly from her sister Elizabeth. Records at the Academy Bookstore show that in a list of foreign books for October 1762, which were taken on credit, Elizabeth's tastes ran to entertaining, fashionable French publications such as *Amusements des dames, Galanteries des rois de France, Galanterie d'une religieuse, Recueil de frivolités, Avis aux jeunes gens,* and other such books.[26]

Hence, on the one hand, Dashkova was brought up in the best European tradition of the time, based on the established view of women as the unfailing supporters of their husbands, educators of their children, and supervisors of their families. In addition to expectations relating to female accomplishments, she was prepared for the customary roles of wife, mother, and tutor to her children in the fields of religion, morals, and politics. On the other hand, Dashkova was self-educated and her reading advanced her far beyond the general needs of wife and mother into areas of professional and scholarly competence. By her own admission, she strove to read everything she deemed important, and at thirteen, having liberated herself from the stern guidance of her governess, she spent all of her money on the acquisition of serious books.[27] It would be a lifelong passion, and in June 1764, Simon complained from Vienna that Dashkova and their sister Maria had removed the books he had left in Russia. Three years later, at the death of Mikhail Vorontsov, Simon was given his choice of books from his uncle's library. He selected some three hundred to four hundred volumes, although Dashkova had beaten him there and had removed over five hundred of the best volumes.[28]

Dashkova's education came to an abrupt halt when she fell ill with measles and was required to leave her uncle's house. Measles, cholera, and smallpox were the dreaded diseases of the age and greatly feared at court, especially after smallpox had infected several members of the royal family. In order to guard the Grand Duke Paul in particular, she was quarantined at the first symptoms of measles and confined to a family estate ten miles outside of St. Petersburg under the oppressive eyes of her German governess and another woman, both of whom the rebellious youngster disliked thoroughly. There she felt even more alone and abandoned, and her isolation would be a defining moment in her life, establishing the seemingly inevitable design in her future of an active, unconventional life and proximity to power, followed by banishment, reclusiveness, contemplation, and the sustaining power of study and reading. Her music, writing, and above all books—her best and most trustworthy friends—would provide

her with constancy, permanence, and unwavering companionship in an otherwise uncertain and capricious sphere of service to the crown. Indeed, almost a half-century later, it would be the same Grand Duke Paul, who upon his ascension to the throne would immediately order Dashkova into her most rigorous and distant exile.

In the isolation of the Russian countryside, she was lonelier then ever, and her virtual captivity on the estate became all but intolerable when the measles affected her eyes. With the ensuing blindness, her usual strength and resolve failed her, leaving her vulnerable, anxious, and beset by self-doubt. No longer able to indulge her greatest passion, reading, alone and in the darkness, she grew introspective and began to reconsider her life in her uncle's house, her family, and her future. The palpable immediacy of the splendor and luxury she had been immersed in fell away, and she saw more clearly the life being prepared for her. The women surrounding her, family members and friends, embodied the stifling and conventional possibilities available to her. Dashkova's aunt Anna Vorontsova, a lady-in-waiting, was active at court serving the empress and in charge of the royal household. She passed the time at court gambling at various card games such as pharaoh, a destructive pleasure prevalent among the leisured and privileged class. She was famous for her fondness of English beer, and was the mistress of the Saxon Sieur Prasse, secretary of the legation and resident of Saxony, which, according to some commentators, explained the accuracy of the legation's dispatches.[29] Her daughter, Anna, was drawn to the glitter of St. Petersburg society and was to gain some notoriety for her amorous adventures. It was whispered at court that the mother loved cards, while the daughter loved men. In 1758, shortly before Dashkova's marriage, Anna wed Aleksandr Stroganov, a senator, president of the Academy of Arts, and director of the Public Library. Anna traveled abroad in 1761, when Empress Elizabeth sent Aleksandr Stroganov to Vienna to congratulate Maria Teresa on the marriage of her son Joseph. Anna's marriage, which had begun so brilliantly, was to end tragically, and in time she would grow to detest her husband and would be unable to "bear the sight of him" (60). Opposing political views aggravated their marital incompatibility, with Stroganov supporting Catherine II. The unhappy union came to an end when Anna's early death averted the initiation of divorce proceedings.

Dashkova's sisters also followed traditional paths: Maria was forced into a prearranged and unhappy union with Petr Buturlin, although she was in love with another.[30] Elizabeth became Peter III's mistress, participating in his crude games and raucous drinking bouts. In contrast, Dashkova envied

the choices available to her brothers and the attention bestowed on them as they were being groomed for careers in government or military service. Mikhail and Roman Vorontsov oversaw and financed the education and travel of her brothers, who enjoyed the full attention of the family, for they were being prepared for a life of action and influence. In many ways, Dashkova was to emulate her older brother Aleksandr, who was also interested in literature, philosophy, politics, and public service. Their father provided the boys with the best education possible and ordered books for them from France, among them the writings of Voltaire, Racine, Corneille, and Boileau. In 1754, Aleksandr and his brother Simon were sent to study at a private boarding school run by Professor Schtrube, a specialist in jurisprudence at the Academy of Sciences. When he turned seventeen, Aleksandr, through the intersession of the French ambassador L'Hôpital and with Louis XV's permission, was enrolled at the L'Ecole de Chevaux-légers at Versailles where he studied with the sons of French aristocracy. His uncle and father wrote to him frequently providing guidance and support. Aleksandr was a serious young man and complained often about wasting his time on empty activities such as horseback riding and dancing, rather than on the development of the mind. He remained in Paris for seven years and met representatives of the French Enlightenment such as the philosopher and mathematician Jean d'Alembert. Subsequently, Aleksandr corresponded with Voltaire. His father decided that a Grand Tour of Europe would be required to complete his education, and from the end of 1759 to 1761 Aleksandr traveled in France, Italy, and Spain, visiting Rome, Pisa, Naples, and Vienna, before going into government service, initially abroad in the diplomatic corps and eventually in Russia.

Simon, Dashkova's younger brother, would also travel. At sixteen, his father sent him on a journey across all of Russia to inspect the family's extensive holdings, estates, and copper-smelting mills in the Urals. He was expected one day to manage the family fortune, but such plans would never be realized, since his career would be abruptly interrupted by Dashkova's political activities. Eventually, Simon would live abroad, first occupying diplomatic posts in Vienna, Venice, and London and then as a private citizen in England. Dashkova too felt the allure of far away places. From an early age she dreamed of traveling to foreign lands, of learning about the world, and of perhaps someday putting her knowledge to good use for the betterment of humanity.[31] Deprived of her brothers' opportunities, she was convinced that if she could uncover the inner strength and resources to do so, she would study and travel on her own, with or without the help of her father, uncle, or anybody else.

Her dreams of becoming an eminent woman in the man's world of her brothers made her exceptional and incongruous mostly because in her public life—as opposed to her inner, private self—she was representative of a man's life. Perhaps painting too broad a picture of the condition of noblewomen in Russia, Lotman explains: "The availability of *choice* sharply separated the nobleman's behavior from that of the peasant. It is curious that from this point of view the behavior of the noblewoman was much closer in principle to that of the peasant than to that of the nobleman." He then provides a diagram of behavioral choices in a nobleman's life that defines without exception the possible paths that Dashkova chose to follow.[32] She decided to participate in a palace revolution, to overthrow the government of Russia, and to travel abroad where she became a prominent figure in the intellectual circles of eighteenth-century Europe. Interestingly, while Dashkova argued unconvincingly that state service was unsought and a surprise, she did not feel unqualified for military service. It seems that she petitioned for a regiment of guards to be placed under her command, but Catherine denied the request. In fact, Dashkova always aspired to public service, and only when opportunities did not materialize did she fall back on her family, education of children, and the administration of her estates.

Soon the measles began to fade and her condition improved as the swelling on her eyes subsided. Dashkova presented the recovery of her eyesight in the *Memoirs* as a moment of illumination and enlightenment, from the darkness of her present life to the light of hope and aspiration. Now stronger, she was committed more than ever to the creation of her future in an unconventional manner, modeled more on her brothers' lives, rather than her sisters'. Controlled, serious-minded, and determined, she sought support and consolation in books and began the process of self-instruction by exploring the extensive library on the estate. Although she was young, and not yet capable of absorbing everything she read, her awakening to the new ideas of the French Enlightenment occurred when she was introduced to Bayle, Montesquieu, Voltaire, and Boileau. They opened her eyes to the spirit of freedom, human dignity, and the transformation of society by means of the education of the people, the dissemination of science and learning, and the fight against superstition. As she saw it, personal change through education would lead to social change and was the most effective way of bringing about reforms. The creation of a just society depended on a properly enlightened citizenry prepared to fulfill conscientiously and willingly their civic responsibilities before family and the state. Accordingly, a world of reason, intellectual energy, and critical thinking opened

up before her. Although she hardly mentioned Rousseau's influence in the *Memoirs,* and seemed to disapprove of his ideas, her library contained an extensive collection of his works. Indeed, Voltaire and Rousseau were important early influences, their works echoing her own dislike and deepseated mistrust of everything artificial and hypocritical, particularly St. Petersburg court society. She began to reconsider and revaluate the world in which she lived: the irrational and often contradictory nature of the established order, the hypocrisy of power at court and among the clergy, the backwardness of Russia and its institutions, the low quality of education at all levels, and the evils of governmental corruption. And the most troubling of all was the reliance of the economy on the injustices of serfdom, a system in which landowners had full and complete power over the men, women, and children they owned. These were the questions she would address honestly, if not always adequately, for the rest of her life.

When Dashkova returned to St. Petersburg, her ideas came head to head with the opulence and lavishness of her surroundings. She felt more isolated than before, even when among crowds of people and attending official functions or dinners at home, which were elaborate affairs with some two hundred persons in attendance. Again, she felt that she was always on display and alone, and the loneliness she experienced publicly and privately was to be one of the main factors to influence her development and form her character. She had no one to turn to, rarely saw her brothers and sisters, and Aleksandr, her closest friend, was far away studying in Versailles. She grew listless, reserved, introspective, and was depressed by the coldness of her uncle's house, the indifference of her family, and the juxtaposition of her intellectually stimulating reading and the artificiality of her life. Her inability to resolve the discrepancy between firmly held principles and her everyday existence, to realize these principles fully in the process of self-creation, and to apply them successfully to her life were to have tragic consequences. She felt strongly the contradictions that existed between the goal of maintaining a free and independent existence and the servility required at court. Court society strangled the development of her energetic nature, to the point that her solitude and sense of alienation developed into a psychological crisis. They were major causes for the recurring darkness and depressions that would pursue her continually to the end of her days, and by her own admission, only her religious beliefs prevented her from taking her own life.

As her psychological condition worsened, it was noticed at court and there were fears of a nervous breakdown. The empress's personal physician, Herman Boerhaave-Kaau, treated her depression ("melancholy")

but could not find any underlining physical ailments for her ill health.[33] Nor was there anybody with whom she could share her innermost feelings, and who was truly concerned about her inner turmoil.

> Thereupon I was subjected to innumerable questions. Most of them, however, dictated neither by feeling nor by any interest for me and thus could not draw a sincere confession from me, a confession, which, in any case, would have presented nothing but an incoherent portrayal of my pride, of my wounded sensibility, of my resolve to become all I could be by my own efforts, and of my presumptuous attempt to be self-sufficient (33–34).

As time went on and she grew older, Dashkova would learn how to camouflage and conceal her dreams, aspirations, and true feelings.

Dashkova grew up in one of the most extravagant and luxurious courts in Europe, a place where great emphasis was placed on mask, costume, comportment, and lighthearted entertainment. Empress Elizabeth's interest in elaborate dresses of hand-embroidered silks turned into an obsession. She claimed to have lost some four thousand dresses during the fire of 1744 in Moscow, and at her death, she is said to have left some fifteen thousand dresses in her wardrobe. The Vorontsov children were often taken to Elizabeth's specially organized court fêtes, concerts, and theatrical presentations. In winter, they participated in outdoor and indoor festivities, games, and sledging parties. The empress organized balls for children (*les bals d'enfants*) in the interior apartments of her palace. Such occasions provided the children with a training ground for their future presentations at court.

Elizabeth loved balls and lavish receptions, events that were grand operatic spectacles. The opulence of the ballrooms dazzled Dashkova as a young girl: the blinding light of the chandeliers and everywhere the smell of exotic perfumes, powders, bright rouge, and the pomatum applied to fix the powder to the hair. At the empress's grand entrance, the women in her cortège were attired in the finest bejeweled trappings: exquisite dresses of shimmering gold and silver lace trimmings with flowing sleeves and long trains. Covered in precious and semi-precious stones, the dresses distended widely around the waist, requiring the women to keep their arms bent at the elbow as they carried their closed fans, silent in the presence of Her Majesty.[34] Dashkova looked in awe at their unnaturally high coiffures (*poufs*) with imaginative and elaborate ornamentations. The stylish headdresses were fancifully identified as blossoming pleasure or delightful

simplicity and could be adorned in anything from miniature doves and cupids to ships and military encampments. Men too wore the latest French style, and were no less aglitter with rows of diamonds all over, on their hats, buttons, buckles, epaulettes, and saber hilts.

Dancing was at the center of these balls with the minuet as the main, opening dance, followed by the polonaises and contra dances. In time, the quadrille, cotillion, and the ecossaise gained in popularity. They set the tone for the light, gay chatter that avoided depth, erudition, and profundity as deathly boring and was based on witty repartee, all in the spirit of lightness and ease. While there was a certain charm and even freedom of communication between men and women at these functions, they lacked the intellectual and educational rigor that Dashkova sought. She soon concluded that they were tiresome. At fifteen Dashkova declared that she would never use powder or rouge and found that rouge and the very idea of painting bright red circles on her cheeks repugnant. In later life, highly critical of Castéra's work, she objected to his representation of her as a provocatively dressed society beauty.[35] Most eyewitnesses, Martha Wilmot among them, contradict Castéra's description and write that Dashkova was simplicity personified, a plainly dressed woman in an age of sartorial excess, with no conception of what a love of dress meant.

Predictably, Dashkova grew tired of the mindless diversions and frivolity at court. The romantic role-playing of masked balls and masquerades, however, was an exception. Masquerades had the capacity, at least for a time, to grant her a degree of freedom and a sense of newfound power. Especially entrancing where the so-called metamorphoses, when all the guests were required to attend masked, with the men dressed as women and the women dressed as men. Women were thereby allowed to take on new roles usually forbidden them and could dress up *en militaire* for fun and the entertainment of others. Elizabeth thought she looked dashing in military uniforms and often planned masquerades where the men were comically attired in dresses. Although such transvestite events proved extremely unpopular with most of her male guests, the women seemed to enjoy them as much as Dashkova, and they were repeated regularly thereafter into the reign of Catherine, who delighted in the metamorphoses. While they were often ridiculed, even the most powerful men in Catherine's court felt obliged to participate in these celebrations of cross-dressing. During the Christmas merriments of 1765, the doors to the empress's inner chambers opened and seven "ladies" emerged. Some of Catherine's most influential supporters — G. G. Orlov, A. S. Stroganov, N. A. Golovin, P. B. Passek, L. A. Naryshkin, M. E. Baskakov, A. M. Belosel'skii — had dressed

up as women, with Belosel'skii especially striking in the simple attire of a governess.

"A man's dress is what suits her [Catherine] best," wrote Lord Buckinghamshire, the British envoy; "she wears it always when she rides on horseback."[36] In a disposition for a masked ball at court Catherine stipulated,

> There will be four stalls of clothes and masks on one side for men and the same on the other side for women. The French comedians will act as tradesmen and tradeswomen and distribute women's dresses to the men and men's clothes to the women. The stalls with men's clothes will bear an inscription: *Clothes' shop for Women* and on the women's stall there will be an inscription: *Clothes' shop for Men*.[37]

On another occasion only some of the guests cross-dressed and Catherine recounted how masked and attired in an officer's uniform, she flirted eagerly with Princess Nastasia Dolgorukaia.

> I put on an officer's uniform and over that a pink domino and, entering the hall stood in the circle where dancing was going on. . . . The Princess threw a glance at me as she passed by. I rose and followed her, we returned to the dancing circle, and I took up a place near her. She turned round and finding me there, asked: "Mask, can we dance?" I said yes. She suggested we should dance and as we circled round I pressed her hand. . . . After the dance I bent over her hand and kissed it. She blushed and left me at once.[38]

The spirit of cross-dressing and the masquerade was extended beyond the confines of the palace. Both Elizabeth and Catherine gained the throne by force of arms dressed as officers rather than grand duchesses. They were excellent horsewomen, and both eschewed the sidesaddle. Resplendently attired as men, they regularly rode out astride in firm control of a high-strung horse. Catherine loved to ride in the masculine manner on her favorite stallion, Brilliant, but Elizabeth strictly forbade her to do so, on the assumption that after she became a woman, such practices were allegedly a cause of miscarriages. Catherine was forced to order a convertible saddle so she could indulge her great passion, and in opposition to the empress's prohibition, disguised as a man, she would slip out of the palace. At home, the thirteen-year-old Dashkova possibly met or heard rumors about the French envoy, Chevalier d'Eon de Beaumont, who bore an astonishing resemblance to a certain Lia de Beaumont. The resemblance led to the

conclusion at court that they were the same person, since on one occasion the Chevalier was supposedly seen traveling to France dressed as a woman. The Chevalier was often in the company of Mikhail Vorontsov, who amused others with stories about this mysterious woman.

Eventually, Dashkova's lack of enthusiasm for the amusements and gaiety of court entertainments subjected her to the jeers and ridicule of her friends and relations.[39] Proud and independent, she attempted to conceal her feelings of isolation and dissatisfaction, disguising them as best she could. She continued her studies and books became her primary interest. Because of his great erudition, she was drawn to the handsome Ivan Shuvalov, champion of the muses and the lover of Empress Elizabeth. A Francophile and enthusiastic patron of literature, the arts, and learning in Russia, together with Lomonosov he founded Moscow University in 1755 and was its first curator. In St. Petersburg, he also established the Russian Academy of Art, which he headed until 1763. His house was situated nearby, on the corner of Nevsky Prospect and Bol'shaia Sadovaia, and over the years Dashkova participated in his literary circle, a gathering place for many of the most influential Russian writers of the eighteenth century. There, in a brightly lit corner room, the intellectual elite of St. Petersburg would come together in the evening for discussions of art, literature, and philosophy. Over the years, the Shuvalov soirées included Lomonosov and Sumarokov, famous for their noisy and heated debates, and the habitually intoxicated Kostrov, translator of Homer. Derzhavin was among those who attended as well as Bogdanovich the dandy, who was always dressed in the latest French fashion and refused to discuss his own works, preferring current events. Shuvalov would sit back in a large armchair, surrounded by books and friends, most often speaking Russian and regularly punctuating salient points with French words and phrases. He was charmed by Dashkova, the eager and erudite young woman, encouraged her, and acquired for her all of the latest editions from abroad.

Dashkova's library would soon grow to some nine hundred volumes, and in time would number an estimated 4,500 volumes. It was to become one of the major eighteenth-century collections in Russia.[40] Dashkova wrote, "Never would the finest piece of jewelry have given me as much pleasure [as a book]. Thus, it was that all the money I could spare was spent on the purchase of books (35). She acquired Louis Moréri's *Le Grand Dictionnaire historique,* and Diderot and d'Alembert's *L'Encyclopédie ou Dictionnaire raisonné des sciences, des arts et des métiers,* which appeared in seventeen volumes (with eleven volumes of plates) between 1751 and 1772. These volumes arguably represented the greatest literary monuments of the

eighteenth century Europe, and the articles in the *Encyclopédie* introduced Dashkova to the writings of Diderot and other *philosophes* such as Condillac, Montesquieu, and Helvétius. The *Encyclopédie* was all the more attractive to the young woman since it was temporarily suppressed in the late 1750s and the pope condemned it in 1759. In addition to writing about the latest scientific discoveries, particularly in the natural sciences, the *philosophes* advocated reforms based on the ideas of the Enlightenment in commerce, government, and other areas. They introduced her to the notion of progress through natural philosophy and the objective study of nature and the physical universe before the development of modern science. Their ideas sought to secure social justice through the enlightenment of people, the development of their rational capabilities, and the establishment of legal and governmental systems that were fair and equitable. The impressionable Dashkova began to reconsider her elite life of luxury as she was exposed to a spirit of opposition to inequality, abuses of justice, intolerance, and religious authority.

Her reading trained her to look critically and irreverently at the world of her childhood. Rulhière writes that at fifteen she held republican views, spoke against Russian despotism, and admired civil liberty and religious tolerance: "She exclaimed vehemently against Russian despotism and declared her intention of going to settle in Holland, the civil liberty and religious tolerance of that country were her favorite topics."[41] Her impatience with the status quo was based on the expectation that the transformation of society could be achieved through the rule of law, democratic principles, and individual freedom, and that a proper education of the citizenry and the authority of science and learning would support gradual change. Dashkova was not advocating the revolutionary overthrow of the existing order, but the introduction of reforms based on a new relationship between the state, its leaders, the ruling class, and the people. For her, the *philosophes* were primarily critics of despotism and tyranny. They called for a model form of government organized on the principles of reason, law, and humanism to replace antiquated, crude, and immoral systems.

A seminal study that crystallized Dashkova's ideas on the inseparability of education and the transformation of society was K. A. Helvétius's *De l'Esprit*, a work that influenced other progressive Russian readers, Radishchev among them. Helvétius published his treatise in Paris in 1758, but a year later by order of the Paris parliament the book was condemned and burned. In the first volume, to which Dashkova referred in her *Memoirs*, Helvétius discussed the intellectual equality of all people, from which follows the radical idea that regardless of origin, anyone who has devel-

oped and cultivated their intellectual potential can govern. Agreeing with Locke's doctrine that an individual's mind is originally a blank tablet, Helvétius maintained that we are all born with equivalent abilities and that distinctions develop from the totality of educational influences. However, the lack of practical recommendations in the application of these ideas disappointed Dashkova.

> On rereading Helvétius's book *De l'Esprit* I was struck by the thought that unless it were followed by a second volume better adapted to the understanding of most people, enumerating a theory more applicable to the circumstances of the time and generally accepted notions, its principles would merely serve to destroy the harmony and break the link uniting the several parts which both promote and constitute civilized society. I cite this reflection of mine because it gave me later much real satisfaction (34).[42]

Dashkova was referring to Helvétius's elaboration of his theories in *De l'homme*, published many years later under a false imprint, which lead to some confusion concerning the first edition. It is likely that the volume appeared in The Hague (1773) with the support of the Russian ambassador to the Netherlands, Dmitrii A Golitsyn, with whom Dashkova was well acquainted and who is mentioned several times in her *Memoirs*.[43]

Dashkova sought to bring together theory and practice. For her, theory was important mostly in its practical application and the measure in which it could be understood more fully and used to promote a better society. Her uncle's house constantly resonated with current political discussions. Affairs of state always held her interest, for she dreamed that despite being a woman, it might some day be possible for her to participate in the great changes that, based on her readings, seemed to be imminent. Her indulgent and distracted uncle often allowed her to rummage among his official papers, so that in addition to philosophical tracts, she read negotiations, treaties, and agreements with distant lands, and these too were the narratives that stirred her imagination. Often, even as a child, she found humor in these documents as, for example, when the Shah of Persia wrote Catherine I, the wife of Peter the Great, warning her of the evils of alcohol, unaware of her great fondness for vodka.

She also listened avidly to stories about her family, her mother's life at court, and the time-honored custom of Russian tsars to punish minor opponents and transgressors by assigning them the role of buffoons. The unfortunate victim of the monarch's cruel games would immediately become

a laughing stock at court or even worse, the object of beatings. Empress Anne's amusements were often coarse and cruel. For instance, Mikhail Golitsyn, an educated man who had graduated from the Sorbonne, was obliged to cackle like a hen while sitting on a basket full of straw and eggs. The monarch had also subjected Dashkova's mother to insults, brutality, and abuse, when she ordered her to perform a Russian national dance with three other married women in the empress's presence. Nervous and intimidated, they missed their steps. Thereupon, the empress rose, walked over to the trembling young women, and slapped each of them in the face. Little did Dashkova suspect at the time that she too would become the object of ridicule and derision on the part of the monarch she served. But as her understanding of Russian society grew she began to discern the impact an autocratic state could have on a woman and her family, leading to "the foreboding that I would not be happy in this world" (35).

Her uncle was a generous patron of science and the arts, so at home she met many writers, artists, and scholars. Greatly interested in literature and antiquities, Mikhail Vorontsov possessed a magnificent collection of curios, corresponded with Kantemir, and supported, among many others, the mathematician and physicist Leonard Euler. Along with Ivan Shuvalov, he was a major patron of Russia's celebrated man of learning M. V. Lomonosov. Lomonosov was a frequent visitor at the Vorontsov house, and the entire Vorontsov family held him in high esteem. Lomonosov dedicated his translation of Wolf's *Experimental Physics* (1746) to Mikhail Vorontsov.[44] In Rome, during his tour of Italy, Mikhail Vorontsov commissioned a mosaic of Elizabeth. This portrait and the technique of mosaic making would become the object of great interest in Russia and would influence the work of Lomonosov in this area. Vorontsov sponsored Lomonosov's revival of the manufacture of colored glass mosaic cubes, founding for that purpose the glass works at Ust Ruditsky, some sixty versts from St. Petersburg. A few days after the death of Lomonosov, Chancellor Vorontsov ordered a marble monument to be erected in the Lazarovskoe Cemetery of the Aleksandro-Nevsky Lavra in St. Petersburg. He commissioned Jacob Shtälin to compose an inscription and to draw a design of a monument in the Florentine style. Both the inscription and design were sent to Livorno and the following year the monument of Carraran marble arrived. Many years later Dashkova's nephew, M. S. Vorontsov, had the monument restored.

From a young age, Dashkova was quite taken by Lomonosov's poetry and greatly enjoyed reading his verse aloud.[45] The great poet and man of science was to have a profound influence on the next several generations of

writers and scholars, including Dashkova, who strove to sustain and continue his legacy of learning and scholarship at the Academy. The monument she erected, however, was to another person. It still stands today on her estate: an obelisk supported by four granite spheres commemorating the most significant day of her life, the coup of 1762, and the memory of Catherine II — the woman who made it all possible and the woman Dashkova adored.

Chapter Two

Conspiracy

WITH CHARACTERISTIC ENERGY, Dashkova prepared herself for a life allowing her to escape the stifling confinement of her childhood and to live beyond the restrictive possibilities available to most women of the time. Always eager to learn more about other countries, cultures, and forms of government, Dashkova would seek out and question relentlessly the representatives of foreign courts and eminent figures from the world of politics, academia, and the arts. The involvement of the Vorontsov family in the affairs of state engendered in Dashkova an interest in diplomatic and government services. At home, she would hear debates concerning the burning social and political issues of the day and was introduced to new and intriguing ideas from abroad. Never shy about talking to foreign dignitaries, she listened avidly to their stories of faraway places and imagined traveling there some day and seeing them herself. Her dreams of a career on the stage of world events would have certainly remained unfulfilled, except for a meeting at which Dashkova was present that was to change her life forever. During the winter of 1758–1759, the Grand Duke Peter and his wife Catherine were invited to a supper held in their honor at the chancellor's palace. Born Princess Sophia Augusta Frederica Dorothea of Anhalt-Zerbst in the Baltic seaport of Stettin in 1729, the future empress was rechristened Catherine on her admission to the Orthodox faith before her marriage to Peter in 1745. Dashkova fell under Catherine's spell, and despite the disputes and the sorrows that lay ahead, she would never abandon her initial infatuation. Dashkova made every attempt to overlook Catherine's imperfection and her unwavering loyalty to her remained mostly intact, notwithstanding many disappointments. She realized that only through Catherine's intercession, her life, destined for the conventional and proper

roles of wife and mother, was forever altered and permanently set on its course of conspiracy and open rebellion.

From the beginning, Dashkova's dreams of transformation and opportunity were to be inspired and sanctioned by the older Catherine. The encounter with Catherine that evening led to Dashkova's enchantment with a woman twice her age: she was fifteen and the grand duchess thirty. Herzen wrote, "From their first meeting Dashkova loved Catherine passionately, 'adored her'" and "believed and wanted to believe in an ideal Catherine."[1] In a letter to her friend, Catherine Hamilton, she wrote that in her youth "Catherine was the embodiment of my ideal on earth; with delight and fervent love I followed the brilliant progress of her fame completely certain that they were inseparably linked to the happiness of the people."[2] The future empress represented for her an ideal of the enlightened monarch who would assure the well-being of her subjects during her benevolent and judicious reign. She would be the source of happiness and security, a philosopher queen, who, with the aid of equally enlightened advisers such as Dashkova, would abolish all forms of despotism through the enactment and enforcement of rational laws. Dashkova spent the entire evening speaking to Catherine, all the time deriving great pleasure and intellectual satisfaction from the conversation with the witty, courteous, and worldly woman.

Educated and well read, Catherine corresponded with Voltaire, Diderot, and d'Alembert, and espoused an adherence to the principles of the French Enlightenment. She stood in sharp contrast to Empress Elizabeth, whom Catherine herself considered lazy, lacking discipline, and never interested in the cultivation of her mind. Dashkova did not know at the time that Elizabeth was also much less calculating than Catherine and her munificence was far more disinterested and sincere. Nevertheless, it seemed to Dashkova, still young and susceptible, that Catherine and she were mutually drawn to each other and that their encounter was a true meeting of the minds. To be sure, the characterization that Dashkova had a man's mind was often employed to describe Catherine as well, but Dashkova saw in Catherine a woman whose readings and ideas seemed to correspond exactly with hers. Their upbringing and childhood experiences were in many ways similar — they had grown up reading the same authors and they shared common intellectual predilections. Both were taken by the works of Voltaire and by the writers of the French Enlightenment and the *Encyclopedie:* Diderot, d'Alembert, Montesquieu, Bayle, and Boileau. Mme de Sévigné's intelligent and highly dramatic correspondence with her daughter touched them deeply and predicted their own complex and

tragic relationship with their children.[3] Dashkova was to write enthusiastically, but inaccurately, that she and Catherine were the only two women in Russia who read books. This was certainly an exaggeration since by the time she came to write her *Memoirs,* Dashkova knew personally and collaborated with Catherine Kniazhnina, the daughter of A. P. Sumarokov and wife of the playwright Ia. B. Kniazhnin. Kniazhnina's first published work appeared in 1759, and in the court of Empress Elizabeth she was referred to as an ardent amateur of the Muses. Also, by 1760 Elizaveta Kheraskova, wife of the writer Mikhail Kheraskov, was publishing her poems, and Dashkova may have heard of the writer Maria Sushkova.

Dashkova and Catherine seemed to have much in common. Proud and ambitious, they both composed memoirs that were primarily polemical in nature, written to explain and justify their actions in their public and private lives. Many similarities and common motifs appear in the two texts: Both women discuss their sadness, melancholy, disillusionment in their surroundings, and the inhibiting effects of their upbringing on their otherwise energetic and happy natures. Friendship with older women plays a major role, and for Catherine it was realized primarily in the person of the lively and independent Countess Bentinck. She separated from her husband, rode horseback expertly, supposedly bore a child out of wedlock, and lived with another woman, Fraulein Donep, most likely in a lesbian relationship. Like Dashkova, Catherine was rebellious, refusing to apply the customary cosmetics: the obligatory ceruse to whiten her skin and rouge for her cheeks. Both women saw themselves as sensitive, prone to bouts of depression, and considered suicide, although thoughts of death were to pursue Dashkova throughout her life, while Catherine admits to them only in her youth. Thanks to their reading, they were able to endure their strong feelings of isolation, and in their writings stressed their sense of being superfluous and unwanted, with most of the attention bestowed on their siblings and cousins, but especially their brothers. They wanted to be noticed, appreciated, but above all else—they wanted to be loved. The two women found a common language based on their analogous thoughts of being virtual orphans in their families and a growing desire to participate and succeed in the world of politics. Their ambition was considered inappropriate for young women of the time, and in Dashkova's case, her family would never appreciate or approve of her achievements. Finally, illness and childbearing are important motifs in the memoirs, and the two women presented them as turning points in their life, a time when they gathered their strength, overcame adversity, and embarked on new paths.

Despite the many parallels they discovered in their lives, based on shared influences and readings, the application and adaptation of enlightened ideas inevitably brought Dashkova and Catherine into direct conflict. Catherine was a seasoned courtier; ruthless and ambitious, she proved skillful at court intrigues. Dashkova was a wide-eyed idealist, fervently believing in the possibilities of a new order based on new beginnings. Catherine needed support at court and her motives were mostly political in nature. The years 1744-1759 had been difficult on Catherine. Her marriage to Peter was an unhappy one, she felt isolated at court, and her position there was precarious. During the early period of her friendship with Dashkova, Catherine was in disgrace because of her dealings with Aleksei Bestuzhev-Riumin. She was a German princess and an outsider in Russian court society, while Dashkova was a member of one of the most powerful families in Russia. Describing her dislike and fear of the Vorontsovs, Catherine wrote, "An extremely dangerous person existed in the brother of the princess, Simon Romanovich Vorontsov, whom Elizaveta Romanovna and with her Peter III quite particularly loved. The most dangerous of all was the father of the Vorontsovs, Roman Illarionovich, on account of his querulous and untrustworthy nature."[4]

Catherine would continue to encourage the naive young woman because she needed her friendship, hoping that it would help to neutralize her family's influence. Dashkova, on the other hand, thought that she had discovered an ideal—a female model for self-creation and individual achievement, with whom she could work and cooperate in the public arena. Above all else, Dashkova imagined herself at Catherine's side, collaborating with her in the transformation of eighteenth-century Russian society. At the end of their fateful first meeting that evening, Catherine presented her with a richly ornamented fan that Dashkova treasured and guarded all her life—a talisman representing their alliance—which she would pass on to Martha Wilmot shortly before her death. The symbolic bestowal of a fan is particularly significant, since women employed it as a mask and as a form of nonverbal expression.

A lively correspondence ensued, and Catherine would send the young Dashkova some of her own writings, although she had to take precautions, for there had been trouble at court in 1758, when several of her confidential letters to General S. F. Apraksin were discovered. She relied on Dashkova's discretion:

> I have, as you know, the most implicit reliance on your candor; tell me then truly, is it for this purpose that you have detained a paper three days

which could not have taken you more than half an hour to read? Do not, I beseech you, delay another moment in returning it, for I begin to be uneasy about it, knowing as I do, from experience, that in a situation like mine, the most trivial circumstances are liable to the most unfavorable and, sometimes the most unjust, construction. Remove, then, my anxiety on this point, and be assured now as ever, of my unalterable esteem and gratitude.[5]

Catherine routinely burned Dashkova's letters and asked her to do the same. Fortunately, Dashkova did not, and they have survived to this day.[6]

The two women exchanged books and Dashkova sent the grand duchess copies of her early writings, a practice she was to continue after Catherine's coronation. The openness and sincerity of Dashkova's feelings toward Catherine did not coincide with the picture of the willful and scheming shrew drawn by Rulhière and others. In 1762, an engraving was prepared from P. Rotari's portrait of Catherine II and inscriptions were solicited from Dashkova, Lomonosov, and Sumarokov, among others. Her youthful enthusiasm for the empress was given voice in a quatrain entitled "Inscription to a Portrait of Catherine II" ("*Nadpis' k portretu Ekateriny II*"). Dashkova's contribution was an ebullient example of her juvenilia she had composed some time earlier:

> Nature, in bringing You into the world,
> Bestowed all of its gifts on You alone.
> By granting all to You, it granted all to us,
> And elevated You to the majesty of the throne.[7]

Catherine encouraged Dashkova, whom she considered more intelligent than most men.[8] She responded enthusiastically, though not entirely sincerely, to Dashkova's early literary works, and not surprisingly, she was especially complimentary of the "Inscription":

> What verse and what prose — and this at seventeen! I beg, nay, I conjure you not to neglect so singular a talent. Perhaps I may appear not quite an unprejudiced judge, since in this instance, dearest princess; it is your too flattering partiality which has made me the subject of your charming composition. Tax me, however, with vanity, or what you please, I must be allowed to say, that I do not know when I have read four such correct and poetical lines.[9]

The only rival for Dashkova's heart was the young prince she had met during the summer of 1758. Her uncle, aunt, and cousin were with the Empress Elizabeth in Peterhof and Tsarskoe Selo, her residences outside the city. Dashkova was alone studying and indulging her love of music by attending Giovanni Locatelli's productions of the opera-buffa with ballet in the Imperial Summer Gardens. The Italian musical theater of Locatelli, who performed in St. Petersburg from the end of the 1750s to the beginning of the 1760s, was very popular at court. On one particularly hot summer evening, Dashkova, deciding that she required exercise after supper, sent her carriage ahead, and walked with her friend down the dark and deserted street. Almost immediately, a tall and what appeared to her to be an enormous dark figure of a man emerged from the shadows. Initially startled, Dashkova was soon won over by the handsome young man's fine features, polite conversation, and restrained modesty. But Mikhail-Kondrat Dashkov was not what he seemed to be and had a bad reputation. The meeting was prearranged, for he had been barred from many of the leading houses of St. Petersburg, including the chancellor's, making it impossible for him to meet with members of the Vorontsov family. It seems that he had committed an unpardonable indiscretion and been involved in a scandalous affair with Dashkova's cousin, Anna. It might have precluded the possibility of any future contacts between Dashkova and her future husband, except for the steadfast spirit of the young woman who would not allow minor impediments to stand in her way. "Never, it seemed, could our union occur; but heaven willed otherwise, and nothing was able to prevent our hearts from irrevocably giving themselves to each other" (37).

In reality, heaven had little to do with it, and as opposed to her initial impression of Catherine, the prince's mind could not have attracted Dashkova. Rather, she was drawn in by his stylish dress, refined manners, social graces, and princely title. Dashkova was not titled, since her father and his brother Ivan became counts only in 1760. In her choice of the prince, Dashkova revealed her inability to break entirely with the conventions of her time. She was far more a product of court society, with its emphasis on elegance, beauty, and hierarchy, than she would admit. Yet, his unacceptability to her family also answered to her own deep-seated feelings of rebelliousness and an ongoing rivalry with her cousin Anna. Marriage was a possible escape for her from everything she detested about St. Petersburg. With everyone out of town during the summer, she felt compelled to share her feelings with someone. Straightaway, she wrote her best friend and brother Aleksandr, with whom she regularly corresponded about current events, family news, and court gossip. On July 20, 1758, the fifteen-year-

old Dashkova notified Aleksandr in Paris about her recent matters of the heart and promised to let him know in "three weeks, a month, or a little longer . . . about the consent (or refusal) Prince Dashkov, to whom she gave permission to ask for her hand, will receive from her family." There was a sense of conspiracy and the fear of being discovered in her letters. The correspondence about her possible marriage seemed so intimate and so private to her that she promised to let him know more only if he wrote in code.[10]

In view of the secretive nature of her engagement, Rulhière's comments that she pressured Mikhail Dashkov into marrying her is highly suspect. He writes unconvincingly that the headstrong Dashkova did not hesitate to announce her plans to her uncle, who in turn summoned her suitor for a conversation concerning his intentions.[11] Already disgraced, the young man had no way out, since he could hardly incur further opprobrium from one of the most powerful individuals in the empire. Dashkova was outraged and vigorously disputed these allegations, claiming that a third party had been found to plead her future husband's case to her family, which in the end had no objections, and that her future mother-in-law also gave her consent and blessing, even though she had selected another for his bride. Nevertheless, it is doubtful that by going against established conventions and arranging her own marriage, Dashkova had won the approbation of her family. The chancellor's wife, whose illness initially delayed the marriage, finally did not attend the ceremony, unable to forget Dashkov's dishonorable actions toward her daughter, even though the year before Anna Vorontsova had married Aleksandr Stroganov. The very quiet ceremony took place on February 14, 1759, when the fifteen-year-old girl wed the twenty-two-year-old Mikhail-Kondrat Dashkov.

Dashkova was to receive from her father a highly reduced dowry of ten thousand rubles and personal possessions valued at close to thirteen thousand, while her sister Maria just over a year earlier had received nearly twice that amount, or from thirty to forty thousand rubles.[12] While Roman Vorontsov was never exceptionally generous to his children, in Dashkova's case he failed to provide for her when, later in life, she was particularly constrained and required his financial support the most. Even worse, her husband, who loved gaming and high living, frittered away the dowry in the first year of their marriage, and his indebtedness became so severe that Dashkova was forced to sell an estate she had acquired to settle his accounts.[13] Despite any resentment she might have felt over her smaller dowry and financial woes generally, Dashkova made every attempt to be a good and dutiful daughter and wrote her father regularly about her

health, the baptism of her daughter, and other family events.[14] But Roman Vorontsov remained cold and distant, and rarely replied. Dashkova was hurt, and matters deteriorated further when in May she traveled south to Moscow to meet her husband's family and her mother-in-law. The trip there seemed to presage the many difficulties and uneasy progress of her marriage. The road between St. Petersburg and Moscow was treacherous and exhausting as she bounced over rock-hard ruts, potholes, stones, and at best, log-filled carriageways. She would travel that road countless times in her life.

Dashkova and her spouse were in many ways complete opposites. He was handsome, mild-mannered, sociable, and outgoing. Considered a good dancer, he was at home in the glitter and whirl of balls and social events. She was reflective, serious, straightforward, and resolute. Moreover, they came from two different worlds in eighteenth-century Russia. Dashkova's family was wealthy and powerful; they were representative of St. Petersburg society, which considered itself Western and enlightened. Her husband came from an older, Muscovite, patriarchal order, and it was through her husband's family that the young bride was immersed into a new and unfamiliar Russian life. Far from the St. Petersburg court, she felt at times like a foreigner in a distant land. The diverse backgrounds of the newlyweds were sure to create problems in their family life.

Although her son's marriage represented an alliance of the old Moscow nobility and the powerful elite of St. Petersburg, Anastasia Dashkova did not like, nor approve of her daughter-in-law. She was the niece of Natalia Naryshkina, mother of Peter the Great, and the third wife and widow of Ivan Dashkov. The Dashkov family, along with a handful of other Russian families, traced its origins back to the most prestigious and venerable Rurik dynasty, to which Dashkova could now claim cousinage. They had served their country as voevods, stolniks, and boyars, but by the eighteenth century they were no longer at the center of political power and their influence had waned. Those who retired from the court or from the military and no longer served in St. Petersburg lived in Moscow and on their estates surrounding the ancient capital of Russia. Thus Dashkova, who had been energized by the most progressive ideas of her age, found herself in the stifling world of the old Moscow nobility among elderly, backward looking relations. They spent their time mostly recalling the past glory of their illustrious forbearers and debating genealogical issues.

In Moscow, the newlyweds moved into the Dashkov house on Leont'ev Lane near Tversakaya Street. Anastasia Dashkova did not understand her daughter-in-law's unconventional manners, her independent spirit, studi-

ousness, interest in what seemed to her the radical ideas of France, and her unwillingness to accept the proper, acceptable norms of eighteenth-century female behavior. In fact, the two women could hardly communicate, since the mother-in-law knew no French while Dashkova spoke Russian badly. In the beginning, Anastasia Dashkova strove to conceal her dislike of Dashkova, and Simon Vorontsov, visiting them in Moscow, wrote to his father that his sister was on very good terms with her new family and that the mother-in-law "loves my sister."[15] Dashkova too made every effort to accommodate her husband's family, and hoping to be more acceptable to them, initiated an intense program of Russian language study. Despite her efforts, she could not be a model wife and mother, content with overseeing the domestic economy and the education of her children. The exclusive care of just her family would never be to her liking, no matter how she tried to convince herself to the contrary, and she continued to associate with the Moscow groups of leading writers and thinkers.

Dashkova became pregnant, and on February 21, 1760, after enduring labor lasting over twenty hours, she gave birth to a daughter, named Anastasia in honor of her grandmother. The infant was not healthy and according to Dashkova, she was underdeveloped. Exhausted by the physical and emotional trauma of her first delivery, Dashkova nevertheless noticed her husband's and mother-in-law's disappointment. Ironically, the woman who had dreamed of creating an alternative genealogy based on the friendship of women was now expected to produce a male heir and preserve the Dashkov name from extinction. The relationship with her mother-in-law remained strained, and even though Anastasia Dashkova would accompany them, it was with a sense of relief that in May of that year Dashkova, having regained her strength, left Moscow with her husband and three-month-old daughter. They traveled south by way of Serpukhov to Troitskoe, the Dashkov ancestral estate some sixty miles from Moscow in the Kaluga Province. The first in the family to own these lands was Ivan Dashkov, who distinguished himself in 1618 along with Prince D. I. Pozharskii at the Arbat Gates in Moscow during the battle with the Polish invaders. Situated in a gentle, pastoral landscape on the high banks of the Protva River, it was to become Dashkova's favorite residence and, in the end, her burial place. Although the estate was run down and in a severe state of disrepair, Dashkova felt freer and more comfortable there. Time seemed to fly in the company of her library and harpsichord as she returned to her reading, writing, and music.

Her seclusion was interrupted only by Simon's visit, who in the fall of 1760 was traveling through Russia and inspecting the family estates and

holdings. Once more, he wrote home about his sister without dispelling the impression that Dashkova felt happy among her new relations.[16] Toward the end of the year, Mikhail Dashkov's leave from the Preobrazhenskii Guards was due to run out and the family moved back to Moscow. Dashkova was loath to allow her husband to return to St. Petersburg at a time when doctors prohibited her from traveling since she was pregnant again. She wrote her father requesting him to exert his influence and obtain a five-month extension for her husband, but to no avail, and Dashkov was obliged to report for a time to his regiment. With his departure, Dashkova fell ill with fever and delirium, and subsequently succumbed to a depression, which left her weeping and listless to the point of breaking off her correspondence with her husband. She knew that while she was suffering the loneliness, emotional pain, and physical discomfort of her confinement, her husband was enjoying the privileged life of a junior officer in the capital—gambling, drinking, and attending carnivals and sledding parties at Oranienbaum. She further suspected that he was not a pillar of conjugal probity.

Her confinement was especially difficult during the last week of pregnancy. That winter the midwife was summoned at the onset of labor, and it was at this inopportune moment that the stunned Dashkova learned from the maidservant that her husband had returned to Moscow. Incredibly, rather than rushing directly to her bedside during her physical trials, he had stopped at an aunt's house. It seemed that not all was right between them, and Dashkova freely admitted that nothing made her angrier than the least suspicion of her husband's infidelity. The "hot-headed and impetuous girl of seventeen," as Dashkova would describe herself, did not hesitate for a moment (41). Despite their vigorous objections, the astonished midwife and an old servant were ordered to support the staggering and faltering Dashkova downstairs, where the renewal of labor pains halted their uncertain advance. Fearing that the sound of a horse and sleigh would be heard and her escapade discovered, Dashkova, with the aid of the two women, walked through the frigid and snowy Moscow night to the end of the street, where labor pains once again seized her. Somehow reaching her goal, she climbed the long staircase and notwithstanding the pain and cramping confronted her horrified husband, who made every effort to explain that he had caught a chill and did not want to expose her to illness. Dashkova lost consciousness; her frantic mother-in-law took her home and in less than an hour Dashkova delivered a son, who was given his father's name, Mikhail. It was a healthy baby—and a boy. Not only had she produced a baby, but a male heir as well, and there was great joy

in the Dashkov household that night. A priest was summoned to perform a thanksgiving service for the safe delivery of the child, who represented the long-awaited continuation of the Dashkov line. Physically and emotionally spent by the exertions of the past two days, Dashkova could not stop crying. Her husband, who was now sleeping in an adjacent room, attempted to entertain his distraught wife by sending her humorous and often childish notes. Dashkova's recovery was slow, but she was young and soon regained her strength. She had restored order and harmony to her family—if only for a time.

Leaving her infant son in the care of her mother-in-law, Dashkova, with her husband and daughter, returned to St. Petersburg after a two-year absence on June 28, 1761—a year to the day before her participation in the events that would transform her life and Russia forever. "One of the most memorable and most glorious days in the history of my country," Dashkova would write (44). The next twelve months, from the summer of 1761 to the summer of 1762, would be devoted primarily to planning and carrying out a plot designed to undermine and overthrow her godfather, the soon to be crowned Emperor Peter III. Dashkova was happy to escape the strait-laced life of her husband's family and to return to the familiar surroundings of the capital where she "was no longer disconcerted, as I frequently was, by habits and customs which I sometimes encountered [in Moscow]" (44). Driving to the house her husband had rented, she felt that she was home at last as she gazed with delight from her carriage windows at the wide prospects and uniform beauty of the Western city of her birth. And yet, nobody greeted her there, so immediately she proceeded to visit her uncle and father, only to learn that they were out of town. The enthusiasm for her return home to the capital was further dampened when sailors from the Admiralty broke into her residence and burglarized it.

That summer the Empress Elizabeth resided at Peterhof and the Grand Duchess Catherine at Oranienbaum, while the Grand Duke Peter was preparing to ascend the throne and surrounding himself with influential members of the nobility. But Dashkova had no desire to return permanently to Peter's young court and was allowed to live in her father's house located on the Gulf of Finland.[17] The years in Moscow and motherhood had changed her and marked her passage from adolescence into maturity. When Dashkova at last met with her relations, they noticed that she did not look well and had lost weight. Although no less rebellious and idealistic, she was no longer a naïve girl of fifteen. If in the past she had felt disdain for the frivolity of Elizabeth's court, she now thoroughly detested Peter's idealization of Frederick II of Prussia and his simpleminded military games

with his sycophantic Holstein soldiers. To complicate matters further, at his side was Elizaveta Vorontsova, his mistress and Dashkova's sister. Peter, Elizaveta, and their entourage would remove themselves to the grand duke's residence of Oranienbaum and there to their hearts' delight would play military games with Peter's Holstein guard. They marched around with his imaginary army, smoked, drank, and mostly spoke German with his "generals," whom Dashkova described as "either ex-Prussian warrant officers or sons of German shoemakers who had escaped from their families" (46). She despised such silly and childish pastimes; her own games with the Preobrazhenskii Guard would be for real and for keeps.

Dashkova, a perceptive and erudite woman, looked upon her sister's entertainments with scorn and ridicule. In her *Memoirs* she dramatized Peter's court through a series of cutting and highly theatrical tableaux, in which she often dressed up her opinions and judgments in the camouflage of male voices.[18] For instance, Dashkova sought Catherine's company whenever possible, and her partiality for the grand duchess did not go unnoticed. According to her account, Peter III took her aside and cautioned her to remember that "it is safer to live and deal with simpletons like us [Peter and his mistress Elizaveta] than with those great minds [Catherine] who squeeze all the juice out of a lemon and throw it away" (45). In truth, Peter's admonition illuminates Dashkova's own misgivings concerning Catherine as she gives voice to her feelings concerning Catherine's propensity to use people. Therefore, she has Peter paraphrase Castéra's formulation, which Peter could not have read since it appeared after his death and which Dashkova read many years later. Castéra wrote that "when she [Catherine II] has made what use she wanted of anyone . . . she does with him as we do with an orange, after sucking out the juice we throw the peel out of a window."[19] Dashkova may also have been aware that Voltaire had quoted Frederick II as having said of him, "Don't worry: we shall squeeze the orange, and then, when we have swallowed the juice, we shall throw it away."[20] In effect, Dashkova simply replaced an orange with a lemon, masked her opinions, and thereby distanced herself from private sentiments by having Peter, her acknowledged enemy, express them.

Dashkova did not heed Peter's advice nor did she submit to his authority. Since she was his goddaughter, Dashkova felt she could openly chide him for cheating at his favorite card game, Campis. He did not play by the rules and after losing a hand, would throw in another gold coin, thereby avoiding elimination, until in the end Dashkova refused to play with him. She also brazenly corrected chronological inaccuracies in his historical anecdotes or challenged him on legal matters. At a palace dinner with some

eighty guests present, the intoxicated Peter began to expound on the necessity to decapitate a certain ensign of the Horse Guards for carrying on an affair with a cousin of Empress Elizabeth. Dashkova was outraged and challenged him publicly, explaining that such an insignificant offense certainly did not warrant execution, and that further, Peter must have forgotten that the death penalty had been abolished in Russia with the decrees of 1753-1754 during the reign of Empress Elizabeth. The astonished grand duke attempted to make light of the incident by sticking out his tongue at his mischievous goddaughter. Yet the confrontation created quite a stir at court and Herzen felt that such open rebellion on Dashkova's part marked the beginning of her political career.

Concurrently, she grew closer to Catherine, who would stop her carriage near Dashkova's house and send a message of invitation to spend the evening with her at the palace. As the two women grew increasingly attached to each other, a mutual confidence developed, and with the court's return to town, they continued to exchange letters and messages. Over time, the secret meetings and correspondence gave rise to their conspiracy against Peter. In her active opposition to the monarch, Dashkova went against her entire family; completely swayed by Catherine, her loyalty to her remained unwavering.

Catherine encouraged her support and adoration. In September 1761, Dashkova returned to Petersburg from Oranienbaum while Catherine remained in Peterhof. Catherine wrote Dashkova, "I am sensible, so sensible, indeed, of all your kindness that I have been the victim of ennui ever since you left me. Difficult, indeed, would be the search to find your equal here, when, throughout Russia, the person I am sure does not exist worthy to replace a friend like you." By the end of the year, it became increasingly evident that the empress's health was failing and that she could not last much longer. Catherine gave voice to the conspiratorial nature of their friendship: "I received your little note on retiring to my bedchamber last night. As the apparition of a man or woman at that hour might alarm suspicion, you had better come to me at five o'clock this afternoon, by the little staircase." A spirit of holiday merriment and festive amusement is contained in many of Catherine's letters to Dashkova during the months preceding the coup: "Between five and six o'clock I intend going to Caterinhof, where I shall change my dress, as it would not be prudent to pass through the streets in man's attire. I advise you to drive thither direct in your own carriage, lest you should be mistaken for a cavalier in good earnest, and of course be set down as my lover."[21]

On December 20, 1761, or five days before the death of the Empress

Elizabeth, Dashkova rose from her sickbed with a headcold, put on boots, dressed warmly in a fur, and drove in her carriage to meet with Catherine. Catherine had written to arrange a clandestine meeting and cautioned her to arrive unnoticed and to take the back stairs. It was midnight when she reached the wooden palace on the Moika, and leaving the carriage some distance from the imperial residence, so as not to be spotted at such a late hour, she set out on foot to the servants' entrance and the little staircase by which she was to enter the grand duchess's apartments. Catherine's personal maid and trusted confident, Katerina Sharagorodskaia, was waiting for her there and escorted her through the dark passageways of the palace to the grand duchess's boudoir, where Catherine was waiting for her in bed. She seemed surprised that Dashkova would venture out on such a cold night, sick and shivering as she was, and invited her into bed to warm her feet. It was the first of three nights, described by Dashkova, during which she shared a bed with Catherine.

The extent of their physical intimacy and the degree to which it played a role in their relationship is difficult to determine.[22] Literary models influenced their flirtations with other women and the nature of their expressive and often highly charged communications. Such sentiments between women are eloquently rendered, for instance, in the sensitive and passionate letters of the heroine Julie d'Etanges to her confidante and cousin Claire in Rousseau's epistolary novel *La Nouvelle Héloïse* (1761). They are primarily indicative of the bond and expression of friendship common among young women of the time. It was a traditionally eighteenth-century woman's world of emotion, kisses, and embraces, expressed in a language of sentiment and feeling. The language was often conventional, learned, and acquired mostly through reading the fashionable writers of the time.

On this occasion, in contrast to Catherine's dominating and overwhelming presence, Dashkova portrayed herself as deferential, compliant, and subservient, exclaiming, "I am yours to command—tell me what to do." Whereupon Catherine took her hand, pressed it to her heart, and assured Dashkova that "it is with perfect truth and every confidence in you that I say to you now: I have formed no plan." The enthusiastic and trusting eighteen-year-old swore complete and abiding devotion to the older woman and in her *Memoirs* described how Catherine "threw herself into my arms and for several minutes we remained in close embrace" (49–50). Only afterward would Dashkova learn that Catherine had not been forthright with her, that she had been manipulated, and that for some time now a grand plan was being hatched with individuals Dashkova knew nothing about. Later in life, in a letter to her friend Catherine Hamilton, Dashkova

freely admitted that in her youth she had been too naïve and had thought too highly of human nature.[23]

Empress Elizabeth died December 25, 1761, and was succeeded to the throne by her nephew Peter III, who reigned for only six months. At Peter's accession, Mikhail Vorontsov managed to retain his post as grand chancellor and all the Vorontsovs, with the notable exception of Dashkova, supported the monarch. Roman Vorontsov's fortune increased and a promotion to the rank of general followed. His son Aleksandr was appointed Minister Plenipotentiary to the Court of St. James's and shortly afterwards ambassador to Holland. A decisive reason for the great favor shown Roman Vorontsov at court was the relationship that existed between the monarch and Elizaveta, Roman's second daughter. Catherine succinctly described the situation at court: "His [Peter III] more or less considered plans were: to start a war with Denmark on account of Schleswig, ... to divorce his wife [Catherine] and marry his mistress [Elizaveta], and to ally himself with the king of Prussia, whom he called his master and to whom he insisted he had sworn the oath of allegiance."[24]

Dashkova's unhappiness and dissatisfaction with Peter reflected the feelings of many at court, especially those who wanted to see Catherine enthroned as regent during the minority of her son Paul. Despite repeated invitations, she chose to stay away from his court on the pretext of ill health, until her sister Elizaveta wrote and explained that Peter did not believe her indisposition. Proud and certain of her intellectual superiority, Dashkova could not help but be jealous of her sister's position in court. Fearing the consequences of Peter's displeasure, she presented herself at court, and according to her *Memoirs,* Peter confronted her immediately. Dashkova could hardly believe her ears when Peter warned her about ignoring him and her sister, since he fully intended to marry Elizaveta after ridding himself of his wife. According to Catherine, Peter "wanted to change his religion, marry Elizaveta Vorontsova, and arrest me."[25] No doubt, he would have sent Catherine off to a convent, the traditional destination of tiresome women at the Russian court. Andrei Bolotov wrote that Peter was completely attached to Elizaveta and blinded by his love for her. Yet Peter's devotion to Elizaveta is suspect in light of Shcherbatov's account concerning the monarch's machinations to escape his mistress in order to spend the night with Princess Kurakina.[26] Nor was Elizaveta an attractive woman capable of captivating the Emperor and holding his attention for long. Catherine, who cannot be considered impartial in this case, compared her disparagingly to Dashkova: "She [Dashkova] was the younger sister of the mistress of Peter III, nineteen-years-old and prettier than her sister, who was very

ugly. If her outward appearance was dissimilar, their souls were still more different. The younger had much intelligence and understanding; she was industrious, well read, had a strong liking for Catherine, and was loyal to her with her heart, mind, and soul."[27] Panin too wrote, "His [Peter's] mistress, Fräulein Vorontsova, was ugly, stupid, annoying, and offensive."[28]

Members of the Vorontsov family did not unanimously condone Elizaveta's liaison with Peter, even though it offered them access to the emperor. Most of all they detested the scandals, and in eighteenth-century Russian society, much would be tolerated, as long as there were no scandals. Unfortunately, Elizaveta was known for her hysterical behavior at court, and in her memoirs, Catherine described Elizaveta's jealousy after a violent dispute with Peter:

> The next day after dinner, at five o'clock, she sent me a letter in which she begged me for heaven's sake to come to her . . . I went to see her and found her dissolved in tears. When she saw me she could not speak for a long time. I sat down beside her and asked what was wrong. She seized my hands, kissed them and pressed them and wet them with her tears.[29]

On another occasion she caused a scene and refused to wear Catherine's portrait, required of maids of honor, preferring Peter's.[30]

Mikhail Vorontsov considered his niece's behavior to be a blemish on the family name, and had grown tired of her hysterical scenes at court. Aleksandr wrote that his sister's affair was "disagreeable to my family" and he regretted her reputation as a loose, unstable woman.[31] In his autobiography, he attempted to rehabilitate his sister's reputation and to defend her good name, stating implausibly that the relationship between Elizaveta and Peter "may be characterized as Platonic."[32] Dashkova was less charitable and criticized Elizaveta for thinking only about herself, about Peter, about her pleasures, but little about her family—and Mikhail Vorontsov agreed. In the end, Dashkova could not comprehend Peter's preference for her crude and unattractive sister over the intelligent, witty, decorous, and beautiful Catherine. Nevertheless, she submitted herself to the whims of her godfather and remained at court.

In general, Dashkova's description of Peter's reign is unflattering and subjective. Life at court seemed unreal to her—everything had changed, people were now acting out new, unaccustomed roles dressed in recently acquired, often-ridiculous costumes. In her descriptions, fun changes to ridicule when the image of the masquerade is used to satirize Peter and

his courtiers. Dashkova recalls how in passing a hall full of various ranking dignitaries she "had the impression of witnessing a masquerade. Everyone had changed his clothes. Not a man but was laced into his uniform, booted and spurred—even old Prince Trubetskoi" who "now that he was seventy" and overweight had put on a tight-fitting officer's uniform (53).[33] A feeling of the artificial and anachronistic is again conveyed in the brief sketch of Nikita Panin, who is described as wearing a wig with three ties hanging down his back. He was "always the perfect courtier—a somewhat old-fashioned one, truth to tell, like a picture-book idea of those at the court of Louis XIV" (56).

Even at the august and imposing observances of Elizabeth's passing, Peter's conduct was deplorable and out of keeping with the occasion. In contrast to his wife, who visited the catafalque daily and "bathed in tears the precious remains of her aunt and benefactress" (53–54), Peter acted out a different role, and his undue attention to the officers' appearance was equally contemptuous as his laughter and ridicule. Educated in the Lutheran faith, he was often at odds with the Russian Orthodox clergy and demonstrated his disdain and disrespect by rarely attending the services, and "when he did come it was to laugh with the ladies on duty, ridicule the clergy that happened to be there, or scold the duty officers and noncommissioned officers for their curls and cravats or uniforms" (54). Dashkova paints a picture of the emperor's increasingly unpredictable and even dangerous conduct, and her intense personal dislike of Peter was a deciding factor in her decision to support Catherine. She would take every opportunity to cast him in the most unfavorable or ridiculous light. For instance, she writes that Peter openly related stories about how his friend Dmitrii Volkov, secretary of the council of state, had assisted him in a treasonous collaboration with Frederick II of Prussia. Later, Volkov would vehemently deny these charges.[34] Also, Peter mostly ignored his son, but on one occasion he was greatly pleased with the progress of Paul's studies when he witnessed his performance during an examination. He thereupon promoted his tutor, Nikita Panin, to the rank of general in the infantry. The aging diplomat, however, fond of his serene and comfortable life, was horrified and, to Peter's surprise, refused the honor.

Peter's erratic behavior soon became a matter of personal concern for Dashkova. In January, during a changing of the guard at the palace, the emperor upbraided Mikhail Dashkov for deploying his troops incorrectly. The confrontation grew heated and may have been prompted by Peter's displeasure with the closeness developing between Catherine

and Dashkov, who had expressed his complete loyalty to Catherine and willingness to help her gain the throne. Catherine recalled Dashkov's devotion to her:

> Immediately after the death of Empress Elizabeth Petrovna, Prince Mikhail Ivanovich Dashkov, at that time captain of the guard, sent this message to me: "Give the order, and we will place you on the throne!" I sent him this reply: "For God's sake, do nothing foolish. All will happen as providence wills. But your undertaking is premature and untimely."[35]

Fearing for her husband's safety, aware of his impulsiveness, and possibly prompted by a feeling of jealousy, Dashkova decided to send him away, somewhere far from Petersburg. It seems that she was also concerned about her own banishment to Moscow, now that her husband had fallen out of favor. During the second week of January 1762, she petitioned her uncle, and beseeched her sister, to help her obtain a foreign mission for Mikhail Dashkov. Their efforts proved successful and to her great satisfaction, Dashkova learned that her husband was to be dispatched immediately as ambassador to Constantinople. In February, he left the capital for Moscow and then proceeded to his estate, Troitskoe, going no farther and remaining there until the beginning of July. He must have known that dramatic changes were about to take place in the capital. As he waited out the turbulent events in St. Petersburg, it seemed that his wife's only antidote to the heartache of his departure was conspiracy. "I remained behind," Dashkova wrote, "feeling ill and sad with nothing to cheer me up except for the different plans which I kept forming and rejecting and which distracted me sufficiently to soothe somewhat the grief and separation from a beloved and esteemed husband" (59).

Discontent and contempt for the new emperor were growing daily and fueling the desire for change. Particularly distasteful for Dashkova was the Prussian influence at court and Peter's support of Frederick the Great. Peter was planning an unpopular war with Denmark in the interests of his native Holstein. He consequently ordered a cessation of military action against Prussia and agreed to a truce, giving up territories the Russian army had taken in hard-fought victories on the battlefield. Meanwhile, on April 11, 1762, Catherine gave birth to a son Alexei, but the father was Grigorii Orlov, not Peter, and the infant was given the title of Count Bobrinskii. The treaty with Prussia was signed on May 5, and soon after, on June 9, Peter gave a grand banquet of celebration at which, with the sound of cannons in the background, he offered up three toasts: to the

imperial family, to the King of Prussia, and to peace. Assuming that she was a member of the imperial family, Catherine did not rise, but Peter apparently felt that she was giving offense to his idol, Frederick II; he angrily insulted her publicly, calling her a fool (*dura*), whereupon Catherine burst into tears.

Peter's treasonous, as Dashkova saw it, alliance with Prussia against the Austrians and his appalling conduct with his wife hardened Dashkova's resolve. She met often with Robert Keith, the British ambassador who was highly critical of the emperor and whom Dashkova described as a "worthy old man [who] loved me like a daughter" (54). Because of her frequent meetings with diplomats and officials from other countries, Dashkova was suspected of being in the pay of foreign powers. Although she was chronically short of funds, she claimed never to have received money from the English, the French, or anybody else. Yet mounting debts, primarily due to her husband's improvident and wasteful ways, forced her to observe a strict frugality. "I imposed the strictest economy on myself, wore nothing but the oldest clothes and remains of my trousseau, and even restricted my *penchant* for books, etc., as much as possible" (64).

She plotted with her husband's friends and young officers of the Preobrazhenskii, Izmailovskii, and Semenovskii Guard Regiments, who were also dissatisfied with Peter's reign. Among them were individuals who would play an important role in the coup: Peter Passek, Sergei Bredikhin, and the brothers Nikolai and Alexander Roslavlev. Dashkova helped win over to her cause Kirill Razumovskii, although it is likely that Catherine, the Orlovs, or Panin had recruited him even earlier, and during the coup, he would rally the Izmailovskii Guards. A highly influential individual, he owed his promotions and appointments to fieldmarshal, hetman of the Ukaraine, and president of the Academy of Sciences, at least partially to his brother Aleksei's love affair and, according to some, secret marriage to Empress Elizabeth. In addition, Dashkova was instrumental in drawing into the conspiracy one of its most prominent participants, her relative Nikita Panin.

If Catherine was the mother she never knew, Panin replaced the father who was always absent. A man of wide education and liberal views, he played a major role in the development of Dashkova's political views. Panin was a diplomat, statesman, and Russian ambassador in Sweden, who two years before the coup was called back to Russia and named tutor (*oberhofmeister*) to the grand duke, a position he would hold until Paul's first marriage in 1773. His appointment was a great victory for the Vorontsovs over the Shuvalov faction at court, which had made every effort to install

Ivan Shuvalov as tutor to the future emperor. Panin hoped, and mostly failed, to realize in Paul a model enlightened monarch by way of a proper education, the reading of the *philosophes*, and a thorough understanding of European history as described by, among others, the Scottish historian William Robertson. Robertson would play a central role in the education of Dashkova's son and she too admired him greatly. Besides, Panin patronized some to the leading Russian writers of the time such as A. P. Sumarokov, I. F. Bogdanovich, and D. I. Fonvizin, and invited them to read their latest works to the grand duke. Eventually, he would go on to head the Foreign Affairs Collegium for close to twenty years. Panin's views arguably represented "the most completely expressed political program of the liberal-minded nobility."[36] He was the author of "The Manifesto on the Establishment of an Imperial Council and the Division of the Senate into Departments" and the "Discourse on Fundamental Law." In his writings, he expressed his opposition to despotism and described a model state, where power is shared between the judicial, executive, and legislative branches of government. As ambassador to Sweden, he was introduced to Sweden's form of constitutional monarchy and became a staunch advocate of a limited monarchy. Upon his return to Russia, Panin strove to limit and impose restrictions on autocratic rule in Russia and to institute a type of enlightened absolutism. In the formulation and articulation of his views he was greatly influenced by Montesquieu's *Esprit des lois*, a work Dashkova, and for that matter Catherine, also read with great enthusiasm.[37]

Dashkova discussed with Panin the necessity for reform, and her political ideas were similarly based on Montesquieu's basic principle that individuals were endowed with fundamental rights that had to be protected against despotism and uncontrolled government power. She shared Panin's dreams that one day Russia would be governed by the rule of law and by a constitution, although she felt that the English rather than the Swedish model was more appropriate. But Dashkova's views were not democratic in spirit and were firmly rooted in the patriarchal and hierarchical assumptions of eighteenth-century Russia.

> Limited monarchy, headed by a master who could be a father to his people and who knows that he is respected and even loved by his subjects, and yet feared by the wicked, must be the goal of every thinking person. For power, lodged with the masses, whose opinions are lightly held and forever changing, is unstable; it is exercised either too slowly or with undue precipitancy; the great variety of views and convictions deprives it of harmony (60).

Her mistrust of the monarchy did not translate into a wish for its abolition, and although she challenged absolutism, it was primarily to limit it through the constitutional rights and political autonomy of the nobility. An enlightened monarch would bring about change from above with the support and active participation of the educated nobility.

Dashkova was unquestionably very close to Panin, and she revealed to him the extent of the conspiracy against Peter, all of its participants, and her own schemes, plots, and projects. Panin supported Catherine but asserted correctly that the empress was without legal title to the throne of Russia and that Paul should be proclaimed sovereign, with Catherine restricted to the role of regent. Thwarted in his attempts to establish Catherine as regent during the minority of her son and to establish a council of nobles that would review and countersign her decrees, he focused on Paul's young court. From there Panin headed a group of nobles generally at odds with Catherine's policies. In time, because of Dashkova's close association with this opposition group, the sycophants surrounding Catherine made every effort to ridicule and debase her close relationship with Panin.

She felt that it was in all probability Catherine's confidant, Maria Travina, who was instrumental in spreading the malicious gossip at court that before assuming ambassadorship in Sweden, Panin had an affair with Dashkova's mother and that he was her father. Others were very eager to communicate further the spicy tattle and Sir George Macartney, for instance, in a dispatch dated 1765 wrote, "Mr. Panin is supposed by the world to be her [Dashkova's] real father."[38] The Orlovs, and others, wishing to discredit the Panin faction, fueled the rumor and embellished it by insinuating that Panin and Dashkova were also lovers despite their great age difference of twenty-five years.[39] Panin's fondness for young women was well known and it often distracted him from his duties at court. In fact, he had an affair with Dashkova's cousin and exact contemporary, Anna Vorontsova.[40] Rulhière and Casanova wrote that Panin was passionately in love with Dashkova, and Lord Buckinghamshire repeated the rumor: "The Princess D'Ashkow is the favorite of his [Panin's] heart; many doubt whether as his child or his mistress."[41] The Vorontsov family also suspected that they were lovers. Mikhail Vorontsov twice mentioned the matter in letters to Aleksander stating that Panin "to his own disparagement, passionately loves, and reveres Daskhova" and that he "blindly makes himself a slave to her."[42]

Dashkova disputed and was deeply troubled by the "slanderous insinuations which credited this respectable old cousin with being either my lover or my father—on the supposition that he had been my mother's lover

... But enough on a subject that is painful to me even now" (57). The French chargé d'affaires, M. Béranger doubted Dashkova's involvement with Panin and on July 16, 1762, commented, "Panin was head over heels in love (*amoureux fou*) with Dashkova. This young woman, who never pretended to be a vestal virgin but in whom ambition dominated all other feelings, had no taste for Panin."[43] Although Dashkova wrote that she was not Panin's nor anybody else's lover, a close relationship existed between them and was both politically and personally motivated. Panin's attraction to Dashkova would be very important for her, since on a number of occasions he protected her, and his intercession with Catherine allowed Dashkova to return from banishment. But eventually, Dashkova's association with Panin and his group, as well as with other disaffected nobles, and her outspoken criticism of the Orlovs, led to suspicion, persecution, and the surveillance to which she was subjected.

Chapter Three

The Coup

PARTICIPATION IN THE COUP D'ÉTAT of 1762 was the one event that would forever define Dashkova's future. It marked her entrance onto the stage of world affairs. It was a night when the masquerades of her youth, the disguises she assumed throughout her life, and questions of gender and identity came to a head. The coup determined her existence inside and outside public life, which in the end would not be a success story in the traditional sense. It led to the disintegration of the Vorontsov faction's hard-fought position of dominance at court, to a permanent rift with some members of her family, and to the eventual falling out with Catherine.

The months preceding the coup d'état were a difficult and hazardous time for Dashkova, culminating in a terrifying and inauspicious event that did not bode well for her future. She was alone with her children, and spent her time writing her husband in Troitskoe and reading everything she could find on the subject of insurgency and revolution. With her father's help, she acquired a "small summer place" on some marshy and thickly forested land located two and a half miles from the city on the Peterhof Road, not far from Roman Vorontsov's country house.[1] The Peterhof Road was a major thoroughfare traveled by the carriages of the nobility and Russian monarchs on their way from St. Petersburg to Peterhof, Oranienbaum, or Kronstadt. In the words of contemporaries, the Peterhof road during this period was beginning to resemble the beautiful way from Paris to Versailles, with many fine estates built at the roadside. Due to a lack of funds, Dashkova would not live on this land for another ten years and would build her house there only in 1783, or some twenty years later. She would eventually call her property Kirianovo. In her autobiography, the dark, cold, and swampy area is consistently associated with

misfortune. Dashkova describes how one day, while exploring the land she had acquired, she accidentally ventured into a deep bog and caught a severe chill that led to a high fever. For several days she was bedridden and was visited by her friends and family, among them Nikita Panin. Catherine, for her part, in a gentle, parental manner chided Dashkova's for her misfortune:

> I am really sorry that your sore throat prevents you from coming to see me, and deprives me of the pleasure of enjoying your society. But pray, how comes it that you will enact the water nymph? I should certainly scold you, did I not recollect that at nineteen years of age I too had a tenderness for such adventures. To chastise you, however, a little for the injury you inflicted, and with your eyes open, I will pronounce for your mortification, that a few years will effectually cure you of all these frolics.[2]

Dashkova's first thoughts of a possible coup seem to have come to her at some point in the spring of 1762, about the time she met Grigorii Orlov. That summer the court departed for Peterhof and Oranienbaum while Dashkova remained in the city enjoying a respite from the gatherings and entertainments of the social season and continuing to meet with her fellow conspirators. Robert Keith, British ambassador in St. Petersburg, wrote about the time just preceding the coup: "The most singular circumstance of the whole is that the place of rendezvous [for the conspirators] was the house of the Princess Dashkoff, a young Lady not above twenty years old."[3]

In her *Memoirs,* Dashkova described how Grigorii Orlov came to her house in the afternoon of June 27 with news that the plot had been revealed and Captain Passek arrested. Actually, Dashkova knew this information to be incorrect since the events of 1762 began at night, when Passek was arrested at 9 P.M. This detail presented her with a personal problem of decorum, for that night Panin was with her, and by the time she came to write her autobiography, she was aware of rumors at court that he was her lover. It was therefore improper to locate him in her house in the middle of the night, and Dashkova shifted the time to the afternoon. In a long letter written shortly after the coup, Dashkova accurately stated that Orlov had arrived at 11 P.M.[4]

It was, Dashkova continued in the *Memoirs,* Orlov's second visit in two days to inform her that the troops in the city were impatient and growing ever more restless. Dashkova wrote a note to the wife of Vasilii Shkurin,

Catherine's gentleman of the bedchamber, ordering her to send a hired carriage to Peterhof, where Catherine was residing, so that she could secretly return to the capital.[5] It would then be ready, if necessary, to return the empress to the city to assume command of the guard regiments, something that was accomplished early in the morning of June 27. Dashkova declared that Panin did not see the need for such precautions and that his participation was mostly passive and halfhearted. In recounting his version of the events, Panin claimed that he, and not Dashkova, gave the preliminary orders to initiate the first phase of the coup and that he sent a carriage and six horses to Peterhof.[6] Otherwise, Dashkova's and Panin's accounts are very close and the major disparity in the three major eyewitness accounts of the coup—Dashkova's, Panin's, and Catherine's—concern the question of who initiated it and who was at its center. In addition, the tone of the three narratives differs: Catherine, the empress, was triumphant and offhanded; Panin was calmly modest; while Dashkova, who was seeking to regain her proper place in history, became stubbornly insistent on the significance of her role and hoped to convince the reader through the use of detail. In the end, the Orlovs drove Catherine back to St. Petersburg—first Aleksei and then Grigorii. They, along with Catherine, were the original conspirators, and Dashkova could not aspire to this position.

Dashkova went on to relate that while others hesitated to take action, she immediately donned a man's overcoat and set out on foot to notify the brothers Nikolai and Aleksandr Roslavlev, both officers in the Izmailovskii Guards. Nikolai would later be exiled for two years for his participation in the Khitrovo affair, allegedly an attempt to overthrow Catherine, in which Dashkova would also be implicated. On the way, she ran into Aleksei Orlov riding full gallop from the Roslavlevs' house. Although they had not met previously, the unusual sight of a woman dressed in a man's coat out in the street at the late hour must have struck Aleksei. He pulled up and informed her that events had been set in motion—there was no turning back. Dashkova urged him to have some of the officers, Mikhail Lasunskii, Egraf Chertkov, Sergei Bredikhin, and others, return to the barracks of their regiments and ordered Aleksei Orlov to ride without delay to Peterhof in order to bring Catherine back to the capital.

Dashkova returned home agitated and disappointed. She had planned her costume in advance, as if preparing for a metamorphosis ball. Now the constraints of her female garb prevented her from acting out the role of a conspirator, since "to my great disappointment I learned from my maid that the tailor had not yet brought my suit of man's clothes." She therefore "could do nothing, and in default of male clothes I could not even follow

my natural impulse to go to meet the empress" (76–77). In order not to arouse suspicion, Dashkova retired to bed but could not sleep and jumped out of bed when she heard Fedor Orlov, the youngest of the four brothers, knocking at her front door. Panin inaccurately related, "Aleksei Orlov's spirits sank and instead of driving directly to Peterhof, he [actually Fedor] returned to Princess Dashkova's house at four in the morning to learn if there had been any change of plan, and he finally departed only after the princess ordered him immediately to make haste and warn the empress about everything."[7] Dashkova went back to bed, but as the sleepless night dragged on, she was tormented by visions of what might befall her and her cohorts if the revolution should fail and they all be sentenced to share the scaffold. "I saw the empress — the idol of my heart and soul — pale, disfigured, dying, the victim more perhaps of our love for her than of our rashness. I drew a mental picture of the fate that would await me, and my only consolation was that I should suffer death like all those whom I had involved in my own ruin" (77).

As Dashkova tossed and turned that night, beset by doubts and fears, Aleksei Orlov had at last driven to Peterhof. On the morning of June 28, 1762, he roused Catherine, who was sleeping in the Monplaisir pavilion in Peterhof, led her to the waiting carriage, and with his brother Grigorii, drove her at full speed back to the capital to enlist the support of the Izmailovskii, Semenovskii, and Preobrazhenskii Guard Regiments. Catherine then marched along the Nevskii to the Kazan Cathedral where she participated in a service of thanksgiving, received the blessing of the church hierarchy, and was proclaimed Empress of Russia. Those who opposed her, or favored her regency only, were either silenced or arrested. A few of the officers in the Preobrazhenskii Regiment followed the example of Petr Izmailov and Petr Voeikov and remained loyal to the emperor. Among them was Dashkova's brother, Simon, who first attempted to remind his subordinates of the allegiance they had sworn to Peter III and then rushed to Oranienbaum to Peter's aid. Arrested by his soldiers, he was marched off to the Winter Palace, imprisoned there, and spent eleven days in custody.[8] The other loyalist officers of the Preobrazhenskii Regiment were arrested along with Vorontsov.

Dashkova did not hurry to Catherine's side that night, and either because she did not fully realize the gravity of the situation, or because she feared its consequences, she was not present during the initial, crucial stages of the coup. Now in broad daylight she no longer needed to disguise herself as a man. So at six in the morning Dashkova put on a dress she wore at state occasions and made haste to the Winter Palace where

the ceremony of the oath of allegiance was taking place. It was a courageous decision, for she was risking her life, but by then there was no turning back, she was too heavily implicated. When she arrived, a throng of supporters greeted her and some soldiers lifted her up and carried her to Catherine's antechamber, where the two women embraced excitedly. Without further ado, Dashkova made every effort to take charge of the moment by rearranging colors, costumes, and representations of rank. That night Nikita Panin had gone to the Summer Palace to be with the Grand Duke Paul, then proceeded to the Cathedral of Kazan', and from there to the Winter Palace. Dashkova approached him and removed from his shoulder the blue ribbon of the Order of St. Andrew the First-Called. At that time, the wives of emperors did not regularly wear the decoration, but Catherine was now empress and Dashkova ceremonially put it on her. To make room for the new decoration, Catherine took off the Order of St. Catherine, which only women wore, almost without exception, and Dashkova placed it in her pocket.[9] The symbolic gesture would have pleased Catherine had it not been for the bold self-assurance and brazenness of Dashkova's initiative.

It was resolved to march to Peterhof in order to engage the emperor, and the two women required appropriate, properly fitted attire. They located officers who were roughly their size and weight and Catherine dressed in the Semenovskii Regiment's uniform of Aleksandr Talyzin, while Dashkova borrowed the uniform of the Preobrazhenskii Regiment taken from Mikhail Pushkin. The latter was the great-uncle of A. S. Pushkin and a particularly colorful character, whom Dashkova had earlier extricated from some doubtful business transactions. He would later be found guilty of issuing counterfeit banknotes and sentenced to penal servitude in Siberia, where he would die. The uniforms they selected where of an older, more traditional cut. Peter the Great had introduced the relatively simple, straightforward, and unadorned officer's uniform in the Preobrazhenskii Regiment. Green, and cut similarly to a soldier's uniform, it included gold galloons, an officer's insignia in the shape of a half moon worn on the chest, and a tricolor belt. By implying that the uniform she selected represented Russia's glorious past, Dashkova was in effect redressing some of the wrongs Peter III committed with his pro-Prussian policies.

> These uniforms, by the way, were those the Preobrazhenskii Regiment formerly wore from the time of Peter the Great down to the reign of Peter III, who abolished them in favor of Prussian-type uniforms. And it is a peculiar thing that no sooner did the empress arrive in Petersburg that

the soldiers threw off their new Prussian uniforms and donned their old ones, which they somehow managed to find" (78).

The putting on of a military uniform bestowed a newfound mobility on the nineteen-year-old Dashkova and lent authority to her actions during the coup d'état of 1762. Yet not everyone was pleased with Dashkova's transformation into a military officer. Mikhail Buturlin related how during the afternoon of June 28, Dashkova, dressed in an officer's uniform but without a hat, rode out to meet the Izmailovskii regiment. She then requested that her relative V. S. Naryshkin, an officer in the regiment, give her his hat. He flatly refused and added, "This broad decides to get dressed up like a clown, while I'm supposed to give her my hat and go around bareheaded!"[10] Dashkova's actions were indeed threatening to some of the other officers, dressed as she was and acting as a man on the stage of historical events. Dashkova, however, presented herself much more innocently, and because of her feminine appearance, she often saw herself as a youth, "There I was in an officer's uniform . . . only one spur and for all the world like a boy of fourteen" (86).[11] When Catherine was meeting with her council, Dashkova did not hesitate to rush into the senate with a great sense of the dramatic and whisper her recommendations in the empress's ear. "I looked like a boy of fifteen in my uniform, and the appearance of a young and totally unknown guards officer in the midst of their [the venerable old statesmen's] sanctuary speaking in Her Majesty's ear must have been strange indeed." But no sooner was she identified than all who had gathered bowed and welcomed her. "I really did behave rather like a small boy and at this mark of respect I blushed and was overcome with confusion," writes the delighted Dashkova (79). Despite her boyishness, the officer's uniform underlined the acquisition of unprecedented power and social influence, which were completely dependent on male disguise and were impossible without it.

In order to complete the take over of the government, in the evening of June 28 Catherine made ready to march on Peterhof. After mounting their horses and reviewing the troops, the two women set off to do battle, if necessary, with Peter's Holstein army. Catherine was in command of her mounted guardsmen, three regiments of infantry guardsmen, a regiment of hussars, and two additional infantry regiments. The infantry was positioned in the advance guard. Though perilous and deathly serious, the march was reminiscent of a masquerade ball and its inversion of prescribed hierarchies with women in charge. Dashkova was Catherine's trusted cohort, but it all seemed unreal—the nighttime preparations and

maneuvers, the danger, the new and unfamiliar course they were following with the resolution still in doubt, the potential for military action, and the contradictory feelings of the legitimacy and the illegitimacy of their endeavor. Peter had to be removed for the good of Russia, but Catherine had no legal rights to the throne. Yet, women were at last gaining the upper hand and effecting long-needed change. For a brief time Dashkova was almost of equal rank to the empress and she could hardly believe that she was riding astride next to Catherine dressed in an officer's uniform and on the brink of effecting an overthrow of the government. It was a moment in Russian history that was to have far-reaching consequences on the subsequent development of the Russian Empire, although some noted historians, Vasilii Kliuchevskii among them, would disparagingly refer to it as a veritable ladies' revolution.

On that night disguise and gender came together dramatically during the heady events of 1762, when both women adopted male roles as they celebrated an atmosphere of ambiguity and the inversion of once rigid social and political categories. The women were marching against Peter III: Catherine acted against her husband, Dashkova against her godfather. Just as Catherine, the woman Dashkova admired above all others, was about to dethrone her spouse, so too Dashkova had usurped the position and power of her brother, appropriating the uniform and the officer's commission of her brother's Preobrazhenskii Regiment. Their actions represented a subversion of male authority, while also implying recognition of masculine strength and influence that could defeat, at least temporarily, established gender roles, undo past injustices, and promote the recreation of society. She was acting out her dreams, effecting change through force of military action, riding next to Catherine, now commander-in-chief and soon to be sovereign. Dashkova was leading men, and while she was commanding the troops dressed in the uniform of Simon's regiment, he was under arrest. Simon, who was released on the night of July 8, only after the death of Peter, was a proud, strict, and inflexible man when it came to matters of honor.[12] He never forgave his sister the dishonor she had subjected him to that night, and once released, resigned his commission in the guards.[13]

While her brother was under arrest, helpless and fuming, Dashkova was approaching Krasnyi Kabak, a march of just over six miles. She was the only woman in Catherine's impressive entourage, which included Prince Troubetskoi, Count Buturlin, Count Razumovskii, Prince Volkonskii, Quartermaster-General Villebois, and Count Shuvalov. At two in the morning, they reached Krasnyi Kabak, a coaching inn located on the Peterhof road, which according to Dashkova was "nothing but a wretched

tavern" (79).[14] She was badly in need of rest, having slept little the previous night, and since there was only a single bed in the house, "her majesty decided that we should both of us lie on it without undressing" (79). As opposed to their first night together, Dashkova was far more in command this time around. While Catherine always retained her position of power and control, Dashkova, in her officer's uniform, was more active and much less subservient. She took Colonel Vasilii Karr's cloak, covered the filthy bed, and then provided security for Catherine by posting sentries at the door.

Catherine in her *Memoirs* also recalled that night. She mirrored Dashkova's sense of equality and esprit de corps, but additionally interjected a tone of conviviality and companionship. Referring to herself in the third person singular, she wrote,

> She [Catherine] kept quiet in order not to disturb Princess Dashkova who lay by her side. When she accidentally turned her head, she saw the great blue eyes of the latter were open and gazing at her. Thereupon they both burst into a loud laugh, because each had thought that the other was asleep and respected her sleep."[15]

In bed, they purportedly read manifestos and dreamed of the future. Discussing their relationship, Herzen elaborated, "Where was the time, when they lay on a bed under the same blanket and wept, and embraced, or dreamed on Colonel Karr's overcoat the whole night through about governmental reforms?"[16] Herzen's observation is very much to the point, for in the *Memoirs*, the bond of friendship and solidarity that existed between the two women was most clearly expressed in the scenes where Dashkova and Catherine shared a bed.

Initially, Peter was unaware of the events transpiring in St. Petersburg and was at Oranienbaum preparing to celebrate his name day with most of Dashkova's family. Her father was in attendance, as well as her uncle with his wife and daughter, now the Countess Stroganov, and of course her sister. They all remained loyal to the emperor when he learned of the coup and they accompanied him as he helplessly attempted to muster a response to the revolt. Peter sent out his envoys to the advancing Catherine. They were at first demanding, then conciliatory, then pleading, as Peter's support progressively dwindled, and many former followers defected to the other side. But Roman Vorontsov and Elizaveta stayed at the emperor's side as he sailed to Kronstadt where the commandant of the fortress, Admiral Ivan Talyzin, refused them the right to land and sent them back to

the mainland. Mikhail Vorontsov, however, had not joined them because earlier he had volunteered to remonstrate with Catherine and was sent off with a letter hoping to appeal to the conscience of Peter's determined and combative spouse. Having failed at his mission, Vorontsov submitted his resignation to Catherine in which, according to Dashkova, he asserted the impossibility of swearing allegiance to Catherine and thereby betraying Peter while the latter was still alive. "Seeing that his arguments got him nowhere, he retired to his own house and refused to swear the oath of allegiance to her" (80). A number of family members repeated the tale of Vorontsov's proud repudiation of Catherine's ascendancy; however, since Vorontsov stayed on for a time as chancellor, it is highly unlikely that he could have refused to swear allegiance to the empress. According to the eyewitness account of J. Pozier, jeweler to the court, Vorontsov arrived as Peter's envoy, met with Catherine, and transmitted the emperor's grievances. He also requested that he be allowed to postpone the oath of allegiance until he could write a report to Peter with a full account of his mission. He was then placed under arrest and two officers escorted him out. In a letter to Poniatovskii, dated August 2, 1762, Catherine explained that Vorontsov was in fact taken to church for administration of the oath of allegiance.[17]

The vice-chancellor Aleksandr Golitsyn had also been dispatched to Catherine with a letter, but Peter's offer to negotiate remained unanswered. In a second letter, Peter abdicated the throne of Russia, agreeing to give himself up and begging to be allowed to leave for Holstein with his *Fräulein*, Elizaveta Vorontsova.[18] His requests were denied, and at last, Aleksandr Golitsyn, Grigorii Orlov, and Mikhail L. Izmailov persuaded him to sign an unconditional abdication. Nikita Panin personally supervised Peter's arrest, supposedly for his own protection, while Peter pitifully tried to kiss his hand and Elizaveta fell to her knees and begged to be allowed to stay with her lover. This too was disallowed and the vanquished emperor was confined to his nearby estate, Ropsha, located just over twenty-five miles outside St. Petersburg. Despite the disdain Dashkova felt for her godfather, she did retain a measure of sympathy for him: "He was not wicked, but his incompetence and lack of education, as well as his inclination and natural bent, all combined to make him a good Prussian corporal and not the sovereign of a great empire" (81). In her eyes, it was Peter's intellectual limitations and brutish nature that disqualified him from ruling an empire, and the objective of the conspiracy was principally to remove Peter from the throne. She shared Panin's opinion that the succession should be conferred on Paul with Catherine serving as regent during her son's

minority. After all, Catherine was a usurper of power without legal claim to the Russian throne. Interestingly, Dashkova once again had somebody else voice her thoughts when in her *Memoirs* she expressed Panin's views concerning Catherine. "I agree with you [Panin]," wrote Dashkova, "the empress has not right to the throne, that by rights it is her son who should be proclaimed sovereign with the empress as regent until he comes of age" (67). Diderot also mentioned that "the princess wished to make her friend [Catherine] regent."[19] Years later, Dashkova took issue with the notion that she wanted Catherine to occupy the throne, and in a seventeen-point rejoinder to Rulhière's account of the coup, she stated outright, "I always said that the empress could only be regent until the maturity [of Paul]."[20]

The march had ended peacefully and the emperor had abdicated the throne in writing by noon of the next day. The insurrectionists had not met the expected opposition outside of Oranienbaum, and the bloodless revolution had come to an end without a single shot being fired. On July 29, 1762, the day of Catherine's ascension to the throne, the weather was hot, and the doors of all the inns, taverns, and wine cellars remained wide open for celebration, with the beer, vodka, wine, and champagne flowing freely. Dashkova had not been at Catherine's side to unseat and arrest the emperor. Rather, in the flush of excitement and still dressed in her uniform, she rushed about issuing orders, guarding the wine cellars, and checking on sentries. It was a magical time for her, but the spell was soon broken even before she returned to St. Petersburg. When she entered Catherine's inner rooms at the palace, she was surprised to come upon Grigorii Orlov, who had stretched out his six-foot frame on a sofa and was unceremoniously sifting through large bundles of official, government documents. She left immediately, stunned by Orlov's boldness. What right did he have to intrude himself into the empress's sanctuary and to impose himself on their relationship? Later, "when I came back to the palace, I saw in the room in which Grigorii Orlov was lying on a sofa a table laid for three" (82). Gradually she began to understand, and though painful, the evidence was conclusive and inescapable: "I realized with a pang that Orlov was her lover and that never would she be able to keep it a secret" (83). Dashkova felt that Orlov's presence was an intrusion—a violation and sundering of a union based on mutual respect and understanding. "It was an unpleasant discovery, for with it vanished her dreams of exclusive confidence and romantic friendship with Catherine."[21]

Dashkova had become emotionally dependant on Catherine, and now as she dined with her and her lover, she felt humiliated. Her idealism and

her dreams of inseparable friendship and boundless trust were replaced first by surprise and then by an invidious rage, which was to last for decades and grow in intensity. Dashkova never learned to make her peace with Grigorii Orlov, or for that matter, any of Catherine's lovers. She could never conceal her anger adequately and her undisguised feelings that Orlov was unfit for governmental service were not appreciated or well received. The tension at the dinner table would lead to an ongoing jealous rivalry between Dashkova and the Orlovs.[22] There was one too many at the table that day and Orlov would take every opportunity to make sure it was Dashkova. He would do this primarily by casting suspicion on her complicity in one conspiracy after another at court. As a result, the empress, who was known for her artfulness, skillfully dealt with Dashkova, and when she suspected her most, Catherine would keep her guessing and at bay through a coordinated method of exile and reward. Her manner of handling Dashkova was to punish her with prolonged banishment and then to pacify her with occasional gifts of money. In the end, Dashkova's political and personal relationship with Catherine was a complex one, and for her part, Dashkova insisted that she never endured a prolonged, humiliating exile, and if the empress and she did not always see eye to eye, it was due to the intrigues of the courtiers.

On the way back to the capital from Peterhof, Dashkova was plagued by mixed feelings. The revolt had succeeded and she had played an important part in the overthrow of Peter's government, while simultaneously undermining her family's political fortunes during their ascendancy. Her role in the events of 1762 was an important one, mostly as an ardent proponent of the coup rallying support for Catherine's cause, and helping to bring over to her side a number of influential individuals. And yet, there was a growing tension between the two women and the unconstrained camaraderie of the past had vanished. So too faded her dreams of working with the empress for the betterment of society through its transformation along the lines of the Enlightenment, since others held Catherine's attention. Halfway to St. Petersburg, they stopped to rest at the Kurakin estate, and Dashkova's description of the third night she spent with Catherine is conspicuously terse, dry, and matter of fact. She only mentions it in passing: "We broke our journey at Prince Kurakin's country house, which had only one bed and again we had to share it" (83).

As they neared the city, people greeted them joyfully, and when they entered St. Petersburg, emotions overwhelmed Dashkova as she rode at Catherine's side. There were throngs in the streets, shouting and scream-

ing to the sound of regimental bands and the tolling of church bells. This was the moment of her greatest triumph, her prayers had been answered and she was "almost oblivious of reality," although she could not shake entirely her fears for the fate of her family (83). They were all under arrest—father, uncle, sister, brother. Uncertain about how she would be received, Dashkova nevertheless resolved to visit her uncle first and then her father and sister. She drove directly to Mikhail Vorontsov's house where the chancellor appeared to be "in fairly good spirits and as cool and collected as ever" (83). Once again, in her *Memoirs* Dashkova dramatized events and had her uncle express feelings of resentment that she harbored toward Catherine and the Orlovs:

> He spoke to me of Peter's overthrow as of something he had expected, and then gave me a few words of warning on the subject of the friendship of princes, which, he said, was neither very stable nor very sincere. He had proof on this in the reign of a princess [Elizabeth] who had avowedly been friendly to him and to whom he had been devoted from the time of his youth, yet all the purity of his actions and intentions had not saved him from the poison of intrigue and envy (83–84).

In Dashkova's reconstruction of events, her uncle became a character in a narrative expressing her own opinions. His words echo her thoughts articulated openly in the concluding chapter of the *Memoirs*, when she indirectly voiced her personal feelings on the fickleness and inconstancy of those in power. She was alluding to Catherine and the Orlovs primarily when she concluded, "Nature had not endowed me with the gift of pretense, so essential when dealing with sovereigns and even more with the people round them" (276). In a later addition to the *Memoirs*, which was included in the British Museum manuscript but not in the St. Petersburg version, Dashkova wrote, "The days of my illusions regarding the friendship of sovereigns are nearly over" (94).[23] In reality, Mikhail Vorontsov was furious. He had devoted his life to state service, had risen through the ranks to attain as chancellor the highest office in the land, and in the process, he had patiently built up over the years the family fortune and enriched all of its members. And now, this young woman, the girl he had taken into his house and had brought up together with his daughter, had turned against him, and enthusiastically brought everything crashing down.

In letter after letter, he shared with Aleksandr and other relations his dissatisfaction with his niece. Always thinking about the Vorontsovs first and foremost, on August 21, 1762, he criticized Dashkova for being distant

and aloof and added that she was not working on behalf of the family and her actions might in fact result in disfavor. Her indifference to the family pained him, and he feared that her "capricious and immoderate behavior," as well as her unrestrained speech, could anger the empress. Consequently, she could be banished from court and thereby bring public censure on the family name. Her conduct did not allow anyone in the family to love her because "her indifference to us is hurtful and essentially intolerable, especially as we derive no benefits from her success, but may yet suffer unnecessary ill will from her fall." Moreover, Mikhail Vorontsov denounced her unconventional pursuits and mode of living by implying that her corrupted and vainglorious nature was a consequence of the inordinate time she devoted to study and to other empty activities. "As it seems to me, her ways are corrupt and vain, concerned with the empty and the imaginary, she wastes her time on the high minded and learning." Her husband, by way of contrast, was courteous, modest, and reasonable.[24]

Although Mikhail Vorontsov stayed on as chancellor for another year, his situation at court soon became untenable and his career came to an end. At odds with Grigorii Orlov in particular, he was relieved of his responsibilities in 1763, though nominally retaining the title of chancellor until 1765. His duties were taken over by Nikita Panin, and Vorontsov was sent abroad into a gentle exile officially for rest and reasons of health. He departed on August 7, 1763, traveling to Italy, France, Prussia, and Austria. In Vienna, he met his nephew Simon, who after the coup had obtained, with his uncle's assistance, a position as a consultant attached to the embassy. Simon introduced him to François Germaine Lafermière, a musician, librettist, and man of the theater, who upon Mikhail Vorontsov's invitation came to Russia and became Aleksandr's close friend and lifelong companion. In due course, Simon would go back to military life and serve under the command of Petr Rumiantsev in the Turkish War of 1768. Mikhail Vorontsov returned home in 1765 and was officially dismissed the same year.

After visiting her uncle, Dashkova then went to see her arrested sister and father, Roman Vorontsov, "who was not quite his usual self" since his house was "guarded" by two regiments of soldiers under the command of Nikolai Kakovinskii (84). Dashkova considered Kakovinskii to be of unsound mind (even though he went on to attain the rank of lieutenant-general) and saw no reason to have so many soldiers stationed at her father's house with sentries posted at every door. She told Kakovinskii as much and ordered all but twelve soldiers to depart, sending them off to guard the empress. Dashkova does not specify in the *Memoirs* whether the

soldiers heeded her orders, and presumably, they did not, since Simon stated that they were still there at his arrival on July 8.[25] When Catherine learned that Dashkova had countermanded her orders, she was irate and reproached her for acting so independently. Dashkova's actions evoked Catherine's angry order to cease at once commanding the troops. This incident marked the first of many open quarrels, and the ongoing tiffs between the two women were an expected consequence of Dashkova's actions, which were often too direct, willful, and undiplomatic.

Roman Vorontsov had always been cold and distant with his youngest daughter, and he was repeatedly put off by her independent and rebellious ways. But she had gone too far! He would never be able to erase from his mind the memory of the last two days. Because of his daughter's actions against the emperor, he would be deprived of a large portion of his properties and for a time be banished from St. Petersburg to Moscow.[26] He broke off communications with her and never fully forgave her the insurrection against his paternal authority, the patriarchal rule of the tsar, and the family's power and influence. Dashkova's relationship with her father worsened to such a degree that while she continued writing him for years, he did not respond to her letters.[27] In his presence that day, she made every effort to return to the more conventional roles of daughter, sister, and mother, pointing out to him that she soon had to see her sister Elizaveta, then go home to check on her daughter and "change into something other than my military uniform." Nevertheless, it is hardly plausible that during his arrest, Roman Vorontsov received Dashkova "without a trace of anger," and did not want to let her go. Even less convincing is Dashkova's assurance that her father was displeased with Elizaveta and "never had much affection for her" (84–85). Actually, he was very fond of Elizaveta and she was his only legitimate daughter to receive an inheritance at his death. According to Roman's will, and as proof of his love for her, Elizaveta received a sizable inheritance of ten thousand rubles — Dashkova was disinherited.[28]

The meeting between the sisters, and sometime rivals, was not a happy one. Elizaveta was beside herself, blaming her sister for her ruin and accusing her of stealing all her possessions, especially her jewelry. Aleksandr would again level these charges against Dashkova, who always defended herself and would go so far as to claim that she never had a falling out with her sister. In order to calm her, Dashkova, who must have already spoken to Catherine, assured Elizaveta that the empress would treat her kindly but only if she promised not to attend the coronation in Moscow. Elizaveta

would be dismissed from her duties as maid of honor and whisked away from St. Petersburg in a closed sleeping carriage (*dormez*) in order to avoid notice, first to Moscow and then to her father's estate (possibly Demidkovo).[29] She lived there until she was allowed to return to Moscow after the coronation. Catherine ordered Elizaveta to stay there and not to give cause for people "to talk about her."[30]

Leaving her sister and father, Dashkova went home to kiss her daughter, little Anastasia, but had no time left to change into something more conventional than the military uniform she was wearing. It was then that in her pocket she came across the Order of St. Catherine, about which she had forgotten completely. Later, when she attempted to return it to Catherine, the empress bestowed the order on her, pinning the ribbon on her shoulder and adding, "This . . . is for your services" (86). Dashkova was now wearing the red ribbon of the Order of St. Catherine that until recently adorned the empress. She was well pleased with the honor and with her achievements: "I kissed her hand—and there I was in an officer's uniform, with a ribbon (but no star) across the shoulder" (86). Thus, in the first flush of victory, Dashkova became a cavalier of the Order of St. Catherine. Catherine had bestowed on her the highest order of chivalry, which was the only such order women could receive in eighteenth-century Russia. Orders of knighthood—St. Andrew the First-Called, for men, and St. Catherine, for women—were in theory presented as awards for extraordinary service. The first woman to be granted knighthood was Peter the Great's wife, Catherine I, and for the most part, only members of the royal family and princesses of the blood were awarded the Order of St. Catherine of the big cross; others received the small cross. Catherine not only honored Dashkova highly, she also presented her with a generous and costly gift, since Dashkova was allowed to retain Catherine's large, diamond-incrusted star, appraised at 6,500 rubles, which she had discovered in her pocket.

Dashkova was now on equal footing with some of the most prominent and powerful members of her family. On February 9, 1762, as part of his celebrations marking Russia's intentions to negotiate a peace with Prussia and return all conquered territories, Peter III had awarded the Order of St. Catherine to Anna Vorontsova, her aunt.[31] It is said that in contrast to Dashkova's actions after the coup, Anna removed the ribbon and returned it to Catherine. As a cavalier of the order, she could not be disloyal to Peter, yet Catherine would not accept it and urged her to continue wearing it.[32] On June 9, 1762, Peter had also conferred the order on

Dashkova's sister, Elizaveta, and less then three weeks later, by participating in the palace revolution, Dashkova was instrumental in taking it away from her.[33] She claimed that Elizaveta had been elevated to knighthood only because Peter had been in high spirits and drunk. Only those women who had rendered exceptional service to the fatherland were so honored, and in Dashkova's eyes serving as the emperor's mistress was not a qualification. It was therefore not a coincidence that Dashkova gained glory at the cost of her sister's disgrace, from whom the order had been removed. The contrast roused further resentment and antagonism in the family, and Elizaveta would accuse her sister of stealing from her the order and various items of jewelry.[34]

Others at court were also critical of Dashkova's actions toward her family, and Count Florimund Mercy d'Argenteau, the Austrian ambassador to Russia, wrote that "during the coup d'état Princess Dashkova did not pay any attention to her family."[35] Dashkova was aware of the criticism leveled at her and claimed that she had petitioned the empress on behalf of the family. Rulhière described the scene with great dramatic, if inaccurate, flair. In Peterhof, on the day of the coup, when Dashkova noticed that her family was in attendance, she "threw herself down amongst them, saying 'Your Majesty, here is my family that I have sacrificed to you.' The empress then received all of them with the most fascinating kindness and in their presence she presented to Dashkova the ribbon [of the order of St. Catherine] and the jewels of her sister."[36] Dashkova strongly disagreed, pointing out correctly that nobody from the family was in Peterhof on July 29.[37]

Dashkova's behavior incensed Aleksandr, the family member closest to her. He worried about Elizaveta and petitioned Catherine on her behalf; the empress assured him that she would "change for the better" the situation of his sister, as much as that was possible.[38] He also wrote Dashkova repeatedly that her primary duty was toward Elizaveta, about whom he was concerned. From London, where he was the Russian envoy, he sent off a letter, ostensibly to compliment her on the receipt of the Order of St. Catherine. It was, however, only an occasion to upbraid her for the manner in which she had acted toward her sister and to chastise Dashkova for not living up to the principles she so fervently espoused.

> According to the news reaching me from Petersburg, her imperial majesty has been very kind to you; therefore, I cannot excuse your unwillingness to take greater interest in the fate of our sister.... It seems to me that

even if she had wronged the empress in some way, and I have not heard anything to that effect, you should have obtained, rather than honors for yourself, a pardon for her and preferred it to the ribbon of St. Catherine. You would not have then violated those philosophical principles which you professed to me and which led me to believe that you disdain vain distinctions. But I was mistaken, you hold them in high regard, just like everybody else.[39]

Thereby, Aleksandr repeated Mikhail Vorontsov's rebuke that she did not do more for the family's fortune and again a few days later urged her to come to their aid.[40] He was so annoyed with Dashkova that he seriously considered never writing her again, but felt that he could not do so without first consulting his uncle. He therefore sent him a copy of what he hoped would be his last letter to her. Mikhail would have none of it — she was a family member after all. He did not allow Aleksandr to break entirely with his sister and replied that while Dashkova's behavior could not evoke feelings of love on their part, he forbade him to cut off communications with her. He explained to Aleksandr that in accordance with the wishes of his father, Roman Vorontsov, he destroyed his last letter to Dashkova.[41] Again, Aleksandr stubbornly wrote his uncle that having learned more about Dashkova's actions, he did not intend to communicate with her any longer.[42] In the meantime, Dashkova vigorously defended herself and claimed that she had done everything she possibly could for her aunt and uncle and that her sister was safe and living on their father's estate.[43]

Still, Aleksandr delayed, finding it difficult to comply with Mikhail Vorontsov's wishes, so again his uncle urged him to continue his correspondence with her, even if only in a "properly restrained manner."[44] At last, Aleksandr gave in and wrote Dashkova reproaching her once more for not interceding on his sister's behalf. Even worse, he unequivocally accused her of theft. "They say," wrote Aleksandr, "you took possession of everything that my sister owned, and you refused to provide her with even the essentials she required for her departure to the country."[45] Dashkova responded forcefully, defending herself vigorously against the charge that she had stolen her sister's jewelry. She asserted that she had never removed any of her sister's belongings. Elizaveta had left her things in her apartment at the Summer Palace, Roslavlev had sealed her wardrobe, and all the jewelry was in Catherine's possession.[46]

Although Dashkova's impudent tone upset him, Aleksandr seemed mollified and was ready to make peace with his delinquent sister. In his

conciliatory response, he explained to Dashkova that he had learned more about her actions directly after the coup and about how she went to console Elizaveta at their father's house. Unable to curb his propensity for moralization, he added that she must not forget the gratitude she owed her sister. After all, Elizaveta had helped in arranging her husband's mission to Constantinople, had interceded with Peter on Dashkova's behalf forestalling her banishment to Moscow, had allowed her to live in her house for a while, and had rendered her countless other favors and acts of kindness. Finally, he hoped that she had not forgotten her father, uncle, and aunt, persons to whom she owed her upbringing, education, and position in society.[47] Aleksandr also tried to mediate on her behalf with the rest of the family, but matters were not that easily patched up and Mikhail Vorontsov, for one, would not be appeased. He wrote that as a rule he detested gossip and especially family disputes, so he would no longer dwell on her deeds, for she deserved more pity than anger. Perhaps in time she would realize her mistakes and would attempt to correct the errors of her ideas and deportment. He recommended that their actions toward her remain strictly decorous and should not be cause for further anger. They should deal with her as if they were dealing with a stranger.[48] Grudgingly, Dashkova too was ready to forgive her accusers and wrote her brother that she was willing to "forget all of his unfair allegations."[49]

The exhilarating events of the past several days during the coup were to have an irrevocable effect on Dashkova's life. She had tried to live beyond conventional expectations and had dreamed of personal freedom and individual opportunity. In reality, she awoke to ostracism, sorrow, and disappointment. Dashkova felt that she was slighted and her contribution unacknowledged despite Catherine's note that she was to be paid twenty-four thousand rubles for her faithful service to the throne and to society. But the sum was an affront, since Dashkova was not among the leading award recipients when the list was published in the *St. Petersburg Gazette*.[50] The top category included forty individuals to whom Catherine was most indebted and was subdivided into four groups. Dashkova, along with sixteen others, were rewarded as second tier participants. She was dissatisfied, and in her *Memoirs* again disguised her anger by having Ivan Betskoi, who was Catherine's chamberlain and Privy Council, express his displeasure to the empress that his participation in the revolt had not been fully appreciated. A man of intelligence, ability, and energy, Betskoi was also greatly influenced by the French *philosophes*, especially Rousseau. An early proponent of universal education for both sexes in Russia, he founded the Smolny Institute for young women and a number of charitable institutions.

Apparently because of his willingness to express openly his displeasure, Dashkova called him a madman.

Dashkova failed to mention that the inner, emotional exclusion and alienation were equally painful for her, and once she lost Catherine's companionship and support, she found herself alone and friendless. Having joined the conspirators in their rebellion against Peter III, and sharing their beliefs, Dashkova had gone against her family in the hope of creating a different, unconventional alliance with Catherine. By doing so, however, she had defied the strictest rules of propriety and her decision was to have personal and political consequences. She had violated one of the strongest taboos of eighteenth-century Russian society regarding the sanctity of the family and of a daughter's obedience to her father. After the coup she turned to Nikita Panin, whom she considered to be one of the most educated and honorable persons in the Russian Empire, and the British envoy John Hobart, the 2nd Earl of Buckinghamshire, who in his dispatches corroborated her close association with the Panin group.[51] Dashkova thereby joined a new family, which was actually a faction at court, and from that moment, her fortunes were linked to the intrigues and political vicissitudes of the Panin group. Accordingly, Safonov states emphatically, "The battle between Catherine's supporters, the Orlov brothers, and those who backed the grand duke Paul, illuminates for us the most puzzling areas of Dashkova's biography."[52]

Dashkova's betrayal of the Vorontsovs at court was more than merely a family matter. In the eighteenth century, at least until the appearance of G. A. Potemkin in the 1770s, the Russian court and administration were controlled not by political parties as such, but by broadly defined coalitions of powerful families along with their extended kin groups (*rod*).[53] These power structures were essentially private, personal alliances among friends, relatives, and occasionally lovers, who shared common goals and objectives. These were not restricted groups with a well-defined political agenda. Rather, these extended families consisted of wide-ranging networks brought together by shared beliefs, common interests, patronage, and kinship. This was a time when aristocratic oligarchic families wielded enormous power in Russia, to the point of creating and unseating monarchs. In the middle of the century, during the reign of Empress Elizabeth, it was the Vorontsov family, along with the Shuvalov's, who commanded Russia's institutions of internal and external affairs. During Catherine's reign, the extended Panin family opposed the Orlov brothers and their supporters such as Bestuzhev-Riumin. The major distinction between these two major factions was that the Orlov group defended authoritar-

ian forms of government, while the Panin faction brought together those among the nobility who sought to limit the power of the monarch through the rule of law. The former was centered round the Empress Catherine and the power of the crown, while the latter was more closely allied to the young court of the Grand Duke Paul. Like Dashkova, the Panin group was opposed to the immediate enthronement of Catherine, the growing influence of the Orlov brothers, and, as it seemed to them, the conspicuous disregard for Paul's rights to succession. They participated in the coup not primarily in the hope of putting Catherine on the throne, but in the desire to remove Peter III. The senior statesmen of the group included Panin's brother-in-law Ivan Nepliuev, Count B. C. Münnich, along with the Kurakins, Repnins, Everlakovs, Leont'evs, Eropkins, Rumiantsevs, and others.[54]

The Panin group also took in holdovers from the deposed Vorontsov faction, like Mikhail Vorontsov himself, his brother, and his nephews. Departing from the practice of those who during the first half of the century had gained the throne through a military overthrow of the existing regime, Catherine did not persecute or send into permanent exile those who had served Peter III. Thus, Catherine's lenient, more enlightened policy was set in relief by Empress Anne's cruelty toward Dashkova's mother and to the Dolgorukii family, as well as by Dashkova's subsequent harsh exile during the reign of Emperor Paul. Certainly, some of the Vorontsovs were removed for a time, but most soon returned to hold important posts. Although Mikhail Vorontsov and Nikita Panin differed on a number of issues, there were also many similarities in their views. For instance, the Vorontsov party was instrumental in the release of nobles from obligatory state service, and Panin's party would continue their effort to limit the empress's power through the participation of leading aristocratic families in the government of Russia. In foreign policy, Vorontsov and Panin differed: Vorontsov favored closer ties to Austria and a pro-France policy, while Panin's "Northern Accord" called for an alliance with Prussia and Denmark.

Like Panin, Dashkova dreamed of a time of justice and learning, a new era of rational enlightenment ushered in by an educated nobility freed from oppression. Never comfortable at the court in St. Petersburg, even when her uncle headed the government, Dashkova now witnessed its transformation as new people were installed in positions of power. Many who were banished during previous reigns returned from exile, including the former chancellor Bestuzhev-Rumin, her uncle's enemy. He arrived on August 31,

1762, with his former rank and honors restored and supported the Orlov faction at court. Others, such as the Field-Marshal Burkhard-Christoph Münnich and Dr. Johann-Hermann Lestocq, both experienced, older men over seventy, as well as Nikita Panin who was in his mid-forties, provided the nineteen-year-old Dashkova, "so artless, so unspoiled," with guidance and support (96). Although many of the faces had changed, life at court was again refined, elegant, and stylized, confronting her with impressions and ambiguities that she could not fully resolve. Dashkova characterized it as a *tableau vivant* "with new objects appearing one after another in quick succession, and indeed, the very disparity of these objects, gave me much food for thought and helped my mind to mature" (92).

In July, the mannered and theatrical existence was shattered, when six days after the coup Peter III was strangled at Ropsha, where he was imprisoned. She was stunned by the immediacy and harsh reality of Peter's assassination, "which absorbed all my thoughts and filled me with horror and consternation" (92). Officially, it was declared that he had died of colic after a severe hemorrhoidal attack, but the cover up would be exposed by the discovery of Aleksei Orlov's letter of confession to Catherine.[55]

> My dear Lady, merciful Sovereign! How can I explain or describe what has happened: never will you believe your faithful servant, but I shall speak the truth as before God. My dear Lady! I swear by my life I know not myself how the misfortune happened. We are lost if you do not show mercy. My dear Lady he [the Emperor] is no more. But it never occurred to anyone, and how could it occur to us, to lift a hand against our Sovereign. But, my Sovereign Lady, a misfortune happened. He started arguing at table with Prince Fedor [Bariatinskii]. We did not have time to separate them before he passed away. We cannot remember what we were doing, but we are all guilty, every one of us, and worthy of death. Show mercy on me if only for my brother's [Grigorii Orlov's] sake. You have my full confession and there is nothing to investigate. Forgive me or give orders to make a quick end. Life's not worth living: we have aroused your anger and lost our souls forever (93–94, n.1).

Dashkova considered Aleksei Orlov and his brothers to be her implacable enemies, but she refused to believe Catherine's possible complicity in the crime. To her death, she defended Catherine, her reign, and the manner in which she wielded power. Diderot wrote that she "protested to me that there was not a man in Russia, even amongst the peasants, who

believed that Catherine was an accomplice in the death of Peter III; in the empire, however, as well as throughout Europe, everyone was convinced that his death was a violent one."[56] She could never abandon her own, fictitious vision of an ideal Catherine and an almost perfect friendship, choosing to rationalize the conflicts and to blame mostly the empress's advisers and courtiers. Nevertheless, the murder, which allegedly occurred during a drunken brawl, would forever tarnish the memory of her glorious revolution and would cast her in a new role — for she was now an accessory to regicide. Once again, Dashkova found herself on the side of the opposition against the reigning monarch. She openly expressed her horror and disapproval of Peter's assassination, and such frankness would not serve her well.

PART II

European Travel
1763–1782

Chapter Four

Banishment

EVENTS AT COURT ASSOCIATED WITH CATHERINE and a proximity to power shaped and determined Dashkova's expectations and disappointments. Early on, these events included her first meeting with Catherine in 1759, the palace revolution of 1762, and the discovery of Orlov in Catherine's boudoir. The latter, fueled by Orlov's hostility toward her, led to the first major falling out with the empress and for the next twenty years of her life, 1763–1782, banishment, travel in Russia, and journeys abroad characterized her life. For her part, Dashkova, always uneasy with the strictures of court life, was too unconventional and inflexible to adapt to the life of a noblewoman among Catherine's courtiers. Gradually, as her disappointment in the empress grew, she realized that ostracism and isolation would follow upon the alienation she had known in the court of Peter III.

Yet even with her disillusionment in Catherine, Dashkova would remember with great satisfaction the glory of her participation in the palace revolution that brought down Emperor Peter III. To the end of her days she would celebrate June 29, the anniversary of Catherine's accession to the throne, with "a sentiment of pleasure and delight which beams over her countenance as often as the idea recurs."[1] While she might have been disappointed in Catherine and disapproved of her personal life, Dashkova never gave up on her deeply held ideals of an enlightened monarch — a philosopher on the throne, enacting rational legislation for the good of the people with the aid of enlightened advisers such as Dashkova herself. Unfortunately, she freely admitted that she could never adapt to the exigencies of court life. Well-read and one of the best-educated women in Russia, she held strong opinions and did not hesitate to defend them forcefully. She was too intelligent, too energetic, and most of all too straightforward

to feel comfortable in an atmosphere of empty pomp, frivolous activities, and petty intrigues. Rather than the company of courtiers and careerists, she preferred the intellectually challenging conversations of contemporary Russian writers and intellectuals.

Dashkova's energy, directness, and drive were indispensable qualities during the coup, but subsequently they were not valued at court and in diplomatic circles. Although Count Merci reported that she "possesses a romantic imagination and exceptional intellectual capabilities, but combines them with a talent for intrigue," Dashkova was not an adept and skillful courtier.[2] She never mastered the necessary proficiency in the art of double-dealing, disingenuousness, and sycophancy—deceit did not come easily to her. Her candor, impatience, and lack of diplomatic tact made her many powerful enemies, chief among them the empress's favorites from Grigorii Orlov to Platon Zubov. Catherine Wilmot would observe many years later that Dashkova exacted deference "and lucky it is that she has sensibility and gentleness in nature, for if she had not, she wou'd be a public scourge."[3] The assessments of her contemporaries, especially at court, were often openly hostile, or in the very least highly critical. While agreeing that she was highly educated and well read, many felt that age had not yet tempered the rage of her passions, nor had it ripened her judgment: "During her discussion with others, her behavior would often become extreme, demonstrating excessive obstinacy and intolerance."[4] Her primary shortcomings at court were the inability to remain silent—to hold her tongue even when in the right—and her inflexibility.

Dashkova was far too unconventional and independent and found it difficult to conform to the expected behavior of eighteenth-century Russian noblewomen. Years after her death, she was still a topic of conversation, and those who had known Dashkova would comment on the inappropriateness of her attitudes and deportment. On December 4, 1833, Aleksandr Pushkin described in his diary a story he had heard from Natal'ia Zagriazhskaia, a close acquaintance of the Vorontsov family who had been in the galley with Peter III when he attempted to escape to Kronstadt. She stated categorically that she had seen Catherine truly angry only twice—and both times at Dashkova. She related one incident when Catherine learned that Dashkova, with her ten-year-old son, had come late to the Hermitage, and to make up for lost time took the shortest distance directly through the church altar. She was furious and admonished Dashkova: Certainly, Dashkova, a Russian, should have known about the prohibition in the Russian Orthodox Church forbidding women to enter the church sanctu-

ary. Pushkin also noted how one of the guests at Natal'ia Zagriazhskaia's gathering quipped that Dashkova must have felt her directorship at the Academy exempted her from established laws.[5] Such spurious stories and anecdotes about Dashkova endured because they seemed in character, and while they were perhaps indicative of the tension existing between the two women and the attitudes toward Dashkova at court, they were historically inaccurate and far from the truth. By the time her son was ten, Dashkova was in Europe, and even if the event had occurred a year earlier, when Dashkova was in Russia, it would be another dozen years before she was appointed director of the Academy.

With the end of the heady days of the insurrection and with the reestablishment of the controls and imperatives of autocratic rule, the relationship between Dashkova and Catherine deteriorated and powerful enemies such as the Orlovs hastened its demise. Catherine's close personal relationship with Dashkova was to rally the intriguers and backbiters against her and to fuel jealousy and gossip. Nor was it difficult to set Catherine against Dashkova, since her former devotee's persistent high-mindedness, unyielding temper, demanding attitude toward the enlightened monarch, and excessively liberal views now displeased her. Catherine found Dashkova to be meddlesome and could not abide her tendency to dominate and to be involved in everything. Dashkova, for her part, could not overcome her profound dissatisfaction with the elevation of the Orlovs to positions of power as well as her own loss of influence. In a letter dated September 10, Louis XV of France recognized Dashkova's unhappiness and predeliction for participation in "newly hatched cospiracies," while Baron de Breteuil, the French ambassador, described her disappointment: "Immediately after the troubles [coup], it was thought that Princess Dashkova and Mr. Panin were unhappy and had left the court. When Princess Dashkova returned, the empress derided her and no longer trusted Mr. Panin." He also stated that Dashkova and the entire country ardently desired the reformation of despotism and added, "The Princess Dashkova, who was an enthusiastic supporter of the empress, was the first to turn away from her."[6]

Catherine had made full use of Dashkova's contacts in the Preobrazhenskii and Izmailovskii regiments and in the Panin circle, but she was unwilling to share the limelight and her newly acquired power with the ambitious Dashkova. She took every opportunity to minimize her role in the coup, and Breteuil noted, "Nothing demonstrates better the excessive *amour proper* of the empress than her jealousy toward Princess Dashkova and her desire to alter our understanding of the assistance Dashkova ren-

dered her."[7] While Dashkova exaggerated her role in the events of 1762, Catherine attempted to diminish its importance and to present it as secondary. The dispute was a source of great conflict between the two proud women and activated a rivalry that was to last a lifetime. The situation was aggravated as contemporaries began to represent Dashkova dramatically as the nineteen-year-old woman dressed in an officer's uniform who almost single-handedly brought down the legitimate heir to the vast Russian Empire. She was rapidly becoming a celebrity in Europe, and most foreign commentators wrote that Dashkova's participation was vital to the success of the palace revolution. Catherine was offended that her own fame and reputation were not receiving the attention they deserved. Commenting on Catherine's feelings, Herzen wrote that she could not tolerate at her side a woman "proclaiming her own glory, with Dashkova's energy, with her mind, and with her fire and her youth," and that she distanced Dashkova "with the swiftness of truly imperial ingratitude."[8]

Matters grew worse when Catherine learned that Ivan Shuvalov had written Voltaire about Dashkova's central role in the coup. Baron de Breteuil described the situation: "Despite the actual service Princess Dashkova rendered, she is neglected now. The empress is jealous of her and wishes that Voltaire would not attribute the success of the revolution to her."[9] Shuvalov's letter contributed to Dashkova's fall from grace and evoked Catherine's angry letter to Poniatowski.

> Princess Dashkova, the younger sister of Elizabeth Vorontsova, wishes indeed to take all the honors because she was acquainted with a few of the leaders. But on account of her family connections and her age, which was only nineteen, she did not stand in good repute; she inspired confidence in no one. To be sure, she always insisted that everything had come to me through her. But all of the conspirators had been in touch with me for six months before she even knew their names. It is true that she is very clever, but besides her great vanity she has a muddle-headed character and our leaders did not like her. Only thoughtless people put her in possession of what they knew and this consisted only of small details. I. I. Shuvalov, the basest and most infamous human being that could be imagined, has nevertheless, it seems, written to Voltaire that a nineteen-year-old woman has changed the government of this country. Please teach the great author better! We had to conceal from the princess the ways by which the others communicated with me, five months before she knew the least thing and during the last four weeks she was told as little as possible.[10]

Catherine acknowledged Dashkova's intelligence but also stressed her untrustworthiness due to her enormous vanity and the unreliability of her personality. The empress needed to assert her authority and to demonstrate to all that she had gained the throne through her own efforts and that others had not installed her there. She reiterated in her memoirs that Dashkova could not be trusted and that she "never mentioned the Orlovs to the princess, in order not to expose their names. The great zeal and the youth of the princess caused her to fear that, in the throng of her acquaintances, there might be some one who would inadvertently betray the matter."[11] Therefore, Catherine presented Dashkova's participation as marginal and incidental, and her harsh judgments differed greatly from the flattery found in her early letters to Dashkova.

Dashkova admitted that Catherine's characterizations were especially hurtful, and some forty years later she still found it difficult to believe that Catherine could paint such a distorted portrait of her contribution to the empress's triumph.

> There is one portrait, let me observe, traced, as is pretended, by the hand of her majesty, who in writing to the king of Poland after her accession to the throne, and speaking of that event, assures him that I had very little to do with it, and was in fact no better than an ambitious simpleton. Now I do not believe a word of this story. Besides, I can never be led to imagine that so superior a being as the empress could have spoken thus of a poor individual, her subject, so soon after that very individual had testified a devotion to her without limit, and had risked the loss of life on the scaffold in her service.[12]

Nor could Dashkova believe that Catherine would define her as a fickle and undependable young woman in a letter to Frederick II, the emperor of Prussia, who in turn would refer to her as a conceited fly (*la mouche vaniteuse*).[13] "It has also been said," wrote Dashkova, "that her majesty represented me to the emperor as a most *capricious* person. I am little disposed to believe this of the empress . . . knowing me as she did, and knowing that nothing could be more opposite to my real character."[14] Despite Dashkova's protestations, Catherine had indeed written the letter and it reflected her former friend's jealousy and personal animosity.

In response to her belittlement and the repeated denigration of her contributions, Dashkova in turn minimized significantly everybody else's role in the coup, except for her own. As a result, historians have criticized her for inflating and overemphasizing her actions, when in the *Memoirs* she pre-

sented only her point of view in an attempt to rehabilitate her reputation. Her family, however, never doubted the significance of her exploits that night, particularly because of the damaging effect they would have on their lives. On August 21, 1762, Mikhail Vorontsov, for one, wrote his nephew, Aleksandr, that Dashkova "played a major role in the successful ascension to the throne of our all-merciful sovereign."[15] Others also defended Dashkova's interpretation and commented on the extent of her involvement. Robert Keith, the British ambassador wrote, "It was certain that she bore a principal share in contriving and carrying on the conspiracy, from the beginning to the conclusion of it."[16] Actually, while Dashkova's role was not primarily an organizational one, it was nevertheless central, and the Orlov brothers could not have acted without her assistance and guidance. Dashkova knew many of the conspirators personally, since many of the guard officers, as well as Nikita Panin, met and discussed the impending revolt in her house.

Misgivings replaced conviction, and never again would Dashkova and Catherine trust each other fully. Dashkova's actions, in particular her undisguised ambition, displeased Catherine. The empress's apprehension of Dashkova's determination and political designs removed her forever from any possibility of an appointment to the highest and most influential positions of governmental power. Dashkova was dissatisfied with Catherine's attempts to diminish her influence and generally disapproved of the empress's policies and courtiers. She was often in disfavor and at odds with Catherine, and the return of Mikhail Dashkov from his mission to Constantinople made matters worse. It further strained the two women's friendship by rekindling former feelings of jealousy and suspicion, especially after Dashkova and her husband moved into apartments provided them in the palace. As opposed to his wife, Mikhail Dashkov got along exceptionally well with Catherine. They regularly dined with the empress and participated in evening entertainments. Typically, there was an established schedule of entertainments: Sunday — a ball in the palace; Monday — a French comedy; Tuesday — rest; Wednesday — a Russian comedy; Thursday — a tragedy or an opera. Frequently the audience was encouraged to come to the theater in masks, so that after the performance they could go directly to a masquerade.

Amateur concerts were very popular among the nobility and characterized the musical life of the court during the early stages of Catherine's reign, when Dashkova was still part of the empress's inner circle. Catherine's entourage, including Count Segur, Prince de Ligne, Kobentsel', L. A. Naryshkin, Stroganov, and the Dashkovs, would be invited to *les*

petite soirées. They often took on a comic spirit of childlike games with cross-dressing and other forms of buffoonery and play. Games or short skits parodying events or individuals at court would be organized, and strict rules imposed order on these games. When the skits and literary parodies became too personal or insulting, offenders were required to pay a penalty. This could be a donation of a gold coin to charity or the memorization of verses from Trediakovsky's *Tilemakhida*. More often than not, the principal transgressor was Lev Naryshkin, who would then recite the wanderings of Telelmachus with extreme affectation and pomposity, to the great delight of those present. Dashkova was not amused; she detested Naryshkin intensely.

She preferred to perform her songs—something she took very seriously. Mikhail Dashkov and Catherine, however, did not share Dashkova's passion for music. The empress was not gifted musically, and it is said that at concerts musicians were assigned specifically to signal her when to applaud. Catherine and Mikhail Dashkov parodied Dashkova by performing disharmonious and cacophonous cat concerts, which amused them greatly and seemed to bring them closer together. In fact, Dashkova's daughter, Anastasia, revealed to A. S. Pushkin during a ball at her house that her father had been in love with Catherine. Twenty years after her mother's death, however, Anastasia still harbored an intense dislike for her, and the information she disclosed to Pushkin may have been nothing more than a disgruntled daughter's attempt at revenge.[17]

In September 1762, Dashkova and her husband traveled to Moscow for Catherine's coronation, stopping on the way at Petrovskoe, Kirill Razumovskii's estate. From there, Dashkova was planning to go directly to see her young son, who for over a year had been living with her mother-in-law. Before she could leave, however, her husband took her aside into an empty room and tried to dissuade her from going to town, finally revealing the truth. He had been in Moscow and learned from his mother that their son, little Mishenka, had died. The news devastated Dashkova; overcome with grief she retreated to the house where her son had lived his short life, and took no further part in the public entertainments preceding the coronation. Catherine sent her a note of consolation: "I cannot let you abandon yourself to melancholy, for that, indeed, would be unworthy of a mind like yours."[18] It was a common feature of eighteenth-century life in Russia for parents of the nobility not to bring up their children, leaving them in the care of wet nurses, nannies, tutors, governesses, grandparents, or other family members. Dashkova must have thought back to her own lonely childhood, to the mother she never knew, and to the father who

continued to take little interest in her life. Now it seemed to her that she had abandoned her son, sacrificing him to a preoccupation with political events and dreams of personal glory. Dashkova would never neglect her children again—she would devote her life to them. Their education would become her obsession and they would become shining examples of a new enlightened generation spearheading the transformation of Russia.

While she was in mourning and still struggling with a debilitating sorrow, the Orlovs, according to Dashkova, were preparing new humiliations. Catherine began to distance herself from her friend and loyal supporter, and Dashkova discovered that at the coronation her assigned place was far from the empress. She immediately suspected Grigorii Orlov to be the perpetrator of the insult. Hierarchy and rank were paramount in Russia, and during the Petersburg or imperial period of Russian culture "the concept of rank acquired a special, almost mystical character."[19] It defined individuals based on their position in the established and rigid hierarchy, which mostly excluded women. The vast majority of women in Russia did not participate in government or military service and therefore did not attain ranks. Only a small minority of elite women served at court as ladies-in-waiting, maids of honor, and so on—appointments with equivalences to men's ranks and with well-defined duties and rewards. However, in the Table of Ranks, which Peter the Great instituted, it specified that women were also eligible for certain privileges based on the rank of their father, before marriage, and their husband, after marriage. As the wife of a lieutenant colonel, during the coronation, Dashkova would be in the last group admitted to the Uspenskii Cathedral and she would be obliged to occupy the last rows of seats erected for the guests, far from Catherine. Neither her support of Catherine, nor her title of cavalier of the Order of St. Catherine, made any difference. Dashkova was obliged therefore to enter the cathedral in Catherine's entourage and from there she respectfully "went with a smile to my humble post" (101).

The coronation festivities, both private and public, were elaborate, highly theatrical, and went on for days. Extreme contrasts between wealth and poverty, magnificence and squalor, abundance and want, marked Russian life in the eighteenth century. Riches, along with rank, determined all aspects of everyday life, from one's attire to the number of horses harnessed to a carriage. Some, as befitting their station and the occasion, rode about in gilded carriages upholstered in soft, red velvet with horses adorned in flowers or plumes. The footmen wore livery reflecting the coat of arms on the carriage, powdered wigs with a bun, and tri-cornered hats. For instance, Metropolitan Platon of Moscow lived in the grand style, and

Dashkova provocatively inquired why he rode about town in a magnificent carriage drawn by six white horses, attended by postillions, and a retinue of colorfully attired servants. After all, Christ went everywhere on foot. The surprised prelate's attempt at witty repartee fell flat when he replied that Christ's flock followed him everywhere, while he could not keep up with his in a coach-and-six. Although Dashkova was compelled to challenge the church hierarch on his extravagance, according to an inventory compiled at her death she owned a fleet of carriages and closed sledges.[20]

Indignity followed upon indignity, as it seemed to Dashkova. On a guest list of 122 persons admitted to the balls and concerts during the inauguration, Dashkova's name appeared at the bottom in the 109th position.[21] There was also considerable tension between the old and newly elevated service nobility, so Dashkova considered a demonstration of disdain for awards and rankings to be good form. Some so-called "ladies of a certain class" ostentatiously wore a special brocade of gold, a badge of their rank and distinction; others wore brocades only of silver, their rank determining the width of their lace, ranging from one to six inches. Dashkova proudly donned her Order of St. Catherine, and the announcement of her appointment as lady-in-waiting only temporarily mollified her anger. As lady-in-waiting, she replaced her father, sister, uncle, and aunt at court, but seemingly, she did not prize her appointment very highly and referred to it only in passing in a letter to her brother.[22] Her husband was appointed gentleman-of-the-bedchamber and received a promotion to the rank of brigadier of the Cuirassier regiment, as well as an invitation to serve on the Commission for the Reconstruction of Moscow and St. Petersburg.

The winter festivities in Moscow continued for several weeks following the coronation, yet already opposition to Catherine was mounting and new schemes hatched. After the coup d'état, Nikita Panin submitted a proposal for reform of the senate and for the creation of an imperial council of six to eight ministers. It was critical of the monarchy and gave the council wide-ranging powers, but soon it became clear that Catherine would reject the proposal. At court, many believed that Panin hoped eventually to impose constitutional limitations on Catherine's power. Rulhière wrote that Dashkova too was unhappy with despotism in Russia and that she plotted with Panin to limit autocracy.

> Panin and the Princess were both of the same way of thinking, with respect to the government of their country; and if the Princess was indebted to her natural disposition for the violent horror of slavery, Count Panin, who had been minister from his own court to that of Sweden for fourteen

years, had there imbibed some republican ideas. Both of them, therefore, united in the resolution of rescuing their country from despotism.[23]

The defeat of Panin's proposal lead to his loss of influence, but Dashkova would nevertheless continue holding to the ideals of constitutionalism.

Additionally, dissatisfaction with Catherine's ascension to the throne and with her relationship with Orlov grew among those who were plotting her overthrow in favor of the imprisoned former emperor Ivan VI, the great grandson of Ivan V and grandson of Empress Anne's elder sister. Panin and Ivan Shuvalov were leading candidates for appointment to the regency. The authorities discovered a potential plot among a group of young officers and then arrested, tortured, and tried the suspects. Meanwhile, Bestuzhev-Rumin and others were circulating a petition allowing the empress to choose a consort for herself, thereby clearing the way for Catherine's marriage to Grigorii Orlov. Early on Dashkova had warned Nikita Panin and Kirill Razumovskii that Catherine and Orlov were lovers, though they did not believe her and she called them "a couple of fools" (88). Indeed, "such outspokenness" on her part "was sooner or later bound to lead to trouble."[24] She vociferously opposed Orlov's ambitions, but while rumors flew round Moscow, events at home were to preoccupy Dashkova. Still suffering from the memory of her son's death, she learned that she was again pregnant and that Anastasia, her husband's youngest and favorite sister, was gravely ill. In April, Anastasia Dashkova died and on May 12, 1763, during a time of grief and mourning, Dashkova delivered her son, Pavel, the last male heir to the Dashkov family.

At the end of the month, Catherine's visit to the Monastery of the Resurrection in Rostov led to speculations that she had gone there to marry Grigorii Orlov. The Orlovs pressed for the betrothal, and there was some support for it at court. But Panin and his group resisted and enlisted the aid of others, including Mikhail Vorontsov. Mounting discontent and unrest resulted in the arrest of Fedor Khitrovo, who purportedly revealed to his interrogators that Nikita Panin, Kirill Razumovskii, and Zakhar Chernyshev were part of a conspiracy discovered among the guards. Supposedly, they opposed the marriage and in the event it took place, they planned to overthrow Catherine and assassinate Orlov. Moreover, Khitrovo claimed that he knew of a secret agreement that Catherine had signed with Panin prior to the coup promising to serve only as regent during Paul's minority. The marriage plans came to a grinding halt and in the subsequent investigation, Khitrovo implicated Dashkova. Allegedly, on a number of occasions Khitrovo had visited her to consult on how to

prevent the empress's marriage. Dashkova recalled that Khitrovo's "honesty, his good looks, his polite and dignified manners had helped, perhaps, to excite the jealousy of the Orlovs," thereby implying that the same jealousy was directed at her (104).

There is no conclusive evidence that Dashkova took part in the affair. According to the dispatch of the French chargé d'affaires M. Béranger, dated July 15, 1763, Catherine wrote a kind note to Dashkova in which she mentioned the conspiracy and promised to investigate it fully. She also inquired if Dashkova knew anything about it. Dashkova responded curtly that she knew nothing and even if she did, she would not inform on anyone. In addition, what did the empress want, her execution? If so, she was ready.[25] Dashkova could hardly contain her indignation and disapproval; she was certain that Grigorii Orlov was her accuser and felt nothing but animosity toward him. In fact, on May 26, 1763, Grigorii Orlov identified Dashkova as one of the conspirators, although later, Catherine wrote to Vasilii Suvorov, who was heading the inquiry into the affair, that Khitrovo himself had also exposed Dashkova's and Nikita Panin's participation in the conspiracy.[26]

Responding to Castéra's history, Dashkova protested that she never "instigated" any plots against Catherine, whom she loved tenderly.[27] While the extent of Dashkova's involvement in the Khitrovo affair is uncertain, it is clear that Catherine suspected her of complicity in most subsequent intrigues of the Panin faction. Le comte de Solms wrote that "she is capable of instigating new coups every eight days, solely for the pleasure of their instigation."[28] In a few days, during a visit of the Panin brothers, Mikhail Dashkov received a letter from the empress admonishing Dashkova for the effrontery to threaten her and warning Dashkova about her impudent behavior. The empress instructed Mikhail to control his wife and to take measures curtailing her propensity to indulge in loose talk that bordered on outright hostility. Thus, less than a year after the successful palace revolution open antagonism and intimidation replaced friendship. To mollify the empress, Dashkova and her husband decided to test the waters at court and in light of Catherine's earlier offer, they invited her and the Grand Duke Paul to hold their newborn son at the baptismal font. While Catherine did not refuse, she was noticeably aloof, distant, and "did not even inquire after [Dashkova's] health" (106).

A month after childbirth Dashkova was still weak and experiencing paralysis of her hand and foot. According to Diderot, who was obviously restating Dashkova's account, only her illness saved her from arrest. Catherine decided on distancing her from the court and instructed her to join

her husband, now stationed in Riga, Latvia. The Earl of Buckinghamshire, British ambassador at the beginning of Catherine's reign, reported that Dashkova,

> who so much distinguished herself in the revolution, is ordered to accompany her husband to Riga, where his regiment is quartered. The Lady's arrogant behaviour had in a great measure lost her the Empress's esteem, even before my arrival at Moscow. Her spirit was too great either to try to appease her Mistress, or to submit to her disgrace, and she has been suspected since of exciting and encouraging those who were disaffected to the present Government.

Concerning her departure from court, he added, "Mr. Panin will be very much affected by her departure from Court, as she was his relation, and a great favourite."[29] Only because of Panin's intercession on her behalf was her punishment limited to exile in Riga. It seemed to Dashkova that enemies surrounded her everywhere and that Panin was her only ally. Le comte de Solms wrote with justification that "she has not made many friends, and only count Panin still sides with her."[30]

Dashkova did not stay long in Riga, and when her husband rejoined his regiment in Dorpat (*Tartu*), she went with her children and their governess Pelageia Kamenskaia to live in their country house in Mikhalkovo, five miles from Moscow. There she enjoyed the wholesome air and took cold baths to restore her health. Away from the turmoil and political machinations of the capital, Dashkova could once again devote herself to reading, writing, and literary studies. The new journals of the time were giving public expression to the ideas of the Panin group and other opposition groups at court, while criticizing the foibles of Russian society. Writers such as Aleksandr Sumarokov and Mikhail Kheraskov, along with members of their literary circles, looked to the new ruler to fulfill their hopes for a legal order based upon reason and moral enlightenment. In 1759 Sumarokov published in St. Petersburg the *Industrious Bee* (*Trudoliubivaia pchela*), which was dedicated to Catherine. *Idle Time Put to Good Use* (*Prazdnoe vremia v pol'zu upotreblennoe*) was a similar journal, and at Moscow University, Kheraskov, with a group of students, published *Useful Entertainment* (*Poleznoe uveselenie*). Denis Fonvizin, Russia's first major dramatist, was a member of this group and was later to become Panin's secretary and chief spokesperson for the Panin party. In 1763, during the coronation ceremonies in Moscow, Dashkova founded the monthly literary and philosophical journal *Innocent Exercise* (*Nevinnoe uprazhnenie*), whose main editor would be

Ippolit Bogdanovich. Issues appeared from January to June 1763 at Moscow University. As opposed to Kheraskov's journal, it did not show any support for Catherine's regime and was devoted exclusively to propagating ideas of the Enlightenment.

Dashkova was actively involved in the work of *Innocent Exercise*, both as a patron and contributor. The first issue of the journal included S. I. Glebov's translation of Voltaire's didactic poem *"De L'Egalité des Conditions"* (*"O ravenstve sostoianii"*), which was published at Dashkova's insistence.[31] Dashkova's translations from Helvétius's *De l'Esprit* were serialized in 1763, and in the same year, she published her translation of Voltaire's *"Essai sur la poésie épique"* (*"Iz opyta o epischeskom stikhotvorstve"*), a series of essays devoted to Homer, Virgil, Lucain, Trissino, Camoens, Tasso, and Milton.[32] Her brother Aleksandr sparked her interest in the work, when at the age of fourteen he published a translation of Voltaire in the *Monthly Essays* (*Ezhemesiachnye sochineniia*) at the Academy of Sciences. Nikolai Novikov in his *Dictionary of Writers* (*Opyt istoricheskago slovaria o rossiiskikh pisateliakh,* 1772) wrote that Dashkova published some of her early poems in *Innocent Exercises*, but it is now difficult to identify them with any certainty.[33] The only poetic work in the journal ascribed to her positively is the twenty-six-line translation of Lucain's verse based on G. de Brebeuf's French version, *La Pharsale de Lucain.*[34] The Lucain piece attracted her most in Voltaire's work, since it describes the proud and courageous Caton's refusal to enter the temple of Jupiter Amon to seek guidance.[35] Instead, he expresses the pantheistic idea that God's true temple is the sky, the earth, and the human heart, which loves truth beyond all else. Human happiness, then, depends not on prophesy or divine intervention, but on self-sufficiency and self-reliance.

As Dashkova read and studied in Moscow and on her estate, she reflected on her life: the defeat she had suffered at the hands of the Orlovs, Catherine's dissatisfaction with her, and what the future held for her. Now, during her times of trouble, it was impossible to restore the empress's favor, since her family had fallen from power and her uncle was not present at court. Only Nikita Panin, whose influence had also plummeted to a new low, would be able to help her in the future. Catherine, who did not like or trust the Panin brothers generally, respected Nikita Panin's intelligence, calling him an encyclopedia. She would rely on his expertise in foreign policy, for example, on the question of the Polish Succession, and in October 1763, she called on Panin to direct Russia's foreign policy.

Eventually, Panin was able to mediate on Dashkova's behalf, and consequently she retained her position of lady-in-waiting, requiring her atten-

dance at court, and at the end of 1763 she returned to the capital. According to the Earl of Buckinghamshire, Panin was enamored of Dashkova, spoke to her tenderly, and tried to see her on every occasion. When he learned of her arrival, he excused himself from a dinner engagement with the British ambassador to rush off and greet her.

> The Princess Dashkoff is arrived here; Mr. Panin, who had promised to sup with me on Tuesday last, made his excuse, which I was afterward informed, was to have the opportunity of being with her; it will require all his flegm and authority to keep her active spirit in a tolerable state of tranquility, I wait with some sort of impatience to see the reception she receives at Court.[36]

In November 1763, Dashkova returned to St. Petersburg and settled in a house on Bolshaia Koniushennaia Street belonging to Odart, which she rented from 1763 to 1764.[37] Piedmontese by origin, Jean-Dominique-Joseph Odart for a time enjoyed the patronage of Mikhail Vorontsov, who obtained a position for him at the Commerce Collegium. Although she was his patron, Dashkova claimed that Odart was never her agent in any plots against Catherine, as Rulhière had written, and she rejected any notion of collaboration with him.[38]

At this time, a struggle ensued for the vacated throne of Poland, with Catherine backing Stanislav-August Poniatowski, her former lover. Mikhail Dashkov was serving with the Russian forces involved in the installation of Poniatowski. Sent there to reconnoiter the situation in Latvia and Lithuania, he reported his findings in code directly to Count Keiserling and Prince Repnin.[39] In the summer of 1764, upset by her husband's absence and by her daughter's illness, Dashkova went to live at Gatchina, the estate of Aleksandr Kurakin, whose wife Aleksandra was Panin's older sister. Ironically, less than two years later, Catherine II would buy the property and present it to Grigorii Orlov. Dashkova remained there in seclusion, only occasionally going out to ride for exercise. Possibly, she went there to remain inconspicuous and to avoid implication in the next conspiracy. She was still under suspicion and the tension that previously had been simmering between Dashkova and Catherine was coming to a boiling point, brought about primarily by Dashkova's desire for greater sway at court and her continued support of the Panin faction.

That summer Catherine was touring Livonia and on July 9, 1764, in Riga, she learned that five days earlier Vasilii Mirovich, a second lieuten-

ant in the Smolenskii Regiment, had unsuccessfully attempted to liberate the deposed Ivan VI and proclaim him emperor. Her son Paul and Ivan VI were the two living princes whose rights to the throne preceded her own. Ivan VI was the infant emperor from 1740 to 1741; proclaimed tsarevich at birth, he was therefore legally entitled to reign, first with Biron and then Empress Anne as regents. Following her overthrow of the regency, Elizabeth imprisoned Ivan first in Kholmogory, and then in 1756 in Schlusselburg, a fortress near St. Petersburg. He was now in his twenties and his legitimate claims to the throne presented Catherine with a problem. The jailers were under orders authorizing them to murder Ivan at the first sign of any attempt to liberate him, and conveniently for Catherine, they executed her orders during the bungled rescue. Ivan was dead and Mirovich became the scapegoat: found guilty of high treason, Catherine had him beheaded and his body burned.

St. Petersburg was rife with speculation that Panin and his group were involved in the aborted attempt to overthrow Catherine's government. Early in July 1764, the Earl of Buckinghamshire wrote, "The Princess d'Ashkow [sic] has been seen in man's cloaths amongst the Guards, but her steps are narrowly looked into, and she is soon to set out for Moscow." Almost certainly, Catherine did not fully believe the allegations of Panin's involvement in the plot, since she consulted with members of the opposition and with Petr Panin, general and senator, and Nikita Panin's brother, whom she appointed head of the committee investigating the Mirovich affair. During the trial Dashkova, who had returned to Odart's house in the fall, was again implicated and the Earl of Buckinghamshire elaborated that "there are many reports concerning the Princess D'Ashkow; she certainly is much suspected."[40] Dashkova defended herself, explaining that the house was large and her husband was away, therefore Petr Panin had been residing in their house. On several occasions, Mirovich visited Panin and not her, since he was there on official business concerning a case due to come up in the senate. Although Nikita Panin intervened on her behalf, Dashkova nevertheless felt that the "story brought me a great deal of sorrow as a result of the undeserved suspicion attached to my name and the unfair and unjust treatment to which I was subjected in consequence" (110).[41]

As in the case of Peter III, Dashkova would never admit publicly to Catherine's possible involvement in the removal and murder of yet another emperor of Russia. Catherine, on the other hand, continued to suspect Dashkova's motives, assigning undercover agents to surround her house and watch her actions closely. Sir George Macartney commented,

> Though scarcely twenty two years old, she [Dashkova] has been already in half a dozen plots; the first succeeded, but not being considered, nor rewarded, as she imagined, according to her service, she engaged in new conspiracies which proved abortive; she was not otherwise punished than by a total loss of her Mistress's favour, who still had retained some degree of kindness for her; she is a woman of an uncommon strength of mind, bold beyond the most manly courage.[42]

Dashkova continued to attend the empress at court, but the Mirovich fiasco was to separate her from Catherine, and the British diplomat Henry Shirley wrote in 1764 that she had little respect for Dashkova but treated her politely.[43]

A personal tragedy, however, was to overshadow the turmoil of her life in the public sphere. One morning Dashkova's friend Anna Panina, the wife of Petr Panin, proposed that they go for a carriage ride to get some air and then dine together. After dinner, taking every precaution to assure her friend's safety, should she faint, Anna revealed to her the recent news from Poland. In support of Catherine's policies in Poland, Mikhail Dashkov remained far from home commanding the advance army ordered to Warsaw. During a long march across Poland, on August 17, 1764, after a twelve-day bout with a high fever, he died in Pulava. He was twenty-seven and had been married to Dashkova for five years. Dashkova collapsed, fell seriously ill with paralysis of her left side, and for the next several weeks was bedridden from weakness and shock. She could not believe that her husband, a young and healthy man, had inexplicably come down with a fever and died suddenly—and there were no other explanations! The next winter, Dashkova saw the arrival of her husband's body in Moscow and on January 11, 1765, she buried him in the family burial-vault in the Novospasskii Monastery. Shortly after, his mother retreated to a convent and Dashkova spent the next five years on her estate.

She was now completely alone and most of all she wanted to see her brother. "Aleksandr, whose friendship for me had never faltered, was abroad as minister extraordinary and plenipotentiary in Holland, and the rest of my family had abandoned me" (113). For years after her husband's death, Dashkova remained inconsolable and admitted to suffering from deep depressions. In her letters to her brothers, she expressed her feelings of isolation and regretted that her family, especially her father, shunned and treated her like a criminal. She had hoped that their relationship would improve, but sincerely doubted it.[44] Others in the family extended little support to her and Simon wrote their father, "I learned in the news-

paper about the death of Prince Mikhail Ivanovich in Poland. Since he was honest and possessed a very kind heart, and of course did not participate in the outrageous and unrestrained behavior of his wife, we are all greatly grieved here." Alluding to Nikita Panin, he felt that his sister would undoubtedly marry "a certain person, with whom she has such a sincere and friendly relationship."[45] He was mistaken, and at the end of her life Dashkova wrote that the perfect emotion in her life was the intense love she felt for her husband, while the pain and torment of his early death left such a lasting and profound sense of loss that she could never remarry.[46]

Her lonesomeness intensified when Anna Panina, who had cared for her during her illness and grief despite being in failing health, died from consumption at the young age of thirty-five. During her mourning for the two persons closest to her, revelation followed revelation concerning financial matters Dashkova knew nothing about. Always in need of money and accustomed to a life of pleasure, Mikhail Dashkov had left his family with enormous debts. There were also rumors concerning the misallocation of regiment funds. He had succumbed to a passion for gaming, which was prevalent among the aristocracy and led to the financial ruin of many noble families. He would pass on this passion to his children, while Dashkova, who loved to play cards, was too frugal to bet heavily. Now, her finances were in disarray and creditors were clamoring to be paid. Thus, in 1764 at the age of twenty-one, she was confronted with crippling debts while receiving no support from her husband's family or her own.

Before his death, Mikhail Dashkov had written a letter to his second cousin Nikita Panin asking him to serve as guardian to his children and trustee of his property. Caught up in affairs of state and his own career, Panin was unwilling to take full responsibility for the oversight of the estate and invited his brother Petr, and then Dashkova, to share in the duties and to serve as legal co-guardians. Hoping to take care of Mikhail Dashkov's insolvency immediately, Panin requested permission from Catherine to sell off some of the property, but Dashkova interceded and categorically refused to divest of any of her children's property, feeling that this would be contrary to their best interest. The property belonged to her son, her daughter, and to her, since Russian noblewomen could own property and did not forfeit it at marriage. Dashkova wrested control from the Panins and administered the family estate solely and successfully for many years until her children's maturity. A practical, efficient overseer of their inheritance, she petitioned Catherine to save her and the children from penury, and to placate her, Catherine sent Dashkova twenty thousand rubles for payment of debts. The letter Dashkova sent the empress con-

trasted sharply to the representation of her strength, pride, and resolve in the *Memoirs*: "My children and I prostrate ourselves at you royal feet. Cast your merciful glance, my All-Powerful Sovereign, upon the weeping widow and her two orphans, extend your generous hand and save us, unfortunate ones, from degradation and poverty."[47] She also resolved to leave St. Petersburg as soon as possible and by doing so avoid the extreme expenditures associated with life at court, since courtiers surrounding the sovereign were obliged to spend enormous sums in order to maintain their position in society. With the money she had in her possession, Dashkova bought a furnished house on the Fontanka in the area of the Semenovskii Regiment Sloboda, and she soon rented it out.

Whatever funds Dashkova accrued in her life, she was able to acquire and save them through her own efforts. Always practical and pragmatic, she kept expenses to a minimum, and her stringent, cost-cutting measures and thriftiness, a by-product of her insecurity and inexperience, earned her a reputation for being closefisted and parsimonious. Catherine would characterize her as a miser who hides money away.[48] A story was told about how on Sundays, Dashkova would often dine with her sister Maria, who was married to Petr Buturlin. Family lore had it that Dashkova possessed a great taste for lemonade, so a large lemon was always placed by her plate. At the end of the meal, she would put the fully squeezed lemon rinds into her pocket for further use.[49]

Because of economic constraints and the court intrigues directed at her, it was clear that Dashkova could not remain in the capital, despite Panin's protection. Sir George Macartney commented on her situation:

> You know that Mr. Panin is supposed by the world to be her real father, and indeed, notwithstanding all her extravagances, he has always regarded her with the tenderness of a parent. Those who wished well both to him and the favourite, advised that she should no longer remain at Petersburg; while she stayed, he was often with her.[50]

Dashkova sold her dinner service and her jewelry to cover the most pressing obligations to her creditors. Although the spring thaw made the roads almost impassable and the river crossings dangerous, Dashkova left the capital in March 1765. Sir George Macartney described her final meeting with Catherine:

> The Princess Dashkova, who has lived here extremely retired ever since the death of her husband, has at last taken the resolution of quitting the

Capital, and going to reside at Moscow. She set out yesterday; but before her departure, had the honour of kissing the Empress's hands, and taking leave in form; she had been forbidden the Court long since, but as she was now to leave it, perhaps forever, Her Majesty at the persuasion of Mr. Panin, consented to see her before she went. Her reception was such as she ought to have expected; it was cold and ungracious; everybody seems pleased that she is no longer here.[51]

In the summer of 1765, on the third anniversary of the coup, Dashkova received a magnificent silver dinner service, along with more than thirty other supporters of Catherine who were sent gifts. She was nevertheless out of favor and would return to the capital only once in three years, for a short visit to request permission from the empress to travel abroad. In Moscow, she learned that the house in Troitskoe, which had been in a state of extreme disrepair, had collapsed, and therefore had a small, hastily constructed timber dwelling erected, where she lived for eight months. It became her retreat where she remained primarily to economize and pay off her debts, far from the splendor of Catherine's court. "Had I been told before my marriage," Dashkova considered, "that accustomed as I was to luxury and expense, I should be capable, after becoming a widow at twenty, of stinting myself for several years of everything save the simplest clothes, I should never have believed it" (114). Notwithstanding the cruel anecdotes about her stinginess, Dashkova's actions demonstrated great willpower and strength of character, rather than miserliness. In five years, she paid her husband's debts in full.

Living as frugally as possible, and not receiving any support from her wealthy family, she felt humiliated and upset by her mother-in-law's actions.[52] After the death of Mikhail Dashkov, their relationship had deteriorated to the point that Anastasia Dashkova ignored the plight of her daughter-in-law, a young widow, and her two grandchildren. She bequeathed her Moscow house on Nikitskaia Street "to her granddaughter, Miss Glebov, and I," Dashkova wrote, "remained without a home in town" (114).[53] Undeterred, in 1766 Dashkova purchased from Nikolai Dolgorukov a property on Nikitskaia Street in the parish of the Church of the Ascension, but the house there was in ruins and not fit for habitation. As she had done in Troitskoe, Dashkova put up a small temporary structure, and later, the distinguished architect Vasilii Bazhenov, with her close participation, constructed a new house on the same land. Built in the 1770s, renovated and expanded in 1780, it was an expansive two-story residence with a half rotunda as the main feature of its façade.[54] Dashkova

was directly involved in the building process and Simon commented unkindly on her collaboration with Bazhenov: "My sister, who felt that she possessed great taste in the fine arts, was quite peculiar, and most certainly constrained her architect Bazhenov by foisting on him her ideas and not worrying whether they conform to the design of the architect."[55]

Her banishment from the court continued, and as a result Dashkova did not take part as she had hoped in the political, social, and cultural events transforming Russia. The Academy of Arts officially opened in St. Petersburg, and Catherine acquired some 225 works by European masters, thereby laying the foundation for the Hermitage Museum. It was a time of change in Russia, with Catherine setting forth her political ideas in the *Nakaz*, or *Great Instruction*, although in the end the much-needed legal reforms were never completed. Diderot recalled Dashkova's thoughts on these changes: "When Catherine projected her code of laws, the princess, whom she consulted, said, 'You will never witness its conclusion, and at another time I would have told you the reason; but it will always be a great thing to have made the attempt; the very project will not fail to make an epoch.'"[56] Ignored, Dashkova felt like an outsider. Bitter and deeply unhappy with the situation in St. Petersburg, she wrote Aleksandr in Holland not to return to Russia, where it was impossible to do anything for people of intelligence and talents, since everything depended on the will of the empress.[57]

From the spring of 1765 to 1769, Dashkova's life followed an established pattern: in the summer, she resided principally on her estate in Troitskoe and spent the coldest winter months in Moscow. Because of the impassability of the muddy roads in spring, she made every effort to leave Moscow by sledge in March. She liked to celebrate her birthday on March 17 in Troitskoe and tried to leave Moscow by that time. Otherwise, she would have to wait for the roads to dry in late spring. For the return journey to Moscow, she waited for the first snow of winter, which, depending on the season, would be suitable for travel either in November or as late as the end of December. Winter made travel much easier and more comfortable as she glided smoothly in a closed sledge over the ice and snow warmly wrapped in her furs. Only family concerns and sadness intruded on the slower, calmer pace of her life, as Russian country life alternated with Moscow high society and one season flowed into the next. While her children were recovering from smallpox, her uncle was undergoing treatment for consumption. His condition worsened, he grew weaker, and on February 13, 1767, Mikhail Vorontsov, the man who had provided Dash-

kova with a home, died in Moscow. Nikita Panin was fully involved in the preparations of the former chancellor's funeral, while the Orlovs were conspicuous by their absence.[58]

These years of solitude and seclusion were devoted primarily to study, work, and the education of her children. She continued to pursue her literary interests, meeting with young Moscow writers. In addition, she was compelled to take possession of her life and the life of her children, since there was nobody left she could rely on. Unprepared as she was for running her husband's estates, she threw herself into learning the details and methods for the efficient administration of a large but mostly mismanaged and neglected property. Dashkova familiarized herself with the everyday running of the estate's self-sustaining economy, which included its own carpenters, blacksmiths, weavers, artisans, artists, and musicians. The work necessitated short trips to inspect her villages and to see to business matters in Tula and Kaluga. Such trips were always distasteful to her, and she complained angrily about the poor conditions of the roads and the dishonesty of local judges and administrators. They all demanded bribes and were, according to Dashkova, nothing but scoundrels, fools, and drunkards. Dashkova was a conscientious, assiduous manager of her estate with an instinctive aptitude for administration, organization, and accounting. P. I. Bartenev wrote about the young Dashkova that at eighteen she was already "frugal and practical."[59] Gradually, she added to the family fortune, supervising and guiding every aspect of its growth and development.

In addition, the overprotective Dashkova devoted herself zealously to the education of her children, whom she was determined to provide with the best possible and most enlightened upbringing. Dashkova saw herself as being in the forefront of the new, progressive mothers in Russia of the second half of the eighteenth century, instilling in their children the ideas of the Enlightenment.[60] She confined her children from an early age to their rooms with the shades drawn where they were required to sit for hours at their lessons bent over their books. Many years later Martha Wilmot would write: "By the by, if the Princess sometimes treats men as boys (or as dogs when they don't please her), she often treats children as men and women, expecting the same intelligence and understanding and pursuits which occupy her own mind and putting her own mind into competition with theirs."[61] Dashkova too often expressed an almost obsessive love for her children through dominating and manipulative behavior. The program of study she introduced neglected outdoor physical activity and was so mentally rigorous that it undermined the children's health. They

suffered from rickets, and eight-year-old Anastasia showed signs of spinal deformation.

Dashkova kept a close watch on the political events of the time, such as the war with Turkey, and continued meeting with diplomats and foreign dignitaries. On November 4/15, 1767, Henry Shirley wrote from Moscow, "I am surrounded by enemies, the more to be feared as they all cover themselves under a cloak of friendship, without a single friend except the Princess Dashkow, who is in the greatest favour with Count Panin."[62] Especially disturbing for her was the news of the opposition to Panin's Northern Accord Policy among Catherine's advisors and the closing of the Great Assembly of Deputies, which contributed to his loss of influence. Consequently, there was little hope that she could return to court anytime soon. In 1768, Catherine learned of a new conspiracy among the guard regiments and the name of the grand duke again came up during the inquiry. The punishment for those involved was demotion and hard labor in Siberia. Dashkova decided it would be a propitious time to travel abroad, ostensibly for the sake of her children. She hoped to take advantage of the medical resources available in the West and to take the cure at some of the most celebrated spas of Europe. A change of scenery and climate was in order, and travel would provide her children with an essential supplement to their home schooling and would advance their education. Although the manifesto of 1762 allowed the nobility to travel at will, as a lady-in-waiting Dashkova required the empress's permission. Yet letter after letter remained unanswered. Openly expressed anger did not come easily to Dashkova, so in her *Memoirs* she simply stated that, in lieu of traveling to Europe, she and the children embarked on a three-month journey to Kiev.

Travel, if pursued seriously and conscientiously, was for Dashkova an essential element of education and personal betterment. Therefore, their three-month trip to Kiev was a lesson in history, art, and current events with Dashkova lecturing on Kievan Rus'. She told her children about the birthplace of Russia, its cultural heritage, Russian Orthodox Christianity, and about the destructive force of the Mongol invasion in the thirteenth century. They made detours along the way to visit cities and settlements, witnessing Russia's colonization and consolidation under its civil and military administration of the Ukraine, often referred to as Little Russia in the eighteenth century. In Kiev, they were the guests of the governor, Fedor Voeikov, who accompanied them on their excursions to the Cathedral of St. Sophia, where the princes of Kiev were crowned during the years of the city's grandeur. At the Pecherska Lavra, the Monastery of the Caves,

they viewed the Uspenskii Cathedral and other churches with their magnificent frescos and mosaics dating back to the eleventh century. They also descended into the catacombs where in the recesses and grottos they could see the preserved remains of monks and saints. Of special interest to Dashkova was the Academy. Founded in 1615, at the beginning of the eighteenth century it was still a center of learning with some two thousand students enrolled. Over the years, many distinguished scholars studied there, M. V. Lomonosov and the Ukrainian philosopher G. S. Skovoroda, among them. Its tradition of learning was a source of great pride to Dashkova, and she pointed out to her children that members of the Academy read Newton's philosophy at a time when the Catholic Church banned it in France. According to Dashkova, science and scholarship arrived there long before reaching some European countries. Her commentary in her autobiography is characteristic of her defense of Russia against the charge of backwardness and her attempt to educate and transmit to the West an understanding of Russian culture, of which she saw herself to be a representative and an envoy.

Returning from Kiev, Dashkova was more determined than ever to receive permission for travel abroad and to undertake a grand educational tour. If her letters remained unanswered and did not produce the necessary results, then she would petition the empress directly, and to that purpose the following year she went to St. Petersburg. Most of the conversation in the capital concerned the First Turkish War, but Dashkova was single-minded in the pursuit of her goal. At an anniversary ball in Peterhof celebrating the empress's ascension to the throne, Dashkova boldly and provocatively broached the subject of her journey publicly, in front of a group of foreign dignitaries. A tense situation ensued, since she had put Catherine on the spot. The empress's response was controlled and measured, assuring Dashkova that she could do whatever she pleased. Her manner was perfunctory and polite, but no more, yet Dashkova was delighted with the success of her tactics and immediately began to set her affairs in order and prepare for departure. A Grand Tour of the continent was a costly undertaking, and the annoyed empress's support amounted to what Dashkova considered a paltry sum of four thousand rubles. She was therefore required to travel incognito under the name Mikhalkova, derived from one of her children's estates outside of Moscow. Dashkova could then pass up invitations to the many courts of Europe, with their stringent rules of decorum, and keep her expenses limited mostly to food, lodging, and horses. Travel would be easier without an array of court dresses, ball gowns, and riding habits. As it was, it would be necessary to

carry with them scores of morning, evening, walking, and visiting dresses along with shoes, slippers, stockings, hats, cloaks, shawls, wraps, gloves, and feathers.

In theory, the pseudonym allowed Dashkova a degree of mobility and the freedom of action to devote herself to her own projects and interests. Actually, many Russians undertook the Grand Tour in imitation of an earlier traveler, Peter the Great, who assumed the name Peter Mikhailov. Royals traveling incognito were participating in an elaborate masquerade, since everyone knew their identity perfectly well. For Dashkova, however, the masquerade was something far more serious than a game or the transvestite balls of her youth. By assuming various identities, she was making every effort to frustrate Catherine's spies. As a celebrity traveling abroad and a suspected seditionist banished from the St. Petersburg court, a disguise would offer her a measure of protection from surveillance. Moreover, concealment was now a way of life for Dashkova as she cloaked her feelings, withdrew from court, and never expressed her disillusionment openly. Rather, she created masks for unrecognized or unarticulated anger — for the frustration she felt at court, for her disenchantment with Catherine, and for the sadness of her personal life. Officially, she would travel to Europe on account of her children's health and education, in that way shielding them from the boorish and corrupt tutors such as the seminarian Kuteikin, the ex-sergeant Tsyfirkin, and the German liar Vralman, all of whom Fonvizin immortalized in his drama. Emphasizing great concern for her children and reticently enacting what she thought was proper and appropriate behavior for a mother and a widow, Dashkova prepared to leave Russia.

Chapter Five

First Journey Abroad

*I*N DECEMBER 1769, DASHKOVA DEPARTED on a journey lasting two years and taking her to the countries of continental Europe and on to England. Disheartened and angered by her rejection at court, she was nevertheless determined to restore her standing with Catherine. Travel would offer her the freedom to assume various disguises, but mostly she would present herself as Catherine's loyal and valuable subject. She would study all aspects of contemporary European life with an eye to adapting them to the transformation and modernization of Russia. Dashkova drove to Riga, where she hired horses for the trip to Berlin. Her party included nine-year-old Anastasia and six-year-old Pavel, the governess Pelageia Kamenskaia, her companion of many years, and her second cousin Ivan Vorontsov. Ivan, a diplomat attached to the Russian embassies in London and in The Hague, was well acquainted with life in Western Europe. He would be her guide and advisor during her first journey through Europe. They traveled overland in a caravan with attendants, servants, cooks, and an entire kitchen containing dishes, pots, and pans. On the way, in Koenigsberg, Dashkova visited her friend Charlotta-Amalie, the well-known miniaturist and daughter-in-law of Herman Keiserling, Russian diplomat and former president of the Academy of Sciences. As Russian minister plenipotentiary, he was instrumental in getting Poniatowski elected to the throne of Poland. Enjoying the company of her friend, she stayed there six days, after which the travelers proceeded on to Danzig.

The stopover in Danzig provided Dashkova with the opportunity for a dramatic re-enactment of the coup. In the *Memoirs*, she described her stay at the Hôtel de Russie, where Russians traveling abroad often lodged, and where she was annoyed to see two large tableaux representing the defeat

of Russian troops and their surrender to the victorious Prussian forces. For Dashkova, such depiction of the Seven Years War was a travesty, since she associated the Russian involvement in the war with Field-Marshal Zakhar Chernyshev's glorious capture of Berlin. Earlier, these paintings had also upset Aleksei Orlov, who had done nothing—he had neither purchased the paintings nor burned them. It was just like 1762, Dashkova thought, when Peter III had attempted to subjugate all things Russian to his Prussian policies and the Orlovs had failed to act. In comparison, her reaction had been bold, courageous, and innovative. On this occasion too, she immediately sent out for some oil paints and that night, locking herself into the room with the paintings, she devoted herself to redrawing them. Here accomplices included Peter Stählin, a skilled artist, engraver and translator, who was traveling with her as far as Berlin. He knew how to handle a brush and worked all night, until they finally achieved the desired result: "The Prussians—supposed to be victors in the two battles—became Russians, and the defeated were given Prussian uniforms" (119).

The merry crew's nighttime redrawing of the paintings was more than simply an innocent frolic. Recalling and reenacting her participation in the coup, Dashkova was quite pleased with her "boyish prank" (119). This scene in her autobiography was anecdotal and seemingly unimportant, but there was nothing random or accidental about it. Rather, this episode of Dashkova's everyday life was a typical detail that uncovers major organizational motifs in the *Memoirs*. In a casual, almost off-hand manner Dashkova provided a rare insight into the concerns, attitudes, and relationships that defined her narrative. In the Danzig passage, a sense of gaiety and play characterized Dashkova's actions. Nevertheless, they were destructive and provocative, for they flew in the face of propriety, challenged prescriptive rules of decorum, and implied a certain deliverance from the confines of the established order. In addition, by repainting the Russian and Prussian soldiers, she subordinated the question of historical veracity to the tailoring and putting in uniform of past events, and to a reenactment of the coup according to her interpretation of history. Moreover, the spirit of masquerade, with its potential for destabilization and release, informed Dashkova's attitudes toward society, history, and self: "I was very proud of my feat, and when we left the Hôtel de Russie behind us we laughed a great deal" (119).

Pleased with herself, Dashkova continued on to Berlin, where she remained for two months, and where her cleverly conceived incognito failed her. Her reputation, as the young woman who had spearheaded the palace revolution and brought down an emperor, had preceded her. Abroad,

some thought that Catherine had banished her from Russia, while others considered her the empress's spy. The royal family learned of Dashkova's presence in Berlin and from Sans-Souci Frederick II bid her to appear at court. Her easy discovery and unmasking, despite the elaborate preparations of her disguise, disgruntled Dashkova, yet the attention she was receiving pleased her. She reluctantly purchased a new black dress befitting a woman still in mourning. Queen Elisabeth Christine, with whom she shared an interest in literature, received her warmly, and from then on, either the queen or her sister repeatedly invited her to court. Dashkova was grateful to the two women for their kindness, even to the point of grudgingly paying Frederick II a compliment: "If outstanding genius as well as constant and unflinching zeal in working for the benefit of one's subjects make for greatness, Frederick was unquestioningly one of the greatest of kings" (120). Still, she had come to Europe for the sake of her children's health and she was determined to continue on, in order to take advantage of the baths and waters of Aachen and Spa.

Leaving Berlin, Dashkova and her group of travelers crossed Westphalia and then stopped in Hanover to repair their carriages. At the present, she was free to resume her masquerade and escape any further invitations and unwanted social commitments. That evening she and Kamenskaia attended the opera and shared a box with two courteous ladies. At the end of the last act, Dashkova, motivated by a sense of release and mischievousness, revealed that she was a singer and her companion a dancer seeking employment in Hanover. Displeased, the two proper local women became significantly less courteous and even moved away as far as possible from them. The prank delighted Dashkova and gave her an opportunity to assume an identity denied her in childhood. Her family considered professional training in voice and music to be inappropriate for a young woman of her class, and now, far from home and anonymous, she could imagine herself in the role of an entertainer and performer in order to shock and provoke others.

While the break in her journey was brief, it allowed Dashkova to record carefully the pedigree of horses and the agricultural features in and around Hanover. Finally, they were on their way again and on arrival in Aachen, Dashkova took a house opposite the baths. Today a plaque commemorates her visits in 1770 and 1776, along with other prominent eighteenth-century Russian travelers such as Grigorii and Aleksei Orlov in 1780. In February, she wrote her father begging him to "let me know ... that I have not been deprived of your paternal favor, only then can I be untroubled."[1] During her trip Dashkova wrote him a series of letters,

but her father replied rarely and reluctantly. Only in the summer of 1771, with Dashkova still abroad, did her letters indicate that their relationship had improved. Dashkova hoped against hope that the rift lasting almost ten years was at an end. After a brief stay in Aachen, she passed on to Spa in the Ardennes forest, with its warm springs and pastoral setting. It was a favorite watering place of the European elite. The titled, high-ranking, and powerful came to rest and take the waters, to bathe in the pools, to socialize, and to leave their money at the gambling tables playing pharaoh and other games of chance.

In Spa she met Jacques Necker, Swiss banker and Minister of Finance to Louis XVI, and his wife Suzanne Necker, a writer whose literary salon in Paris rivaled those of Madame Geoffrin and Madame du Deffand. The Neckers' four-year-old daughter, Anne-Louise-Germaine, would come to be better known as Madame de Staël. Dashkova's meetings with the Neckers in Spa, and years later in Paris, may have instilled in the young girl an interest in Russia. Other acquaintances included the Lord and Lady Sussex, and two women who would become her lifelong friends: Catherine Hamilton, the daughter of John Ryder, Protestant archbishop of Taum and Bishop of Ardagh, and Elizabeth Morgan, daughter of the Irish politician Philip Tisdal. Tisdal's wife was the chief patron in Dublin of Angelica Kauffmann, an artist Dashkova admired greatly. With the help of her two friends, Dashkova began to study English in Spa. Every morning they would read English books together, and after a time, Dashkova began to work her way through the writings of Shakespeare. The women agreed to meet again soon, to return to Spa in the future, and Dashkova promised to come to Aix-en-Provence where Catherine Hamilton would be spending the winter with her father. In September 1770, Dashkova received a copy of Archbishop Platon's sermon celebrating the Russian naval victory at Chesme. She translated it into French and gave it to her friend Dr. John Hinchcliffe, Bishop of Peterborough, who in turn translated it into English and published it in Oxford. Dr. Hinchcliffe recommended the Westminster School in London for Pavel, and in September, she left Spa with the intention of enrolling her son there.[2]

The crossing at the Straits of Dover presented Dashkova with a new and unhappy adventure. It was her first time at sea, and during the entire passage, she was seasick and in the care of the Tisdal family, with whom she was traveling. Dashkova arrived in London with her children and their governess Kamenskaia and took rooms at the Gentleman's Hotel.[3] On August 20, 1770, she had written Aleksei Musin-Pushkin, the Russian ambassador, requesting that he reserve the rooms and prepare a house for

her and her entourage. London at the end of the eighteenth century was a city grown out of proportion with a population of nearly a million. The dome of St. Paul's Cathedral rose majestically over a cityscape of endless towers, church spires, and chimneys. In Dashkova's mind, it was a city like no other: a center of art, architecture, manufacturing, finance, and trade. While she was there, she divided her time between the ambassador's wife and Elizabeth Morgan, her companion from Spa, and made every effort, in Horace Walpole's words, to "put her son to Westminster School."[4] Catherine Wilmot wrote that Pavel attended Westminster School for two months, but it is more likely that Dashkova's wish to enroll him came to nothing.[5]

In the brief time she would be in England, Dashkova wanted to see as much as possible, and when Elizabeth Morgan departed for Dublin, she prepared for a two-week excursion through northern England. On the morning of October 15, she embarked on a tour of England with her daughter, governess, and cousin, Ivan Vorontsov, but without her son, presumably left behind with the Musin-Pushkins in order to pursue his studies. The group headed for Guildford and Portsmouth, where Dashkova inspected the naval installations, and then on to Southampton and Salisbury. She was not enthusiastic about the great cathedral of Salisbury and preferred the rug factory, the metal-works, and the shops in town. Stonehenge fascinated her. She then went on to the fashionable resort cities of Bristol and Bath, where she joined others seeking relief from rheumatism, gout, and various ailments of the age. She stayed longest in Bath, studied its classical architecture, took the waters there, attended a concert, a ball, and heard the sermon of her acquaintance the Bishop of Peterboro. From Bath, she returned to London by way of Woodstock, Oxford, Windsor, and Hampton Court. In Oxford, Russian students studying at the university greeted her and the vice-chancellor presented her with an album of sculptures and bas-reliefs. She took a tour of the colleges, the Ashmolean Museum, the Clarendon Press, and the Bodleian Library, where she inspected Russian manuscripts. Of great interest to her was a Russian-Greek dictionary, since she was already thinking about the need for a comprehensive Russian dictionary. She stayed in Oxford for three days, but it disappointed her and she felt that the university had fallen far from what it once was.

Dashkova was a serious, enlightened traveler, writing down her observations and keeping a diary of her journey. She decided, however, to publish only her journeys in England, a country she admired greatly, and thereby introduced contemporary England to the Russian reader. She de-

scribed her excursion in the *Journey of a Certain Distinguished Russian Lady through Some English Provinces,* a travelogue that was the "the first account of its kind ever to appear in Russia."[6] In it she related how along the way she inspected the layout of English gardens and visited the great houses and estates of, among others, the Duke of Marlborough at Blenheim and Lord Pembroke's Wilton House. She did not at the time suspect that in 1808 her niece, Simon's daughter, would marry George August Herbert, 11th Count of Pembroke, and 8th Earl of Montgomery.[7] She would become mistress of the house and would "ride her Russian sleigh through those very grounds."[8] Landscaping played a special role in Dashkova's life, and she observed the new-style English gardens, referred to as *jardins paysagers,* which were the order of the day. Their arrangements seemed natural and irregular, combining lawns, open areas, winding paths, groves of trees with streams, artificial ponds, and waterfalls. Yet the plantings evoked an idealized English landscape and stirred the romantic spirit. Often, there were surprises among the trees and water: pavilions, classical temples, grottos, or faux ruins. Such gardens were for Dashkova a representation of paradise regained, of an enlightened heaven on earth bringing together passion and reason, order and chaos, the spontaneous and the organized, the individual and nature. She felt they were worthy of epic descriptions, and from the Grand Tour Dashkova took back to Russia her findings on how to improve her estate after the English manner. Her plantings became much less formal as she abandoned the laying out of gardens in the stylized French manner, along the grand designs of seventeenth-century France, preferring the lawns and vistas of the English style. Both in architecture and landscaping Dashkova applied her observations to the construction and recreation of her Moscow house and her estate in Troitskoe.

Dashkova examined everything with an eye to practical application, from gardens to recent advances in technology, and recorded her interest not only in art, society, and education, but also in modern advancements and agricultural achievements. In London, she visited an exhibit of technological innovations in the area of agriculture and industry; all of them, Dashkova wrote, were developed for the benefit of a fortunate and enlightened people. She was very interested in the repository of the Royal Society for the encouragement of Arts, Manufactures & Commerce, which was founded in 1754 to promote the development of a principled and prosperous society. Dashkova subscribed to William Bailey's *The Advancement of Arts, Manufactures and Commerce; or, descriptions of the useful machines and models contained in the Repository of the Society for the Encouragement of Arts, Manufactures and Commerce.* The extensive, illustrated work, with fifty-five

plates documenting contemporary industrial machinery, first appeared in English in 1772. Dashkova stood on the side of progress when many years later she took part in the lively debates on the merits of the traditional wooden plough as opposed to the western iron plough. In 1807, Fedor Rostopchin in his article "The Iron and Wooden Plough" (*"Plug i sokha"*) wrote in defense of established Russian methods of agriculture and criticized foreign, particularly English, influence. Dashkova in her "Opinion on the Iron and Wooden Ploughs" (*"Mnenie o pluge i sokhe"*) disputed his traditional views.[9]

Back in London on October 29, 1770, Dashkova spent more than two weeks there. She did not go to court, where her brother Aleksandr, after joining the diplomatic corps, had served as Minister Plenipotentiary to the Court of St. James, but continued her education in the art and history of England. She met Horace Walpole at the Duchess of Northumberland's, and he noted that she "talks on all subjects, and not at all nor with striking pedantry, and is very quick and animated. She puts herself above all attention to dress and everything feminine, and yet sings tenderly and agreeably with a pretty voice."[10] The remaining days of her stay were mostly devoted to sightseeing, and it was with great regret that she prepared for departure. Dashkova had come to love England above all other foreign countries and to admire its system of education and form of government, which "surpasses arduous experiments of other people in this area."[11] She exclaimed, "Why was I not born an Englishwoman? How I adore the freedom and spirit of that Nation!"[12] Dashkova also said, "I do think God Almighty himself ought to be proud when he says, I have made the English woman," and Catherine Wilmot added, "She is not, however, half so fond of English *men*."[13] Dashkova was determined to return to England, to see more of the country, and to provide her son with an English education.

The passage back to the Continent, from Dover to Calais, was dangerous and rough. The wind howled, the storm raged, and for twenty-six hours waves splashed water onto the deck and into their cabin. Frightened, the children could not fall asleep and Dashkova, who was also unable to sleep, spoke to them on the virtues of courage and the importance of submission to the Divine Will. Happily, they at last arrived in Calais unharmed and after short visits to Brussels and Antwerp, traveled on to Paris. In Paris, Dashkova rented rooms on the Rue de Grenville. Since she would remain there only seventeen days, she made the most of every minute. She woke early and her morning excursions would often last well into the afternoon as she visited churches, monuments, and the studios of artists, or in the evenings she would humbly sit in the galleries of theaters, disguised in "an

old black dress and shawl and a close cap in order to escape all notice" (123). She always looked forward to her meetings with Diderot, a man of learning whom Dashkova respected highly. "His sincerity, his loyalty to friends, his shrewd and profound mind, and the interest and esteem he invariably showed me, were all traits that won me over for life" (126). She got together with Diderot often — according to Dashkova daily — and they would take a carriage to her residence where they dined and then talked late into the night. But Diderot wrote that he spent four evenings with her from approximately five o'clock to midnight.

With Diderot's assistance, she made every effort to avoid certain dignitaries, many of whom were eager to meet the young woman who according to some contemporary historians had single-handedly altered the course of a vast empire. The events of 1762, and especially the extent of Catherine's participation in these events, were an object of great interest among the French men of learning, including Diderot and Voltaire, who in the past had supported and placed great hope in the newly crowned empress. With Dashkova now in Paris, the opportunity arose to hear the firsthand account of an eyewitness and to learn more about Catherine's complicity in the murder of her husband, the emperor. Dashkova was suddenly a celebrity and fully conscious of being the object of great interest in intellectual and official circles. One evening, as she and Diderot sat alone, Mesdames Necker and Geoffrin called on her. Dashkova had met Suzanne Necker in Spa, and she knew Marie Geoffrin to be one of the most gifted and enlightened women of the eighteenth century, who was friends with most of the leading *philosophes, encyclopédists,* artists, writers, and intellectual elite of Paris. In her youth, she had been a friend of Antioch Kantemir, the Russian poet and ambassador to France from 1738 to 1744. She corresponded with Catherine II, Stanislav Poniatowski, and other monarchs.

Diderot advised her not to see these celebrated women of letters and hosts of Paris's leading literary salons. He felt that they merely wanted to satisfy their curiosity, and that soon after their meeting, she would become the talk of the town. A meeting with these women would not serve her well and might indeed do great damage to her standing in Russia. For three years, Madame Geoffrin had been on bad terms with Catherine, ceased corresponding with her, and proclaimed publicly her suspicions that Catherine was not the enlightened monarch that Voltaire and Diderot made her out to be. Following Diderot's advice, Dashkova refused to see them and declined further invitations, fearing that she would become the object of unrestrained rumors that might reach Catherine's attention. While in

Europe, she was careful to leave a favorable impression so that it might be passed on to the empress, and therefore carefully avoided individuals such as De Choiseul and others whom Catherine did not hold in high esteem.

For the same reason she refused to meet Claude-Carloman de Rulhière, the French historian, writer, poet, and diplomat, who in 1787 would gain membership in the French Academy. He was secretary to the Baron de Breteuil in the French embassy in St. Petersburg; Dashkova knew him well and he often visited Kamenskaia's house in Moscow. In 1768, he wrote the *Histoire ou Anecdotes sur la révolution de Russie en l'an 1762*, which attributes to Dashkova the role of chief organizer of the palace revolution and is generally unflattering to Catherine. The empress was able to block its publication for a time and charged the Russian envoy in Paris with acquiring the manuscript, but was only able to have Rulhière promise not to publish the book during her lifetime. Rulhière, however, read excerpts in the literary salons of Paris. The first reading took place at De Choiseul's, the second at Madame du Deffand's, and the third at Madame Geoffrin's.[14] By receiving him, Diderot explained, Dashkova would be giving her approval to the work. Politically, it would be a mistake for Dashkova to associate herself with this publication, for word would certainly get back to Catherine. Dashkova was doubly indebted to her friend, for after her departure Diderot wrote Catherine, stressing her great affection for the empress. He described how she had declined to meet Rulhière on a number of occasions and thereby had cast doubt in the eyes of Parisian society on the veracity of his narrative. Dashkova was forever grateful to Diderot for aiding her in the restoration of her reputation at the Russian court. She would meet Rulhière during her second visit to Paris, but seemingly only read his history much later, possibly in manuscript form.

Apparently, the French women were quite displeased with Dashkova and expressed their disappointment in most unflattering terms. Rulhière wrote to the countess D'Egmont in 1773,

> Some persons, it is true, who were acquainted with the princess Dashkova, when on her travels, did not recognize in her the young princess who had interested them in my narrative. I entreat them to observe, that she is there painted at the age of eighteen, and that I myself announced, before I concluded, the change which her disgrace produced upon her. . . . She has lost, at an age so tender, all the illusions of fortune, of friendship, and of glory. Humiliation has blighted that ardent and generous character, which promoted her to sacrifice her family.[15]

Diderot wrote a generally objective description of Dashkova, who at twenty-seven was not beautiful and looked like she was closer to forty: "Her sorrows had brought on the appearance of age, and greatly deranged her health."[16] In his "Portraiture of the Princess Dashkova" Diderot wrote,

> She is little, with a high and open forehead, large puffed-out cheeks, eyes neither large nor small, a little sunk in the socket, dark hair and eyebrows, nose somewhat flat, a side mouth, thick lips, a round straight neck of the national form, open chest, not much of a figure. She has ease in her movements, without the graces, and much affability of manner. The general expression of physiognomy is favorable. Her character is grave; she speaks our language fluently; all she knows and thinks she does not say, but what she says she says simply and forcibly, and with the tone of truth. She has a heart lacerated by misfortune; and exhibits a decision and grandeur in her ideas, as well as boldness and pride in her mode of thinking. There is in her also, I am convinced, a profound spirit of rectitude and dignity.[17]

It was not an unequivocally flattering portrait, still Dashkova impressed Diderot, and he noted that she was an animated, courageous, and determined woman. Her directness, incisiveness, and erudition attracted him. Serious, eloquent, thoughtful, and dignified, she appeared to be "a decided enemy of gallantry."[18] Although she spoke fluent French, in his eyes she was the embodiment of Russianness, a Russian woman "in body and mind" who greatly valued justice and whose ideas were high-minded and expressed with conviction. She loved science and art and detested all forms of oppression: "She has a cordial aversion for despotism, as well as for everything which nearly or remotely tends to tyranny."[19]

Yet Dashkova's Anglophilia displeased Diderot and offended his feelings of national pride. "Her taste for the English nation is so pronounced, that I fear her partiality for this anti-monarchical people may somewhat indispose her to render justice to our own."[20] When their conversation turned to political matters Dashkova argued the advantages of a constitutional monarchy based on the English parliamentary system of government. Like most of her family, including her brothers Simon and Aleksandr, she held pro-English views, and her great admiration for England was at that time considered liberal. She spoke with Diderot openly and objectively about the current government in Russia, and while firmly on the side of constitutional governance, she felt that Russia was not yet ready to adopt it. Her

critical analysis of the present situation in Russia excluded Catherine, for whom she professed great admiration, despite her many disappointments. Indeed, her discussions with Diderot quite possibly influenced his decision to visit Russia.

Diderot could not ignore the major contradiction in Dashkova's life, nor could Dashkova herself satisfactorily justify the incompatibility of her sincerely held ideals and the reality of serfdom. During the eighteenth century, the situation of serfs in Russia had deteriorated and their economic exploitation worsened to the point of virtually complete dependence on their masters. It was therefore inevitable that one evening the question of serfdom in Russia would come up, and that Diderot would confront Dashkova with questions concerning the peasant slavery she depended on economically. In the mid-eighteenth century, from Moscow and St. Petersburg to Monticello and Mount Vernon, the disparity between enlightened principles of the inherent dignity of all people and the abominations of slavery and serfdom were matters of concern in educated circles. The Europeanization of Russia brought into conflict the new ideas on social organization, natural law, human rights, and equality with Russia's economic dependence on agriculture and the labor of serfs. Montesquieu's *De l'esprit des lois* and the articles of the French *philosophes* were to sway Russian thinkers toward the abolition of human bondage in all its forms. Catherine too in her *Instruction* drew heavily on Montesquieu's work in the analysis of the nature of government and social structures. While she hinted at the eventual elimination of serfdom, when there was resistance from the nobility she withdrew the proposal.

Catherine had encouraged a public debate on the institution of serfdom. In 1765, representatives of the liberal nobility at the Free Economic Society hosted an essay competition on the question of serfdom and on the advisability of peasant ownership of land. The eventual winner was Beardé de l'Abbaye, member of the Dijon Academy, whose prize-winning work stressed the self-evident truth that freedom is the desired end of all. While describing the harsh conditions of the peasantry in Russia, he also urged that reforms be properly prepared and not advanced prematurely. He concluded that gradual emancipation was the order of the day and that the peasants must be prepared for the acceptance of freedom, before any property is turned over to them. As the nobles grew more and more dependent on their serfs and considered them to be their private property and a measure of their wealth, they embraced justifications for the continuation of a cruel and odious institution.[21] Dashkova's father championed the winning essay and in November 1767 argued in the Legislative Commission

for its publication in both Russian and French. Beardé de l'Abbaye's thesis was acceptable to the nobility and to Dashkova, and her argument with Diderot reflected many of its main points.

In the *Memoirs*, Dashkova presented her meetings with Diderot as an occasion to rationalize and validate her views on serfdom, since the resolution of obvious inconsistencies in her ideas detracted from her representation of Russia and her own life in a positive light. She felt compelled to defend herself forcefully, dramatizing her disputation in the form of a monologue, with Diderot in the role of an imaginary adversary offering no compelling opposition to her indefensible position. Such reticence on Diderot's part was highly unlikely, since he was quite eloquent and rarely at a loss for words. It would seem obvious, that in light of influential and enlightened notions from Europe concerning an individual's natural rights, the institution of serfdom would be abhorrent to Dashkova. Yet her words and actions did not express a sense of indignation or revulsion. She was opposed to serfdom in principle only, but practically, she could not ignore economic and social factors. Dashkova felt that the peasantry could not yet exist without the guidance of their masters, and that it would be a mistake to make them aware of their condition. Accordingly, "one of the most progressive Russian women of the eighteenth-century explained that the peasants reminded her of blind persons, happily unaware that they are living on the edge of a cliff. If they regained their sight, they would be deeply unhappy."[22] Straight off, Dashkova declared herself to be objective and unbiased, advancing neither a peasant's nor a master's point of view. She admitted to idealism early on in her life, when she granted greater freedom to the serfs on her estate in the Orel Province, hoping that it would lead to their happiness and well-being. Regrettably, the experiment failed when rapacious and corrupt local officials victimized the unprotected peasants. With this look into her early idealism, Dashkova presented one of the most widely held contemporary defenses of serfdom, which lay emphasis on the helplessness of the peasants and the paternalism of the master. If left to their own devices, free peasants would suffer oppression from intermediaries and dishonest profiteers, would require protection, and would be unable to take full advantage of legal or economic freedom.

Dashkova, as did many of her contemporaries, considered it the obligation of the landed gentry to preserve its human chattel from harm and excessive exploitation. It was their duty to protect and provide for the well-being of the labor force working their estates. Indeed, paternalism seemed to make perfect sense, since the welfare of the peasants was crucial to the wealth and prosperity of the landowner. Dashkova was not a harsh or cruel

landowner, neither was she unusually generous or exceptionally liberal. Prudence and good sense always governed her actions, since she knew perfectly well that serfdom represented her economic base. Faced with a contradiction between the institution of serfdom, which was essential to her financial recovery, and the ideals of enlightenment, she opted for the former. Mistreatment of the serfs would be economic folly, and in the long run counterproductive. Dashkova presented the customary argument that it would be madness to destroy one's assets, although she was fully aware of serfdom's inhuman features, such as forced recruitment into the military, sale of peasants to distant villages far from their families, and the unrestricted and arbitrary power of owners over subjects without legal rights. In a letter to Aleksandr, written during Paul's reign, she condemned the brutal and violent actions of the landowner Mikhail Kamenskii.[23] Surely, there was a need to redress the wrongs, prosecute the offenders, and make reparations for damages, but Dashkova felt that sadistic masters were an anomaly in Russia.

Evidently, she was judging from her own experiences, since by all accounts, she was a kind landowner who cared greatly about her peasants. Martha Wilmot's journal indicated that the lot of Dashkova's peasants was comparatively better than those who lived in the poorer areas of Russia, and that she strove to be an enlightened master: a rational organizer and conscientious manager of her estates overseeing the happiness and prosperity of her serfs. Accordingly, Dashkova became angry when her daughter sold a hundred persons from the village of Korotovo. She bought them back for four thousand rubles and to cover her expenses, set their dues (*obrok*) at seven rubles for a period of four years, after which she reduced their obligation to two rubles.[24] This was not an inordinately large sum, as Semevskii claimed, nor was it particularly openhanded, as Dashkova would write. "The dues I imposed on her [Anastasia's] peasants were so moderate that they considered themselves lucky indeed and those of them that had left their house came back again" (242-43).[25] Mostly, she was practical and financially responsible, since at the time money dues for peasants averaged approximately two to five rubles, and Dashkova felt that generally three rubles was a fair amount.[26] As opposed to her daughter, she was not thoughtlessly cruel or inhumane to her serfs, and consequently, the peasants Anastasia inherited requested that they remain in the Vorontsov family.[27] In the end, the student of Diderot and Voltaire, whose life was unconventional in so many ways, became the prudently thrifty administrator of human property and was mostly concerned with her own well-being and independence.

A defense of serfdom based solely on economic factors could not satisfy Diderot. The philosopher insisted that freedom is far more important and that in time it would lead to greater knowledge and productivity. He expressed his views on serfdom, which he equated with slavery in his notes to Catherine and comments on the *Instruction*. With Voltaire and Rousseau, whose ideas only differed on the question of property distribution, he insisted on the immediate and complete abolition of serfdom. Grounded in Russian reality and the determining role of social classes, Dashkova's response was neither democratic nor egalitarian. She evaluated the question of reform in the context of an established hierarchy, the existing law, and the common good. While she was a woman seeking independence and self-determination for herself, her argument bears the stamp of the eighteenth-century Russian ideal of a hierarchical state with clearly defined castes where individuals belong to a certain social group or estate that legally defined their duties and responsibilities. There were of course exceptions, notably Lomonosov, the son of a wealthy state peasant from Archangel, who became a serf owner at the end of his life. For Dashkova, the premature application of abstract, philosophical notions of human dignity and liberty would threaten the existing hierarchy, undermine the nobility's leading role, and loosen controls essential for the preservation of the established order.

Dashkova protected her elite position in Russian society and deflected the question of human bondage by considering the issue of obligatory service on the part of the nobility. If the nobility ever realized its release from service to the sovereign, she would be the first to sign a declaration of the peasants' freedom. Dashkova knew full well, but chose to ignore, the many actual gains nobles had achieved, and she failed to mention that the manifesto on the freedom of the nobility of 1762 had in effect freed them from compulsory duty in the military and the state bureaucracy. Therefore, they could retire to their estates and pursue lives of leisure and extravagance. Dashkova was also aware that Catherine had convened the commission on noble freedom early in February 1763 and had ordered the senate to act on the issue Peter III began a year earlier. Dashkova's husband had been overjoyed at the prospect of liberation, and Catherine described Prince Dashkov's elation: "Weeping tears of joy, he rushed up to me and said: 'The emperor [Peter III] deserves to have a gold statue put up to him—he has given freedom to all the nobles and is now going to the senate to declare this.' I asked him: 'Had you been serfs until now?'"[28] In addition, Dashkova's father had been involved in the formulation of the legislation, although Catherine scoffed at his participation and downplayed his influ-

ence. "Roman Vorontsov and the procurator-general thought they were doing something great when they recommended to the emperor [Peter III] that he grant freedom to the nobles; but in reality they ask for nothing more than that each should have the right to serve or not to serve."[29]

Dashkova, to her credit, did not contend that the ownership of serfs was a fundamental right of the nobility. While some of her contemporaries considered the peasants to be incorrigible and a breed apart, Dashkova felt that their condition was a result of historical determinants and social factors and that it could be improved through proper education and gradual preparation for self-sufficiency. She therefore fell back on the prevalent argument that education must precede liberation, and that the inculcation of enlightened ideas would inevitably bring positive change and reform, both personal and social. Freedom without proper preparation and education of the lower classes would result in anarchy, and chaos would prevail in Russia. Dashkova proposed the liberalization of all levels of society through education, not only the peasantry. Ironically, while her life was devoted to education, she did little for the serfs. She did not advance any reforms or necessary measures as a first step toward the abolition of serfdom, nor is there any evidence that she educated the peasants on her estates. Rather, her area of greatest concentration was the pedagogical mission of the two academies she headed, where, among other projects, she greatly expanded the Academy school and instituted public lectures.[30]

Dashkova's position reflected the views of the gentry opposition at court and members of the Panin group. They were less concerned with the abolition of the system of serfdom than with government regulation of excesses and measured reforms. The hope existed among them that good example, education, and enlightenment of the landowners would improve the situation. Although some of the major landowners established elementary schools for peasants, most of the training there was applied or vocational, designed to serve the estate better or to entertain the nobility. Serfs received training as painters, musicians, actors, dancers, and singers. While Dashkova's attitude might have been typical, there were exceptions, such as the moderate reforms of D. A. Golitsyn, as well as the more radical publications of Aleksandr Radishchev. The next generation would continue their efforts; for example, Dashkova's nephew, Mikhail Vorontsov, would establish a school for peasant children (almost exclusively boys) in Andreevskoe, the estate he inherited from his uncle Aleksandr. It was based on the ideas of the Quaker educator Joseph Lancaster, who developed a system of peer instruction with older, more advanced students acting as monitors and supervising the education of younger students. On May 5,

1820, with the brothers Nikolai and Aleksandr Turgenev, P. A. Viazemskii, and A. S. Menshikov, he cosigned and sent to Emperor Alexander I the so-called "Note" ("*Zapiska*") calling for the liberation of their peasants.

In the end, Dashkova was mainly interested in practical economic matters and their application to existing conditions in Russia. Despite her absorption in the ideas of the Enlightenment, with their emphasis on the rights of individuals, the dependence of Russia's economy on serfdom and the ownership of people troubled her less. She concluded her discussion in the *Memoirs* on a typically theatrical moment with Diderot at last enlightened and completely swayed. "Diderot jumped up as if my little story had touched off a mechanical device to propel him out of his chair. He walked up and down the room and spat on the floor in a kind of anger. "What a woman you are!" he burst out, "You have upset ideas I have cherished and upheld for twenty years" (125). Unquestionably, Dashkova had little if any effect on Diderot's opinions and he remained a determined enemy of slavery in all its manifestations. More to the point was his letter to Dashkova, dated April 3, 1771, in which he seemingly continued the conversation they had in Paris: "Each age has its characteristic spirit. The spirit of our age is—liberty."[31]

Before leaving Paris, Dashkova wished to visit Versailles on the day the public could look on as the royals, Louis XV and his family, took their food at the *grand couvert*. In order to go there unobserved, she made all necessary preparations to elude the constabulary watching her closely. She therefore prepared horses and a borrowed coach outside of town to take her and her children to the gates of the Versailles Park. Access to Versailles was not a difficult matter since the gates were all but unguarded. Disguised, they walked about for a while in the garden mingling with the crowd eager to witness the royal family's eating habits. At last they were escorted into what seemed to her a dirty and squalid room, where they awaited the entrance of the royals. The King, the Dauphin, who would be crowned Louis XVI, the Dauphine, Marie Antoinette, and their daughters Adelaide and Victoria "came in and I saw them take their seats and have a hearty meal" (128). Her excursion and her successful escape from the watchful eye of the authorities delighted Dashkova. When the Duke of Choiseul, the minister of foreign affairs and the virtual prime minister of France, heard of Dashkova's adventure, he would not believe the story. He offered to give a reception in her honor. For Dashkova, however, that was impossible since he had disparaged Catherine, and using her pseudonym, she replied that Madame Mikhalkova could not accept his invitation and preferred on this

occasion to see "things of local interest rather than distinguished persons for whom she had esteem and regard" (129).

From Paris, Dashkova set off for Aix-en-Provence to spend the winter there with Catherine Hamilton, her father, brother, aunt, Lady Ryder, and other English families. She took advantage of the mineral springs, continued to study English, and traveled with Catherine Hamilton to Montpelier, Marseilles, Hyères, and along the Royal Canal. Notwithstanding her carefree life in the south of France, Dashkova was aware of political change and the coming social upheaval in France. The provincial parliament had been dissolved and letters addressed to her, particularly from Paris, were looked upon with suspicion and were being scrutinized closely. In one such letter to her, Diderot, according to Dashkova, displayed "the depth and the acuteness of his genius" and accurately predicted great changes in his native land and "what has since happened in the French Revolution" (130).

In the *Memoirs*, Dashkova presented the breakdown of civility and order in France through her own perception of proper eighteenth-century behavior and her sense of being part of a social and intellectual elite. While critical of any form of unthinking absolutism, she was as a rule alarmed at any limitations of her own personal freedom. She was quite conscious of being a noblewoman and was more than willing to return to her elevated status in moments of crisis. By way of illustration, Dashkova described an evening in Lyons when she attended a public performance at the local theater with Kamenskaia, Catherine Hamilton, and Lady Ryder. They were surprised to find their box occupied by four "ill-bred" women from Lyon, as Dashkova referred to them derisively, who refused to move even when the usher told them that the box had been reserved for "foreign ladies of distinction" (132). In a manuscript copy of the *Memoirs* that A. S. Pushkin read, Dashkova's characterization of these women from Lyon is underlined. In the margins the poet wrote, "Diderot, the teacher and apostle of equality, whom the author [Dashkova] admired greatly, would not have expressed himself so."[32] Annoyed that others had appropriated her place in the theater, Dashkova was on her way out when a significantly more troubling, even dangerous, incident confronted her. Soldiers guarding the entrance to the theater were using the butt-ends of their muskets to contain a disorderly crowd. Caught up in the melee and crush of humanity, Dashkova received a blow and almost fell to the floor. To extricate herself she abandoned her masquerade of mingling with the crowd, fell back on title, privilege, and gender, and identified herself as the Princess Dashkova. As

the soldiers escorted her out to her carriage, Dashkova complained of the brutal treatment she had been subjected to, although she was a woman.

In the spring of 1771 it was time to leave for Switzerland to meet Voltaire, the author who in her youth had influenced her more than any other. The day after arriving in Geneva, she inquired whether he could see her. On Thursday, May 9, 1771, "the old hermit of Ferney," as Voltaire referred to himself, "grown nearly blind and overwhelmed with infirmities" invited Dashkova and her party the next day to sup with him and his niece.[33] Dashkova and her traveling companions, Catherine Hamilton, Kamenskaia, Lady Ryder, and Ivan Vorontsov, went to the majestic château de Ferney to meet the weak and ailing philosopher, who was seventy-six years old. In so doing, Dashkova was following in the footsteps of other Russians, such as the Shuvalov brothers and Dmitrii A. Golitsyn, who had paid homage to the sage of Ferney. On May 10, 1771, the day of the meeting, Dashkova's expectations were high as she imagined herself listening in awe to the words of her mentor. Right away, Voltaire's theatrical and exaggerated manner disappointed her. He seemed insincere and affected as he "raised both his arms, as is done on the stage," and exclaimed, "Her voice is the voice of an angel" (133). When Dashkova presented Voltaire with a French language copy of Metropolitan Platon's sermon delivered at the tomb of Peter the Great, he unconvincingly called it one of the finest documents ever written and assured her that it was "worthy of Plato the Grecian himself."[34]

But Dashkova too was performing, since during her trip to Europe she made every effort to rehabilitate herself in the eyes of Catherine and to win back her friendship. Dashkova's words were premeditated, and she spoke with the understanding that they would get back to the empress. In Voltaire's room, she noticed Philippe de la Salle's profile portrait of Catherine in woven silk. When their conversation turned to Catherine, she looked at the portrait and her eyes filled with tears. She hoped that Voltaire would write to Catherine and describe the incident as well as Dashkova's devotion to her. Five days after their meeting, Voltaire did in fact praise Dashkova highly to Catherine, referred to her as the empress's loyal subject, and related how Dashkova's eyes grew misty upon seeing the portrait.[35] Catherine wrote back in June 1771 that Voltaire's four-hour conversation with Dashkova served as proof of the friendship between the empress and her loyal subject.[36] Dashkova's dramatics had the desired effect and on her return to St. Petersburg, the empress would be gracious to her.

Because Voltaire suffered greatly from a number of ailments, bleeding hemorrhoids among them, his valet and his niece, Marie Louise Denis,

helped him to the supper table where he kneeled on an armchair with its back to his guests dressed *en robe de chambre*, being a long time unable to dress otherwise. Dashkova considered Voltaire's niece, who was his mistress and the author of several stories and at least one play, to be a "slow-witted woman" (133). Overall, the conversation at supper was uninteresting and her initial visit disappointing. The next day, however, she was able to spend some time alone with him in his study and garden with its magnificent view of the Alps. On that occasion, she found him to be "such as I had imagined and pictured him to be from reading his books" (133). They discussed politics, the first Turkish War and peace negotiations, and especially the northern Semiramida, or Catherine. In a letter to his friend, the philosopher Marmontel, Voltaire wrote on June 21, 1771, that Dashkova, as well as Catherine, were committed to the ideas of the Enlightenment and that she was "a heroine who is fighting for you."[37] Nevertheless, Dashkova felt disenchanted, and did not describe in detail her conversations with Voltaire, as she had with Diderot. While in Geneva, Dashkova greatly enjoyed the company of Jean Hubert, the Swiss painter best known for his representations of Voltaire's domestic life, which upon the recommendation of Baron Grimm, Catherine purchased. In the evenings, Jean Hubert would go out boating on Lake Geneva with Dashkova and her friends. Hoisting the Russian flag on the largest boat of their tiny flotilla, Dashkova and Kamenskaia would sing Russian songs on the beautiful Swiss lake. In Geneva she also became friends with Avraam Veselovskii, a diplomat who during the reign of Peter I had renounced his country and refused to return to Russia because of his involvement in political intrigues surrounding Peter's son, the Tsarevich Aleksei. His eldest daughter had married Voltaire's close friend and publisher, Gabriel Kramer.

It was with deep regret that Dashkova left Geneva and traveled down the Rhine in two large boats, one of which transported her carriage and other belongings. In the cities where they stopped, she and Kamenskaia would sneak ashore dressed in black dresses and straw hats. Thus, they remained anonymous and free to do what they pleased, at times bringing their own provisions back to be prepared on board for dinner. Karlsruhe, purportedly a place of rest and relaxation, as the name implies, was anything but for Dashkova. She was again recognized when she hired two carriages to visit the magnificent Baroque palace there, modeled on Versailles, and the Schlossgarten Park. Karl Friedrich, the Margrave of Baden, considered himself an enlightened, absolute sovereign who abolished torture and serfdom in his realm. He therefore interested Dashkova very much, but she refused the invitation to appear at court and excused

herself on the pretext that she had taken along only traveling clothes. The Margravine, Caroline Luise, would not hear of it. The reputation of Karlsruhe as a court of the muses was a result of her interest in arts and natural sciences. She corresponded with prominent thinkers, poets, and musicians: Voltaire, Herder, Goethe, Klopstock, and Gluck were among her many guests at court. She reminded her Russian guest that they were fellow cavaliers of the Order of St. Catherine, and Dashkova had no choice but to comply. After an extended tour of the park, Dashkova enjoyed a concert and conversation at supper with the hosts and their guests. In later life, that evening was all the more memorable in Dashkova's mind because the Margrave's granddaughter became Empress Elizabeth, the wife of Alexander I of Russia.

From Karlsruhe, Dashkova went on to Düsseldorf and then Frankfort, where she made the acquaintance of Vladimir Orlov, the youngest of the Orlov brothers. He was educated at Leipzig University and at the time of their meeting was director of the Academy of Sciences. Dashkova found him to be "a man of shallow mind who had derived from his studies in Germany nothing but a pedantic tone and an entirely unfortunate conviction of his own deep learning." They discussed Rousseau, whom Dashkova considered an "eloquent but dangerous writer" (136). In her *Memoirs*, Dashkova would have Catherine repeat the same idea. When Dashkova mentioned the *New Héloïse*, the empress replied, "He is a dangerous author.... His style makes him fascinating reading, and he goes to young people's heads" (235). After the French Revolution Dashkova distanced herself from that "dangerous author," but in her youth, Rousseau was one of her favorite writers and her Moscow library contained more volumes by Rousseau than by perhaps any other writer, including Voltaire.

On June 12/1, 1771, she wrote Aleksandr about her meeting with Voltaire, who had spoken highly of him.[38] Otherwise, she seemed anxious and out of sorts. Her son had fallen ill in Strasbourg, so they would be going to Spa to recuperate for three months. She regretted that Simon and their father would have nothing to do with her and never wrote. Completing her Grand Tour of Europe, Dashkova returned to Spa to begin retracing her steps to Russia. In Spa, she met often with Charles, the future king of Sweden, known as the Duke of Sudermania during the reign of his brother. He would be the unlikely link bringing together Dashkova and the American Philosophical Society. Mostly, these were months of sadness for Dashkova, for the time was approaching when she would have to part with Catherine Hamilton and the Ryder family and make her way back to Russia. That summer in Spa, she had a tumor removed from her

leg, an operation that left her bedridden for several weeks. Dejected as she was, Dashkova promised her companions that within five years, she would return to Spa and they would all live together in a house then under construction on the Promenade de Sept Heures. It was a promise that Dashkova was determined to keep. When her friends left Spa, Dashkova traveled back to Berlin by way of Dresden, where for a few days she spent most of her time at the Old Masters Picture Gallery, "for which, indeed, a lifetime would not suffice" (138). In Berlin at last, she received a warm reception once again.

There were rumors from St. Petersburg that her chief enemy at court, Grigorii Orlov, was beginning his inevitable fall from favor, while Potemkin's star was on the rise. It was time to return to Russia where she hoped that happier times were in store for her. Tragically, bad news greeted her immediately, when in Riga she received a letter from Aleksandr informing her that plague had broken out, forcing him to take refuge on his estate, Andreevskoe, some ninety miles east of Moscow. Moscow had been especially hard hit by the great plague of 1769–1771, losing up to one-fifth of its population and bringing with it social unrest and rioting in September 1771. Dashkova wrote back that she would not be going to Troitskoe, since she was unwilling to expose her children to the danger of the plague.[39] She had learned from her steward about the infection of her estate, where many had died, and which was under quarantine. Having returned home to the capital, Dashkova realized that she did not have a place of her own and that she had nowhere to go. In order to cover the expenses of her journey abroad, she had authorized Nikita Panin to sell her house in St. Petersburg. She was beside herself to learn that in 1771 he had sold it to a close friend of his mistress, Madame Talyzina, for less than half its worth. In 1764, Dashkova had purchased the house with a large garden on land that currently stretches from Gorokhovaia Street, along the Fontanka, to Zagorodnyi Prospect. She paid fourteen thousand rubles, and in 1771, A. L. Shcherbachev bought it for six thousand, or less than half the original purchase price.[40] Dashkova was so incensed that in her *Memoirs*, over thirty years later, she still recalled with bitterness her financial blunder. Never again would she entrust her money matters to somebody else. She decided that she had only herself to blame for allowing Panin to take charge of her financial affairs, and she was determined more than ever to take full and undivided control of her properties.

Unwell and distressed, Dashkova turned to her sister, Elizaveta, despite the ill will that existed between them. After her marriage in 1765 to Aleksandr Polianskii, Elizaveta had settled in the Polianskii house on

the English Embankment, 28.[41] Having established herself at her sister's house, Dashkova parted company with Kamenskaia, who went to live with her own sister. Aleksandr's companion Lafermière wrote to him that Dashkova was entertaining many visitors, except for Panin, whom she apparently could not forgive the sale of her house. In addition, Kamenskaia had left her service after a nasty quarrel, which was fortunate since she was, Lafermière asserts, surly, domineering, and completely lacked tact. In England, some women supposedly had liked her, but only because she associated solely with women.[42] Regarding the break up, Dashkova wrote Aleksandr that she welcomed the opportunity to discuss with him further her former relationship with Kamenskaia. Referring to herself, but without elaborating, Dashkova expressed surprise that her lack of propriety (*bienséance*) shocked him. For those who loved her openly, she would do everything, no matter who they were; she always sought psychological and emotional fulfillment in friendship, but regrettably, she could not find it with Kamenskaia.[43]

After a while Dashkova left her sister's house and leased a small one of her own. There were encouraging signs at court and the empress acted kindly toward her, "unlike the manner in which I had been treated during the ten years that had passed since she had ascended the throne" (140). Catherine generously presented her with ten thousand rubles for her immediate expenses, but Dashkova was unhappy with what she considered a paltry sum of money. Shortly after, she received an additional sixty thousand rubles to buy or build a house.[44] Of this sum, Dashkova, in order to ingratiate herself with her father, turned over twenty-three thousand rubles to him for payment of debts, and gave some money to her daughter. Her father at this time seemed more congenial, although for almost a decade he had nothing to do with her, refused to see her, did not reply to her letters, and did not assist her in any way. In the spring, when the weather turned warm, Dashkova and her children moved to her country house on the Peterhof road, but further misfortunes followed them when her son fell ill with a high fever. John Samuel Rogerson, the eminent Scottish physician who spent fifty years of his life in Russia as court physician to Catherine II, Paul I, and Alexander I, treated her son. For over a fortnight Dashkova was at her son's bedside and when he began to recover, she took to her bed, exhausted and worn out by worry and countless sleepless nights.

Inevitably, her relationship with Catherine grew progressively more strained due to events surrounding Paul's imminent majority. Paul, as his father's sole legitimate heir and the last surviving male of the Petrine line,

possessed strong legitimate claims to the throne. He attained his majority in 1772, but Catherine took advantage of his upcoming marriage to Princess Wilhemina of Hesse-Darmstadt a year later to postpone official recognition. Paul's majority resulted in a crisis at court. To make matters worse for Catherine, she had a major dispute with Grigorii Orlov over his infidelity, and in the spring of that year, a month after Orlov's departure, several officers of the Preobrazhenskii Guards Regiment plotted to remove Catherine from the throne and proclaim Paul emperor. Catherine quelled the revolt, arrested the guardsmen, and elevated Aleksandr Vasil'chikov as the newly appointed favorite. Panin's star began to rise, and along with Panin, Dashkova's too—yet soon, she would again be out of favor.

By the first months of 1773, Panin's relations with Catherine deteriorated sharply and continued to be uncertain up to Paul's marriage in September. Grigorii Orlov was recalled and his former ranks and offices restored. Now the Orlov faction turned the tables on Panin, filling Catherine's head with rumors of plots and instilling in her the suspicion that Panin had turned Paul's young court against her. They used every opportunity to implicate Panin and his supporters in real and imagined intrigues, such as the Saldern affair. Caspar von Saldern, a German by birth and Panin's protégée, turned out to be an unsavory character. Known for bribery and extortion, he embezzled twelve thousand rubles that the Danes had sent as a gift to Dashkova.[45] He then instigated a failed plot to establish Paul as co-sovereign with his mother. Panin, however, distanced himself from von Saldern and was able to survive the crises.

When Paul was not able to take over power at his majority, Panin turned to his supporters and to Masonic groups to achieve his goals of limiting the power of the monarch. Some fifty years later, Fonvizin's nephew, the former Decemberist M. I. Fonvizin, wrote in his memoirs that his father had told him that when Paul had attained his majority and married Princess Wilhelmina of Hesse-Darmstadt, the Panin brothers, Dashkova, N. V. Repnin, and some others, entered into a conspiracy to remove Catherine and to enthrone Paul. According to Fonvizin, Paul had agreed to accept and endorse a constitution, which would have limited tsarist authority and would have established the senate as the highest legislative body. With his secretary D. I. Fonvizin, author of *Brigadier* and the yet unwritten *Minor* (*Nedorosl'*), Panin was developing a project for the introduction of a constitution in Russia. Apparently, during the summer of 1773 he, with his closest associates, composed a plan for the installation of Paul on the throne. It seems, however, that P. B. Bakunin revealed the activities of the Panin

faction. The conspirators confessed, Catherine pardoned them, confined them to their estates, and kept them under surveillance.[46] Fonvizin's account is not reliable and contains many errors and contradictions. While there is little corroborating evidence, in light of Dashkova's closeness to Panin, it seems likely that she participated in the work of his group. But Dashkova categorically denied involvement in any plots against Catherine, and as opposed to the Khitrovo and Mirovich affairs, she does not mention the present conspiracy in her *Memoirs*. Yet her political fortunes and misfortunes at court continued to reflect accurately the vicissitudes of the Panin party.[47]

It was a time of crisis and destabilization for Catherine; consequently, to steady the situation and to pacify the opposition, Catherine rewarded some and punished others. On the one hand, Aleksandr Vorontsov, whom Catherine disliked and considered a troublemaker like his sister, received the influential post that was to define his political career. He was named president of the Commerce Collegium, the main institution dealing with foreign trade, which he headed until 1794. On the other hand, Panin and Dashkova, once again suspected of conspiracy, moved to Moscow. From the autumn of 1773 to 1775, Dashkova lived in retirement on her estate, Troitskoe, often traveling to Moscow so her children could visit their grandmother. Her banishment coincided with the Pugachev revolt of 1773–1774, and she was in Moscow when Petr Panin captured the rebel leader Pugachev and brought him to Moscow in an iron cage on November 4, 1774. She met with her close friend Petr Panin, who had aged greatly during the campaign to suppress the Pugachev revolt, but did not join the curious throngs hoping to have a look at the defeated insurgent. In response to Aleksandr's letter, she wrote that she had not seen Pugachev, for despite his evil deeds, a man in chains and awaiting execution could only be an object of great pity to her.[48] Although horrified by the bloodshed of the uprising, she was opposed to violence, the taking of human life, and to Pugachev's execution.

Dashkova's expulsion from the court and life in Moscow coincided with Diderot's arrival in St. Petersburg in 1773, but the two friends could not meet. Dashkova would have rushed to the capital, had it been possible, while the sixty-year-old philosopher, fatigued by his long journey from France, was unwilling to leave his golden cage in St. Petersburg. He wrote that he was too old and too exhausted. Their correspondence at the time reflected disillusionment in Catherine, and on a number of occasions, they alluded to her disparagingly. Diderot felt that "ideas which

are transplanted from Paris to Petersburg assume, it is certain, a very different color" and recalled how in Paris Dashkova had told him that Catherine "possesses the soul of Brutus with all of the fascinations of Cleopatra."[49] His comments give greater credence to Derzhavin's remark that "Dashkova simultaneously loves and hates her [Catherine], and speaks of dark spots on her bright crown."[50] Angry and out of favor, Dashkova met Grigorii Potemkin, general-adjutant, and already one of the most powerful men in Russia. During the winter of 1774, Potemkin visited the houses of several members of the Panin family and their followers, where he met Dashkova. When the conversation turned to the Grand Duke Paul, Dashkova, although she had only recently met Potemkin, did not feel constrained to provide him with unsolicited counsel. "I gave him a certain piece of advice which he followed and thus avoided scandalous public scenes, which the Grand Duke (later Paul I) would not have failed to make in order to injure Potemkin and annoy his own mother" (141). Potemkin supported Catherine over Paul and the Panin faction at court and emerged as Catherine's favorite, remaining her chief confident until his death in 1791. Despite her initial support, Dashkova's relationship with Potemkin would be strained and eventually openly antagonistic.

The years spent at Troitskoe, following her first journey to Europe, were not wasted and Dashkova was never idle. Returning to her books and the education of her children, she read about pedagogical issues and organized a course of study for her children with a curriculum and schedule based on the ideas of the Enlightenment. She was involved in the organization of a learned society at Moscow University, the Free Russian Society (*Vol'noe rossiiskoe sobranie*), and was an active member during its twelve-year existence (1771-1783). Established at Moscow University in 1771 for the advancement and enrichment of the Russian language through the publication of prose and verse translations, its members included prominent professors at the University, men of letters, and public figures. I. I. Melissino, curator of Moscow University, headed and promoted the Society, and with its publications, activities, and list of participants it was a direct precursor to the Russian Academy. The Society put out six issues of its periodical, *Studies of the Free Russian Society at the Imperial University of Moscow* (*Opyt trudov Vol'nogo Rossiiskogo sobraniia pri Imp. Moskovskom universitete*), which for the most part published Russian literary and historical texts, as well as the translations and contributions of M. M. Kheraskov, D. I. Fonvizin, Ia. B. Kniazhnin, and G. R. Derzhavin, among others. Dashkova's articles, often appear-

ing in epistolary form, reveal her complete sympathy and support for the progressive ideas of the time.

In its first issue, she contributed a letter and three translations. The "Letter to a Friend" ("*Pis'mo k drugu*") served as a statement of purpose and introduction to her theory of translation.⁵¹ She argued that in order for a translation to be of benefit to society, it must favor clarity over eloquence. The model she proposed was the prose and verse compositions of Lomonosov, who wrote beautifully and powerfully both in his serious and light works. She also discussed the problems of translating into Russian, a language that often lacked an appropriate terminology, so that "even a woman should be forgiven" for inaccuracies. Dashkova's "Travel of a Certain Distinguished Russian Lady through Some English Provinces" appeared in the second issue of the journal along with yet another introductory "Letter to a Friend."⁵² She wrote that she was attracted to England far more than any other country she had visited, for it represented the embodiment of political freedom and a model of a well-organized and enlightened state. England's well-being was a direct result of its government, and Dashkova felt that the English constitutional monarchy was the most complete and perfect system she had encountered.⁵³

Her translations and writings at the time were a result of her travel abroad and represented a keen interest in the relationship of the state and citizen. In a letter to Aleksandr Kurakin, Dashkova wrote that she was reading and rereading *Le système social* with great enthusiasm. In view of her concentration on questions concerning rightful authority and the will of the people, she is possibly referring to the Rousseau treatise *Le contract social*. Subsequently, she sent Kurakin her translation of the French materialist, Paul Henri Dietrich Holbach, the same translation she had earlier shared with Petr Panin.⁵⁴ She selected two chapters from *La politique naturelle, ou Discours sur les vrais principes du gouvernement* (1773): "Society Must Assure the Well-Being of its Members" ("*Obshchestvo dolzhno delat' blagopoluchie svoikh chlenov*") and "On Social Conditions" ("*O soobshchestvennom uslovii*"). She also translated David Hume's "Of Commerce" ("*Opyt o torge*").⁵⁵ Dashkova believed that a society and its citizens bear mutual responsibility toward each other and in these translations presented the Russian reader with major themes of the Enlightenment. Greatly influenced by the writings of Hobbes and especially Locke, they included principles of "social contract" and "rational egotism," and ideas for the reformation of society and government. The translations focused on the accountability of all before society, with those in power primarily responsible for the economic well-being of society and to this purpose organizing and administering appropriate

economic structures.⁵⁶ Since the well-being of the individual constituted the well-being of the whole, every member of society must strive to oversee an efficient and effective domestic economy.⁵⁷ Hume stressed the need to stimulate industriousness and productivity in the population, which would be impossible in Russia's system of serfdom. Dashkova understood this and could only hope that one day the sources of economic prosperity, wealth, and dynamism of England would become a reality of Russia. In the meantime, she could only dream of returning to England so that her son could study with Hume.

Chapter Six

Second Journey Abroad

BECAUSE OF HER EXCLUSION from the court, Dashkova could not congratulate the empress personally on the Russian victories over Turkey. Instead, she sent her a work by Angelica Kauffmann, the Swiss-born painter Dashkova admired, who was known for her portraits and historical scenes and who was the only female member of the Royal Academy. The painting, entitled the *Embroideress* (1773), is now located at the Pushkin Museum in Moscow and is almost identical to *Grecian Lady at Work* at the Royal Academy. Dashkova's choice of artist and subject matter was significant, since it represented her interest in women artists generally. Specifically, it was one woman's gift to another of a painting by a woman artist, depicting another woman embroidering. Further, it alluded to the liberation of the Greeks from the Turkish yoke and possibly to Penelope the weaver (Catherine), surrounded by false suitors (Catherine's courtiers). Dashkova did not know that her wanderings would be long lasting like Odysseus's, and that Angelica Kauffmann's painting would not lead to a rapprochement with the empress.

In April 1774, she also sent a letter congratulating Catherine on her forty-fifth birthday and received a cordial, if formal reply. Dashkova did not take part in the festivities celebrating the signing of the Treaty of Kuchuk Kainardzhi (1774), which marked a period of peace that would last in Russia until 1787. Nor was she present at the hero's welcome accorded Field-Marshal Rumiantsev in 1775 in Moscow, whom Catherine honored with the title *Zadunaiskii* for his victories beyond the Danube. Rather, she tended to her dying mother-in-law, and after the funeral, feeling alone and disregarded, Dashkova was again determined to go abroad to further her son's "classical and university education" (143). In contrast, Anastasia remained in her brother's shadow due to her physical problems. She was

small, thin, and hunchbacked, and Dashkova thought that in a society where physical beauty played a decisive role, her daughter would have little hope of being successful.[1] Evidently, she had by then little interest in her daughter's education, for rickets had profoundly affected Anastasia's development. Dashkova provided her daughter with the traditional education given to women of the time, but no more, preparing her for marriage and motherhood. At one time, she was contemplating the possible marriage of twelve-year-old Anastasia to Aleksandr Kurakin, who was ten years her senior. In a letter to him, she expressed her concerns about Anastasia's upcoming entrance into St. Petersburg society: "Our people are so unforgiving, so quick to judge on the basis of appearances and demeanor that my head spins when I think of my arrival to your city."[2] Petr Bartenev felt that there was little hope for Dashkova's hunchbacked daughter to make a match with Aleksandr Kurakin.[3]

Since her daughter could not be a luminary in society, Dashkova, a woman whose commitment to her own education had been the defining feature of her youth, disregarded her daughter and concentrated all her efforts on the preparation of her son for a brilliant career. Tragically, her son was far less gifted than Anastasia, who would never forgive Dashkova's neglect and would forever harbor resentment and ill will toward her mother. Moreover, after going against established conventions in her youth and arranging her own marriage, Dashkova now negotiated the betrothal of her fifteen-year-old daughter to the much older Brigadier Andrei Shcherbinin. In the *Memoirs*, she explained the choice of the husband: "Thanks to a certain physical defect, she [the daughter] was not fully developed and I could not expect a younger and more dashing husband to remain loving and submissive."[4] About Andrei Shcherbinin she could only write that "the bad treatment he had received at the hands of his parents had left him with a melancholy, though gentle, disposition" (143).[5] The marriage was not a happy union; it was ill conceived and doomed to fail. The daughter received a dowry of some eighty thousand rubles, but the couple lived extravagantly, incurred enormous debts, quarreled often, and mostly preferred to live apart.

In 1775, Dashkova received Catherine's permission to travel "without delay," which was granted "with unbelievable coldness" at a general audience open to all, and left Dashkova hoping "that the time would come when things would change and greater fairness would be shown me" (143). Accompanied by a suite of people, which now included the newly married Anastasia and her husband, Dashkova, traveling on this occasion as herself and eschewing her former incognito, set out on the road to Pskov

to visit some property belonging to the Shcherbinin family. The journey began badly: One of the servants fell to the road and was injured when two carriages ran over him. Fortunately, they were light and on runners. While everybody else stood there gawking helplessly, including her hapless son-in-law, Dashkova took full charge. According to the medical wisdom of the age, it was essential to bleed the accident victim as soon as possible, but there was nobody qualified to perform the operation. Remembering the lancet in her son's English briefcase, Dashkova undertook the required procedure herself. Afterward, Dashkova continued on her way confident that she had saved the poor man's life, although the event traumatized her and she felt ill with violent palpitations.

She found the Shcherbinin parents to be extremely dull and did not get along with her daughter's father-in-law.[6] Therefore, she cut her visit short and continued her trip to Grodno, which proved to be hazardous and difficult since the roads were poorly maintained and overgrown. They advanced slowly with a company of Cossacks clearing and widening their way through the thick forest. To compound their problems, Pavel came down with measles in a place where proper medical assistance was not available, and the party of travelers found themselves stranded in Grodno for five weeks. Then, Anastasia also caught the measles from her brother. Finally, with her children fully recovered, Dashkova traveled on to Warsaw by way of Vilna. There she often met with Stanislas-Augustus Poniatowski, the last king of Poland and Catherine's second lover. Dashkova admired him for his kindness, intellect, and interest in the arts, but she felt that he was ill suited to be king. Vastly unpopular in Poland, he was above all too weak to rule a turbulent nation and to pursue independent policies best suited for his country. In a letter from Warsaw, dated October 9, 1776, Poniatowski thanked Dashkova for the Angelica Kauffmann prints he had received and wondered if Hume's death in 1776 would alter Dashkova's plans to educate her son at Edinburgh.[7]

In Berlin she was again received warmly but hurried on to Spa to fulfill the promise she had made years earlier to rent the newly built house on the Promenade de Sept Heures. As she waited for the arrival of Catherine Hamilton, the tensions and ill feelings she had felt for Andrei Shcherbinin became intolerable. Dispute followed dispute, and at last he left Spa while his young wife, still emotionally tied to her domineering mother, refused to follow him. In a letter to Dashkova, written after his acrimonious departure from Europe, Andrei Shcherbinin bemoaned the ill will she directed at him, and in particular her aggravation with his pensiveness and melancholy, which he claimed was a result of hypochondria. He begged

Dashkova to release his wife to him.⁸ Anastasia eventually reunited with her husband, after he received his father's inheritance, but soon after they separated for good.

At the end of the season in Spa, Dashkova crossed the English Channel without incident and spent a few days in London, which in October 1776 was abuzz with discussions and debates concerning the American War of Independence. It was a topic of great interest to her, and her library contained many books on the nature and consequences of sociopolitical upheaval and change: Abbé de Vertot's *Histoire des révolutions arrivées dans le gouvernement de la République romaine, Histoire des révolution de Portugal,* and *History of Revolution in Sweden.* Translated in 1729, the latter work depicts the heroic actions of Gustavus Vasa and his fight for liberty in the face of oppressive tyranny. It was then especially popular and widely read in England. After the Terror in France, Daskova's enthusiasm for revolutionary change waned significantly, and in the *Memoirs,* she passed over the American Revolution entirely. The large number of volumes she owned dealing with colonial unrest in the New World, however, attests to her early interest in the subject: for instance, *Histoire des troubles de l'Amérique Anglaise, Abregé des révolutions de l' Amérique Anglaise,* and *Political Pieces by Franklin.*

In London, the Russian artist Gavriil Skorodumov, who was then studying at the Royal Academy, did an engraving of her and her children, a work that remained unfinished. Soon, in November, she continued on to Scotland, and on the way, at Easton Maudit in Northamptonshire, visited Henry, the 3rd Earl of Sussex. There she met Edward Wilmot, father of Martha and Catherine, the young women who were to live with Dashkova at Troitskoe and who would encourage her to write her autobiography. Dashkova arrived in Edinburgh on December 8, during the unusually severe winter of 1776, and settled in the fashionable area of George Street, New Town.⁹ According to her *Memoirs,* she also lived for a time in one of the apartments of the Palace of Holyroodhouse, next to the study of the unfortunate Mary Stuart, Queen of Scots. There she could indulge in romantic role-playing as she acted out in her mind the part of a victimized woman whose involvement in political affairs had led to exile and execution. But her entry into Edinburgh society was hardly the stuff of historical romances and disappointed many eyewitnesses. The Dowager Countess of Fife wrote her son that she had seen Dashkova at the theater. "She was at the play yesterday, the ladies were dissatisfied with her appearance, as they expected to see one uncommonly fine, but she despises dress."¹⁰

The education of her son remained Dashkova's primary concern and the major theme of her second trip to England. As early as her first journey

abroad she had considered where to enroll her son and had decided on Edinburgh University as the most appropriate location for Pavel to pursue classical studies. Edinburgh University was a great hub of learning and scholarship in the eighteenth century. Thomas Jefferson wrote that with respect to learning, there was no other place on Earth like Edinburgh University, and Benjamin Franklin, who visited in 1776, found it to be a center of scholarship where the best of the best had gathered.[11] For Dashkova there were additional incentives to enroll her son there. The university was far from the temptations of larger capital cities in Europe, from which Dashkova wanted to shield her young son, and she felt that an English (or Scottish) education best suited his temperament and personality. Firmly believing that children should be educated outside their familiar environment and thereby exposed to different people and places, she, nevertheless, valued parental guidance denied her in childhood. Therefore, she would accompany her son — and she preferred to live in Scotland.

En route to Edinburgh, Dashkova wrote three letters to William Robertson, the Scottish historian.[12] He was principal of Edinburgh University, the first biographer of Mary Stuart, and author of numerous historical studies including *History of the Reign of Emperor Charles V* (1769), which Voltaire, among others, praised highly. The academic success of the university, the "Athens of the North," was in great measure a consequence of William Robertson's administration. She had hoped that her son would study with Hume, but with his death a few months prior to her arrival in England, she made every effort to persuade Robertson to serve as Pavel's academic adviser. In her letters, she explained her reasons for selecting Edinburgh University and outlined an intensive course of studies for her thirteen-year-old son. She wrote Robertson that she was preparing him for military service, and as was customary then in Russia, at the age of eight Pavel had gained a commission in the military at the rank of cornet. Robertson was skeptical, citing Pavel's youth, but the proud and insistent mother assured him that her son was mature, fully prepared academically, and with adequate proficiency in English. According to Dashkova, her son was not too young for admission to the university. Moreover, he had grown to be a tall and strong young man. He knew languages: French fluently, with a reading knowledge of German and Latin, while in English he understood "all the prose writers and the poets tolerably." She did not mention Russian at all. Dashkova went on to assert that she had acquainted him with the great works of world literature and that he was "over severe in his criticisms, which may be considered somewhat of a characteristic failing." Mathematics had been an important area of emphasis in his preparation,

but he required additional work in algebra. Most of all, Dashkova hoped that he would acquire greater competence in civil and military architecture and apply himself fully to the study of history and the constitutions of government, which "he must go over again, and occupy himself much with them at home with his tutor."[13]

In her next letter, Dashkova provided Robertson with a detailed description of her son's preparation and outlined a two-year or five-semester course of study she wanted him to pursue at the university, followed by two years of travel. It was a broadly based liberal arts curriculum with additional courses in military science and fortifications. There were seven points of concentration:

1. Logic and the philosophy of reasoning
2. Experimental physics
3. A notion of chemistry
4. Philosophy and natural history
5. Natural rights, public and universal rights, and the rights of individuals; and these as they were applicable to the laws and usages of the people of Europe
6. Ethics
7. Politics.[14]

The proposed program was overly ambitious, and in view of his subsequent disappointing behavior, Dashkova's son quite possibly burned out trying to please his mother.[15] D. I. Ilovaiski stated outright that Dashkova overeducated her children into complete intellectual exhaustion.[16]

In Edinburgh, Dashkova was introduced to a community of university professors she deeply admired and considered to be "a group of educated and intelligent people, whom it was always an immense pleasure to see and whose conversation never failed to be instructive" (147). Often, she invited distinguished scholars, some of the leading intellectuals of the age, to her house. In addition to Robertson, her guests included Hugh Blair, professor of rhetoric and author of *Lectures on Rhetoric* (1783); Adam Ferguson, professor of pneumatics, natural and moral philosophy, and mathematics, and author of *Institutes of Moral Philosophy* (1772); and the economist Adam Smith. She sent his influential *Inquiry into the Nature and Causes of the Wealth of Nations* (1776) to her brother Aleksandr, president of the Commerce Collegium. Possibly, she also met Boswell, who mentioned in his diary for Thursday, August 21, 1777, that he "dined at Lord MacDonald's with the Princess."[17] Dashkova never felt more satisfied intellectually and

emotionally than she had at Edinburgh University in the academic world of learning, scholarship, and enlightenment, which contrasted sharply to the petty squabbles and power politics of court life. She traveled, read, wrote, and composed music. "This period of my existence" she claimed, "was both the happiest and most peaceful that has ever fallen to my lot in this world" (147). When she was in Edinburgh two Russian students, I. S. Sheshkovskii and E. Zverev boarded at her house. Sheshkovskii's father was head of Catherine's Secret Chancellery, but Dashkova thought the son was an idler and a brainless youth, and he was eventually thrown into debtor's prison.

During the summer, following her son's first academic year, Dashkova undertook a two-week tour of the Scottish Highlands, a journey Samuel Johnson had made a few years earlier.[18] Her "*Le petit tour dans les Highland,*" is a unique travelogue in diary form describing the journey embarked on from August 25 to September 7, 1777, which eventually took her to an area "not known to have been visited by any other Russian visitors in the eighteenth, or, as far as I know, nineteenth centuries."[19] Dashkova was the rare traveler indeed exploring areas that were not traditionally part of the Grand Tour, for in England the itinerary usually meant only London and Bath. Early on the morning of August 25, 1777, the party set out in two coaches. Along the way, she described the landscape and the ruins of ancient castles as romantic and "sublime" and presented herself as a woman of feeling who "had reason to believe that my head was not worthy of my heart" ("*J'ai eu plusieurs fois raison de croire que ma tête ne valoit* [*sic*] *pas mon Coeur*").[20] Nonetheless, many of her observations were succinct, matter-of-fact, and concerned with the everyday details of her journey. At a local inn in Linlithgow, where they stopped to have eggs and cream for breakfast, Dashkova commented that the English would have thought the place wretched, the French passable, and the Scots clean and comfortable. Initially, they inspected industrial locations such as the Clyde-Forth Canal, where the horses baulked at the drawbridge and would go no further. The brutality of the cruel postillions, who lashed the horses mercilessly, shocked Dashkova, and only the lead of a passing carriage finally induced the gentle animals (*la delicatesse de ces deux animaux*) to cross the bridge. At Carron they inspected the famous ironworks, ovens, chimneys, and instillations for smelting and welding. They then dined in Inch and made an excursion to Stirling Castle before resuming their expedition.

In Perth they took rooms at an inn overlooking the Tay, and in the morning went on to Inver where they crossed by boat to Dunkeld. The Duke of Atholl's gardens did not please Dashkova as she recalled "the Al-

exander Pope's" verse: "To swell the Terrace, or to sink the grot,/ In all let Nature never be forgot."[21] At Taymouth Castle, she found Lord Breadalbane to be charming, the castle beautiful, and the scenery magnificent. She inspected her host's art collection, toured the castle, and stayed there four days. Traveling the old military road to Tyndrum the travelers spent the night in a damp and unpleasant inn. From there they went on to Inverary by way of Dalmally and Loch Awe. In Inverary Dashkova complained that she was obliged to spend the night at an inn where a group of rowdy and noisy men from Fifeshire kept her up all night. Tired after their sleepless night, the travelers proceeded through the dreary pass of Glencrow and admired Loch Lomand. In Dumbarton, where Mary Queen of Scots was a prisoner in the castle, her son received the honor of Freeman of the town. At Buchanan Castle, they inspected letters from Charles I and Charles II and after spending another night in Inch, returned to Edinburgh on Sunday, March 7.

In her travelogue, Dashkova paid close attention to the places of commerce and manufacturing of goods. She visited a sugar and rug-making mill, inspected military fortifications, and evaluated the architecture and functionality of public buildings. Along the way, she noted the estates of the wealthy, where the tastelessness of many of the great houses contrasted sharply with the poverty and harsh living conditions of the peasants. While often critical of living conditions in the Highlands, the beauty of the mountains and the lochs, especially Loch Lomand, filled her heart with feelings of the sublime, and her account contains many passages with elements of preromantic descriptions. Feeling all the while, in the expression of the time, to be a woman of sensibility, she studied romantic landscapes and elaborate gardens while alluding to Laurence Sterne and to the sentimental brush of Angelica Kauffman. Having read John Locke, Jean-Jacques Rousseau, and other writers and philosophers who established the cult of sensibility in Europe, she often utilized the vocabulary of sensibility, even excessive sensibility then much in vogue, especially in the evocation of her heightened emotional response to the magnificent landscapes of the Scottish Highlands. Nevertheless, Dashkova was not a sentimentalist and in her writings cut "a channel between the classical and the sentimental streams of contemporary Russian literature."[22]

Shortly after her return, Dashkova fell seriously ill, and the following summer, after suffering a severe attack of rheumatism, Dr. William Cullen, Scottish physician and professor of medicine at Glasgow University, ordered her to try the waters at the Buxton, Matlock, and Derbyshire spas and to bathe in the sea at Scarborough. During her recovery, she received

tireless care and attention from her friends Catherine Hamilton and Lady Mulgrave, who found Dashkova to be an extraordinary character "very well informed & of a strong Masculine spirit which I should guess was the case from her Appearance."[23] All her life, Dashkova had a great fondness for dogs, especially the King Charles miniature spaniel, a breed much in fashion then among the royalty of Europe. Her lapdog Favori was a source of great comfort to her and she recalled with pleasure how Favori had been terribly distraught by her illness. The little animal hid under the bed, refused to come out, and bared its teeth at anyone who came near. Only after its mistress's health had taken a sharp turn for the better did Favori emerge from its hiding place, gentle and loving once again.

Back in Edinburgh, Dashkova continued to supervise closely the education of her son, who took classes from Hugh Blair, Dugal'd (Donald) Stuart, Adam Ferguson, and Joseph Black, and to oversee private lessons in riding and fencing for Pavel's health. She organized dances for his amusement and many of these activities and entertainments proved to be expensive, forcing her to draw upon her credit and borrow two thousand pounds from her bankers William Forbes and James Hunter-Blair of the Scottish bank Forbes, Hunter, & Co. Despite the costs and her inherent frugality, according to Dashkova, she was nevertheless willing to do everything necessary for her son: "my life was dedicated to the love I bore my children" and "I was trying to give my son the best possible education" (148–149). The proud and adoring mother looked on as her son sat for public examination, "and so amazingly successful were his answers to the questions on all subjects that the audience could not refrain from clapping (even though this is forbidden)" (149). To Dashkova's great joy and personal satisfaction, upon completion of his dissertation and all of the requirements for the degree, on April 6, 1779, Pavel became the first Russian to earn a Master of Arts from Edinburgh University. On May 7, 1779, the Lord Provost of Edinburgh named Pavel an honorary citizen of the city, and in 1781 at the young age of seventeen, he gained membership into the prestigious London Royal Society. Pavel was a serious, polite, and studious young man, but hardly an independent and strong individual, since he was always under the watchful eye of his authoritarian mother. For example, Dashkova would be required to act on her son's behalf and to clear up a misunderstanding as to whether he was in fact a member of the Society. The confusion was caused by the death of Dr. Daniel Charles Solander, who was secretary to Sir Joseph Banks, explorer, naturalist, and president of the Society.

In a letter dated August 5, 1780, Professor Hugh Blair assured the doting

mother that based on his performance at Edinburgh University, her son would in the future measure up to all her expectations.[24] Dashkova for her part presented the university with a selection of Lomonosov's works and a valuable collection of Russian commemorative medals struck to celebrate the births of Russian emperors from Peter I to Catherine's grandson, the future Alexander I. At the end of her stay in Edinburgh and in preparation for the journey, she wrote an instruction to her son on educational travel.[25] Its tone and style recalls Lord Chesterfield's letters to his son (1746), in which he wrote, that knowledge of the world is only to be acquired in the world, and not in a closet. Dashkova too approached travel as an important educational activity and organized it according to some of the same principles found in the composition of her son's curriculum. These she outlined in a long letter in which she urged Pavel not to travel for the sake of pleasure alone. Rather, in order to be a responsible and productive citizen, he must educate himself and thereby become useful to his native country. His journey would offer him the opportunity to learn much about other people and other lands. Indeed, nothing was as illuminating as the diversity of various countries and people, and one should never lose an appropriate opportunity to acquire knowledge. Pavel must remain alert and keep his eyes and ears open concerning

> the nature and form of government; the laws, customs, influence, population, and commerce; the physical circumstances of countries relating to soil and climate; their foreign and domestic policy; the production, religion, manners, resources, real and fictitious, with regard to public credit, income, and taxes; and the variable conditions of different classes in society.[26]

Travel would then enable him to gain a realistic perspective that would set in relief areas requiring change in his native country. Continuous comparison with one's own homeland should lead to the adaptation of everything that might be of use to both the individual and to society, along with the rejection of all that is negative. Therefore, she stressed the need for constant attention and observance during the two years of travel. She concluded her instruction by urging her son to be open-minded, respectful, and tolerant when confronted by the diverse customs and religions of foreign cultures.

> With regard to the religious opinions of those with whom you converse, it is fit they should be held sacred and respected, whatever they be. An

attempt at refutation on these subjects, serious or ironical, leaves behind it a sensation bitter and offensive to that good opinion which every individual entertains of himself, never perhaps to be entirely forgotten.[27]

Having accomplished her goals and successfully fulfilled her duties as tutor to her son, she was ready to depart her beloved Edinburgh. In June, she left for Ireland largely at Catherine Hamilton's suggestion and crossed by packet from Portpatrick to Donaghadee. There she met Elizabeth Morgan, with whom she went on to Coleraine and made an expedition to view the mass of basalt columns at the Giant's Causeway in County Antrim. Dashkova likened her stay in Ireland to a happy dream, as Dublin society proved to be "distinguished by its elegance, its wit, and its manners, and enlivened by that frankness which comes naturally to the Irish" (149). She enjoyed the company of her two close friends, Elizabeth Morgan and Catherine Hamilton, and spent much of her time in the company of Arabella Denny, patron of the arts, philanthropist, and founder of the Magdalen Asylum for Fallen Women and the Foundling Hospital for Children in Dublin. Arabella Denny was the first woman to become a member of the Royal Irish Academy, an institution that would also grant Dashkova honorary membership. A close friendship developed between Dashkova and the much older Lady Arabella, who was then past seventy, as Dashkova held in high esteem her intelligence, energy, and charitable works. Dashkova would often visit her for tea at her house, Peafield Cliff at Blackrock, and spent Christmas 1779 there. In front of the hall door, she planted several ilex trees, two of which have survived to this day and are visible over the wall of the garden.[28] Regrettably, Dashkova's reflections on the state of Ireland during her journey in 1779–80, which Arabella Denny mentioned in a letter to her, were lost.[29]

On one occasion, Lady Arabella persuaded her Russian friend to compose music to a favorite hymn for four voices and an organ, and had it performed to great acclaim at a benefit concert for the Magdalen Hospital. Dashkova was self-effacing, but delighted by its reception. After rehearsing the piece several times,

> She [Arabella Denny] had it sung in church in the presence of a numerous congregation drawn by curiosity to hear what a Russian bear could have composed. The collection was very considerable. Lady Arabella, when I saw her that evening, was charmingly gay, gave me a full account of the morning service, and ascribed the profit made by her Magdalen

establishment to my music. Then she gave me her blessing as affectionately as a mother (150).

Dashkova was the author of a number of musical compositions, including arias, songs, spiritual hymns, and the arrangement of folk songs. The previous year she had sent one of her works to David Garrick, the actor, hoping he might find a place for it on the English stage. His response was courteous, encouraging, but noncommittal: "Yesterday, a most accomplished musician and an excellent composer did all the justice in his power to her highness's composition. The small audience was in raptures; the taste, harmony, and pathetic simplicity of the airs were felt from the heart."[30]

While in Dublin, Dashkova went to the old Irish House of Commons at College Green and was much impressed by the brilliant oratory of Henry Grattan, who labored tirelessly for Irish independence and strongly opposed union with England. At other times, she organized soirées, attended concerts, read books with her friends, or made excursions to see the castle in Kilkenny, the beautiful lake in Killarney, the harbor of Cork, and the magnificent countryside surrounding Limerick. In Cork, she visited the Wilmots and their relations. Dashkova continued organizing entertainments for her children, while never abandoning the ongoing and obsessive education of her son. His preparation for a brilliant career always remained foremost in her mind, and she found him a dance master from Paris. Pavel would become an excellent and enthusiastic dancer, and would take every opportunity to indulge his passion for dance, even later in life when he had grown much older and quite a bit heavier. Dashkova engaged a tutor in Italian, and another, Professor Greenfield, to review the subjects he had studied at the university and to read Greek and Latin classics with him. Arabella Denny wrote Dashkova that as a mother her great love for her children would in the future bring her great happiness.[31] All the while, however, Anastasia remained an afterthought, and in the *Memoirs*, Dashkova hardly mentions her daughter.

After a stay of close to a year, sadly and reluctantly Dashkova sailed from Ireland in May 1780, landed in Holyhead, and from there drove to London. Along the way, as she traveled through the West Midlands, she visited the Soho factory in Handsworth, where the operation of a copying machine piqued her interest and furthered her growing respect for modern science and technology. But no less impressive were the "many most romantic places in Wales," which contrasted sharply to the din, dirt, so-

cial whirlwind and political unrest of London, to which she soon returned (150). This time around, she arranged an audience with King George III and the royal family. George III, an enthusiastic talker despite his stutter, was dedicated to his wife and fifteen children, while Queen Charlotte was mostly apolitical, stayed out of public affairs, and led a retired life at home. Dashkova proudly told them about her son's education in Edinburgh, and the Queen commended her on being such a devoted mother. Before her departure, Dashkova once more met the royal family and the children, "who were really quite angelic" (151).

During her stay in London, Dashkova was acquainted with Joshua Reynolds and James Gandon, the architect of Dublin, and in 1780 Pavel worked and studied with the English engraver and watercolor painter Paul Sandby.[32] She spent the remaining time sightseeing, traveling to Bath and Bristol, and visiting Walpole's Strawberry Hills. In Buckinghamshire, she met the celebrated parliamentarian Edmund Burke. Dashkova, in her *Memoirs,* failed to mention that she was in London during the anti-Catholic disturbances of the first week of June known as the Gordon Riots, when rioting mobs threatened to take over the entire city. In fact, she was under suspicion because of the involvement and arrest on June 2, 1780, of her half-brother, Ivan Rontsov. No less a public figure than Horace Walpole suspected Dashkova of complicity and referred to her as Thalestris, Queen of the Amazons.[33]

When Dashkova sailed from Margrate in August, she could only suspect that she would never return to England, the country she praised above others and whose institutions and form of government she believed Russia should emulate. In later life, she would write on several occasions about returning to England, but never realized her desire. From Ostend, she proceeded to Brussels, Antwerp, Rotterdam, Delft, The Hague, Leyden, Haarlem, and Utrecht. The cleanliness and tidiness of these northern cities astounded her, since they contrasted sharply to the dirt and disorder of London and Paris, to say nothing of the contained chaos of Moscow and St. Petersburg. In Leyden she visited the university that William of Orange founded in the sixteenth century and she studied ancient manuscripts. At the Huis ten Bosc Palace in The Hague, the Prince of Orange, William V, Stadholder of Holland, and his wife Princess Wilhelmina of Prussia received her. Twenty years earlier, her brother Aleksandr had arrived there as the Russian ambassador, but now it was her turn to assemble with the heads of state, if only as a celebrity rather than in any official capacity. Characteristically, in her *Memoirs* she portrayed the people she met in far more detail than the places she visited. Thus, she described at length her

meetings with the Prince and Princess of Orange, proudly recalling that at dinner the "Prince of Orange was also present, and though ordinarily he fell asleep at table however early the hour, that time I was sitting by his side and did not even see him doze" (153).

Even more detailed is her description of the meeting in Leyden with Grigorii Orlov and his young wife Catherine, who was seeking medical treatment for consumption, from which she would die at the age of twenty-three. When the two enemies and political combatants sat down to dinner, they were uncomfortably tense and cautious, perhaps recalling the private dinner they shared years ago with the empress who now had cast off both of them. Dashkova wrote that "the expression of my face, which to my own great detriment always revealed my feelings, gave him to understand that his visit was neither expected nor particularly relished" (153–54). Orlov assured Dashkova that he was there as a friend and did not wish to continue their hostilities. As a gesture of his peaceful intentions and of a possible detente, Orlov remarked that Pavel was a fine-looking young man and volunteered to secure his promotion in the regiment of the Horse Guards he commanded. Dashkova declined the Orlov gambit, fully aware that he and Potemkin, who was minister of war, were at odds. She informed him that she had already written Potemkin on her son's behalf, requesting the appointment of her son as his aide-de-camp.[34] Orlov did not take lightly Dashkova's unequivocal refusal of his overtures to gain her support in opposition to Catherine's new favorite, Potemkin. He renewed his attack at their next meeting in Brussels when they found themselves in the company of, among others, Ivan Melissino, director (then curator) of Moscow University and member of the Academy of Sciences, his wife Proskov'ia Dolgorukova, and Anna Protasova, maid of honor to the empress. Orlov knew that his comments would get back to the empress and therefore, looking directly at Dashkova's son, remarked that Pavel could easily supplant any of Catherine's lovers. Orlov's words acutely embarrassed Dashkova, and she immediately sent her son away on an errand. Barely able to contain her anger, she berated Orlov for publicly discussing Catherine's favorites and thereby sullying Her Majesty's name in front of Pavel, who was her godson. Never would her son be anyone's favorite and, seemingly, never could Dashkova and Orlov become allies.[35] After Orlov's departure, Dashkova, with a great sense of pleasure and relief, resumed her daily activities. Beginning every morning at nine o'clock, she would set off botanizing in the hills surrounding Brussels and compiled a herbarium of plants unknown to her in Russia.

When the money she was expecting finally arrived, Dashkova left Brus-

sels, and stopping in Lille for only two days, drove directly to Paris where she stayed at the Hôtel de la Chine.[36] There, she fell in with a group of Russians and met again with Ivan Melissino "with his well-stocked mind, his pleasant, even temper, and his charming manners" (155). Other acquaintances included Ivan Saltykov and his wife Daria Chernysheva, Aleksandr Samoilov (Potemkin's nephew), and Andrei Shuvalov and his wife Ekaterina Saltykova. Andrei was the cousin of Dashkova's childhood mentor Ivan Shuvalov. A public figure and minor writer, he was involved in the translation and publication of the French encyclopedists in Russia and corresponded with Voltaire, La Harpe, Marmontel, and many others. In 1771, Voltaire wrote incorrectly that Dashkova had participated in the writing of *Antidote, ou Examen du mauvais livre superbement imprimé intitulé Voyage en Sibérie* (1770). In fact, Andrei Shuvalov assisted Catherine in composing that response to the Chappe d'Auteroche's *Voyage en Sibérie* (1768). While conscious of Shuvalov's intelligence and knowledge of French culture, especially poetry, Dashkova felt that, "he lacked the solidity of mind essential for a sound and steady judgment"(156). Shuvalov did not become a member of the Russian Academy, although his literary activities seemed to entitle him for consideration far beyond some of the other academicians. Finally, according to Dashkova's less than objective opinion, "he lost his reason and died insane unlamented by anyone — even by his own family" (156). In Paris in 1781, Aleksandr Samoilov and Ivan Melissino related to Dashkova that Orlov and Shuvalov were spreading rumors that she was preparing her son to become the next in the long line of Catherine's favorites. In so doing, upon his return to Russia, Shuvalov turned Aleksandr Lanskoi, Catherine's lover, against Dashkova and her son. Catherine, for her part, was well disposed at this time to Pavel. On July 13, 1781, she wrote the Baron Grimm that she was "never indifferent to this boy, because it seemed to me that he possessed a superb heart."[37]

Dashkova also renewed old friendships from her previous visit to Paris and was overjoyed to see Diderot, who "threw his arms round [her]" (156). She was not traveling incognito, so Suzanne Necker and a few other friends could extend their welcome to her without delay. Among them was Chrétien Guillaume de Lamoignon de Malesherbes, the French statesman and writer on political and legal subjects, who was largely instrumental in securing the publication of the *Encyclopédie*. By the time Dashkova came to write her *Memoirs,* she knew that Malesherbes, who had defended Louis XVI at his trial, had not escaped arrest and was guillotined along with his family. When asked at the Convention what made him so courageous, he replied that he had contempt for his accusers and contempt for death.

During her short stay in Paris of less than a year, Dashkova felt caught up in the city's tumultuous and hectic world, dividing her time between the smart set of Parisian high society and its intellectual and artistic community. She sat for Jean-Antoine Houdon, the sculptor whose many works included the statues and busts of *Voltaire, Catherine II,* and *George Washington.* Dashkova was displeased with the large bust in bronze he produced: it looked unnatural, idealized, and too much like a French duchess "wearing a dress with a low-cut neck, instead of the simple, unaffected woman I really was" (158). Generally, mornings she visited the homes and studios of influential political leaders, thinkers, writers, and artists. Evenings, she attended concerts, plays, literary salons, or she entertained visitors at home. Most often, she was in the company of her friend Diderot, who was in poor health, and she also met the young Talleyrand and Guillaume-Thomas-François Raynal, the French historian and philosopher who had collaborated on the *Histoire philosophique et politique des établissements et du commerce des Européens dans les deux Indes* (1770). At the time of Dashkova's visit, the French parliament was investigating him for his alleged attacks on the clergy and on colonialism. The Abbé Raynal, as he is better known, introduced Dashkova to the closed and privileged world of the French Academy, and on March 24, 1781, he organized a reception in Dashkova's honor, to which he invited leading French academicians. At such functions, during conversations over drinks and dinner, Dashkova garnered many of the ideas she would implement during her directorship of the Academy of Sciences, and possibly, this is where her first thoughts concerning the creation of a Russian Academy took concrete form.

While lunching at the house of the Abbé Raynal, Madame de Sabran informed Dashkova that Marie Antoinette had expressed a desire to meet her at Versailles in the apartments of Yolande-Martine-Gabrielle de Polignac, the queen's favorite, and governess to the royal children. Dashkova had heard from a number of persons that she would do well to present herself at the French court at Versailles, but had been unwilling to do so. According to etiquette at court, French peers took precedence over foreigners of equal rank. While Dashkova had reluctantly agreed to sit below what she considered her station at Catherine's coronation, she would not do so in France since "as lady-in-waiting to the empress of Russia, I could not be responsible for any slight to my rank" (157). A private visit was another matter and on the appointed day, Dashkova and her children went to the Polignacs' thirteen-room apartment in Versailles and met the queen, who greeted them graciously. She spoke to the children about their dancing lessons and regretted aloud that soon she would be compelled to

give up this form of amusement, since decorum did not allow her to dance after the age of twenty-five. Dashkova, always ready to make a moral point or draw an uplifting lesson from a situation, commented judiciously that dance was a more natural form of entertainment than, say, card playing. She was unaware of Marie Antoinette's passion for the gaming tables and the next day the rumormongers at court reported that Dashkova had lectured the queen.

At last, after carefully avoiding Rulhière during her last stay in Paris, Dashkova met him at a soirée given by Suzanne Necker. Now that the controversy concerning his history of the palace revolution of 1762 had abated, Dashkova greeted him amicably and invited him to visit her at home. Diderot, Malesherbes, and others had assured her that in his narrative Rulhière had portrayed her role truthfully and positively. What was her surprise when many years later she read his account, possibly still in manuscript form? In fact, her outrage at what she felt to be Rulhière's falsifications and mindless repetition of hearsay evidence and unsubstantiated rumors was a prime motivating factor in the writing of her own version of events in the *Memoirs*.[38]

Dashkova also conversed with one of the men she admired most, Benjamin Franklin, who was named minister plenipotentiary to the court of Louis XVI by the congress at Philadelphia on September 14, 1778. While in Paris, she was eager to meet Etienne-Maurice Falconet, the artist, sculptor, and author of Peter the Great's equestrian statue in St. Petersburg, the famous Bronze Horseman. After falling out of favor with Catherine II, he had returned to Paris. Falconet arrived for tea with his student and daughter-in-law Marie-Anne Collot, a gifted artist in her own right. Especially adept at portraiture, she had created the model of Peter's head for Falconet's masterpiece. Their conversation turned to Grigorii Orlov and how he had maliciously insinuated to everybody in Paris that Dashkova had groomed her son to become Catherine's lover. Orlov's underhanded tactics did not surprise Dashkova, but she feared that such rumors would reach Potemkin's ears. She had not yet received an answer to her letter concerning her son's appointment, and it was possible that Potemkin now saw Pavel as a rival.

Despite the many distractions of Paris, Dashkova did not lose sight of her son's education. Pavel continued his intensive studies: He focused on Italian, read ancient Greek and Latin texts, and every morning would review the subjects that had occupied him at Edinburgh. A student of D'Alembert, the mathematician and philosopher who collaborated with Diderot on editing the *Encyclopédie* and who was an honorary member of

the Russian Academy of Sciences, tutored him in mathematics and geometry. Over the years Dashkova employed scores of instructors, among them Jean-Frederic Hermann, later professor of law at Strasbourg. Dashkova's children studied with their tutors, took dancing lessons with the French ballet dancers and choreographers, Maximilian and Pierre Gardel, and accompanied their mother on most of her visits and excursions. On one such outing to St. Cyr, a school for girls and young women founded by Madame de Maintenon in 1686, Dashkova was jubilant when permission was granted her son to inspect the institution: "I afterwards obtained permission for my son to see the St. Cyr establishment where men were generally not admitted" (160). In the *Memoirs,* she once again ignored her daughter, wrote nothing about Anastasia's interests or reactions, and missed an opportunity to discuss the education of her daughter and women in general.

Still without word from St. Petersburg concerning her son's appointment, Dashkova left for Switzerland in March 1781. Along the way, she visited garrison towns so that Pavel could learn more about French military installations and supplement the models and plans of fortifications he had studied in Paris. Dashkova traveled to Berne and then on to Geneva and Lausanne with mixed feelings of happiness and grief, for she was visiting beautifully romantic places and meeting old friends. Yet there was a sense of loss and absence, since Voltaire had died two years earlier and Catherine Hamilton was not accompanying her on this trip. As a token of his friendship, Jean Hubert presented her with one of his portraits of Voltaire. Having crossed over the Alps, Dashkova embarked on the Grand Tour of the Italian peninsula, required of all elite eighteenth-century travelers, and omitted from her previous visit to Europe.

She spent several days examining Milan, only making a side excursion to the lakes Maggiore and Lugano, as well as the islands of Borromeo. "So enchanted were we with the beauties of nature that we found it hard to leave a place which seemed to us to be a paradise upon earth. Orange and lemon trees grew there in the open like birch and linden trees in Russia" (164). Writing many years later, Dashkova had little to say about Parma, Modena, and even Florence, but took greater interest in Pisa with its cathedral, works by Andrea Del Sarto, and manufactory of steel products. The summer months were hot, the lack of air stifling, and fearing the possible spread of malaria, Dashkova spent nine weeks with her children at the Baths of Pisa. They would rise at eight every morning and after a light meal went to the biggest room in the house to pursue a regular course of reading. At eleven, they closed the shutters and took turns reading to

each other by candlelight until approximately four in the afternoon. They would then wash, change, dine, and after another hour of reading, they would open the windows and go out for a walk. As a result, the proud mother concluded that her son "had done more reading with my help than an average young man would have done in a year" (167). Still concerned about her son's future, and possibly learning about the growing tension between Catherine and Paul, Dashkova wrote Aleksandr Kurakin, who had been educated together with Paul and was his friend. In her letters, she requested an audience with Paul, expressing the hope that the grand duke would meet with his godson Pavel and take him under his wing. Dashkova revealed the conspiratorial nature of her correspondence when she promised to write freely only if Kurakin burned her letters.[39]

During Dashkova's tour of Europe, the visit to the Republic of Lucca was of considerable interest to her and she described it in detail, presumably for Nikita Panin.[40] According to the Panin genealogy, the family traced its ancestry back to the Italian family Pagnini, which in the Middle Ages emigrated to Moscovy from the Republic of Lucca. Moreover, the republic's form of representational government, with well-defined restrictions imposed on the prince's sovereignty, would have been close to Nikita Panin's, as well as Dashkova's heart. While a tiny dot on the map containing some one hundred and twenty thousand inhabitants could not provide an appropriate model for the vast Russian Empire, Dashkova felt that certain features of its aristocratic governance, such as elections and balance of power, could be illuminating. The ruling council consisted of the hereditary nobility, although citizens could purchase the patent of nobility or could acquire it through service to the state. Two parties, or congregations, consisting entirely of nobles, elected members of the council, magistrates, and the prince or Gonfalonier, as he was called, to terms of office varying in length from two months to a year. Vested with legislative and supreme powers, the ruling council voted on decrees that required a three-quarters majority for adoption. The Gonfalonier and his nine advisers, who made up the Supreme Magistrature, exercised executive power. But their terms were severely limited and the Gonfalonier's influence consisted essentially of first representative and advocate of items under discussion and deliberation. The third power, supported by a strong and disciplined police force, was that of the judiciary, which dealt with all criminal and civil matters. Criminal justice was swift and unforgiving. Judges summarily sentenced any citizen found bearing firearms to the galleys, but since Lucca had none of its own, executions took place in Genoa. Proud of its tradition of self-

rule, at all ceremonial processions in Lucca the supreme judge carried a silver rod bearing an inscription of the Republic's motto — *Libertas.*

Dashkova's *Memoirs* are full of her observations on art and history, with emphasis on conservation, preservation, and education. She wrote many of her travel notes with specific applications in mind and with the hope that one day she would again play a more active role in reshaping and modernizing Russia. Dashkova knew about Catherine's interest in health care, her establishment of a Medical Collegium in 1763, campaign against infection, and her project to build more hospitals in Russia. So in Leghorn she inspected a new quarantine hospital. Its order, sanitary conditions, and humanitarian purposes impressed her to such a degree that she requested copies of additional information concerning the building and its administration. It would provide her with the opportunity to gain Catherine's attention and favor, since the "sovereign's constant conquests gradually brought us nearer countries whose climate was favorable to epidemics" (170). In a few days, she dispatched the hospital materials to Nikolai L'vov, the architect, poet, and artist who was a close friend of her brother, Aleksandr. She requested that he show them to the empress to whom she also sent details of the harbor at Terracino. Most importantly for Dashkova, she capitalized on the occasion to write Catherine explaining that eight months earlier she had sent Potemkin a letter recommending her son, but had not yet received an answer. Extolling his many virtues, his natural aptitude, and brilliant education, she pressed the empress for a clarification concerning her son's assignment and rank.

Apprehensive, but still hoping that a favorable reply to her letter would arrive, Dashkova set off for Rome by way of Siena. Eighteenth-century Rome was an independent papal state, and a high point of the Grand Tour. With its cultural vitality, antiquities, art, and architecture from the Renaissance to the Baroque, as well as its tumultuous carnivals and solemn church ceremonies, it attracted artists, scholars, and travelers from all over the world. Dashkova wrote that in contrast to Paris, where her calendar was filled with invitations to endless functions and gatherings, "I spent my time very agreeably in Rome without wasting it on a social life, receiving, and paying visits" (173). As was her habit, she would rise early with her children and spend the day admiring and studying the history and artistic masterpieces of Rome and its environs, or attending other events such as the horse races, which she found to be ridiculous. In St. Peter's, where she spent every spare moment, Dashkova met with Pope Pius VI and discussed with him his projects to reclaim the Via Appia through the

Pontine Marshes and to create a museum in the Vatican. Returning home in the late afternoon, and after a hasty dinner, she was ready to receive her new friends and acquaintances. Among them was the Cardinal François-Joachim de Pierre de Bernis, French ambassador to Rome, member of the French Academy, and poet, who was called Babelat Bouquetière for his little poems and *bouquets poétiques*. Dashkova admired him for his gentleness, manners, and wit, and ingratiated herself by quoting to him one of his epistles. She also met the Hackert brothers, a family of artists and engravers, one of whom, the recently deceased Wilhelm, had taught drawing at the St. Petersburg Academy of Arts. The Scottish painter and excavator Gavin Hamilton converted Dashkova's room into a studio. An early neoclassical artist, he unearthed a huge statue of the seated Jupiter from Hadrian's villa at Trivoli and offered it to Catherine, who declined to buy it. Meanwhile, Pavel spent his time with easel and chisel in hand studying studio art, sculpting, and engraving.

The Scottish architect, archeologist, and antiquary James Byers was Dashkova's guide and consultant on questions of art. He had lived and worked in Rome for over thirty years, and eventually, Dashkova acquired his art collection for Catherine. He advised driving to the cellars of the Villa Farnese where many damaged, though nonetheless priceless, sculptures were stored. On the way down into one of the cellars, she knocked her foot painfully against a large stone, which Dashkova represented in her *Memoirs* as almost magical—possibly a sign of her emotionally bruising relationship with Catherine. She learned from Byers that the stone was in fact a matrix of emerald brought in the sixteenth century from Africa for Cosimo De' Medici, and through the Farnese succession it came to belong to the King of Naples. He recommended sawing the stone in half and making two tables. It occurred to Dashkova that she could present them to Catherine, but perhaps because of her mixed feelings toward the empress, Dashkova reconsidered the gift, and in 1807 presented the tables to Alexander I.

Following the established path of most Grand Tourists, Dashkova then headed south down the newly built road to Naples. There, she again found herself surrounded by a diverse group of artists, expatriates, and intellectuals, who met at the house of William Hamilton, British envoy in Naples and antiquarian. His first wife, Catherine, was an accomplished pianist and their house in Naples was a cultural center, while his second wife was the infamous Emma, the mistress of Lord Nelson. Andrei Razumovskii, the son of Kirill Razumovskii with whom Dashkova had rallied the troops in 1762, was also visiting Naples. Subsequently named ambassador to

Austria, he did not return to Russia and remained in Vienna, where he collected an extensive picture gallery and organized concerts by the leading musicians of his time. Beethoven dedicated the *Razumovsky Quartets* to him. Other notables included Fernando (Abbé) Galiani, Italian diplomat, writer, and political economist, and Anne Seymour Damer, English sculptor of works such as a statue of George III, a bust of Nelson, and Father Thames on Henley Bridge in London. She was traveling with her aunt and allegedly preferred women to her drunk and dissipated husband, who in 1775 had put a bullet in his head. Dashkova had met her in Rome, and often, after a morning and afternoon of sightseeing and shopping for works of marble, paintings, prints, and other art objects, Dashkova's day would end in Damer's studio. It was a sanctum open only to her closest friends. There the artist wrestled with a block of marble, trying to impart on it the shape she wanted, much like Dashkova with the narrative of her life. Dashkova thought that her friend possessed "excellent good sense, natural gifts, and a modesty which inclined her to hide her natural superiority" (173). In Caserta, at the magnificent eighteenth-century palace situated some twenty miles outside of Naples, Ferdinand IV, king of Naples, and his wife, Maria Carolina of Austria, the sister of Marie Antoinette and who would survive eighteen pregnancies, received Dashkova. They discussed the treasures found in Pompeii and Herculaneum and the advisability of creating a museum of everyday ancient life on these sites. While Dashkova was hobnobbing with royalty, visiting museums, and climbing to the top of Mount Vesuvius, changes were occurring in St. Petersburg, which would propel her to the peak of her political career, only to drop her to the depths of estrangement and despair.

In 1780, despite the efforts of the Panin party to maintain closer ties with Prussia, a break occurred in the alliance between St. Petersburg and Berlin, in great measure a result of the Potemkin inspired "Greek Project" that required Austria's help. The Austro-Russian treaty of 1781 represented a major shift from Panin's "Northern system," which the Grand Duke Paul supported. Panin steadily lost power and influence to Potemkin, but Catherine delayed taking decisive action against the Panin faction until Paul and his second wife Maria Fedorovna went abroad. In September 1781, Catherine dismissed Panin from his post at the College of Foreign Affairs and forced him into retirement. The next month Paul traveled to Italy surrounded by Catherine's spies, who were informing on his every move and intercepting the correspondences between Paul and members of the Panin faction.[41] After years of silence, Dashkova finally received the letter she was expecting from Catherine and read it with mixed feelings. The

tone of the letter, dated December 22, 1781, was quite different: kindness and benevolence replaced the coldness of the past. The empress thanked her personally for the materials describing the quarantine hospital at Leghorn and reassured her about her son's future. "I have ordered that my godson should have a commission in the guards, in whatever regiment you may prefer; and in assuring you of the continuation of my regard, I have pleasure in adding, that it is no less sincere than affectionate."[42] Still wary of recent rumors concerning her son's possible elevation to the position of Catherine's lover, Dashkova replied that it would be preferable for her son to pursue a military career, rather than seek appointment at court.

It was, however, obvious to her that a crucial shift in power had occurred at court and that it was time to make haste and return home. Nevertheless, she delayed her departure from Rome in expectation of the arrival of Paul and his wife, who were traveling in Europe as Count and Countess of the North. In the *Memoirs,* Dashkova remained close-lipped about her meetings with Paul and about the presentation of Pavel to his godfather, which took place immediately after the arrival of Catherine's letter. The grand ducal pair was very gracious toward Dashkova, meeting with her on several occasions and greeting her with favor and good will. Yet Ellis Cornelia Knight, who was then in Rome, described a conversation between Paul and Dashkova at a concert given by the Cardinal de Bernis. She felt that Dashkova's presence displeased Paul, and she was convinced that Dashkova was there to spy on him. The accusation is hardly convincing, and it is more likely that it was Dashkova's plain, black dress and the impropriety of her appearance that annoyed the grand duke. Dashkova explained that she had packed all of her dresses in anticipation of her departure from Rome.[43] Paul knew that Dashkova was sympathetic to the group of nobles who were hoping to bring him to power; it is also highly doubtful that the doting mother could have resisted the opportunity to broach the subject of her son's military career.[44] Paul possibly reassured her or even promised to assist her with the matter. Whatever the case may be, the meeting with Paul was a crucial one for Dashkova, since she would soon have to clarify her loyalties and choose between Catherine and the grand duke, who was actively seeking the dethronement of his mother. Paul would consider Dashkova's eventual decision to be a betrayal.

With Paul's departure, Dashkova embarked on her journey back to Russia, passing through Loretto, Bologna, Ferrara, and soon reaching Venice, where she paused to take in the rare splendors of the Basilica, the Doge's Palace, the Rialto, and the Grand Canal. But the enchanted beauty of the water-bound, unreal city left her feeling uneasy as she traveled to

churches and convents in long, black gondolas, which seemed to her dark and gloomy ("*bien lugubres;*"178). She was all too prescient. It was as if she had a premonition of the death just two years later in 1784 of her sister-in-law, Simon's young wife Catherine, and her burial there in the Greek Orthodox Church off the Piazza San Marco. From Venice, it was on to Padua, Vicenza, and Verona, before crossing the Tyrolean Alps into Austria. In Vienna, Dashkova met with Wenzel Anton von Kaunitz-Rietberg, the Austrian chancellor who had a major influence on the foreign and domestic policies of Maria Theresa (who had died in 1780), Joseph II, and later Leopold II. He was a friend and great admirer of Voltaire and the encyclopedists and as ambassador in Paris had retained Jean-Jacques Rousseau as a private secretary. Dashkova learned that shortly before her arrival in 1782, Pope Pius VI had visited Vienna and unsuccessfully attempted to prevail on Joseph II and Kaunitz to abandon their ecclesiastical reforms. Kaunitz advised Joseph II to make no concessions in ecclesiastical affairs and generally treated the pontiff rudely. He had arrived late to their dinner appointment dressed in boots and with a riding crop in hand. Dashkova was determined not to suffer the same indignity and accepted his invitation only on the condition she would not wait for him beyond the appointed hour. When she arrived, Kaunitz was there to greet her in his drawing room.

Their conversation that evening provided Dashkova with yet another opportunity in her *Memoirs* to expound on her views concerning Russia, its history, its development in the European context, and inevitably, the enlightened rule of Catherine the Great. On this occasion, she contrasted the empress to the imposing figure of Peter I. For many years, Catherine had made every effort to exploit the Petrine legend and to establish continuity with those initiatives that Peter had left unfinished. Some fifteen years earlier she had commissioned Falconet to create his majestic equestrian statue of Peter the Great, and now on August 7, 1782, during the centennial of Peter's enthronement, she organized the ceremonial unveiling of the Bronze Horseman. Bearing the inscription *Petro Primo Catherina Secunda,* it "boldly proclaimed the historical significance of her reign as the rightful successor to the creator of modern Russia."[45] Among Russian intellectuals and progressive writers of the time, Peter's legacy was undergoing a reappraisal, and Dashkova, for one, saw Peter as a brutal tyrant who showed utter contempt for things Russian, and especially for the nobility. Although Russia was in his debt for all his accomplishments, Dashkova felt that his status as a ruler of almost mythic proportions was an invention of foreign writers, and almost wholly based on his policies of westernization.

She negatively assessed Peter's coarseness, despotism, disdain for the law, excessive ambitiousness, vanity, and most of all, Peter's rule, which for Dashkova was a military despotism (181).

In her *Memoirs*, Dashkova wrote that Russia, with its resources and wealth, did not depend on the West. Peter's reforms and the manner in which he forcefully imposed them on the Russian people were a result of his cruelty, course nature, and the deficiency of his upbringing. "He had genius, energy and zeal for improvement, but his total lack of education had left him with unbridled passions which completely swayed his reason; quick-tempered, brutal, and despotic, he treated all people without distinction as slaves" (181).[46] He implemented change violently, treated all his subjects harshly, including the nobility, and undermined the established traditions and laws of Russia, such as the new legal code (*Ulozhenie*, 1649) his father, Tsar Aleksis, had introduced. Largely, he was obsessed with power and driven by personal ambition and pride, and built a capital city where "thousands of workmen died in the marshes" (181). Nor was there reason for him to abrogate his duties as sovereign and work as a carpenter in the dockyards of Saardam. By way of contrast, Dashkova proposed Catherine's reign — a woman's kinder, more humane rule — that saw St. Petersburg grow four-fold with the construction of magnificent buildings, a feat accomplished "without any taxation and without discontent" (181). Dashkova conveniently omitted the Pugachov revolt and other less attractive features of Catherine's Russia, but privately, in a letter to her brother Aleksandr written around 1790, she expressed very different sentiments, characterizing Catherine's regime as almost completely dependent on the whip (*le knut*).[47] With her glorification of the enlightened, gentle administration of Catherine the Great, as opposed to the brutal and violent regime of Peter the Great, Dashkova did not intend to gain favor with Catherine, who died some six years prior to the writing of the *Memoirs*. Rather, she was sternly cautioning against a return to despotism and a growing militarism during Paul's four-year reign when "military reviews and uniforms occupied the center of his [the emperor's] attention" (277).

While visiting the natural history collection in the Imperial Gallery, Dashkova spoke briefly with Joseph II, who expressed his deepest reverence and respect for Catherine, although privately his feelings were far less flattering. From Vienna, Dashkova and her children rushed off to Prague so that Pavel could learn more about the Austrian army stationed there, and then on to Dresden to revisit the Old Masters Picture Gallery. They could not linger and soon headed on to Berlin, for Frederick II, in a letter dated April 10, 1782, had granted Pavel permission to follow the maneu-

vers of the Prussian troops.[48] As a rule, Frederick never allowed women to attend military reviews, but according to Dashkova, in her case he made an exception to his aversion to the company of women and riding up to her, hat in hand, spoke to her briefly—to the great astonishment of his soldiers and officers. The Abbé Raynal joined her in Berlin. Now in exile, he wrote her that he had "become a fixture in Berlin from motives which will not escape your penetration."[49] Dashkova's old friend had fled persecution in Paris after the parliament had his *Histoire Philosophique* publicly burned. Baron F. M. Grimm wrote Catherine on May 16/27, 1782, that the Abbé was often in the company of Dashkova.[50] She would dine with him or they would meet with academicians. One such dinner party included the mathematician Joseph-Louis Lagrange, who in 1766 accepted Leonard Euler's position in the Berlin Academy when Euler left for St. Petersburg; Johann Formey, Prussian man of letters and secretary of the Berlin Academy of Sciences; and Jean Bernard Mérian, philosopher and specialist on Hume. Dieudonné Thiébault, member of the faculty of the Ecole Militaire in Berlin, was also present. Dashkova's erudition put him off and he took great offense when she delivered an attack on the immense sum spent on the wedding of the Dauphin to the Princess of Sardinia. In his memoirs, he wrote she was "sturdy like a man and quite unattractive, her gait was wide and her head was held high with a bold and imperious expression on her face."[51] The Abbé Raynal had a higher opinion of Dashkova: "The more I read history, and the more attentively I observe the present age, the more do you appear to me as being advanced beyond it."[52] He would eventually follow her to St. Petersburg.

At last, it was time to embark on the last leg of their return to Russia, and they drove without mishap to Koenigsberg and then to Memel. From Riga, Dashkova wrote Simon on June 17/28, 1782, about her joy on learning about the birth of her nephew, Mikhail.[53] Finally, in July 1782 she arrived in St. Petersburg. Some seven years had passed since her departure, during which time she had provided her son with an outstanding education, introduced him to the best that the enlightened West had to offer, and assured his promotion and career. Although the question of her daughter's future still lingered and was far from clear, Dashkova was happy—she had realized all her wishes and now, for better or for worse, she was home.

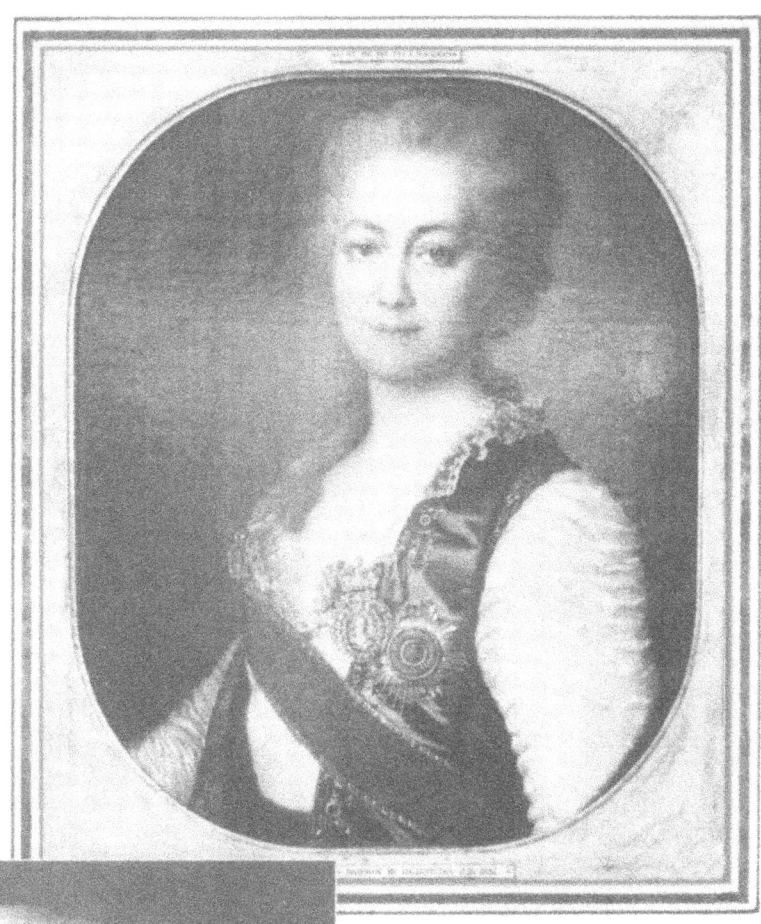

Print of Dashkova from the original portrait by Dmitrii Levitskii

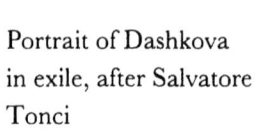

Portrait of Dashkova in exile, after Salvatore Tonci

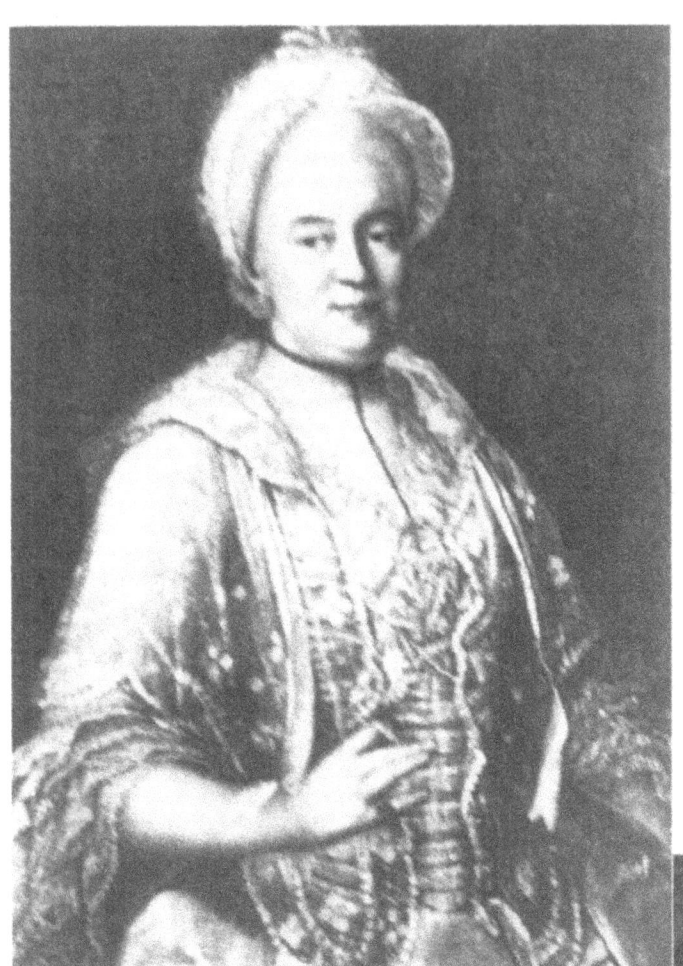

Thought to be
Marfa Vorontsova,
Dashkova's mother,
by an unknown artist

Print of Roman Vorontsov,
Dashkova's father, by
A. Kolpachnikov

Print of Catherine II by C. Guttenberg, from a portrait by P. Rotari

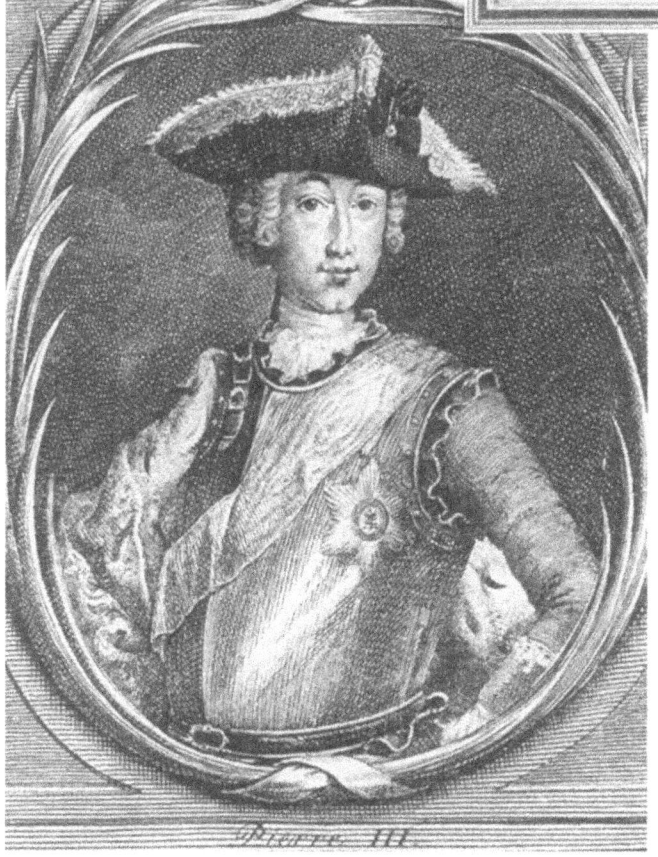

Print of Peter III

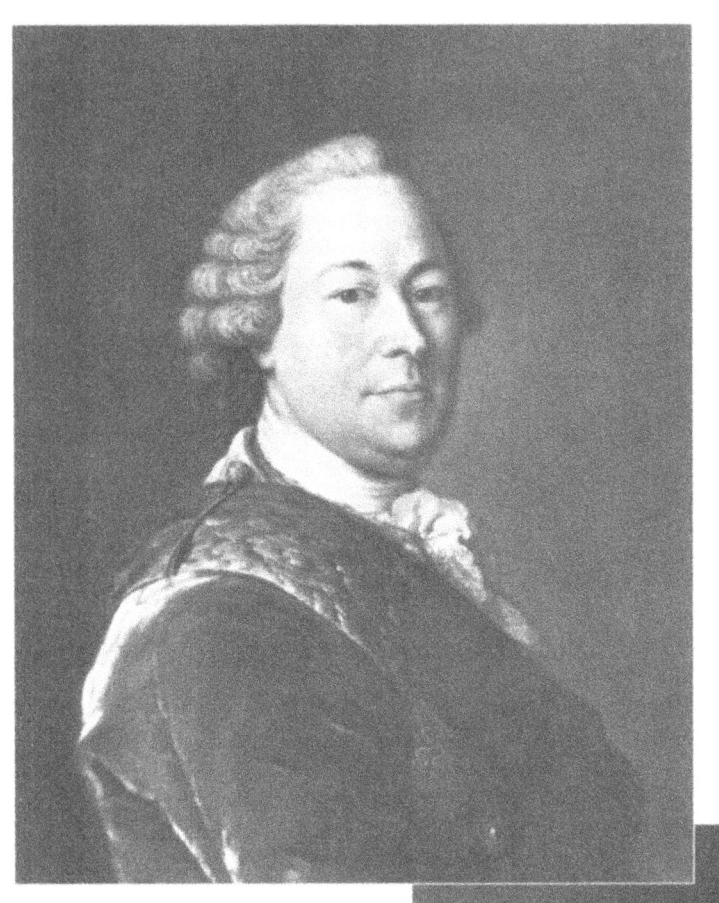

Mikhail Vorontsov, Dashkova's uncle, by Iakov Ulianov after a portrait by L. Tocqué

Anna Vorontsova, Dashkova's aunt, by Iakov Ulianov after a portrait by P. Rotari

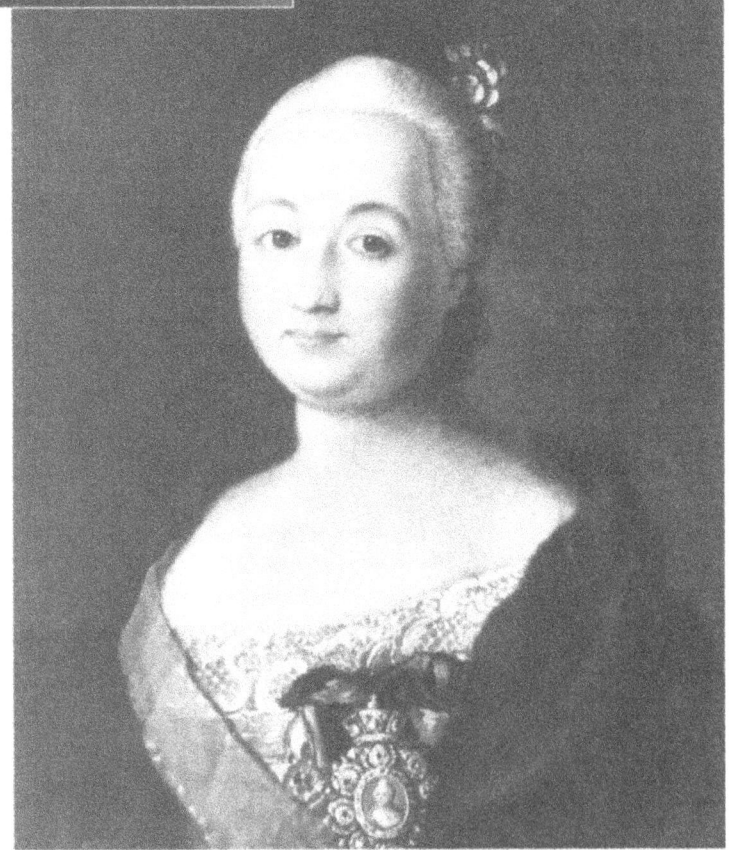

Print of Mikhail Vorontsov's palace, St. Petersburg

Print of church in the Vorontsov palace

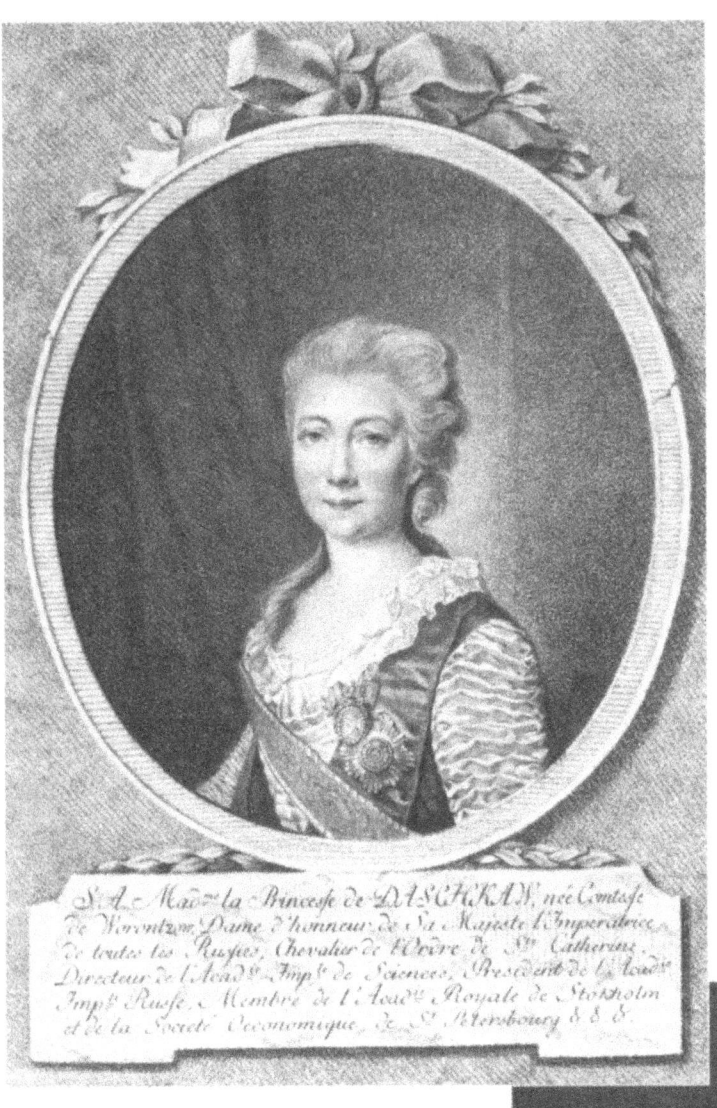

Print of Dashkova by Johann Conrad Mayr, from the original portrait by Dmitrii Levitskii

Print of Elizaveta Vorontsova, Dashkova's sister, from the original portrait by L. Tocqué

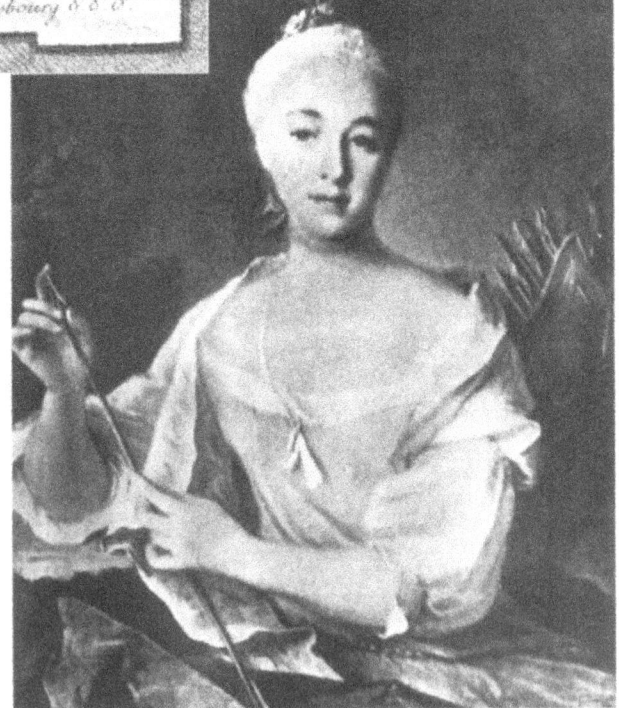

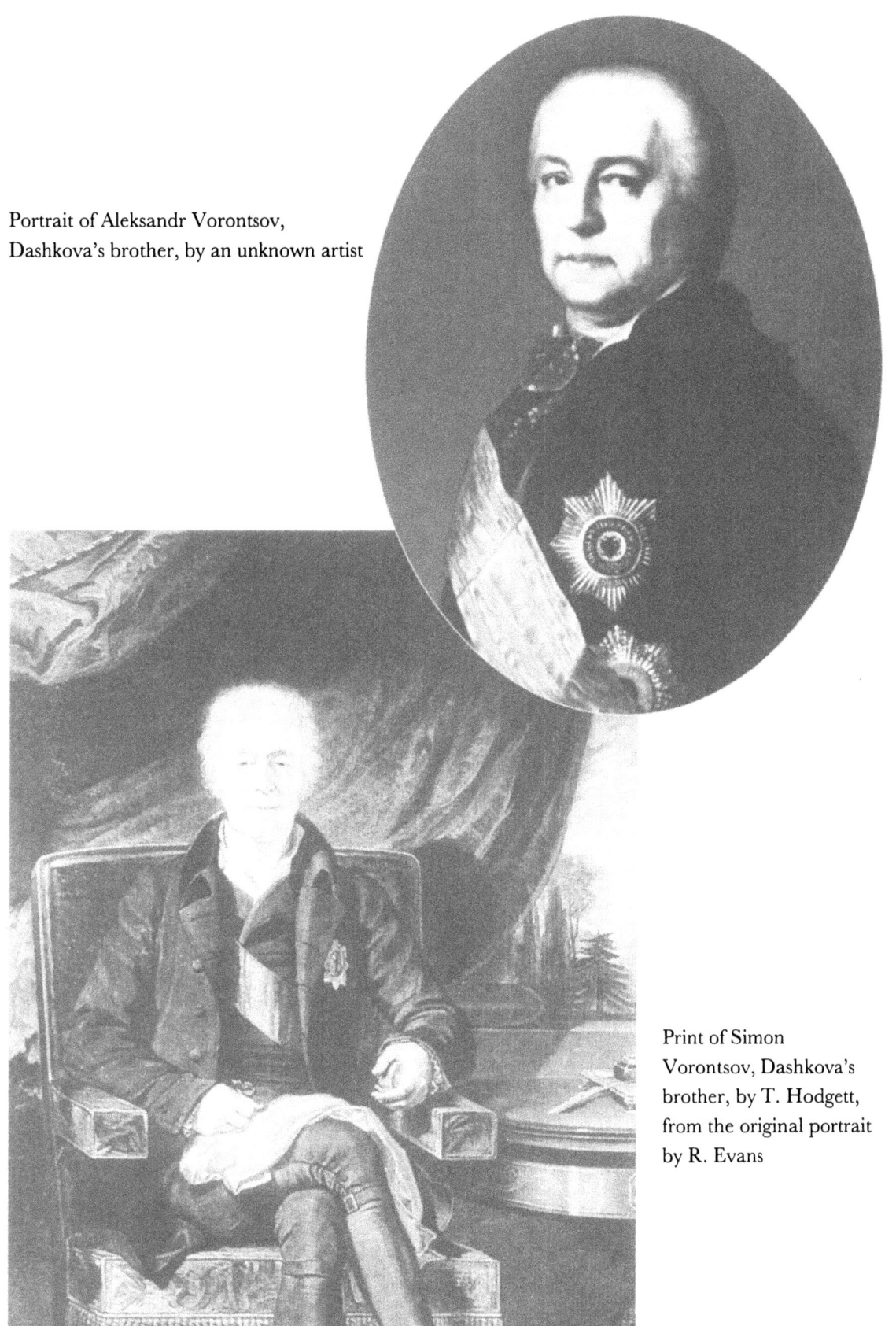

Portrait of Aleksandr Vorontsov, Dashkova's brother, by an unknown artist

Print of Simon Vorontsov, Dashkova's brother, by T. Hodgett, from the original portrait by R. Evans

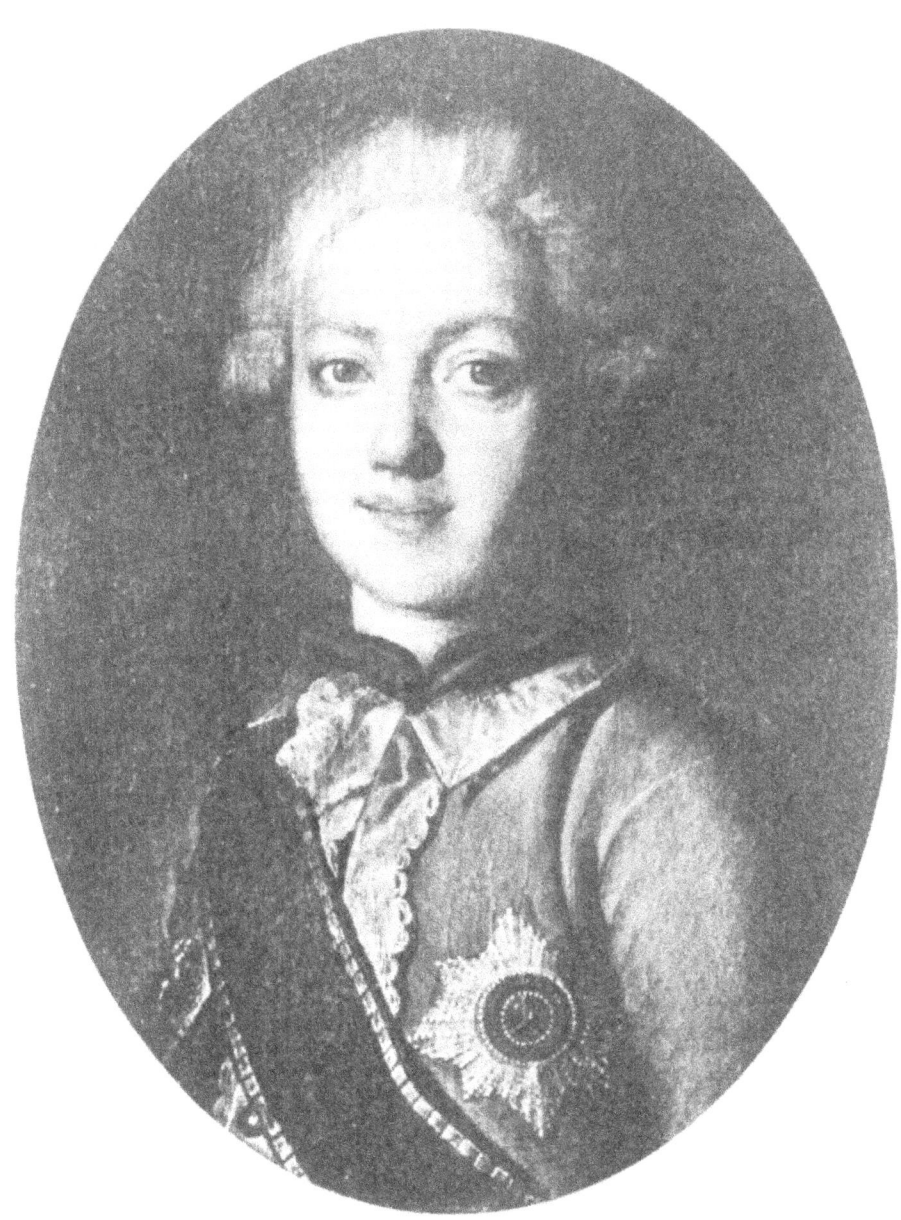

Portrait of Dashkova
in military uniform
by an unknown artist

The Academy of Sciences in St. Petersburg
photographed from the English Embankment

Photograph of Kirianovo

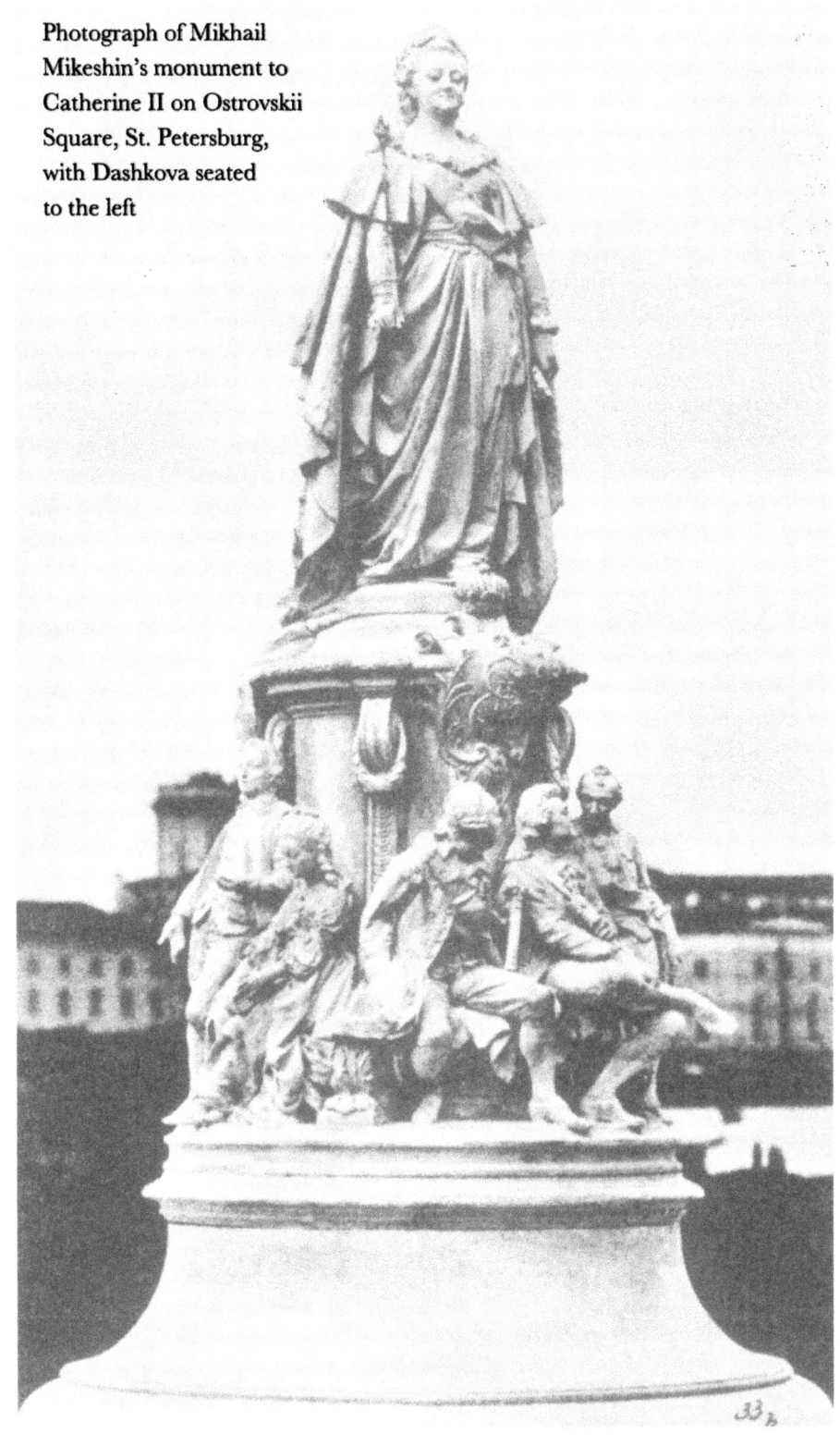

Photograph of Mikhail Mikeshin's monument to Catherine II on Ostrovskii Square, St. Petersburg, with Dashkova seated to the left

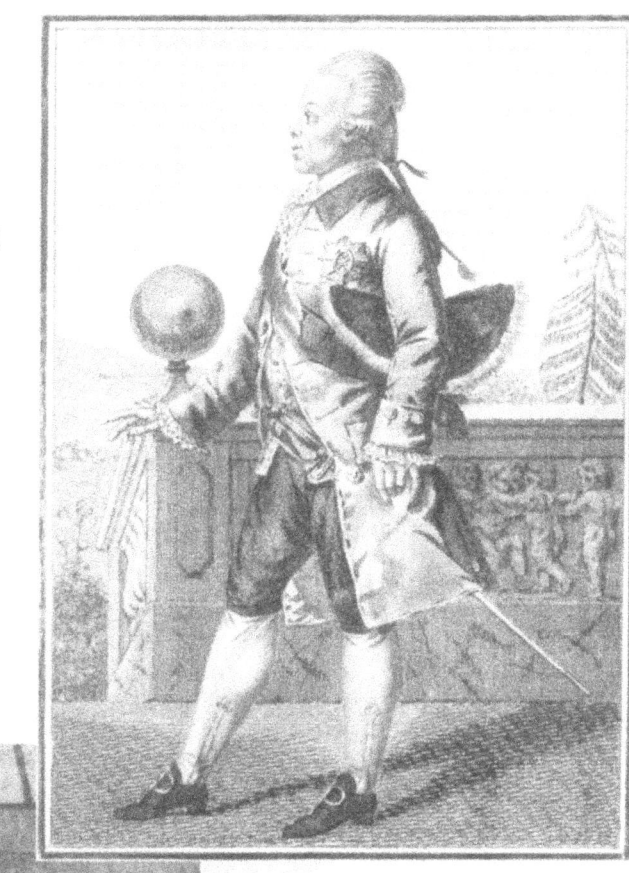

Print of Paul I

Print of Dashkova in exile by A. Osipov, from the original portrait by Salvatore Tonci

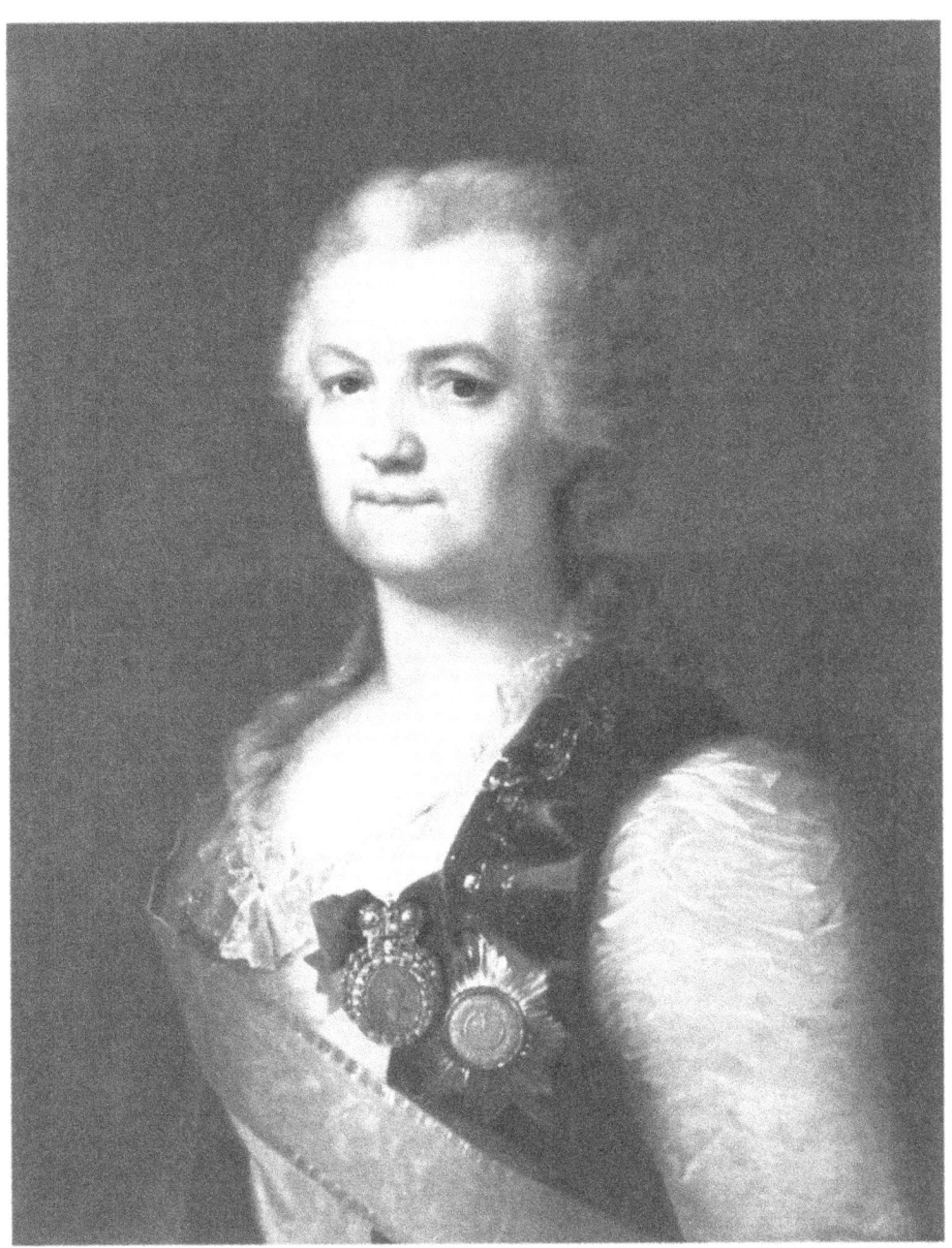

Dashkova in later life
by an unknown artist

Photograph of the gates to Troitskoe

Photograph of Andreevskoe, Aleksandr Vorontsov's estate

Photograph of Dashkova's monument
to Catherine in Troitskoe

PART III

Influence and Intellectual Pursuits
1782–1794

Chapter Seven

The Academy of Sciences

*D*ASHKOVA COULD NOT HAVE IMAGINED the degree to which her standing had improved at court, but her prudent behavior abroad was now paying dividends, and soon she would be appointed to an administrative position never before held by a woman in Russia. She returned to St. Petersburg in the summer of 1782 and settled in her country house on the Peterhof Road, since at that time she did not own a residence in town. Apparently, little had changed vis-à-vis her family. Most members were out of town during the summer months, while her father lived in Vladimir, where he was viceroy. Simon remained unresponsive and distant. In her absence, he had married Ekaterina Seniavina in 1781 and now lived with his wife and infant son on the family estate in Murino to the northeast of St. Petersburg on the Okhta River. After the early death of his wife in 1784, he and Aleksandr commissioned their friend, the architect Nikolai L'vov to build in her honor the Church of St. Catherine. Roman Vorontsov continued to provide handsomely for his sons, presenting Simon with the estate and the highly profitable alcohol distillery located there, which Aleksandr supervised when Simon lived abroad. When the weather turned cold and her problems seemed crushing, Dashkova would write her brother Aleksandr to send her some vodka from Murino.

Only her sister Elizaveta and niece, Anna, came to greet Dashkova upon her arrival to the capital. Rather than harboring any sincere feelings of love and affection for her long-absent sister, Elizaveta was primarily interested in enlisting Dashkova's influence with the empress in support of her daughter's appointment as maid of honor. It was something Dashkova would be able to accomplish while she remained in favor. There were also personal matters to take care of, as she visited her friends the Panins, espe-

cially Nikita, who was close to death. She also made every effort to obtain permission to present her children to the empress and to learn more about the nature of her son's appointment. Rather than send a letter to the War Collegium or to the Potemkin residence, where her inquiry would possibly be lost or would remain unanswered, Dashkova decided on more direct action. She sent her servant to a neighboring summerhouse, where she knew that Potemkin could be located daily during his love hour. The astonished Prince was hand-delivered Dashkova's message while he was visiting Ekaterina Skavronskaia, née Engelhardt, his niece and mistress.

Unfortunately, Dashkova could not take advantage of Catherine's invitation when it came, since Pavel had come down with a violent attack of fever and was delirious. Dashkova stayed up nights nursing him back to health. On the fourth day, Dr. Rogerson declared Pavel to be out of danger, and it was Dashkova's turn to recover from a bout of chronic rheumatism, with complications, that left her bedridden for a fortnight.

Still weak and only beginning her convalescence, Dashkova spirits rose when she was at last able to present her children to the empress, who greeted them kindly and graciously, even inviting them to dinner. As Dashkova awaited Catherine, who liked to play chess before dinner, she considered her own moves, since she was now certain that the political situation at court had changed and her status had improved dramatically. Soon, it was Dashkova sitting next to the empress, enjoying Her Majesty's special attention at table and during evening walks. With Grigorii Orlov gone, Catherine invited her to court functions and to the more personal gatherings at the Hermitage. The following day Pavel received his long-awaited commission of junior captain in the Semenovskii Guards Regiment, a promotion equivalent to the rank of lieutenant colonel, and on June 14, 1782, he received the appointment he desired of aide-de-camp to Potemkin. Sadly, surrounded by the many distractions that the capital had to offer, Pavel would soon forsake his studies and the wisdom of his mother's moral guidance.

Dashkova was yet unaware of the full magnitude of Catherine's largesse and of the many imperial rewards of real estate, money, and distinctive appointments still to come. Soon she received Catherine's order granting her the village Krugloe in Mogilev, a province annexed at the first partition of Poland in 1772, which became a part of Belorussia. The Statute of Local Administration of 1775 replaced Polish landowners with Russians in order to strengthen Russian control of Belorussia. It was a generous gift of land inhabited by up to 2,500 peasants once belonging to Mikhail-Kazimir Oginskii, hetman of Lithuania and candidate for the Polish throne. Dashkova

hesitated, even though the land would legally belong to her, as opposed to the properties she administrated for her children. It was located in a distant and unfamiliar area of Russia, which had once been part of the Grand Duchy of Lithuania and then the Polish-Lithuanian Commonwealth. Its annexation brought into Russia an ethnically varied region comprised of Ukrainians, Cossacks, Polish Catholics, Lutheran Swedes, Orthodox Russians, and a large number of Jews. While turning local administration and control over to her ministers and gentry, partially through land grants such as Dashkova's, Catherine introduced legislation providing some civil equality to the general population and the Jewish community.

In 1780 Catherine traveled to the province on an official inspection and met with Joseph II in Mogilev, where the Jewish population received her with expressions of joy. They decorated the public square with flowers and erected an arch in her honor. Nevertheless, ethnic and religious conflicts, especially anti-Semitism on the part of the local inhabitants and Russian officials, continued to be widespread. Apart from politically motivated anti-French and anti-Prussian sentiments, Dashkova's writings attest to her religious tolerance and to a lack of prejudice toward ethnic minorities. Her *Memoirs* are free of ethnic slurs or any anti-Semitic comments, yet she was uncertain of her ability to oversee successfully "peasants who were half Polish and half Jewish and of whose customs and language I was quite ignorant" (194). The following year, after visiting her estate and finding the conditions there to be wretchedly poor and in a state of complete neglect, she petitioned Potemkin to exchange it for property in central Russia. Potemkin denied the request and accordingly, she took on the challenge of revitalizing the estate and making it into a productive and profitable economy. Dashkova would later write, "For two years I invested what, for me, was considerable capital to improve the estate" (195).[1]

Catherine also offered to purchase Dashkova a townhouse, as floods had damaged her country house, and the marshy land on which it stood aggravated her rheumatism. After some uneasiness and worry over the choices available to her, she selected the furnished house of A. Neledinskii-Meletskii; however, when his wife removed all of the furniture the sale fell through, and Dashkova decided to rent the house.[2] She then requested that in lieu of the house, Catherine appoint her niece Anna Polianskaia as maid of honor, thereby fulfilling her sister's request. Catherine agreed, but did not withdraw the money and Dashkova settled on the house of the recently deceased court banker, Ivan Fredericks, for which the empress agreed to pay thirty thousand rubles from her private purse and later an additional two thousand.[3] Dashkova wanted to buy a house on

the English Embankment where, as she explained to Catherine, she was born (198).[4] Martin Skavronskii, Mikhail Vorontsov's brother-in-law, had built the two-story, stone house with a mezzanine, and it is therefore possible that Dashkova's parents lived there for a time in the 1740s and that Dashkova was born there. The house became her primary residence in St. Petersburg for twelve years at the time when she headed the Academy of Sciences. The English Embankment had developed into a fashionable street of luxurious, two- and three-story houses. Intersected by the Kriukov Canal, which was spanned by a small drawbridge with four imposing granite columns, it was a popular destination for outings and strolls — a place to be seen. From her windows, Dashkova could look out directly across the Neva River to the far bank where, under her supervision, Quarenghi would construct the new building of the Academy of Sciences.

No amount of property or money she had received from the empress could match in Dashkova's mind the exhilaration she felt upon learning of Catherine's next proposal. At a court ball, Catherine approached Dashkova and requested a word with her. Dashkova stood there dumbstruck as she listened to Catherine's words, seemingly dropping from the clouds, urging her to accept an appointment of director of the Academy of Sciences. The unanticipated opportunity she had dreamed of since her youth was now in reach; it would allow her to work side by side with Catherine and to participate in the transformation and modernization of Russia. That evening Catherine propelled Dashkova to the center of Russia's cultural and intellectual life as head of two academies, where from 1783 to 1794 she was to have a profound influence on the development of education, science, and scholarship in Russia. Officially for thirteen years, including a two-year leave of absence, and actually for eleven years, Dashkova headed the Imperial Academy of Sciences in St. Petersburg (Academy of Sciences) and the Imperial Russian Academy (Russian Academy).

After keeping her at a distance for so many years, the decision to return the volatile and often brutally direct Dashkova to a sphere of influence at court must have been a difficult one for the empress. Yet Catherine's initiative was ingenious, and unprecedented, for never had a woman in Russia held such an influential and powerful academic appointment. Peter I planned and founded the Academy, which came into being only a few months after his death. He envisioned a triune institution for research and teaching consisting of an academy, a university, and a gymnasium (secondary school). Originally, the Academy of Sciences was greatly involved in the humanities and, above all, philology. Although it was just over fifty years old, by 1783 it was in disarray. The death in 1765 of its greatest man

of learning, Lomonosov, as well as a diminishment of interest in the early initiatives based on the Enlightenment, particularly after the Pugachev rebellion, translated into fewer subsidies. Lack of leadership and reduced revenues had a profoundly negative effect on the overall work of the Academy, the pursuit of its research projects, and the preparation of future academicians in its gymnasium and university. Administrative and financial mismanagement hastened its decline. Kirill Razumovskii had taken over the presidency of the Academy when he was eighteen and held the sinecure for some fifty years. He showed no interest in the efficient administration of the Academy, and as a result, Catherine instituted the position of director in 1766 along with an administrative commission for the oversight of scientific, scholarly, and academic affairs.

The presidency still existed, although it was now ceremonial in nature. Prior to Dashkova, the director was Vladimir Orlov, youngest of the Orlov brothers. He too was ineffectual and inept as an administrator and turned the position over to his protégé Sergei Domashnev, a poet and translator, who headed the Academy from 1775 to 1783. Domashnev and his disorganized administration of the Academy became the object of ridicule and satire, but more seriously, he brought the scholarly life of the Academy into complete chaos, demonstrated no respect toward scholars and scholarship, and misused funds.[5] His lack of tact and interpersonal skills led to incessant squabbling and conflicts between the academicians and their director. He could be dictatorial and meddled in their work, which he did not fully appreciate or understand. The Academy was in a state of administrative and economic chaos with unpaid debts, withheld salaries, and decisions made unilaterally and without consultation.[6] In an unprecedented move, the academicians actively voiced their displeasure with Domashnev's directorship citing his despotic administration and incompetence.[7] Domashnev defended himself and blamed court intrigue for his termination, especially the intrusiveness of Bezborodko and Aleksandr Vorontsov.

Catherine personally disliked Domashnev, whom she referred to as "*cet animal.*"[8] Dashkova, on the other hand, seemed perfectly suited for the position, and the administration of an institution devoted to higher learning was well within her area of competence. A highly educated, erudite, widely read woman of letters, she was fully committed to the importance of education and the dissemination of Enlightenment ideas. Prior to their implementation at the Academy, she had tested her theories of education on her children with, so she thought, brilliant results. She held scholarship in high esteem, had established extensive personal contacts with the intellectual elite of Europe, and had personally visited foreign academies and

centers of learning during her travels in Russia and abroad: the Kievo-Mogilianskii Academy, Oxford and Edinburgh Universities, St. Cyr, and others. The knowledge she garnered there and the influence of foreign institutions of higher learning, most of all Edinburgh University, played a crucial role in her reorganization and administration of the Academy and its gymnasium. Moreover, she was a determined, energetic woman with a reputation for financial responsibility and frugality, who had efficiently administrated her children's estates. Although at times too direct and less than diplomatic in her relationship with people, she unquestionably possessed the commitment and fortitude to confront and restore order to an academic community with a reputation for dishonesty, intrigue, and petty squabbles.

Nor was it a secret that she aspired to public office; if kept busy in the areas of science and scholarship, she would interfere less with the more sensitive affairs of state. Potentially, the appointment could neutralize her politically, remove her from the list of possible opposition leaders, and serve to distract her from participation in subversive activity. By providing her with responsibilities, obligations, and well-defined duties at the Academy, Catherine would bring Dashkova over to her side. In the end, she would aim to channel Dashkova's energy into productive work in the area of education and learning, far from the centers of power and political influence. It was a brilliant political move on Catherine's part and in keeping with her talent for surrounding herself with gifted individuals such as Petr Rumiantsev, Grigorii Potemkin, and Aleksandr Bezborodko. She did this even when they did not support her policies fully, or even actively opposed them. Such was the case with the Vorontsov family, including Dashkova's father and brothers Aleksandr and Simon, as well as others such as Aleksandr Suvorov and the Panin brothers, all of whom Catherine loathed. By accepting the position, Dashkova would become a member of Catherine's camp, further weakening the forces of opposition at court.

After the ball and back at home, doubts and uncertainty about her future course of action beleaguered her. Acceptance was not an easy matter, since it carried with it serious political consequences. Dashkova's indecision was due to a number of private and public factors. Privately, she understood fully the implications of her decision and how it would compromise the promises or agreements she had made with Paul in Rome. Should she follow the empress who had turned against her in the past and would possibly do so again, or should she continue her support of Paul, the legitimate heir to the throne? Her disloyalty would unquestionably anger him, and he would not forgive or forget her duplicity. Publicly, she recounted in

her *Memoirs* how she sat down to write Catherine a letter. Unconvincingly she argued, "God himself, by creating me a woman, had exempted me from accepting the employment of a director of an Academy of Sciences, that I was aware of my own ignorance, and that I never desired to be a member of a learned society" (201).

When she finished the letter, it was almost midnight. Ignoring the late hour, she rushed off in a state of agitation to consult with Potemkin, who roused from bed and hardly in a mood for Dashkova's dramatics, looked over the letter, crumbled it up, and tore it to pieces. He advised her that Catherine had considered the appointment for some time now, and if Dashkova had any misgivings, she should send the empress a far more restrained letter. In the end, she stayed up all night composing a second letter, in which she wrote, "Please do not think that I always had ambitions to be appointed to this position, to which as a woman I could not aspire."[9] The empress routinely ignored Dashkova's letter and the same day sent her a copy of the senate's decree appointing her director of the Academy of Sciences and dissolving the administrative commission. Interestingly, Catherine had the appropriate decree written up prior to Dashkova's consent, since it seems that she never doubted her ambition. Still, Dashkova hesitated and did not take action for several months after Catherine wrote her officially about the appointment on August 19, 1782.[10] Finally, on January 24, 1783, by order of the decree signed by Catherine, her appointment became official.[11]

The year 1783 was a momentous and unforgettable one for Dashkova—full of great joy and deep sadness. After twenty years of disfavor and ostracism, a new period in Dashkova's life seemed to be beginning, leaving behind many past concerns. Catherine had seen to it that Pavel received the desired commission in the guards regiment, had appointed Dashkova's niece maid of honor, and had named Dashkova head of the Academy of Sciences. There were two deaths in the family: The first was Roman Vorontsov's, with whom she had such a painfully strained relationship. Dashkova learned that he had left her nothing, and she could not help but think back to her heartbreaking life with the father who had mostly ignored her. The second was Nikita Panin's, who, as opposed to her father, had been her mentor and had done so much for her during her troubles at court. Despite her grief, at the Academy all her hesitations abruptly vanished and leaving her sorrows behind, she straightaway sat down to work with the vigor, directness, and a no-nonsense attitude that characterized her style of administration.

Dashkova brought to her work an attitude of innovation, energy, re-

solve, and fiscal responsibility, ushering in an exciting and fruitful time in the life of the Academy of Sciences.[12] There were important advances made connected with Lomonosov's work in chemistry, physics, geography, astronomy, geology, mathematics, and many other areas of inquiry. Additionally, there were vital projects initiated in the description of the empire's natural resources, as well as the publication of the accounts of travelers who had studied Siberia, Kamchatka, the Caucasus, and the south of Russia. The empire's vast and various lands were opening up with, for instance, the appearance of the *Russian Atlas* (*Atlas Rossiiskii*) and the *Russian Georgraphical Lexicon* (*Rossiiskii geograficheskii leksikon*), maps, and other reference works. More work, however, was required for the adaptation and application of new discoveries to the process of education and to the economic growth of Russia. Dashkova stressed that science must serve the needs of the country and its population and that the light of learning must illuminate all of society.

At once, a delegation of academicians, administrators, and support staff visited Dashkova, who announced an open door policy to her office, assuring them of her availability to discuss their questions and concerns at any hour without prior appointment. That night, in preparation for the next day's official meeting at the Academy, she pored over a labyrinth of reports presented to her concerning the Academy's business in order to familiarize herself with the intricacies and complexities of its inner organization. She made every effort to memorize the names of its most influential members, fearing that any mistake on her part would lead to ridicule or censure. Regular, weekly meetings brought together the academicians and their adjuncts (or assistants). These meetings focused mostly on reports, the discussion of scientific and scholarly work, the acquisition of books, equipment, archival material, and the establishment of contacts with other academies and academicians worldwide. During Dashkova's administration, Johann-Albrecht Euler, a mathematician, secretary to the academic conferences at the Academy of Sciences, and son of the famous Swiss mathematician Leonard Euler, kept the minutes of these meetings and published them in Latin, German, and French. The first meeting would be devoted to the inauguration of the new director.[13]

Dashkova's entry into the Academy was dramatic and highly symbolic, demonstrating to all present her resolve to launch a new era where advancement would be based on merit and actual achievements rather than cronyism and back scratching. Before going to her inauguration, she called on Leonard Euler, a man of encyclopedic knowledge who had authored

over eight hundred studies on mathematics, physics, astronomy, and mechanics. Now in his seventies and close to his death in 1783, he had fled the Academy, repelled by the turmoil of the previous administration and the incessant bickering of his colleagues. Old and blind, he continued his research, dictating his work to Nicholas von Fuss, also a mathematician and later permanent secretary at the Academy, who was married to his granddaughter. Dashkova considered Euler to be "the greatest geometrician and mathematician of his age" and urged him to accompany her to the Academy, to lead her into the conference hall, and to introduce her to the academicians gathered there (205). His presence would be a solemn and impressive way to mark her respect for science, while his endorsement would help allay her insecurities and admitted dread of public speaking. The realization that she would be the only woman at the assembly compounded her fears. Should she resort to the standard ploy of presenting herself as an inoffensive, nonthreatening woman or assert a more masculine prerogative over an assemblage of scholars, many of whom would certainly resist her authority?

Euler, for one, was flattered by her invitation, and assisted by his son and Nicholas von Fuss, set off to lend Dashkova support during her initial public appearance at the Academy on January 30, 1783. As they entered, Dashkova noticed that Jacob Stählin, a Swabian by birth and a professor of eloquence and poetry, occupied the chair next to the director. He wrote poetry in German and created allegorical pictures, illuminations, and fireworks at state and royal occasions. Although he was a member of numerous foreign academies, Dashkova believed that his chair was unearned and that "his rank was as allegorical as his science and, indeed, the whole of his personality" (206). She therefore turned to Euler and in a loud voice for all to hear, explained that whichever chair he occupied would be the most prestigious.[14] After reinstating Euler, she turned to those who had gathered and in her opening speech assured them that her appointment to head the Academy was a great honor. She expressed her deep respect and the high esteem in which she held the academicians and assured them of the zeal with which she would work for the honor of the Academy. Emphasizing that she could not compete with them in the area of learning, she pledged to work tirelessly on their behalf and to do everything in her power to continue the legacy of excellence at the Academy.[15] In fact, Dashkova was addressing the complaints of the academicians that the previous administration did not hold them in high regard and that their work was undervalued and unsupported. Her words and actions that day at her

first public appearance represented a forceful, provocative entrance into the academic world, sure to gain some support, but also certain to make scores of enemies.

Officially, many academicians were enthusiastic about Dashkova's appointment. P. B. Inokhodtsev expressed his hopes that "in the humiliated Academy peace and quiet would reign once more," and G. F. Miller wrote that he would consider himself a fortunate man if he could end his days during her "benevolent directorship."[16] Yet notwithstanding her good intentions and positive initiatives, her methods displeased many colleagues and they resisted an administration headed by a woman. A confrontation arose immediately between Dashkova and Aleksandr Viazemskii, procurator general of the senate. A man unattached to any of the leading parties, he was Catherine's trusted commissioner, charged with the internal administration of Russia and oversight of all government institutions. In an effort to reform and rationalize the country's financial administration, she had entrusted him with the supervision and unification of important fiscal matters, including those at the Academy. Reports, budgets, and allocations would therefore be going through his hands.

Dashkova, Panin, and others considered him Catherine's hatchet man and a mediocrity. Problems arose concerning finances and accessibility to the monarch, among many other issues, since at the Academy Dashkova wanted to deal directly and exclusively with the empress and resented Viazemskii's meddling. He offended Dashkova when he questioned the need to administer to her the oath of allegiance in the senate, as was customary with appointments to administrative posts. On this issue, Catherine supported Dashkova and subsequently invited her to the senate for the ceremony. At the appointed time, Dashkova faced the senate for the second time in her life. In 1762, she had audaciously intruded on its proceedings disguised as an officer. Now, nervous to the point of spasms and in a cold sweat, she spoke to the senators about "this unusual event—the appearance of a woman in your august sanctuary" and was sworn in as the first ever woman in Russia to hold the high office of director of the Academy of Sciences (207).

The question of Dashkova's oath of allegiance was only a precursor to countless other encounters with Viazemskii. With the excitement of her inauguration at an end, the tangled financial affairs of the Academy and the resistance of entrenched officials confronted Dashkova. Along with the decree installing Dashkova as director, Catherine signed two others. The first appointed two advisers and a treasurer to oversee economic and fiscal matters.[17] The second addressed Viazemskii as head of the senate and

called for the submission of all Academy expense-sheets and accounts of the previous administration for an audit. The audit uncovered substantive infractions in the financial dealings of the Academy and in response to these violations, on March 31, 1783, the senate passed a decree requiring the Academy to present regularly an accounting of its income and expenditures to its accounting office for review. Dashkova was furious, for she had not been the cause of the problem, yet its solution would now gravely confine her work. Rather than have direct access to the empress on all matters concerning the administration of the Academy, she was subject to the scrutiny of a governmental bureaucracy. Even worse, she was at Viazemskii's mercy.

While Dashkova's main concern was the establishment of fiscal responsibility and accountability, she was soon to discover that her task would not be an easy one. She requested that the dissolved administrative commission stay on for a time longer and that it furnish her with all available details concerning her duties as director, as well as all pertinent information on the Academy's administrative structure. Department heads were then required to submit to her reports on the nature of their duties and the responsibilities of their respective departments. In an attempt to put the Academy's business affairs in order, Dashkova, without further ado, requested Viazemskii to provide her with all records describing the chancellery's complaints with the former administration. She also petitioned for documents that her predecessor Domashnev had sent to the senate concerning the grievances of the academics, in order to address them individually. Viazemskii, however, was not helpful, and many of the records and documents were missing. Undeterred, she demanded a full report from Domashnev, prompting the disgruntled former director to complain directly to the empress.[18] It turned out that Domashnev had taken official papers home with him, and now they could not be located and were conveniently misplaced. In fact, Dashkova even found it necessary to instruct the empress on the proper handling of Academy's accounts, provoking a curt and testy response from Catherine: "I find your meddling highly annoying."[19]

Generally, Viazemskii was uncooperative, feeling that such financial reviews were within his purview. Dashkova was adamant about getting on with her work, and just as she had taken full control of her own and her children's financial matters, she strove to restore order and solvency to the academy's expenditures and operating budget. Again, she found herself embroiled in further disagreements with Viazemskii concerning the Academy's accountability to the senate. In short, the controversy re-

volved around the Academy's two-part budget. The first was a state fund and depended on an allocation it received from the state treasury, just as any other governmental entity. The second was an administrative fund, which depended on the Academy's profits from various commercial ventures such as the publication and sale of books. Traditionally, these assets were fully at the disposal of the director, with spending at her discretion, and might include the payment of bonuses or purchases not covered by the Academy's original charter. The distinction between the two funds was not always clear. For instance, with the money gained through her commercial ventures such as the sale of books at the Academy, Dashkova was able to begin paying off money owed booksellers in Russia and abroad and also to make good on the arrears of the state fund, which was now completely in Viazemskii's control.

Further, Dashkova felt that Viazemskii had attempted to wrest control not only of the state fund, but also of her administrative budget on the pretext of the need for accountability in view of past abuses. By imposing an audit on all profits, the senate was in fact constricting Dashkova's administrative and discretionary powers. She took such an abridgement of her directorial powers personally and it became a point of honor for her. She would not allow such encroachment on her powers through the imposition of "a system of accountancy which had never existed in the history of the Academy—not even," Dashkova added, "under my predecessor who had been suspected of peculation" (211). In an effort to counter the limitations imposed on her authority, Dashkova addressed a series of letters to Bezborodko and Catherine.[20] She pleaded her case to Bezborodko, "Personally, I can endure a great deal, but in my current position I will not allow public humiliation and shame."[21] Chiefly disconcerting was her predecessors' freedom to use profits as they saw fit without official accountability. She also made the point that the senate had not applied such stern measures equitably and Moscow University, among other institutions, was exempt. The debate became so heated that Dashkova was ready to resign, forcing Catherine to step in and look for a compromise solution. According to her decree of May 7, 1783, Dashkova was required to present to the empress herself a short, monthly report, thereby satisfying issues of access and accountability and Dashkova's desire to work with the empress directly.[22] Dashkova had gained the day: She took complete control of the budgets and all expenditures were subject to her authorization.

Nonetheless, another dispute concerning her salary as director of the Academy of Sciences was especially upsetting and humiliating. The director's salary was set at two thousand rubles annually, but Catherine's decree

of January 16, 1777, provided Dashkova's predecessor, Domashnev, with a raise of one thousand rubles. When Dashkova also apportioned three thousand rubles for herself, Viazemskii accused her of improper financial dealings. Dashkova was livid and felt that he had publicly demeaned her with the accusation that she had unilaterally taken more money for herself than was allowed. Indeed, the squabble with Viazemskii over salary had more to do with honor than money. Dashkova wrote Bezborodko about the matter and once again, Catherine stepped in to mediate the dispute.[23] On January 8, 1784, Catherine decreed that Dashkova would be paid three thousand rubles, or a sum equal to what Domashnev had received.[24] Eventually, the economic situation so improved at the Academy that the director's salary came out of Dashkova's budget and not the empress's.

Regrettably, the ignorant and vindictive (as Dashkova would have it) Viazemskii continued to create difficulties for her. He would either ignore her recommendations or refuse to provide her with required funds and materials. For instance, on March 15, 1783, the senate commissioned the Academy to prepare a general atlas of Russia. The Geography Department at the Academy had produced the most recent map of Russia in 1776, when it prepared the "General Map of Russia" for the fiftieth anniversary of the Academy of Sciences. But it was now dated, in light of the recent restructuring of the administrative divisions of Russia, among them, the increase of twenty provinces to forty. Gathering the required data proved to be a difficult task, and Dashkova recalled in her *Memoirs* that Viazemskii impeded her work by restricting her access to information concerning the redrawing of the new provincial borders. Nevertheless, in 1786, the Academy published the "New Map of the Russian Empire," and based on this map, in 1787 V. Kraft for the first time calculated the area of Russia.

Despite ongoing financial constraints imposed on her by Viazemskii, Dashkova was ready to deal with difficult and unpopular matters. Under the former director, the Academy had gained a reputation for corruption and mismanagement, so Dashkova stressed to her subordinates that she was not planning to enrich herself at the Academy's expense and would not tolerate any fiscal irresponsibility on their part. Dashkova assumed the administration of the Academy at a critical moment in its history. It was heavily in debt, owing money to its publishers and booksellers, while academicians and staff were yet to receive their back wages. Because of its economic woes, it could not go forward with many of its projects, conferences, and research, and Dashkova felt that she was "harnessed to the plough which, broken-down as it was, became my responsibility" (203).

With characteristic energy, she threw herself into her administrative work and took on the task of restoring economic order in the highest and most prestigious institute of learning in the country through the implementation of organizational, administrative, and economic initiatives. Focusing on the minutiae of administrative work, as soon as she assumed the directorship of the Academy, Dashkova took an active role in the work of the business office.[25] The business office, which Dashkova headed, oversaw the Academy's administrative and economic affairs. It was, among many other duties, responsible for the gymnasium, various workshops, the printing office, the publication of the *St. Petersburg Gazette,* and the sale of foreign books on commission. Dashkova would arrive promptly at nine in the morning and review the day's reports, petitions, and all current business. She would then issue instructions and record them in the registry of the business office. For the year 1784, of the 926 instructions recorded, Dashkova signed 747, with the only exceptions being the summer months May 24 to September 5, 1784, when she was away from St. Petersburg and had left her assistants in charge.[26]

No organizational or economic matter escaped her notice. She was industrious, enterprising, and involved in academic and commercial ventures. At the Academy bookstore, she organized a sale of academic books at a 30 percent reduction, and was able to realize a profit. Concurrently and without hesitation, she burned all books that Domashnev had ordered that contained what she considered obscene and depraved content. In April 1783, when the manager of the bookstore, E. Vil'kovskii, chose to ignore Dashkova's regulations, she fined him fifteen rubles.[27] In addition to its own publications, the printing office at the Academy accepted outside orders and would often encounter problems collecting payment for its work. In November 1783, Dashkova wrote to Nikolai Novikov, the enlightener, writer, journalist, and publisher, about his nonpayment of bills.[28] The Academy had received the order for his dictionary of Russian writers in 1773 and the book was printed, but Novikov could not pay for it. Despite repeated reminders, Novikov did not settle his account, so Dashkova turned to the curator of Moscow University, Ivan Shuvalov for help.[29] Apparently, her letter had the desired effect and according to records at the Academy, in 1784 it received a sum of 839 rubles and 11 kopeks from Novikov, and shortly thereafter, released to him 461 copies of his book.[30] In the first five months of her directorship, Dashkova settled unpaid debts amounting to over 8,500 rubles.[31]

Dashkova strictly adhered to policies and regulations, especially as they concerned financial matters. When on a number of occasions the widows

of academicians petitioned for supplementary funds, Dashkova denied their requests. Accordingly, A. V. Khrapovitskii wrote that at court many individuals considered Dashkova avaricious and "incapable of getting along with others."[32] In her financial dealings she was honest, and there were no hints of financial irregularities or funds used for her own, private needs. Within a year, she reorganized the institution, brought its financial and administrative matters in order, and established budgetary measures that allowed her to take care of all the debts and to realize a large surplus. The empress complimented Dashkova for her ability to raise money and to use it judiciously on appropriate projects.[33] Her parsimony, however, would engender a number of stories about her handling of seemingly the most insignificant details of academic business. Gilbert Romm, the French tutor of Pavel, thirteen-year-old son of Aleksandr Stroganov, recalled how the old count had purchased a book from Dashkova for five rubles. It turned out to be a presentation copy from the author, so Dashkova, who realized her mistake, requested its return. She then sent the same volume back to the count, but this time with the title page, containing the author's inscription, torn out.[34]

At the Academy, Dashkova's strength as an administrator was the consciousness of her limitations and the understanding that she was not a scientist. She did not ignore the work of her colleagues, nor did she impose her ideologies or methodologies on their work. Rather, her function, as she saw it, was to facilitate their activities, and she soon brought to an end the policy of dismissing members with so-called inappropriate opinions. But Dashkova was not simply an academic administrator; she was involved in every aspect of academic work, to the point of initiating educational programs, writing up instructions for projects, outlining the direction of the research, establishing goals, organizing the itineraries of expeditions, securing financial support, and providing for the dissemination and publication of findings. Her enterprising spirit touched not only the bookstore and printing office, but also the renting of property, sale of maps, and outside consulting work. She personally chaired academic meetings, along with her advisers O. P. Kozodavlev and V. A. Ushakov, and was rarely absent. Kozodavlev counseled her directly and assisted with the publication of her journal, while Ushakov advised her at the business office. When it was impossible to attend meetings, Dashkova relegated the responsibility to her secretary, I. I. Lepekhin. A scientist, naturalist, specialist in the Russian language, and a brilliant stylist, he was her closest colleague, and from 1783 to his death in 1802 the permanent secretary at the Russian Academy. Dashkova handpicked her staff, nominated new members, distributed as-

signments and saw to their execution, and supervised discussions. Her administration was democratic and during deliberations she was equal to other members and carried only one vote: "Despite the biases of the age and existing social conditions, she [Dashkova] acknowledged equality as fundamental to academic life."[35]

Dashkova attempted to create a serious atmosphere conducive to research and inquiry. One of her early goals was to free the academicians from excessive committee work and the burden of bureaucratic and administrative chores. She also set out to relieve scholars of outside interference and to foster a climate of research and scholarship. Academicians now answered to the director of their own conference, rather than an impersonal administrative office.[36] She doubled the salary of Nicholas von Fuss, who was planning to resign his position at the Academy, and of Johann-Gottlieb Georgi, a specialist in natural history and chemistry. A versatile scientist of great learning, Georgi was an accomplished ethnographer who also practiced medicine. To reward the most gifted and productive academicians and staff members she turned to Viazemskii with a request for their promotions; however, it fell on deaf ears and marked her constant frustrations and ongoing battles with Viazemskii.[37] Eventually, she raised the salaries and promoted many of her colleagues at the Academy, although it was always a struggle to find the necessary funds. In January 1784, Dashkova once again turned to the empress and over the years continued petitioning her about the promotions of Kozodavlev, Ushakov, and others.[38] Dashkova demonstrated great concern for her staff, especially for the less fortunate, poorly paid individuals. She proposed to establish a pension fund from a portion of the Academy's profits.[39] Catherine praised and approved Dashkova's plan and on March 21, 1791, signed an edict allocating thirty thousand rubles from the Academy's budget, with interest drawn from this sum going to the establishment of a pension fund.[40]

Dashkova's energy and organizational skills allowed her to activate the publication and translation activities of the Academy, which she felt were essential for the dissemination of knowledge in Russian. One of Dashkova's first projects was to reissue the suspended *Commentaries* and to restore the Academy's business documents, the *Archive of the Conference of the Academy of Sciences* (*Arkhiv Konferentsii Akademii nauk*), which had remained unbound with many omissions.[41] The Academy's scholarly works, an annual publication, appeared with great delays and there were many backlogged articles. In 1783, Dashkova published the first volume, entitled *Acta Academiae*, containing works written in 1779. From 1783 to 1786, she brought out six more volumes with articles written from 1780 to 1782. Although some of

the articles were three years old, she had stepped up the production rate significantly. Under her personal supervision, the Academy undertook the first publication of the collected works of M. V. Lomonosov (*Polnoe sobranie sochinenii*, 1784-87), the fifth and sixth editions of his Russian grammar (*Rossiiskaia grammatika*, 1788, 1799), and three editions of the *Short Guide to Rhetoric* (*Kratkoe rukovodstva k krasnorechiiu*, 1788, 1791, 1797).

Dashkova worked enthusiastically on the preparation and distribution of scholarly editions at the Academy publishing office and the bookstores in St. Petersburg and Moscow. She oversaw the publication of such works as S. P. Krasheninnikov's study of Kamchatka (*Opisanie zemli Kamchatki*, 1786) and the continuation of I. I. Lepekhin's account of various Russian provinces (*Dnevnye zapiski puteshestviia doktora v Akademii nauk ad'iuntka Ivana Lepekhina po raznym provintsiiam Rossiiskogo gosudarstva v 1768-1772, 1771-1805*). A very influential study, which appeared during Dashkova's directorship and which constituted a major event in the history of Russian science and the Enlightenment generally, was L. Euler's *Letters on Various Physical and Philosophical Matters* (*Pi'sma o raznykh fizicheskikh i filosofskikh materiiakh*, 1768-1774, 1785, 1790-1791, 1796). Euler's lucid and generally accessible exposition, which was comprehensible to the non-specialist, assured its success. Dashkova patronized writers and in 1784, she acquired for the academic bookstore a thousand copies of I. F. Bogdanovich's *Dushen'ka*. Earlier she published and distributed at the Academy's expense 2,400 copies of his *Istoricheskoe izobrazhenie Rossii* (*Historical Representation of Russia*), and the next year she published his *Collection of Russian Proverbs*.[42] In 1788, she bought up 150 copies of Ia. Kniazhnin's works, and in 1793, the Academy published five issues of the journal *Sanktpeterburgskii merkurii*, edited by and including the plays of I. A. Krylov and A. I. Klushin.[43]

Dashkova initiated a number of ambitious translation projects, such as G. L. Buffon's multivolume *Histoire Naturelle* (*Vseobshchaia i chastnaia estestvennaia istoriia*, 1789-1808). In February 1790, she established a department for the training of translators, which A. P. Protasov headed. According to Dashkova, it was imperative to create a state system of education, and as head of the Academy of Sciences, she enthusiastically supported Catherine's school reforms of the 1780s and 1790s. The Commission on National Education turned to the Academy with a request to translate some Austrian schoolbooks and work began in March 1783.[44] The Austrian edition of *Schauplatz der Natur und der Künste*, with 480 prints (*Zrelishche prirody i khudozhestv*, 1784-1790) was the first popular encyclopedia of science and technology published in Russia for the edification of its youth. In the main, she was involved in nearly all aspects of the Academy's publications. She reviewed

the lists of books, set their prices, negotiated agreements with booksellers, maintained standards, and reviewed accounts from the printers. Her other actions included the modernization of the printing office with the acquisition of new type, a new press, and the updating of existing equipment. The most important printing press in the country was then located at the Academy of Sciences. According to M. I. Sukhomlinov, "Everything that concerned the internal workings of the Academy and its external condition was close to Dashkova's heart, and she spared neither time nor labor to guide her creation to the highest degree of perfection."[45] She updated the chemistry labs as well as the mineralogical and physical cabinets, to which she contributed some of her own specimens, and expanded the botanical gardens to ten times its original size.[46] From 1783 to 1793, she expended eighteen thousand rubles on the upkeep of facilities and undeterred by criticism, spent ninety-nine thousand on building projects.[47] During the same period, the library grew by some four thousand volumes. Dashkova had the library collection systematized, a catalogue written in Russian and German, and personally contributed many gift editions.[48]

She sought to support the academicians and possessed a close and limitless personal interest in their areas of expertise. A case in point was Dashkova's effort to obtain an exact model of the observatory at Greenwich with a particular description of the means employed in moving the shutters for the purpose of astronomical observations. William Herschel's construction in 1787 of a large and powerful telescope for his observatory in Slough, England, fascinated her. In 1789, Joseph Lalande, French astronomer and director of the Paris Observatory, wrote her of Herschel's discovery of a satellite of Saturn. More ominously, he stressed that in France "politics is what now absorbs the attention of all the world" and that "the troubles of France are a little calmed, but the spirit of insurrection among the people, and even among the soldiers, is a dangerous source of evil."[49] The world was changing while Dashkova worked tirelessly so that research and scholarship could better serve modernization and technical advancement. Because of her participation in her son's studies, she considered military science and engineering an area of special interest. Therefore, she turned her attention to questions concerning navigation and its possible military applications. On February 18, 1793, she commissioned F. I. Schubert to research an article by Jonathan Williams. Williams was secretary to his great-uncle Benjamin Franklin when Franklin was ambassador to France. She corresponded with Williams, the future superintendent of West Point, and channeled many of Williams's and Franklin's scientific and military

writings to the Russian Navy Ministry and the Russian Academy of Sciences for their prompt translation and circulation. On November 12, 1792, Williams sent Dashkova his "Memoir of the Use of the Thermometer in Navigation," reprinted from the third volume of the American Philosophical Society's *Transactions*. Schubert wrote a positive evaluation of the work, and basing his findings on some of Franklin's experiments, he postulated that seawater was colder in the area of shoals and reefs. Outwardly enthusiastic about "the great importance of this discovery," Dashkova was nevertheless skeptical and sent all of the documentation to the Admiralty requesting further experimentation, which proved negative and showed no results. All further testing ended with Dashkova's departure from the Academy.[50]

Since Dashkova personally knew many of the leading minds of the time, the Academy expanded its scholarly and institutional contacts with the West, established closer ties with foreign centers of learning, and inducted members from abroad. The number of honorary foreign members increased, such as the historian William Robertson and the chemist Joseph Black from Scotland in 1783, and the mathematician A. G. Kästner and the philosopher Immanuel Kant from Germany in 1785 and 1794 respectively. Benjamin Franklin became the first American to gain membership in the Academy in 1789. A wide circle of readers in Russia first learned of Franklin's experiments in June 1752 through an article in the *St. Petersburg Gazette* (*Sankt-Peterburgskie vedomsti*). At that time in St. Petersburg, Lomonosov and his friend and sometime collaborator Georg Wilhelm Richmann were investigating atmospheric electric discharges, during which Richmann lost his life. On March 5, 1754, Franklin's *Pennsylvania Gazette* published a detailed description of Lomonosov's experiment. In addition, Ezra Stiles at Yale University requested that Franklin pass on to Russia a letter he had written to Lomonosov on February 20, 1765, concerning some thermometrical observations conducted in Boston. Over the years, there were further contacts between Franklin and Russia, with, for example, D. A. Golitsyn, who was also interested in atmospheric electricity, writing Franklin in 1777. Franklin's *Poor Richard's Almanack* was the first work by an American author translated into Russian, and his *Autobiography* enjoyed great popularity in Russia and was reviewed by Karamzin.[51] In turn, Dashkova became a member of a number of foreign academies. In 1789, on the recommendation of Benjamin Franklin, she was the first woman and second Russian to be elected a member of the American Philosophical Society. Adding to her honors, Dashkova filed in the Academy archive a

copy of a diploma testifying to her selection as an honorary member of the Royal Irish Academy in Dublin in 1791.[52] She was also a member of the Stockholm Academy and the Berlin Society of Naturalists.

A fundamental undertaking of Dashkova's administration at the Academy was the education of young people, and she devoted much of her energy to the revitalization of the gymnasium. The university closed in the 1760s, but the gymnasium would last until 1805, and in 1765 the gymnasium of the Academy of Sciences was located in the house of Baron Strogonov on the Tuchkov Embankment. Again, money matters were her greatest concern. Dashkova's letter to Viazemskii about sending three students to the Tobolsk region, dated December 13, 1783, was full of resentment and exasperation that the Academy's educational mission, and above all the gymnasium where young men were being prepared for teaching and government service, was not properly understood or supported.[53] For instance, she made every effort to place deserving graduates in various positions, and in 1788, she again had to turn to Viazemskii for his assistance; true to form, he refused. Undeterred and as part of her commitment to the educational mission of the Academy, she strove to increase enrollments. Dashkova wrote that there were only two students enrolled in the gymnasium when she assumed control, but she was seemingly exaggerating, since there were close to thirty students studying there. She immediately dismissed six whom she considered incapable of study, and over time she was able to triple enrollments, increasing the number of students to about ninety. Subsequently, from 1786 to 1795 the number of students at the gymnasium increased from 90 to 175.[54] Most of the students were granted financial aid, and some of those who did not receive support were allowed to sit in on courses as auditors. Not all of the students were from the nobility, and in 1785, Vasilii Popugaev began his studies there. Of peasant origin, he went on to be a poet and advocate of freedom associated with Radishchev's circle.[55]

Dashkova concentrated on staffing, strengthened the curriculum, and did not shy away from firm and decisive measures such as releasing incompetent or disinterested educators. Without hesitation, she dismissed an instructor of classics for lacking conscientiousness in the exercise of his pedagogical duties and abolished the position of a violin instructor earning eight hundred rubles annually, replacing it with two positions in English and Italian.[56] Music performance was not a high priority, while preparation in languages represented part of her agenda to further contacts with the West through academic exchanges and the translation of important scholarly works. Dashkova herself even tutored some of the students in

languages. She initiated a more rigorous system of examinations for students, regularly requesting that academicians be present at examinations scheduled twice annually at the gymnasium. She was personally present at some of them and reacted swiftly when dissatisfied with the performance of students. After attending one oral examination in mathematics held during the autumn of 1792, Dashkova became concerned about the low level of performance she had witnessed and after conducting an inquiry, concluded that it was neither the fault of the instruction nor of the students but was a result of the inadequacy of the course of study itself. She therefore commissioned the mathematicians at the Academy to design a more suitable and challenging curriculum, which would be clear, concise, and focused.

In the academic world, the German influence was profound as Russian students attended German universities and many Germans worked at Moscow University and the Academy of Sciences. The most gifted and accomplished students where provided with the opportunity to further their studies abroad, and in 1785, the Academy sent four students to Göttingen University. Tübingen University was also a favorite foreign destination. A prestigious institution of higher learning in the eighteenth century, its name was associated with the Gmelin family of scientists, who were primarily in the areas of chemistry, botany, and mineralogy, with the physicist and writer G. C. Lichtenberg and the mathematician and epigrammatist A. G. Kästner. In order to bring in new ideas and to energize the work of the venerable Academy, Dashkova organized internships for eight university and gymnasium students, who worked alongside the academicians, voted at meetings, and prepared for full-fledged membership. Dashkova's efforts were to show extraordinary results, and three of the gymnasium students went on to become academicians. Also at this time, F. I. T. Epinus wrote his influential "Plan for the Organization of Primary and Middle Schools," a work which was to provide the groundwork for all subsequent school reforms.[57] Under Dashkova's directorship, the Academy took part in the educational reforms of the 1780s and 1790s, in the training and recruitment of the best teachers, and in the writing of new textbooks. Of the eighty books then prepared for newly opened schools, approximately thirty were written at the Academy.

Among Dashkova's most important initiatives at the Academy of Sciences were the lectures she organized for the benefit and edification of students at the gymnasium and the public alike. Given by some of the leading scholars of the time, they played an important role in Dashkova's goal to enlighten and cultivate Russian society by nurturing an interest

in learning while elaborating and elucidating the goals of research and scholarship. On July 3, 1783, Dashkova recommended that members of the Academy might consider devoting "a portion of their free time, over and above their scholarly pursuits, to the reading of public course lectures."[58] This represented an outreach program aimed at individuals who wanted to continue their education or who had not been able to complete it as traditional students. Having restored academic responsibility at the Academy and having saved a considerable sum from its operating budget, on March 25, 1784, Dashkova submitted her report to Catherine requesting permission to initiate these general lectures and stressing that they would be in Russian and not French. Dashkova argued, "The reading of lectures in Russian . . . seems to be all the more useful, since learning will be translated into our language and enlightened ideas will be disseminated."[59] In her decree of April 20, 1784, Catherine approved Dashkova's proposal and allocated thirty thousand rubles, so that the accrued interest from this sum, or approximately 1,500 rubles, would go to professors as honoraria for their participation.[60] Having received Catherine's support, Dashkova revitalized the tradition of public lectures that Lomonosov had established. They served Dashkova's purpose of transforming Russian society through the propagation of Enlightenment ideas, and she modeled them at least partially on similar lectures at the Bavarian Academy of Science and at the Royal London Society.

Schedules and information concerning the lectures appeared in the *St. Petersburg Gazette*, and Dashkova had leaflets distributed to the leading institutions of learning as well as posted in the streets of the city. Lectures were available in St. Petersburg free of charge to all during the four summer months, from May to September, twice weekly for two hours. Inaugurated in 1785, the lecture series continued until 1802 with leading Russian specialists — S. E. Gur'ev, Ia. D. Zakharov, S. K. Kotel'nikov, N. Ia. Ozeretskovskii, V. M. Severgin, N. P. Sokolov — covering a wide range of subjects including mathematics, chemistry, physics, natural history, and mineralogy.[61] The academic lectures were very popular and well received. Dashkova often attended them to monitor their progress and success, and was pleased that young people who could not otherwise afford to continue their education attended them (208). Ozeretskovskii wrote Dashkova that his talks attracted a large number of participants and at times, his enrollments exceeded fifty listeners.[62] Those present included the general public as well as advanced students of diverse interest from various institutes of the city such as the medical school, the military academy, the shipbuilding institute, the central public school, the academic gymnasium, and the

pedagogical seminary. For example, I. I. Martynov, a young seminarian and son of a village priest, regularly attended the lectures. He would be one of the founders of the Lyceum in Tsarskoe Selo, a top school where Pushkin and Kiukhel'beker, as well as many others, studied.

Among Dashkova's many duties at the Academy, nothing was more difficult and frustrating than the solicitation of financial support from Catherine and her advisers. In order to implement and maintain her academic programs and initiatives, she plunged again into the political disputes and intrigues at court. Accordingly, when Paul and his wife returned from abroad, Dashkova avoided the royal couple and rarely visited them "on the pretext," she explained, "that my time was absorbed by work. . . . For ten years afterward I faithfully followed this line of conduct, and never visited Their Imperial Highnesses except on state occasions when they were attended by the whole court" (210). Dashkova witnessed the strained relationship between the grand duke and his mother and in 1783 declined his invitation to come to Gatchina.[63] Distancing herself from Paul did not in the end protect Dashkova from his anger or save her "from being harassed and persecuted by him in common with those whom he claimed to have offended him or harmed his interests" (211). Catherine's court, however, was hardly a place of refuge as Dashkova continued to battle the empress's courtiers and favorites, and at times, the empress herself. Catherine, with her coterie of young lovers, openly disregarded traditional morality in her personal life, something common for a nobleman at that time, but unacceptable for a woman. Dashkova was jealous, did not approve, and universally detested all of the favorites, especially Grigorii Orlov, Aleksandr Lanskoi, and Platon Zubov.

Gradually, new enemies replaced forgotten old ones, and in the *Memoirs,* Dashkova failed to mention the death of her nemesis Grigorii Orlov in 1783. There were new battles to fight at the Academy of Sciences and new opponents to vanquish. She was interested in results and interpersonal skills were rarely a high priority, while her cost-cutting measures, many of which Viazemskii imposed on her, met active opposition. Some of Dashkova's colleagues continued to be displeased with Dashkova's administration and still refused to accept a woman's leadership at the Academy. There were also the inevitable squabbles and deceptions. Dashkova could be too dictatorial, too full of administrative ardor, and at times too inflexible, overbearing, and biased. She could be especially severe and demanding in her dealings with subordinates. For instance, she failed to recognize the talents of I. P. Kulibin and detested Peter Pallas, a geographer, naturalist, paleontologist, geologist, ethnologist, and one of the most

prominent members of the Academy of Sciences. Elected to the American Philosophical Society in 1791, he directed expeditions for the Academy and was the author of studies describing remote areas of Russia and Siberia. A highly regarded naturalist best known for his volumes on travel in southeastern Russia, Siberia, and the Crimea, he lacked, as she would have it, "all principles and morals ... was vicious, [and] was out for personal advantage" (216). Other academicians mentioned his financial improprieties and at one point, officials at the Academy held back Pallas's mail for suspicion of selling specimens abroad. Problems arose at the end of 1783 when the adjutant V. F. Zuev, Pallas's academic assistant, agreed to serve on the Commission for the Establishment of National Schools and as a result was late in submitting the report of his expedition.[64] Dashkova felt that Zuev's tardiness was a result of his willingness to forego academic work in favor of other more profitable endeavors. She considered such additional employment to be a breach of contract and summarily expelled him from the Academy: "Regrettably, but as an example to others."[65]

She also requested that colleagues carefully scrutinize Zuev's published works for inaccuracies and unscientific practices, but a group of academicians came to his defense. Among them was his academic director, Pallas, who was unable to sway the determined Dashkova. Having gotten nowhere with her, he went over her head and petitioned the empress, who issued a signed edict on March 4, 1784, ruling in his favor and stressing the need for the participation of learned individuals such as Zuev on her Commission.[66] Despite Dashkova's disfavor, Zuev went on to become an academician, while Pallas would continue to be her enemy; there were other unpleasant situations, especially when he worked closely with Catherine on editing her dictionary. Dashkova suspected Pallas of spreading rumors at court that the academicians were unhappy with her administration. When she attempted to close down the old chemistry laboratory, the academicians vigorously opposed her. Dashkova was hurt and angered, feeling that they undervalued her understanding of their needs in the sciences. Her response was direct, resolute, and unprecedented—she called for a vote of confidence. The vote went overwhelmingly in her favor, with the notable exceptions of Pallas and A. I. Leksel'. Pallas was still distraught over the Zuev affair, while Leksel' considered himself underpaid.

Dashkova also quarreled repeatedly with the celebrated Italian architect Giacomo Quarenghi during the construction of the new building of the Academy of Sciences. Initially, meetings of the Academy were held at the palace of Tsarina Praskovia Fedorovna (currently the site of the Academy's zoological museum) and in the Kunstkamera. Over time, however,

the buildings required major renovations, since the existing quarters were cramped, uncomfortable, and did not meet the basic requirements of the Academy's ever-expanding role in scholarship and research. Dashkova wrote Catherine of the need to construct a new building for the Academy of Sciences.[67] Quarenghi, who arrived in Russia in 1780, favored a strict neo-classical style based on Palladio over the more ornate Russian baroque style popular during the reign of Empress Elizabeth. Catherine commissioned him to head the project, lasting from 1783 to 1785 at the cost of some ninety thousand rubles. Construction began in 1783 on an open plot of land located on the Vasil'evskii Island between two architectural monuments, the Kunstkamera and the building of the Twelve Collegiums.[68] Qaurenghi designed the building, with its façade facing the Neva, but Dashkova took a keen interest in the work since she always considered architecture to be an area of competence and wrote that "nothing interested me as much as architecture" (215). Dashkova kept close watch over the project's progress and was tireless in her efforts to see it to its conclusion. In his memoirs, F. F. Schubert, the son of the astronomer and academician F. I. Schubert, recalls her close oversight of the construction. She "would visit the site at least once and on occasion twice a day. When she climbed up on the scaffolding she could be mistaken for a man dressed as a woman."[69] Disputes and a clash of wills were inevitable between the royal architect and the director of the Academy. The temperamental architect finally grew tired of what he felt to be her constant meddling and completely lost his temper when she recommended the installation of windows in the Venetian style. On March 21, he wrote her in a fury that "if this project is to be altered according to your ideas, then in that case I will no longer supervise the construction and my involvement will cease on what has been built to this point."[70] Unfortunately, the conflict between the two headstrong individuals could not be resolved, and the project continued without Quarenghi's further involvement. The exterior was finished in 1787, with interior work continuing until the 1790s.[71]

Although she could be impatient with some, particularly timeservers, careerists, and those whom she did not respect, Dashkova was for the most part tactful and respectful to the academicians. M. I. Sukhomlinov greatly admired her work at the Academy and wrote positively about her temperament.[72] Other commentators have written that she was an outstanding organizer with an exceptional mind, brilliant education, and boundless energy — a woman of character and determination.[73] At the Academy, she participated fully in its scholarly, pedagogical, and publishing activities: she oversaw research projects, instituted courses and public lectures, and

initiated the publication of important scholarly works. In the "Report to Catherine II on the Condition of the Imperial Academy of Sciences, When I Assumed its Directorship, 1783, and Currently, 1786" she provided a full account consisting of forty-five points concerning her administration during a three-year period of her tenure.[74] It represents a testament to Dashkova's energy and business-like attitude, it outlines her work in the first few years of her administration, and it predicts her major achievements in the future. In the twelve years of her directorship, the number of important publications grew and included many previously unpublished works. Moreover, Dashkova efficiently reorganized the institution itself, expanded the library and mineral collection, improved the quality of its publications, created maps, organized a number of expeditions into various areas of underexplored Russia, paid the Academy's debt, and eliminated all budget dsweficits. On August 5, 1794, at the end of her directorship, Dashkova again submitted a report to Catherine on the economic state of the once insolvent Academy. Now, its liquid assets, when taking into account the bookstore, library, and printing press, approached half a million rubles.[75] She was justifiably proud of her record and achievements.

Chapter Eight

The Russian Academy

THE YEARS OF HER DIRECTORSHIP were not devoted entirely to running the Academy of Sciences. During the first several years particularly, she was part of the court and high society life of St. Petersburg, attending more than ever before functions at the Winter Palace, performances at the Hermitage Theater, balls at the Tauride Palace, and other social events given by the most powerful people in the land. At Aleksandr Bezborodko's, for instance, she met the Count d'Artois of France, the future Charles X and brother of Louis XVI. While gaining access to the crown and entry to the most influential level of society, Dashkova, as director of the Academy of Sciences, was keenly aware of her eminence and exceptionality. She was a woman temporarily in a position of power and the peaks and valleys of her life described a paradigm of exile and return. They were the by-products of choices available to men, and included the responsibilities and consequences inherent in these choices. An unavoidable result of her prominence was a double identity, as she acted out certain well-defined male roles, although clearly conscious of herself as a woman in a man's world. As never before, the uniqueness of her life at court and at the Academies brought her into direct contact, competition, and inevitable conflict with members of the empress's inner circle.

The distinctive nature of Dashkova's appointment hit home fully only a few months later, when in June 1783 Catherine traveled to Frederikshamn, Finland, for a three-day negotiation with King Gustav III of Sweden. Catherine invited Dashkova to join the delegation and accompany her, and so she embarked with the empress by launch across the Neva River to the Vyborg side of the city, where carriages were waiting for them. On her trip to Finland, Catherine's entourage included the favorite Aleksandr

Lanskoi, state-secretary Aleksandr Bezborodko, the senator Aleksandr Stroganov, the chief-equerry Lev Naryshkin, the steward of the household Fedor Bariatinskii, vice president of the Admiralty Collegium Ivan Chernyshev, the chamberlain Egraf Chertkov, and the equerry Mikhail Potemkin. Listed first in official documents, and riding in Catherine's carriage, Dashkova looked around at the empress's embassy and realized that "I was the only woman. The rest were all men" (223).[1] Dashkova was not blind to the historical and political significance of her accomplishments. It was an invigorating and exciting moment for her as she looked forward to meeting the King of Sweden, an accomplished writer, dramatist, and great patron of the arts. She soon learned that the king's brother, known as the Duke of Sudermania (subsequently crowned Charles XIII), whom she had met in Spa, intended to decorate her with the Grand Cross of the Order of Merit, an honor heretofore never conferred on a woman. Presumably, not to offend Catherine, Dashkova declined the order of the large cross, and in so doing demonstrated her loyalty to her sovereign.

While she considered the king to be an educated, witty, and eloquent ruler, she had mixed feelings about meeting him, perhaps because of his opposition to the Swedish Parliament or his extreme Francophilia. He was an admirer of Voltaire and the *philosophes,* and Dashkova scoffed at his triumphant journey to Paris in 1771, when courtiers and *philosophes* alike hailed him. In her *Memoirs,* she turned criticism of the king into an opportunity to inveigh against the very notion of royal travel:

> For these illustrious travelers are only shown the most favorable side of everything; everything is so arranged that they can see only the deceptive exterior. Another evil attendant on the travels of sovereigns or their heirs is that neither incense nor adulation is spared to gain them over. When they return home, therefore, they expect adoration from their subjects and are not content with anything short of it (224).

In reality, Dashkova was angrily directing her views on the travel of monarchs at the empress, alluding to Catherine's inspection of the Ukraine and Crimea four years later in 1787, and to Grigorii Potemkin's elaborate preparations for the royal trip, the so-called "Potemkin villages." On that occasion, Potemkin, who organized the trip, did not invite Dashkova to accompany the empress. Now, before her departure from Frederikshamn, the king presented Dashkova with a ring bearing his portrait set in diamonds. Almost immediately upon her return to St. Petersburg, she had the diamonds removed and gave them to her niece Anna Polianskaia.

Rumor, gossip, and misinformation surrounded Dashkova's official duties, to the point that Engel'gardt reported erroneously that Dashkova, whose attitude toward Potemkin was always complex and mostly negative, had criticized him unfoundedly and that the empress had removed her from the position of director at the Academy of Sciences.[2] Conflicts often arose over the most insignificant matters, such as the time when Aleksandr Lanskoi, the gentle and boyish reigning favorite, was first suspicious and then incensed by what he felt to be inaccurate and prejudiced reporting of events in the *St. Petersburg Gazette* surrounding Catherine's trip to Finland. The *Gazette*, published at the Academy of Sciences and therefore supportive of Dashkova, mentioned only her name as accompanying the empress, while ignoring Lanskoi. Yet another such confrontation occurred when Catherine presented Dashkova a bust of herself; it was the work of Russia's highly considered sculptor, Fedot Shubin, whose masterpiece, the bust of Catherine II, is now at the Hermitage Museum. Lanskoi took offense, claiming the statue was his. Catherine ruled in her favor, at which point, according to Dashkova, "he threw a furious glance at me, and I answered back with one expressing nothing but contempt" (211). In the end, she dismissed his whims and accusations as stupid and asserted unkindly in the *Memoirs* that at his death "Lanskoi . . . quite literally burst—his belly burst" (226). Sources that are more objective ascribed Lanskoi's death to diphtheria or a heart condition.

Dashkova continued to rely on Catherine's support and sponsorship, and one day, by her account, she was walking with Catherine in the opulent grandeur of the English Garden at Tsarskoe Selo, when their conversation turned to Russian culture, its language, and the need to preserve both against the encroachment of foreign influence. Dashkova spoke of a Russian Academy, based on the French Academy she had admired in Paris and on other previously organized societies in Russian for the study of language and culture. Catherine encouraged her to put her thoughts in writing and submit them to her as soon as possible. Although she seemed to have been reluctant to do so, Dashkova sat down to work that evening after supper. In the proposal to the empress written in August 1783 and entitled "Report to the Empress Catherine II on the Founding of the Russian Academy" ("*Doklad imperatritse Ekaterine II ob uchrezhdenii Rossiiskoi Akademii*"), Dashkova wrote that it was imperative at that time to purify and enrich the Russian language, especially in view of its richness and strength. She also sketched out a preliminary plan, the "Short Draft on the Imperial Russian Academy" ("*Iz kratkogo nachertaniia Imperatorskoi Rossiiskoi Akademii*"), in which she called more concretely for the standardization of grammar,

usage, and rules of versification through the publication of a Russian grammar, an authoritative academic dictionary, and a handbook on rhetoric.³ Having read the draft, Catherine signed a decree on the establishment of the Russian Academy and named Dashkova its first president, "Resolution of Empress Catherine II on the Matter of the Founding of the Russian Academy, 30 September 1783" (*"Rezoliutsiia imperatritsy Ekateriny II po povodu uchrezhdeniia Rossiiskoi Akademii"*).⁴ Subsequently, however, "Catherine appeared to have shown little direct interest in the Russian Academy's proceedings."⁵ Nevertheless, through her support of Dashkova's initiative, Catherine's actions were again groundbreaking, and Herzen went so far as to say, "Catherine II, by appointing her [Dashkova] president of the Academy, acknowledged the political equality of the sexes."⁶

While the Academy of Sciences represented the various branches of the exact and natural sciences, the Russian Academy was devoted primarily to the study of Russian language, literature, and culture. Dashkova modeled it partially on the French Academy, for while in Paris she had regularly dined with the Abbé Raynal, who made a point of also inviting French academicians. The French Academy dated back to 1635, during the time of Cardinal Richelieu, and its mandate included the purification of the French language and the publication of the academic dictionary, the first edition of which appeared in 1694. In 1707, Frederick I of Prussia based as well the Berlin Academy on the French Academy and dedicated it to research in the areas of German philology and literature. Russian precursors also existed, and the direct antecedent to the Russian Academy was the Russian Society (*Rossiiskoe Sobranie*), which was part of the Academy of Sciences. Founded in March 1735, it was the first official study group of Russian philologists such as Lomonosov, Trediakovsky, and Sumarokov. It existed for only three years and Lomonosov later regretted the absence of a philological section at the Academy of Sciences, or of an institute that would monitor and determine the development of the Russian language. After Lomonosov's death, the Academy of Sciences ceased almost entirely to concern itself with questions of Russian philology. Only in 1771, with the establishment of the Free Russian Society (*Vol'noe Rossiiskoe sobranie*) at the University of Moscow, was another effort launched to study the Russian language scientifically. Founded for the enrichment, correction, and perfection of the Russian language through the publication of Russian verse and prose, its members included Dashkova, Rzhevskii, Kheraskov, Fonvizin, Kniazhnin, Derzhavin, Khvostov, Shcherbatov—all future members of the Russian Academy. With time, however, the Free Russian

Society abandoned its philological concerns and became completely involved with issues of the Enlightenment.

Little expenditure of funds was required for the annual maintenance of the Russian Academy since Dashkova reconfigured the translation group Catherine supported at the Academy of Sciences. She thereby freed up five thousand rubles, "which, to judge by the few thousand translations that have appeared up till now, have been considered by them [former administrators] as their pocket-money to be spent for their own needs" (214). Dashkova was referring to the "Assembly for the Translation of Foreign Books," to which Catherine in October 1768 allocated a stipend of five thousand rubles annually. It was part of her program to bring enlightenment to Russia through the translation of foreign books into Russian, and Vladimir Orlov, Andrei Shuvalov, and Grigorii Kozitskii administrated the project. Dashkova, who was not on friendly terms with them, closed it down, and even accused them and others with the misappropriation of funds.[7] The translation commission existed until 1783 when the Russian Academy absorbed it, and therefore, when Dashkova took over the allocated stipend, only an additional 1,250 rubles were required to pay for casts and medals. In November 1783, the Russian Academy's annual budget was set at 6,259 rubles.[8] As president of the Russian Academy, Dashkova did not receive a salary in addition to the three thousand rubles she had insisted on as director of the Academy of Sciences.

The ceremonial opening of the Russian Academy on October 21, 1783, saw Dashkova inaugurated as the first president of the Russian Academy and the induction of thirty-one members. They were drawn from among the most prominent writers, scholars, and political figures of the day, among them Derzhavin, Kheraskov, Rzhevskii, and L'vov; the dramatists Fonvizin and Kniazhnin; and the historians Boltin and Shcherbatov. Kniazhnin, who was a graduate of the academy gymnasium, along with Derzhavin and Kheraskov, dedicated poems to Dashkova and her Academy. Thankful for his induction, Kheraskov, the poet, dramatist, and curator of Moscow University, proclaimed Dashkova to be "chairwoman of the muses," invoking the muses to sing joyfully now that "Parnassus to Dashkova has been entrusted." Dashkova was pleased and published the work in her journal.[9] Later, the architect Bazhenov, the bibliophile Musin-Pushkin, and the archeologist and artist Olenin became academicians, as well as Catherine's secretary Khrapovitskii, the state-secretary Bezborodko, the academicians Lepekhin, Ozeretskovskii, Ivan Shuvalov, and Rumovskii, who was an astronomer and vice president of the Academy of

Sciences. The list of notables drew upon representatives of the sciences, culture, and government service such as G. A. Potemkin-Tavricheskii, A. V. Olsuf'ev, I. P. Elagin, I. L. Golenishchev-Kutuzov, and A. S. Stroganov. Dashkova's father, Roman Vorontsov, appeared as the fifteenth name listed in the category of government servants.[10]

Despite her fear of public speaking, Dashkova gathered herself, took a deep breath, and stepped up to the podium. From there she looked out over the audience and realized that she was the only woman in the hall. "Gentlemen," she began, "a new instance of the solicitude of our august empress for the instruction of her subjects has this day assembled us together."[11] The study and organization of the Russian language, she explained, would be the Academy's mission. The task ahead would not be an easy one, and "the first fruits of our endeavors, the first offering to be laid at the feet of our immortal sovereign, is a grammar of our language, exact and methodical, and a rich and copious dictionary."[12] Most of all she relied on their support in the enterprises that lay ahead. "It is on your aid, gentlemen, that I count, and the confidence which I place in it is the strongest proof I can give of my profound esteem for you."[13] Dashkova's words at the opening of the Russian Academy were in fact a deeply respectful homage to the legacy of Lomonosov. Many of Dashkova's contemporaries were to ridicule her opening remarks, feeling that they praised Catherine too highly and were too close to Lomonosov's ideas, above all those expressed in the dedication of his grammar to the Grand Duke Paul. Derzhavin reported that some in the audience snickered throughout her address.[14] When it was to appear in the *Moscow Gazette*, Catherine herself edited out some of the inordinate praise Dashkova dedicated to her.[15]

There were scores of organizational matters that required Dashkova's attention, and it was in her nature to oversee personally every aspect of her projects. In a letter to Bezborodko, written two days after the opening, Dashkova requested a building for the Russian Academy.[16] For the time being, she held meetings either in the conference room of the Academy of Sciences or in her house, where members were allowed full use of her library. In 1786, with the money allotted her, Dashkova purchased a new home for the Russian Academy and land for the Botanical Gardens.[17] In November of the same year, another decree called for the minting of two medals to encourage attendance at meetings and to honor the achievements and exceptional service of members.[18] The first was a small, silver jetton, which, following the established practice at the French Academy, Dashkova issued to members as a reward for participation at weekly meetings. It was square, and on the obverse there was a rendering of Catherine's

monogram in a laurel wreath with the words "Imperial Russian Academy." The reverse symbolically depicted grammar, rhetoric, and versification above a book and the date of the founding of the Russian Academy, October 21, 1783. The second was a gold medal with Catherine's profile on one side and her monogram on the other along with the words "Excellently Benefiting the Russian Word." In 1784, the Russian Academy awarded its gold medal to mark the first anniversary of its creation. The Metropolitan of Novgorod and St. Petersburg, Gavriil, nominated Dashkova and Ivan Shuvalov seconded him. Dashkova declined the honor and insisted on honoring her permanent secretary I. I. Lepekhin for his "diligence and zeal for the Russian word."[19] Only in 1790 did Dashkova agree to become the fifth recipient of the gold medal.

The Academy devoted much of its attention to research in the areas of Russian and Slavic linguistics, the translation of ancient histories, the publication of Russian and foreign classics, and the encouragement and support of young authors. In addition, its mandate included "the celebration of the Russian language" along with the normalization of grammar, syntax, and pronunciation. It maintained a variety of international contacts, especially with foreign academies. Dashkova took an active part in all of the work and proceedings of the Academy. Its records show that of 364 general meetings during her administration, she personally chaired two-thirds of them. As opposed to the Academy of Sciences, where her role was primarily administrative, Dashkova took an active role in the literary, linguistic, and cultural projects of the Russian Academy. True to her promise in the opening speech, Dashkova charged P. I. Sokolov, a translator and instructor at the academy gymnasium, with the writing of the grammar that was to emphasize the rules of Russian usage. The *Fundamentals of Russian Grammar*, containing a dedication to Dashkova, appeared in 1788 and subsequently went through five reprints, the last in 1808. Dashkova rewarded Sokolov with election to the Russian Academy and awarded him its highest honor, the gold medal. After the death of I. I. Lepekhin in 1802, Sokolov became its permanent secretary.

A week after the ceremonial opening of the Academy, at its second meeting, I. P. Elagin recommended the immediate commencement of work on the academic dictionary. During Dashkova's tenure as president, the Russian Academy's greatest achievement was the six-volume *Dictionary of the Russian Academy (Slovar' Akademii Rossiiskoi)*, which placed Dashkova solidly in the forefront of Slavic lexicology. Completed in the relatively short time of eleven years, on August 4, 1789, Lepekhin announced the publication of the dictionary, which appeared in St. Petersburg from 1789–1794

in six parts and contained 43,257 definitions.[20] By contrast, the Florentine Academic Dictionary took thirty-nine years to compile and the French Academic Dictionary took fifty-nine years. Based on the model of the French Academic Dictionary, Dashkova's work was the first explanatory, normative dictionary and represented a major achievement in Russian lexicography. Nikolai Karamzin and Aleksandr Pushkin, among others, praised it highly.[21] Pushkin gave it high marks in his article "The Russian Academy," published in 1836 in *The Contemporary,* and mentioned it in the first chapter of *Eugene Onegin*: "Although in the past I would consult/The Academic Dictionary."

The organizational committee for the project consisted of Fonvizin, Leont'ev, and Rumovskii, while Lepekhin, overwhelmed as he was with his duties as secretary of the Russian Academy, was not able to participate actively in the committee's work. Fonvizin, as an established writer, translator, and author, took an active, leading role during the preparatory phase, and on November 11, 1783, he submitted an "Outline of the Dictionary" ("*Nachertanie Slovaria*"). Dashkova too played an important role in its composition and organization and supported Fonvizin's controversial proposal that it should be etymological in structure. In 1786, the academicians decided to adapt an alphabetical order to the dictionary, although Dashkova herself preferred an etymological order. She held her ground and in time was able to convince others to come over to her side. Compilers of the dictionary finally came to a compromise, and in presenting her project to the empress, Dashkova assured her that in approximately three years she would produce a new alphabetized edition of the dictionary. This did not in fact occur until much later, in 1806-1812. In accordance to Dashkova's recommendation, there were three workgroups: the grammatical, explanatory, and publication groups. Dashkova belonged to the second group, and for the most part conducted meetings in her house at 16 English Embankment. Work on the dictionary brought together a whole generation of writers and scholars who were confronted with questions of orthography, etymology, and the normalization of modern usage and grammar. Of the sixty members of the Russian Academy, forty-seven worked directly on the dictionary, including the writers Derzhavin and Kniazhnin, the scientist Lepekhin, the astronomer Rumovskii, the mathematicians Inokhodtsev and Kotel'nikov, the historian Shcherbatov, and many others. The novelist Nikolai Emin participated in the work shortly but caused a flap and after a week departed in a snit to join the military.

Dashkova involved herself fully in the compilation of the dictionary, proofread the early drafts, and entered her revisions and comments on

some of the pages. She individually collected and defined over seven hundred words dealing with morality, politics, and government. When she came to consider the meaning of words, she inevitably turned to her personal experiences. Almost certainly, she thought of Catherine's past actions toward her when she wrote that a sense of justice defines the truly virtuous person. Again, with Catherine in mind, Dashkova became concerned with the inadequacy of conventional definitions of the word "friendship." Her uneasiness was a consequence of her relationship with Catherine, and her disillusionment in the sincerity of the empress's feelings.[22] Discussions in the French Academic Dictionary did not satisfy her, and she devoted much time to formulate a definition that would go beyond the predictable categories of age, gender, and context. Primarily, friendship could not exist without mutual love and, Dashkova added, "Friendship depends on respect and trust and it is sacred. It is a force of salvation and a person's mainstay in the battle against adversity. Friendship is essential for the creation of an enlightened society."[23] The sanctity of friendship for Dashkova, especially in light of the empress's duplicity, was a reproach to Catherine.

By way of contrast, Dashkova continued to treasure the fan Catherine had presented her a quarter of a century earlier and wore Catherine Hamilton's handkerchief well into old age. She confessed to her brother Aleksandr that her understanding of friendship was overly romantic, but her ideas were set. She was a sentimental individual willing to be open and attached unconditionally to her friends. Consequently, she suffered when people (such as Catherine, it would seem) treated her otherwise.[24]

A competing project complicated Dashkova's work and once again brought her into direct conflict with her former friend, the empress. Catherine was interested in etymology and initiated work on a comparative dictionary of all languages and dialects, *Linguarum totius orbis vacabularia comparativa* (*Sravnitel'nye slovari vsekh iazykov i narechii, sobrannye desnitseiu vsevysochaishei osoby*). Five hundred copies in four volumes appeared in St. Petersburg from 1787 to 1791 under the editorship of Dashkova's enemy, P. S. Pallas. The selection of words and their arrangement in the dictionary reflected an eighteenth-century perception of a hierarchy grounded in faith and family. The first four words were God, heaven, father, and son with translations provided into two hundred languages, beginning with Slavonic and concluding with Hawaiian. Research on definitions provided another instance of the important role of Benjamin Franklin and the American Philosophical Society on eighteenth-century Russo-American scientific ties. The Marquis de Lafayette, who was then in France, received a query concerning native American dialects, and he, in turn, communicated with another

member of the Society, George Washington, and then with its president, Benjamin Franklin. They supplied Catherine with "a Vocabulary of the Shawanese and Delaware languages ... , a shorter specimen of the language of the Southern Indians," and other information.[25] Dashkova, however, was unimpressed and resented what she felt was Catherine's attempt to distract attention from the work of the Russian Academy. Bitterly, she wrote, "Useless and imperfect as this peculiar work was, it was pronounced to be an admirable dictionary and caused me considerable annoyance" (216). The competition she felt from Catherine's project and her great dislike of the main editor, Pallas, undoubtedly clouded and greatly influenced Dashkova's judgment.

Dashkova worked on her dictionary, administered the two academies, but most of all she worried about her children, since her relationship with her son Pavel and daughter Anastasia brought her much grief. At the beginning of 1783, Pavel left with Potemkin for the south of Russia and the departure of her son devastated the distraught and overprotective mother. Worried about his well-being, on August 14, 1782, Dashkova wrote Potemkin directly pleading with him to take good care of her son and not to station him in an area where the climate might be harmful to his health. She begged the prince to allow Pavel to visit his mother. Dashkova wrote Potemkin on a number of occasions, and six years later in a letter dated September 17, 1789, she repeated the same requests.[26] She communicated to anybody who would listen about her great loss and sorrow and even wrote Robertson in Edinburgh, explaining that her son was now with his regiment and since he was well and fulfilling his duty, she would not complain about his absence. He was, according to Dashkova, away for eighteen months, a period "too long for a fond mother."[27] She did everything possible to reclaim her son. She sent him money and turned over to him his father's inheritance, which had grown significantly under her management. Promoted to the rank of colonel, Pavel visited his mother in the winter of 1786, and the old rumors resurfaced concerning his entry into the select group of Catherine's potential lovers. Dashkova was vehement in her resistance, even threatening to leave Russia. "I was too fond of the empress to oppose her in any of her desires, but I had too much self-respect to have any part in dealings of that nature, and if ever my son became a favorite, I would use his influence but once only—to obtain leave of absence of several years and a passport to go abroad" (220).

Her daughter was more of a problem. Intelligent, educated, and with an excellent knowledge of foreign languages, she worked for a time in Dashkova's shadow at the Academy translating articles for her mother's

journal, the *Companion*. Samuel Bentham, who worked alongside Anastasia, disliked Dashkova and in a letter home to his brother Jeremy, the English jurist and philosopher, described her as "mean, avaricious, and vain." But he was close to Pavel and thought very highly of Anastasia.[28] In a desperate effort to free herself of her mother's imposing and often oppressive influence, Anastasia would not continue at the Academy, and instead pursued an extravagant and profligate life. Aware of what would most wound her prudent and thrifty mother, she revolted against Dashkova, behaved inappropriately, and created public and private scandals. Catherine wrote Grimm about her, "All of the women here have ceased to have anything to do with her. She is the daughter of Princess Dashkova, but is conducting herself in such a manner that her mother will not hear of her."[29] To make matters worse, she was wasteful, gambled away enormous amounts of money, and was perpetually in debt. When she learned that her father-in-law had died, leaving Andrei Shcherbinin a comfortable inheritance, she reconciled with him hoping to escape her mother's influence, despite Dashkova's "tears, entreaties, and bitter sorrow amounting almost to despair" (219). Endless quarrels, disagreements, and disputes followed until, Dashkova wrote, "My mind was alive only to the grief my daughter caused me and to forebodings of the future" (219). Anastasia, however, soon separated from her husband, but not from the gaming tables.

In the summer of 1783, Catherine Hamilton came to St. Petersburg from Ireland for a yearlong visit with her old friend, thus providing Dashkova with a welcome relief from her exhaustive schedule at work and conflicts with her daughter. She took a three-month leave of absence and spent the time traveling to Moscow to see "all the curious and interesting sights of that ancient capital," and then on to Troitskoe for a taste of the "real" Russia that Dashkova loved (217). Dashkova organized celebrations in local villages where the people greeted them dressed in their colorfully embroidered costumes. After offering them the customary bread and salt, so that according to tradition the visitors would never lack these two necessities of life, they would eat, drink, and then break into their traditional choral songs and dances for the Englishwoman, providing her with "a truly national picture ... she enjoyed more than the most magnificent court entertainment" (218). After a brief stay in Troitskoe, they traveled on to Krugloe in Belorussia, by this means providing Catherine Hamilton with a tour of the Moscow, Kaluga, Smolensk, and Mogilev Provinces. In St. Petersburg, they went to inspect her property outside the city on the Peterhof road, where a simple gate of two posts and a beam served as an entrance. As soon as they arrived, some in her party went directly into the

woods to gather mushrooms. When Dashkova followed, a beam of the gate came loose, painfully falling on her head. The event was inauspicious and the land where she was planning to build her new country house seemed unlucky, even from the time twenty years earlier when she had tumbled into a bog there. While physically she recovered, psychologically her condition gradually worsened, and when Catherine Hamilton departed for home, Dashkova once again felt alienated and surrounded by enemies at court. Her recurring bouts of depression would only be alleviated "by constant activity, either by occupying myself with the two Academies or by inspecting the work and buildings on my estate. I even worked with the masons building the walls of my house" (220).

Her administrative work at the two academies left her little time for work on the dictionary and her own writing. Therefore, she would retire to her country house that Quarenghi was building for her in stone.[30] Dashkova was collaborating with him at approximately the same time that they were planning the new building of the Academy of Sciences on the Neva. Quarenghi designed Dashkova's large manor house with a portico of four ionic columns in the style of Russian classicism of the 1780s and 1790s, but she always considered herself its main architect. With characteristic attention to detail, and to the consternation of the harried Quarenghi, Dashkova involved herself in every aspect of the project, modifying the design, overseeing the construction, decorating the interior, and laying out the garden. In his description of St. Petersburg in 1794, I. Georgi wrote about the main house, its wings, and outbuildings then located in an area of mixed forest, marshes, and swampland. Dashkova reclaimed the surrounding area and transformed it into a highly groomed park with planted trees, carefully arranged gardens, and greenhouses.[31] She resolved to name it in honor of the saints venerated on the days coinciding with the palace revolution. The estate came to be known as Kirianovo, although in the Russian Orthodox Church the Saints Cyrus (*Kir*) and John (*Ian*) are not honored on June 28 or 29. Dashkova must have changed her mind when she realized that during the coup the emperor was celebrating the day of his patron saint, St. Peter.

As part of her duties at the Academy of Sciences, Dashkova became one of the first women in Russia to become extensively involved in journalism. Dashkova's work in journalism was an important component of her goals to educate Russia, for in eighteenth-century Russia journals were a major vehicle for the disbursal of enlightened ideas in society. The aims of these journals, as well as literature and art generally, corresponded to Dashkova's ideas and to those of the gentry opposition. Like Lomonosov

and Nikolai Novikov, among others, she sought to disseminate ideas of the Enlightenment among the nobility, to educate it, and to induce individual members to abandon vice and extravagance and to seek moral perfection. Dashkova was optimistic that education and enlightenment would bring about the transformation of individuals and, eventually, society as well. She did not seek major political and social change, but rather the betterment of the existing order, especially of the elite. Satire was central to the literature of the age and the journals stressed the role of moral intent in satire as they sought to correct the vices and errors of the time. Primarily, the satirical journals directed their barbs, often poorly disguised, at corruption, bribery, graft, excesses, current fashion, Francophilia, ignorance, superstition, and all manner of affectation. The empress took a leading role, and her new journal entitled *All Sorts of Things (Vsiakaia vsiachina)* appeared in 1769. Modeled on the English satirical journals *The Tatler* and *The Spectator*, it featured a light, gentle satire aimed at nonspecific features and contemporary mores of Russian society. Catherine contributed anonymously to the journal and served as patron to other journals, even Novikov's, although she disagreed with the nature and proper use of his satire. Catherine would contribute to Dashkova's journal, but this collaboration would sorely test the limits of her forbearance and lead to further conflict between them.

Early on, in 1763, Dashkova participated in Bogdanovich's *Innocent Exercises (Nevinnoe uprazhnenie*, 1763), and there is some evidence that she might have collaborated with Novikov in his journal *The Drone (Truten'* 1769–1770).[32] While this remains uncertain, it is more likely that she was involved in Novikov's later journals, *The Painter (Zhivopisets*, 1772–1773) and possibly *The Purse (Koshel'ek*, 1774*)*. Dashkova had much in common with Novikov's ideological concerns regarding the free expression of social opinion, the defense of individual rights, and the battle with "Gallomania."[33] Indeed, Dashkova's initiative revived Novikov's publication of Russian historical documents in the historical almanac *Continuation of the Old Russian Library (Prilozhenie drevnei rossiiskoi vivliofiki*, 1786–1795) of which twenty additional issues appeared. After her return from her second journey to Europe she planned a new journal, the *St. Petersburg Mercury (Sankt-Peterburgskii merkurii)*, the publication of which was never realized.

But as head of the Academies, Dashkova founded and edited two scholarly journals. In 1783, ten issues of the *Companion for the Connoisseurs of the Russian Word (Sobesednik liubitelei rossiiskogo slova*, May 1783–September 1784) appeared, and in 1784 six more were printed. It was a journal focusing almost exclusively on linguistic, literary, and historical subjects. The *New Monthly Essays (Novye ezhemesiachnye sochineniia*, 1786–1791, 1793–1796), on the

other hand, was concerned with questions pertaining to the Enlightenment and to popular science. It appeared at the Academy of Sciences, which published 121 issues. The *New Monthly Essays* succeeded Lomonosov's academic journal *Monthly Essays* (1755-1764), but by the time Dashkova assumed the directorship, the Academy had ceased publication of all learned periodicals. Dashkova requested that the academicians submit their research for publication in her journals and continued to solicit contributions from both specialists and educated nonspecialists in the humanities and natural sciences. Dashkova also edited *Russian Theater, or the Complete Collection of all Russian Theatrical Works* (*Rossiiskii featr, ili Polnie sobranie vsekh rossiiskikh featral'nykh sochinenii*, 1786-1791, 1793-1794) and published forty-three volumes of contemporary plays, as well as her own. An important source for the Russian theatrical repertoire primarily during the last three decades of the eighteenth century, the journal included major works by Bogdanovich, Catherine II, Fonvizin, Kheraskov, Khvostov, Krylov, Kniazhnin, Lomonosov, Lukin, Nilolev, Maikov, Sumarokov, Tred'iakovskii, and many others.

Arguably, the most influential and enduring of these journals was Dashkova's *Companion*. Consisting of sixteen books, the journal contained a wide-ranging assortment of verse and prose, serious and humorous essays, and satirical and didactic works, with a pronounced emphasis on the former. Enthusiastically participating in all aspects of the journal's preparation and assisted by O. P. Kozodavlev, Dashkova recruited and encouraged the leading literary talent of the age. N. A. Dobroliubov wrote that the *Companion* "brought together nearly all of the major literary activity of Russian writers of the time. Contemporary society was better reflected on its pages than in any other publications."[34] Bogdanovich contributed some twenty poems and Derzhavin published many of his best works: "Ode to Felitsa," "Thanks to Felitsa," "On the Death of Prince Meshcherskii," "God," and others. Kniazhnin and Kheraskov participated actively, as did Kapnist. Already known for his satire, Kapnist, and many other young writers, were still perfecting their art and making a name for themselves. Fonvizin had already gained fame as a dramatist, and his controversial "Questions" to Catherine eventually played a major role in the journal's demise.

Dashkova came up with the idea of a journal like the *Companion* three months after taking charge of the Academy of Sciences. The journal's founding predates the Russian Academy slightly, and five issues were in print by the time the decree for the establishment of the Russian Academy appeared on October 30, 1783. Nevertheless, it was to become its official publication, contained its guiding principles, and leading contributors to

the journal were members of the Russian Academy as well. Dashkova's editorial policy reflected many shared goals and concerns with the Russian Academy regarding the cleansing and refinement of the Russian language, the dissemination of useful knowledge, the presentation of enlightened ideas, and the education of the reading public. The *Companion* was dedicated to the principles of the Enlightenment and to the study of the Russian word, with Dashkova publishing fiction and philological research, essays on manners, and definitions of synonyms. Most articles were critical in nature, evaluating literary or historical works and paying great attention to the grammatical, logical, stylistic, and orthographic norms of literary Russian. Dashkova explained that she intended to publish worthy Russian contributions for the purpose of discussing the Russian language specifically and the Enlightenment generally. The *Companion*, however, was a literary journal, and Dashkova avoided studies of a purely linguistic and scholarly nature. One of Dashkova's primary goals was to combat and protect Russia against the modish adaptation of the French language, culture, and education. The journal parodied the unthinking importation and adaptation of French fashion and also satirized the mindlessly conservative and reactionary tendencies in Russian thought.[35] Since it was not an official governmental publication, the empress ostensibly participated in it on an equal footing with other contributors. Thus, for a time, Catherine's supporters and the more progressive factions at court were to play out their polemics on its pages, and Dashkova found herself in the unenviable position of moderating between the empress and the young writers of her generation, many of whom represented the opposition to the crown. Complications were inevitable and made their presence felt immediately, when on May 20, 1783, the *St. Petersburg Gazette*, number 40, announced the appearance of the journal's initial issue.

The notification advertising the forthcoming publication of the new satirical journal stressed that all submissions should be sent directly to Dashkova. In the note, "From the Editors," she encouraged her readers to submit contributions and responses to published articles, and to send them to the editors or directly to her. She identified herself by name, Ekaterina Romanovna Dashkova, and pledged to read submissions and to publish responses unchanged. It was a bold promise, since Catherine's contributions would also be subject to her direct criticism and evaluation.[36] Dashkova displayed a wide-eyed naiveté by believing that a monarch could participate peacefully in a satirical journal when she made it clear from the outset that the editors would encourage "a free and unrestricted exchange of views by contributors." She added that "anyone wishing to offer criti-

cism of any item appearing in this publication must not seek other printing presses in which to publish such criticism or satirical remarks, but should send them directly to the editors . . . who will positively have them printed therein without the slightest alteration."[37] It would seem that Dashkova's note did not please Catherine, and in the next issue of the *Companion*, a letter appeared from the Zvenigorod correspondent, who from the second issue on was involved in the journal. Although Afanas'ev guessed that the correspondent was Nikolai L'vov, it was almost certainly Catherine herself.[38] In the letter, she praised the journal highly, but also alluded to the policy of direct criticism of published works.[39] Dashkova realized the problematical, even dangerous nature of literary collaboration with an all-powerful monarch, and in her response extolled Catherine's letter, referring to it as a perfect model for others to follow, and even a programmatic "preface" to the entire journal.[40] Dashkova wisely capitulated and deferred to Catherine's authority in editorial matters. Nevertheless, having identified herself as the main editor, she did not retreat from her stated policy. Rather, she futilely made every effort to appease the empress through adulation and lyrical praise.

The journal's title page represented Minerva, the goddess of wisdom, with sword and shield in hand, standing on a cloud next to a double-headed eagle. Such allegorical representation pointed unmistakably to Catherine II. Dashkova did not advertise Catherine's participation, but it soon became clear that the Russian Minerva was not only a highly placed patron, but also a contributor to the journal. Catherine's goal was to influence public opinion and to present her rule in the most favorable light. She was quite prolific, and her anonymously written works included the satirical sketches "Facts and Fancies" (*"Byli i nebylitsy"*), her thoughts on history, "Notes Concerning Russian History" (*"Zapiski kasatel'no rossiiskoi istorii"*), and her responses to Fonvizin. While the empress seemingly supported the journal, Dashkova understood that their collaboration would be an uneasy one. She therefore reprinted her youthful panegyric inscription to Catherine's portrait in the first number of the *Companion*. An example of Dashkova's juvenilia, it is mostly significant as an expression of her desire to pacify the empress by attempting to restore her former close association with her. As a further tribute to the empress, Dashkova also arranged to have Derzhavin's groundbreaking "Ode to Felitsa" published anonymously and without the poet's knowledge in the same issue. Dedicated to Catherine, Derzhavin wrote "Felitsa" in 1782. A masterful blend of panegyric and satire, it ridicules the excesses and extravagance of powerful

individuals at Catherine's court and juxtaposes them to the modesty and moderation of Felitsa — or Catherine.

Derzhavin worried about the ode's reception at court and therefore was not in a hurry to publish it. A year later, O. P. Kozodavlev, Derzhavin's colleague in the senate, a poet, translator, and Dashkova's adviser at the Academy of Sciences and at the *Companion,* made a copy of the poem. Although Derzhavin wanted to keep it secret, Dashkova heard "Felitsa" read aloud at one of Shuvalov's literary evenings, where she was present. In another version of the story, unbeknownst to Derzhavin, Kozodavlev passed a copy of the ode to Dashkova. Upon its publication, Potemkin demanded a copy and Derzhavin was beside himself, worried about the possible consequences and punishment to follow. Fortunately, Catherine, who saw herself in Felitsa, was delighted and Derzhavin's future assured. To his surprise, at a dinner given by his supervisor Viazemskii at the end of May 1783, he received a small packet with a friendly note "From Orenburg and the Kirgiz Queen to Murza Derzhavin."[41] It accompanied a gold snuffbox scattered with brilliants and five hundred gold coins. Based on Derzhavin's calculations, Catherine's generous gift was worth about three thousand rubles and in a letter to Kozodavlev he referred to Dashkova, who had made it all possible, as someone who truly loved the Russian language and who had a true and noble heart.[42] Derzhavin enthusiastically expressed his gratitude to Dashkova for her continuing support, while she continued publishing or reprinting from other sources many of Derzhavin's poems in the *Companion* and the *New Monthly Essays.*

Eventually, when he began to feel the animosity and outright reprisal of the courtiers he had lampooned, Derzhavin's sentiments toward Dashkova changed dramatically. Primarily, he was upset with the adverse effects the ode, which he never wanted to publish, was having on his career. With some justification, he claimed that Dashkova had pulled him into her dispute with Viazemskii. He added that now he could not continue in his current position, was obliged to start selling off his property, and requested that Dashkova support his assertion that "neither my mouth nor my quill were the sources of a satire, which intended to touch somebody personally, rather it was directed at general human weaknesses."[43] Later, Derzhavin did not receive the appointment he desired as governor of his native lands in Kazan, and dejectedly relocated to Petrozavodsk. Possibly, this was due to the intrigues of Viazemskii, who was not pleased with Derzhavin and who acted poorly toward him. Derzhavin, however, accused Dashkova of bragging that she could influence the empress on any question of state. As

a result, when Catherine found out about her remarks, she held back on Derzhavin's appointment mostly because Dashkova had recommended him.[44] Eventually, he felt that Dashkova's patronage was a liability and only hindered his advancement. Then again, she too was angry, certain that the ungrateful Derzhavin was meddling into her administrative duties at the Academy. Derzhavin recalled how he had paid a visit to Dashkova with his wife and encountered only rudeness and disrespect. He recounted how she directed her diatribe even at the empress who, according to her, did not read the decrees she signed. As a result, the Derzhavins cut their visit short and he broke off his friendship with Dashkova.[45] Dashkova's dispute with Derzhavin was a precursor to many more she would have to endure at the *Companion,* a journal she had hoped would be her crowning achievement at the Russian Academy, and a source of harmony and enlightenment.

Chapter Nine

A Woman of Letters

LIKE CATHERINE, DASHKOVA WROTE plays, memoirs, became involved in linguistics, and published articles in what she considered her areas of greatest competence and interest—education, literature, and history. Her most active and productive period of literary activity coincided with the directorship of the two Academies. Many of Dashkova's works, both in prose and verse, appeared anonymously in her journals, with some dozen pieces in the *Companion* and another ten in the *New Monthly Essays*. Dobroliubov praised her honesty, sincerity, and willingness to attack society's foibles, hypocrisy, and falsehoods. "After seventy years," he wrote, "one can still discern the truthfulness, pointedness, and worthy energy of her works."[1] This is especially true in her work "Epistle to the Word 'So'," ("*Poslanie k slovu 'tak'*") that appeared in the *Companion* immediately following Derzhavin's "Ode to Felitsa" and her own "Inscription to a Portrait of Empress Catherine II."[2]

Combining prose and poetry, the "Epistle to the Word 'So'" is one of Dashkova's most successful and original works. Although often tendentious and didactic, it is characteristic of Dashkova's publications generally and is in the spirit of the age, while its gentle satire and emphasis on language served as an example to future contributors to the *Companion*. The poem opens with an invocation in which the word itself is animated and addressed directly. In an exalted tone, Dashkova begins by extolling the unique qualities and innocence of a word so often misused.

> Oh solid word, respected through the ages,
> When on the lips of honorable people!
> My soul now yearns to sing your praises,

To the glory of the just and censure of the loathsome.
These words I dedicate to you with deference,
While exposing mean impostors to the world. (34)[3]

The poem's prose preamble then fluctuates between a serious discussion of usage and a mockingly exaggerated tribute to the word's many virtues:

> Completely sincere in my respect for you and having comprehended your importance, strength, and the precision of meaning, which you essentially contain, I cannot marvel enough at your patience; I wonder at the empty application you are subjected to, when without knowing our own language well, we insert the word *So*, although *No* could be employed more deftly and correctly; we thereby obliterate your significance, while hardly aware of your true authority, and voluntarily forfeit in our language a word so brief and yet so potent. (34–35)

The remainder of the work provides examples of misuse by those who avoid confrontation, though in the right, and await rewards of pleasure, advancement, and financial gain. They utter the word "so" inappropriately to assert what reason refutes, to seduce young women, to hide behind servility, and to flatter those in power. Dashkova challenges the fools, egotists, flatterers, careerists, and "so-sayers" willing to agree to any absurdity, as long as it advances their own selfish interests. "Those who love *so-saying*, and heed the words of flatterers / Are worse than any scoundrel" (39). Like Fonvizin, she attacks obsequiousness and cynicism, which were inimical to her nature, and condemns both the sycophants and the objects of their flattery. Moreover, she indirectly asserts her strength, authorial independence, and the right to express her own opinions by inserting editorial remarks concerning, for example, Lomonosov's genius.

> And should one of the gentry say: learning is pernicious,
> Only ignorance is beneficial and harmless,
> Then all will bow, the wise man and the fool,
> And shamelessly say: *of course, sir, it's so.*
> And if he declares that Lomonosov is also a fool,
> Although a glorious poet, the honor and glory of all Russians,
> Here everyone will smile
> And will repeat to him: *of course, sir, it's so.* (36)

Dashkova then mocks conservative elements at court and takes to task the ignorant flatterers agreeing with any utterance of the powerful.

> We now retire at night in peace,
> Without the fear of innocently suffering,
> But if a person of standing, though seemingly mad,
> Condemns our present times and praises the past,
> Then a scoundrel, whether fool or wise man,
> Will bow and say to him: *of course, sir, it's so.* (36)

Providing a broad and generalized overview of society, and paying close attention to language, she scoffs at some of the stock characters of eighteenth-century Russian satire such as the cleric, the judge, the shrewish wife, and the fashionable lady:

> Some women, while embracing their husbands,
> And mixing French and Russian words,
> Will tenderly say to them: "*Mon coeur,* or my precious,
> Allow me wings, although I am your wife,
> I yearn to live a life of pleasure and of freedom,
> And to show society, that we live fashionably.
> You and my lover will of course be friends,
> He will always be available to lend a helping hand.
> He is intelligent, *aimable* and good looking,
> Won't you please, *mon coeur,* agree?"
> And the husband, though always faithful to his wife,
> Never having flown to other women,
> But hearing this can only sigh,
> And courteously and fashionably say *it's so.*
> The wife then answers: "*Mon coeur, très obligée,*
> Your see, to be always faithful is of course *préjugé,*
> And is not faithfulness in a woman a silly notion?"
> Then the husband says to her: *it's so, dearest, indeed, it's so.* (37)

Dashkova goes on to mock the half-wits, the scoundrels, the flatterers, slanderers, braggarts, persons of great standing, and the careerist who "earns promotion upon promotion, and plays cards with the gentry" (38). Then she returns to praising Catherine and urges her not to give in to insincere adulation. Catherine, as an enlightened and benevolent monarch,

will allow her devoted subjects freedom of expression when they speak the truth, and Dashkova concludes with high praise for the empress in a form approximating a syllogism.

> But we will show the word's proper place,
> When we speak the entire truth:
> CATHERINE is compared to Titus,
> For CATHERINE is likewise honored,
> For all her countless virtues;
> Here as a sign of truth itself,
> The whole world says *it's so.* (39)

In the end, she once again turns to the word itself: "I ask you to believe me, that having the good fortune to reside where the government is a benevolent and an enlightened monarchy, I can and shall guard against any abuse of your name for as long as I live" (40).

Two letters, supposedly from readers of the journal, were submitted in response to Dashkova's poem: the first, sharply critical of the poem, appeared along with the editor's reply pointing to the uncivil tone of the letter and assuring readers that in the future only courteous letters will be published. In the same issue a second letter, "An Answer from the Word 'So'" is almost certainly the work of the journal's editors. The word "so" identifies itself as neither masculine nor feminine but decides that for the purpose of clarity, it will assume the masculine gender. Generally, there is a great deal of self-parody in his commentary, which is excessively pedantic and pompous. He correctly points to grammatical problems in the very first sentence of the poem's preamble and then goes on to stylistic questions while citing Lomonosov's *Rhetoric*. Mostly, the word defends the editors on the grounds that despite the satirical nature of the poem they have nothing to fear, since it is not directed at any specific individual but is general in nature. As opposed to the first response and the poem itself, which were published anonymously, the author proudly signs his letter as "So."[4]

The first issue of the *Companion* also contained Dashkova's "An Abridged Catechism of an Honest Man" ("*Sokrashchenie katekhizisa chestnogo cheloveka*").[5] Ostensibly, a tattered notebook discovered by accident during a walk and sent in to the journal, it is in fact a prayer and an emotional plea for virtue, morality, and justice in the world. The next issue of the journal contained a letter, "To the Editors of the *Companion*" ("*K gospodam izdateliam Sobesednika liubitelei rossiiskogo slova*").[6] In it, Catherine, masquerading as the correspondent from the city Zvenigorod, writes very highly of the jour-

nal and requests a more precise definition of the notion of "honest man." Catherine encourages the author of the work to continue her criticism of society and defend good deeds while attacking vice and the grumbling of the envious. She goes on to compliment the author of the "Epistle to the Word 'So,'" and hopes that similar definitions will appear for words such as "education" and "nobility."[7] In her short response, Dashkova thanks the Zvenigorod correspondent and refers him to her article, "On the Meaning of the Word Education" ("*O smysle slova vospitanie*"), which was published in the same issue of the journal and in which she considers the definition of the word from a historical, moral, and pedagogical perspective.[8]

This article represents Dashkova's major statement on education and an expression of her belief, which was central to her private and public lives, that education is the bulwark of a good and just society. Theorists influencing Dashkova's thoughts were Montaigne, Locke, Fénelon, Rousseau, and others. A fundamental principle of the Enlightenment was that the education of the citizenry and a sustained interest in literature, the arts, science, natural science, commerce, trade, and industry could make over society for the better. Education was the key, for it had the ability to transform people and make them reasonable (*blagorazumnye*). Indeed, Dashkova's prominence and positions of power as director of the Academy of Sciences, president of the Russian Academy, and a distinguished eighteenth-century woman of letters were, for the most part, a consequence of her unique and exceptional education. Moreover, her self-realization and self-assertion provided an early example of a woman's intellectual equality. The eighteenth century was a pivotal time in the development of the education of women. In the West, discussions ranged from arguments that education should develop strong, independent, critical-minded women to those that favored limited instruction for submissive mates overseeing the domestic economy. In Russia, Sumarokov dreamed of an ideal kingdom where girls would also go to school and Novikov, who devoted his life to the dissemination of Enlightenment ideas in Russia, prepared a well thought-out program of reading for women.[9] The enlightened thinker affirmed the equality of women and men and considered women to be individuals who deserved to enjoy the rights of their fathers, husbands, and sons.

Catherine too was concerned with the question of education both publicly and privately through the creation of the Smolny Institute and the education of the Grand Dukes Alexander and Constantine. She actively composed exercises for them and personally wrote instructions to their tutors. Catherine was also interested in adapting in Russia earlier discussions on the education of women. In 1715, during Peter the Great's rule,

Fedor Saltykov had submitted a plan that provided for the education of noblewomen comparable to what was then available in the west. During Catherine's time, Ivan Betskoi, her primary collaborator in the field of education, authored the treatise "On the Education of Young Men and Women" ("*O vospitanii iunoshestva oboego pola*"). Shortly after, Catherine founded the Imperial Educational Society for Noble Girls at the Smolny Institute, a boarding school for girls with courses available for the lower classes as well. Broadly modeled on Mme. de Maintenon's St. Cyr, its mission was to create the new Russian woman. The initiative, however, did not promote scholarship per se. Catherine and Betskoi envisioned an ideal, humane pedagogy of the Enlightenment carried forward by educated women in the family. Learning was to socialize women and enhance their personal development and role in the domestic sphere.[10] Nevertheless, there was a gradual elimination in Russia of the traditional suspicion of women's literacy, and by Fonvizin's time the illiterate woman was the object of satire. Dashkova's own household provided an interesting example of the strides taken to confront illiteracy among Russian noblewomen. Martha Wilmot noted in her journal for January 14, 1804, "Mdlle. Masloff [Dashkova's aunt] . . . has an apartment in this house. She does not know how to write, which circumstance proves the backwardness of education here as she was born to good fortune and is of a first rate family."[11] By contrast, Dashkova's niece studied at the Smolny and provided Martha Wilmot with copies of Catherine's letters to A. P. Levshina, who was a student in the first graduating class of the institute.

The catalogue of Dashkova's Moscow library lists numerous volumes dedicated to the topic of education and attests to her great interest in the subject.[12] There are books on theoretical questions, *Hume on Education*, Locke's *Education of Children* (*Lokka vospitanie detei*), Fénelon's *Traité sur l'éducation des filles*, and Rousseau's *Emile, ou de l'éducation*, even though in 1763 Catherine had used her influence to ban the publication in Russia of Rousseau's book, since she considered his religious views to be subversive. In addition, many of the books are devoted to the practical application of pedagogical issues, including *Regulations for National Schools* (*Pravila dlia narodnykh uchilishch*), *An Attempt at National Education* (*Opyt narodnogo vospitaniia*), and *Statute on the Education of Young Noblewomen* (*Ustav vospitaniia blagorodnykh devits*). Apart from strictly professional considerations, Dashkova's pedagogical and scholarly activities extended to her private life and to the guidance and tutoring of her children. Books on the proper upbringing and conduct of women are well represented in the library: *Discours sur l'éducation des dames, Education de la noblesse française, Cour d'éducation des demoiselles,* The

Duties of Women (*Dolzhnosti zhenskogo pola*). In a letter to Catherine Wilmot, Dashkova explained that from an early age she read everything available to her on the subject of education and singled out Locke, whom she read in French translation.[13] In *Some Thoughts on Education* (1693), Locke describes the proper, moral education for a gentleman's son. He sees extreme malleability as the prime characteristic of childhood, and character development as far more important than the assimilation of knowledge. Education is the cultivation of intellect rather than the accumulation of facts. While Locke sees instruction as a technique of moral education, an important element of Locke's (and later Rousseau's) treatise focuses on the physical welfare of the child. This theory dominates Locke's text and his ideas, as well as those of Rousseau, and greatly influenced Dashkova and others such as Novikov and Betskoi. Novikov's "On the Education and Instruction of Children" (*"O vospitanii i nastavlenii detei,"* 1783) appeared in the "Supplement to the Moscow News" (*"Pribavlenie k Moskovskim vedomostiam"*) the same year as Dashkova's "On the Meaning of the Word Education."

In the nature versus nurture debate Dashkova clearly accords the major role to nurture, and the notion that education as a lifelong endeavor is at the center of her ideas.[14] In her essay "On the Meaning of the Word Education," Dashkova seemingly condemns the education of her great-grandfathers, when the reading of Psalters, counting, loyalty to the tsar, obedience to the law, and reticence were valued above all else. Although such unenlightened instruction can hardly be considered education in the proper sense of the word, Dashkova states that her great grandfathers, at least, were not taught to be ashamed of being Russian. Such feelings of shame and inadequacy were later instilled into her generation by legions of, to paraphrase Dashkova, Paris lackeys, madams and little mademoiselles (*parizhskie lakei, madamy i mamzeliushki*). Dashkova then expresses her dissatisfaction and discusses one of her favorite themes: the current pernicious and corrupting influence of Russia's excessive adherence to frivolous French fashion. She sees education as an antidote to the senseless and vapid imitation of the West, so that Russians, and in particular Russian children, would take pride in their country and its history.

Even though Dashkova does not mention women, or the unique features of a woman's education, she does bring the problem of education into the domestic sphere. Regrettably, she writes, families, tutors, and schools no longer teach children to think for themselves, resulting in scores of social problems such as the increase of unhappy marriages. Almost certainly, although she does not refer to it, Dashkova must have been thinking of her independent choice of a husband as opposed to the unfortunate union

she arranged for her daughter. Due to her own lack of a stable home environment, Dashkova stresses that education needs to begin in the family and that parents need to provide their children with positive role models. Like Novikov, Dashkova, in her definition of a proper education, divides the instructional process into three categories. The first two are physical and moral education and are identical to Novikov's, although Dashkova is always more practical and less abstract. In fact, the moral guidance of children is far more important than any formal or informal course of study. "I am more concerned," she wrote to W. Robertson in 1776, "with the moral condition and character of my son, than with his circle of acquaintances."[15] The third category is classical or school education; Novikov's is rational education. While Novikov looks at a child's innate yearning for knowledge and ability to assess his or her environment, Dashkova evaluates curricular matters.

Novikov was to write about Dashkova that she is "considered to be a woman of learning and an ardent supporter of the liberal arts," and when Dashkova turned her attention to secular education, her course of study was quite intensive.[16] Dashkova bases it on language study, with an emphasis not only on the classics, ancient Greek and Latin, but also German, English, and French for communication with foreigners. Similarly to the curriculum she proposed to Robertson for her son's studies at Edinburgh University, Dashkova stresses that mathematics, particularly higher mathematics, are essential, as well as logic, rhetoric, history, geography, moral philosophy, experimental physics, and chemistry. She recommends the model of British universities, obviously based on her son's experience at Edinburgh, and returns to the idea that for those who are preparing to be useful to society travel is essential. Dashkova had dealt with the question of educational travel in the letter to her son, in which she instructed him on the proper organization of the trip, as well as its goals, and the correct deportment of the young traveler. Elaborating established eighteenth-century notions of educational travel and expanding ideas garnered during her tours of the Continent and England, Dashkova would revisit the subject in her essay "Travelers" (*"Puteshestvuiushchie"*).[17] In the end, continued education while at home, in schools, or traveling, rather than wealth, creates a happy, useful, and perspicacious individual.

Dashkova's article "On the Meaning of the Word Education" provoked in the third issue of the journal another letter from the Zvenigorod correspondent in which Catherine reproved Dashkova for neglecting to consider the question of a child's sensibilities (*chuvstivitel'nost'*) as an essential element of education.[18] She urged Dashkova to elaborate her discussion

more fully with an accurate definition of sensibility, since a correct understanding of the word, too often overlooked, is central to the notion of a proper education. If parents and teachers were to instill and cultivate it correctly in children, they must eradicate all false notions by distinguishing between true and false sentiment. The latter is a weakness of the heart and mind, while the former will lead to the creation of a moral, just, and strong individual. Dashkova replied immediately and reverently that while the Zvenigorod correspondent requested a definition of the word sensibility, there is little to add to his understanding of it. To be sure, Dashkova was to take Catherine's comments seriously, especially in light of the growing interest in sentimentalism and preromantic ideas in Russia at the time. Catherine's discussion of sensibility on the pages of the *Companion* represented an early theoretical formulation in Russia of the aesthetic principles of sentimentalism, and in her *Memoirs*, Dashkova was to point to the absence of sentiment in a critical evaluation of her own education: "And yet, what was done for the improvement of our hearts and minds?" (32)

Catherine, in the guise of the Zvenigorod correspondent, also chastised Dashkova for not differentiating between the education of men and women. Surprisingly, Dashkova did not take on the challenge and requested that the correspondent himself expound further on this topic.[19] There is nothing in Dashkova's article specifically on the education of women, and her reluctance to deal with the question of women's education may be a result of her attempt to act like a man while on the stage of public life, or her unwillingness to face the possible failure of her daughter's education.[20] Yet, Dashkova shared with most of her contemporaries a belief in the moral conception of knowledge. In the very least, she could have interpreted the moral task of education as the conventional imperative to contribute to the woman's natural roles of virtuous wife and mother. Both Dashkova's precursors and contemporaries did not hesitate to propose projects and design institutions that would produce suitable wives and mothers. Locke himself saw no reason to differentiate between the education of girls and boys with respect to moral questions, but did distinguish between physical characteristics and established separate areas of concentration based on actual pedagogical needs.[21] Novikov was much more explicit than Locke and encouraged the literary pursuits of women, although he shared in the general hostility to female scholarship and intellectualism.[22] But Dashkova did not enter into the debate, even though the next year she published a translation of Heinrich Kornelius Agrippa's *On the Superiority and Advantage of Women*. Written in the 1530s, the essay argues that noble women are far superior in everything to men.[23] Metropolitan Platon, for one, was furi-

ous, even though the "subversive" work appeared with the altered and less provocative title of *On the Nobility and Advantage of Women* (*O blagorodstve i preimushchestve zhenskago pola*, 1784).[24] Later in life, Dashkova would return to the question of her daughter's education; nevertheless, her unwillingness to consider in detail questions of gender distinction and the manner in which she privileged her son's education were to have tragic consequences in her relationship with her children.

In her subsequent writings, Dashkova continued to consider education as the primary formative factor of one's character. She believed in an enlightened monarch, with Catherine as its embodiment, and she was interested in Western models and their possible application to Russian reality. Central to her ideas was the need of society and the state to support and sustain the self-sufficiency and self-worth of the individual. Thus, an enlightened citizenry was equally important as an enlightened monarch. Simultaneously, she opposed all forms of extravagance and lavishness. She strove to achieve her ideals through education and a process of gradual, rational reforms leading to a limited, constitutional monarchy on the English model, and a powerful, enlightened nobility. Citizens of an enlightened state were to be educated, virtuous, honest, charitable, patriotic, and involved in the creation of a just society. A proper education, correctly implemented, would produce a happy, moral, virtuous, and socially conscientious individual.

In her article "On Genuine Well-Being" ("*O istinnom blagopoluchii*"), Dashkova finds that the well-being to which all citizens aspire does not consist of wealth, rank, power, or luxury.[25] The accumulation of property for its own sake is a despicable feature of contemporary life, for the goal of one's existence is education, self-reliance, and hard work leading to the improvement of everyone's living conditions. Economic independence must lead "not to the destruction of natural human desires, but to an understanding of how to make use of acquired wealth for the betterment of one's self and society."[26] Dashkova's central idea is that the source of society's and the individual's well-being is located in virtue. Based on the principles of charity, humanity, honesty, sincerity, frugality, and industry, she defines virtue as "that spiritual disposition, which constantly directs us to act in a manner beneficial to us, our neighbors, and society."[27] She goes on to state that it is not enough simply to comprehend the notion of virtue. Rather, all of us, but especially those in power, must embrace and revere it: "It is not enough, Confucius says, to know virtue, one must love it and thereby to possess it. This holy principle is important to everybody, but most of all it must be impressed in the hearts of great rulers."[28] Sub-

sequently, in an essay on virtue, Dashkova clarified and expanded further her understanding of virtue by linking it to education. When virtue is "essential and enduring," Dashkova writes, it depends entirely on justice and the ability to evaluate one's self and others impartially.[29] She fully believed that the educated, enlightened individual would be virtuous and therefore just, honest, charitable, prudent, temperate, and tolerant. Virtue is the primary goal of education, engendering the kind of positive action, without which the social contract and the prosperity of the people are impossible. The attainment of virtue, then, depends on knowledge and instruction in the arts, while useful sciences could improve the human condition and transform society for the better.

Many of Dashkova's works were devoted to the mores of contemporary society. The satirical sketch "Portraits of my Kin or the Past Twelve Days of Christmas" (*"Kartiny moei rodni, ili Proshedshie sviatki"*) describes with Gogolian grotesqueness a young man's frightening, scolding aunt and his wealthy uncle who dabbles in Roman history.[30] Dashkova lampoons hypocrisy as the major vice inimical to friendship and close personal relations. The uncle honors ancient history and considers himself a true Roman at heart. Yet he expresses the classical spirit through the application of Roman law to cheat his neighbors. He refers to himself as an enlightened person, but burns wax candles, as opposed to the cheaper tallow candles, only when showing off to his guests. Dashkova also mentions in passing the suffering of his domestic serfs, when in a generalized manner and without specific details she refers to the beatings they must endure. She assumes a similarly didactic tone in "My Notebook" (*"Moia zapisnaia knizhka"*), a work consisting of a number of entries taken on different days of the week.[31] The wealthier the individual, according to Dashkova, the greater the obligation toward society, and in the eighteenth century it was the landowning gentry, the holders of ancestral and endowed estates, who bore most of the responsibility toward the citizenry of Russia. Therefore, it is the nobility's responsibility to occupy itself with the management of their economic matters and not with frivolous activities such as balls, soirées, and other empty entertainments.[32] Honesty and justice are central to her understanding of both personal and social morality, while the realization of aptitude and personal growth are a matter of a rational and considered plan.[33] One of her characters in the work, a young Russian man educated in Leyden, expresses Dashkova's positive feelings toward England. At the end of this piece, the editor adds that a sequel will follow in a forthcoming issue.[34] While it did not appear in the *Companion*, a few years later Dashkova published "Excerpts from my Notebook" (*"Otryvok zapisnoi knizhki"*)

and "A Continuation to Excerpts from my Notebook" ("*Prodolzhenie otryvka zapisnoi knizhki*") in the *New Monthly Essays*.[35]

In "Excerpts from a Notebook," while considering the proper path for the moral rejuvenation of Russia, Dashkova lists the qualities essential to various members of society: for example, a soldier requires courage and firmness, a judge—objectivity and fairness, a merchant—organization and truthfulness. Individuals who have fulfilled their obligation and responsibilities to the full potential of their innate abilities "will retain a clear conscience and remain above human ingratitude, slander, and folly."[36] Perhaps the most important prerequisites for the realization of inner peace and individual freedom, observes Dashkova, are restraint and the moderation of uncontrollable desires, particularly for the attainment of wealth and power. The absence of such moderation leads to a loss of personal principles and one's enslavement to passion.[37] She stresses that luxury leads to indebtedness and is evidence of faintheartedness distracting individuals from the necessary preparation to serve their country.[38] Conscious of her own reputation for parsimony, she continues the themes of temperance and education in "A Continuation to Excerpts from my Notebook" and writes, "Moderation and thrift deserve to be praised rather than laughed at. It is more honorable and virtuous to live frugally off one's own labor, than to live lavishly off the labor of others."[39] Dashkova also warns about the harmful consequences of superficial knowledge in all areas of science and scholarship, which in limited people may give raise to false and inflated notions of their superiority and infallibility; in the end, such misguided individuals will have a deleterious effect on any endeavor.[40] When she comes to the question of women, once again Dashkova declines to evaluate fully their role in society and falls back on conventional wisdom and generalization. Women in society must be models of "modesty, reserve, adherence to a moral code, maintenance of the household, tenderness of the heart, and willingness to stay at home."[41] Remarkably, the portrait she paints of the ideal woman in Russian society bears little resemblance to Dashkova herself. Yet earlier, in "My Notebook," she had praised highly Catherine's Smolny Institute for its ability to transform its students through education.[42]

The importance of a proper education would remain the central focus of all her writings. Years later, Dashkova was to publish another short piece entitled "This or That from my Notebook" ("*Nechto iz zapisnoi moei knizhki*") in *Friend of the Enlightenment*, in which she laments with her aunt and second cousin the passing of those days in Russia's past when parents brought up and educated their children.[43] "My Aunt's Notes" ("*Za-*

piski tetushki") consists of six chapters relating what the aunt heard, saw, and read, what happened to her, her impressions, and her convictions.[44] Among these notebook pieces, the aunt's "testament" on moral philosophy represents Dashkova's most developed and most thoughtful expression of her views on moral, political, and social issues. Again, her ideal is "an enlightened and gentle sovereign, concerned with the well-being of the people," and she cites the identical passage from the second-century Greek satirist Lucain that appeared twenty years earlier in *Innocent Exercises* in her translation of Voltaire's "*Essai sur la poésie épique.*"[45] Written in Dashkova's didactic, fragmented style, which characterized many of her contributions in the *Companion* and other journals, the aunt's notes conclude on the optimistic note that "sooner or later virtue is always rewarded."

There is an obvious stylistic and thematic continuity in the three initially published "notebooks," which focus on moral, educational, and philosophical issues expressed through fragmented phrases and prescriptive, edifying aphorisms. In her verse and other prose writings Dashkova's style is prone to moralizing with a heavy reliance on adages and maxims: "Without beauty of mind and heart, an adorned person is only doll-like."; "Be not dejected when unlucky, nor prideful when lucky."; "Moderation of one's desires, is the surest path to independence."[46] In many of her works, she demonstrates a penchant for the introduction of conversational language interspersed with aphorisms. They are often drawn from French sources, such as "*Un sot trouve toujours un plus sot qui l'admire*" ("A fool will always find another fool to admire him"), and Russian proverbs, when, for example, a married couple "can't live together, but can't live apart" ("*rozno tak toshno, a vmeste tak tesno*").

Repeatedly, Dashkova returned to her views on the interdependence of virtue and education, although subsequently, and after the French Revolution especially, she placed greater stress on "Francomania" and patriotism. In a "Letter to the Editors of these essays" ("*Pis'mo k izdateliam sikh sochinenii*") Dashkova resorts to her favorite device of eavesdropping.[47] The topic of the conversation she overhears is again virtue and, Dashkova writes, the essential element of all virtue is justice, so that all human virtues are a consequence of our sense of justice. She proposes the initiation of a yearly prize, awarded to the best composition in verse or prose on the question of virtue. By way of an example, she encloses the poem "Parable: Father and Children" ("*Pritcha: Otets i deti*"), which she allegedly commissioned from a certain young man.[48] It is almost certain that the author of this poem is Dashkova herself. Consisting of thirty-three verses of various lengths and written mostly in rhymed couplets, the poems extols universal virtue

personified in the father, whose offspring are generosity, heroism, wisdom, meekness, honor, and peace of mind.

In successive letters to editors, Dashkova discussed how money and salaries should not be the primary motivation of teachers and how they are to be selected from among those who are the most talented and motivated with a true calling to the profession.[49] Parents should be directly involved in the education of their children and, she asks rhetorically, "Is not the primary role of parents the education of their children?"[50] For Dashkova, education in Russia should integrate the methods and experiences of Western theorists with local and national needs. Dashkova felt that the educational system in her native land must address its unique historical development. Even the most progressive European approaches to education should not exclude spiritual and moral considerations based on the century-old customs and traditions of the Russian people. Most of all, influence from abroad must not be a matter of fashion. It was a theme she would return to repeatedly, and in "A Response (to Ioann Priimkov)" ("*Otvet [Ioannu Priimkovu]*"), she presents a satirical caricature of a gossipy, provincial woman concerned mostly with social standing and French fashion.[51]

The letter "To the Gentlemen Editors of the *New Monthly Essays*" ("*K gospodam izdateliam Novykh ezhemesiachnykh sochinenii*") is primarily an expression of Dashkova's disdain for French fashion and her dismay over the excesses of the French revolution.[52] She exhorts the readers to free themselves of French fashion and proclaims that Russians should be Russian and not the imitators of bad examples. Quoting Voltaire's remark that France is a country of tigers and apes, Dashkova concludes that Russians are aping the apes. Also, she is possibly the author of a response to her own letter signed by a certain Andrei Shein. It is highly complementary of Dashkova's sentiments and patriotically calls for a return to all things Russian.[53] The following month, in the next installment of the same journal, Dashkova published eleven questions in the letter "To the Gentlemen Editors of the *Monthly Essays* ("*K gospodam izdateliam Ezhemesiachnykh sochinenii*").[54] Again, she lashes out against the current obsession with a French education, and presents ideas developed previously and more fully in her article "On the Meaning of the Word Education." Critical and unyielding, Dashkova does not relent in her ongoing battle with Francophilia. As before, Andrei Shein is in full agreement with her and even submits some additional questions of his own.[55] In her "Truths that should be Known, Remembered, and Followed to Avoid Misfortune" ("*Istiny, kotorye znat' i pomnit' nadobno, daby, sleduia onym, izbezhat' neschastii*"), she proposes ten truths that will lead to a happy

life.[56] They again elaborate her understanding of words and concepts such as virtue and personal responsibility, while praising reason and condemning all forms of human overindulgence: "All excess is sinful and harmful."[57] Many of these truths were previously stated in Dashkova's other works, such as the catechism and notebook series.

Dashkova predicated her ten enlightened commandments, as well as her ideas in the main, on religious Christian principles, which form the basis for her code of moral behavior.[58] Her writings were not anticlerical, and in her own life she strictly observed the religious traditions of her education and upbringing. While Dashkova dreamed of a new order based on enlightened ideas, she did not discard family practices and religious observances. Annually, for the Vorontsov family's patronal feast, she traveled to her grandfather's estate to pay homage to St. Dmitrii (*Tuptalo*) of Rostov the Great and Iaroslavl'. She observed all of the established rites of her faith and knew by heart the prayers and chants of the Russian Orthodox services. In Troitskoe, she would correct and prompt the village priest, when in a state of confusion and intoxication he would struggle through the liturgy. Martha Wilmot wrote that Dashkova

> was a conscientious observer, both for herself and all the members of her family, of the respect due to the stated forms of the established faith of her country; and although in the free intercourse of private friendship one might easily discover that many of the numerous ceremonies of the Greek church appeared less of Divine than human origin.[59]

Her beliefs were also pantheistic, and influenced by the challenge of deism and skepticism of the age, she saw the manifestation of the Godhead in life and nature.

> That a Creator exists, I have no doubts:
> My heart tells me of his presence;
> But I can only love my God,
> When I perceive divinity in others.[60]

Dashkova did not find her principles to be contrary to rational, enlightened ideas, and she rejected any notions of fate or predestination. Rather, she emphasized choice, personal responsibility, and self-determination as a path to self-creation leading to the potential deliverance of the divine in all of us. Martha Wilmot cited Dashkova: "I cannot suppose that my Creator influences every act of my life; I am not presumptuous enough to

imagine it! In forming a creature, and endowing it with a full perception of right and wrong, I conceive that absolute liberty of choice is placed by the Almighty in the power of each individual; else, what is justice?"[61] Her ideas were derived from Blaise Pascal's *Pensées* and his wager that it is always better to believe in God, because the value of belief in God is always greater than the value resulting from nonbelief. "I am not eloquent enough to puzzle a good cause by force of argument," Dashkova stated, "but here is a very simple idea, which satisfies me. My belief is fixed, and incapable of yielding to your reasoning; but, suppose it otherwise — you make me hazard all to gain nothing."[62] Dashkova, then, did not argue for the existence of God, but rather for the belief in God as she sought to combine the moral upbringing and education of children with spiritual values and to base it on Christian principles.

The third issue of the *Companion*, in which Dashkova published her article "On Genuine Well-Being," saw the appearance of the Fonvizin's "Questions." For Dashkova, Fonvizin was an ally and a source of inspiration; his satirical works were close to her heart in content and form. Dashkova expressed ideas that were similar to Fonvizin's, not only in his plays but also in his "Discussion of Essential State Laws," and both authors cited Confucius, represented the ideal monarch, and expounded on the central political ideas of opposition to Catherine.[63] The empress responded angrily to Fonvizin's "Questions." She was the primary contributor to the *Companion* beginning with the second issue, and of the journal's 2,800 pages, at least 1,456, or more than half, were her submissions.[64] Her involvement was considerable and included letters, "Notes on Russian History" ("*Zapiski kasatel'no rossiiskoi istorii*") and "Facts and Fables" ("*Byli i nebylitsy*"). Catherine had been patient with the satirical pieces in Dashkova's journal, but Fonvizin's questions, submitted anonymously in the third issue, upset her. A significant exchange in the journal ensued between Fonvizin and the empress, since Fonvizin's questions hit too close to home. He directed them at autocracy itself and his attempt to bring up the question of the moral and intellectual limitations of some who were in power roused Catherine's ire. The clamor surrounding Fonvizin's questions led to a parting of the way for Catherine and her literary colleagues and to further tension between Catherine and Dashkova.

Dashkova was unquestionably involved in the affair and privately supported Fonvizin in his polemic with Catherine.[65] Although Fonvizin submitted them anonymously, it is certain that Dashkova knew the author's identity, and according to S. Glinka, together with Ivan Shuvalov she futilely attempted to dissuade Fonvizin from publishing any additional

questions and pressed him to bring the matter to an end.[66] She was well acquainted with Fonvizin personally, shared his political views, and both were close to Panin. In fact, they were on very friendly terms and returning from her stay abroad, Dashkova wrote a good-humored letter to Fonvizin asking him to help her find a house in St. Petersburg, while poking fun at the likelihood of Catherine's lady-in-waiting living in a dilapidated inn.[67] Mostly, the spirit of opposition to Catherine's court united Dashkova and Fonvizin, and it seems that there might have been some discussion and agreement on the direction it would take. One target was their common enemy Viazemskii. In the fourth issue of the *Companion*, Fonvizin published his "Petition to the Russian Minerva from Russian Writers" in which he derided those "famous fools" who "detest all those involved in philology." The allusion was unmistakably directed at the prosecutor-general of the senate, who was at that time persecuting Derzhavin, and in the end, forcing him to retire. In her *Memoirs*, Dashkova comments on Viazemskii's ill will toward her and his predilection to take offense at everything in the journal. Viazemskii became angry with some of the satirical pieces appearing in *Companion*, feeling that Fonvizin and Dashkova were ridiculing him and his wife. He took revenge on, notably, Osip Kozodavlev, Dashkova's assistant and co-editor of her journal; Derzhavin, who was a leading contributor; and Dashkova herself.

For a time, Catherine thought that Ivan Shuvalov had written the "Questions" as a way of revenging himself on the character of the indecisive man parodied in the second issue of *Companion*. But it was question number fourteen concerning jesters attaining high rank at her court that angered Catherine most. The target on this occasion was the master of the court Lev Naryshkin, whom Dashkova considered a "ridiculous buffoon" (71). Fonvizin wrote, "Why is it that in the past jesters, jokers, and clowns did not hold rank, but now they hold even high rank?"[68] The question evoked a cross reply from Catherine, accusing the author of "loose talk." In a letter written in the fall, 1783, Catherine discussed Fonvizin's questions and found them to be dangerous since they might motivate someone to take "similar or even greater liberties."[69] Privately, upon reading the questions, she vowed, "we will get our revenge."[70]

Along with Fonvizin's "Questions," Dashkova's criticism and satires of court society, such as the "Epistle to the Word 'So,'" incensed many of Catherine's most powerful advisers. Lev Naryshkin was one of Dashkova's primary enemies at court, and her quarrel with him was partially responsible for the termination of the *Companion*. Since she was directly linked to Fonvizin's most provocative question, Dashkova understood that it could

potentially rekindle her past rivalry with the empress and inflame additional problems. There were indeed many sore points: For instance, she did not hesitate to read closely the proofs of the sovereign's contributions and to return them with her editorial comments. In this way, she displeased Catherine with criticism and with what the empress considered unauthorized corrections of her submissions to the *Companion*.[71]

As her relationship with Catherine worsened, the proud and ambitious Dashkova became the object of ridicule and gossip concerning both her private and personal lives. Possibly spurred on by Catherine herself, Naryshkin organized and staged skits for the courtiers ridiculing Dashkova's work. In Catherine's presence and to the great delight of those present, he parodied Dashkova's inaugural speech at the ceremonial opening of the Russian Academy. Naryshkin, for all intents and purposes was Catherine's mouthpiece and with her tacit approval, published his parody in the *Companion* satirizing the minutes of a scheduled meeting Dashkova chaired at the Russian Academy, which he dubbed "The Society of the Benighted" or the "*Ignoranti Bambinelli*."[72] He would also refer to Dashkova as an academician in a bonnet. At the next meeting of the Academy, on November 11, 1783, Dashkova publicly called for resistance to the mockery and ignorance directed at them. An angry exchange of letters ensued in the *Companion* between Dashkova and Lev Naryshkin, or the Canon (*Kanonik*) as Naryshkin called himself. Catherine continued her support and endorsement of Naryshkin's assaults, which were far from benign, and when Dashkova complained, Catherine replied, "As to the essay of my friend the Canon, I can do nothing without his counsel; and as it never entered his head to offend any human being, which I think is manifest from the playfulness of his tone, he is not likely to trespass on the rules which you have prescribed. I am sincerely sorry to find you are not quite well."[73] Dashkova felt the sting of the jeers and the derision directed her way, but she refused to accept the role of court jester. Dashkova distanced herself from the court and the publication of the *Companion* ceased temporarily.

The altercation between the empress's supporters and the opposition had grown heated. Catherine ceased sending contributions to the journal, and requested the return of all her manuscripts. Derzhavin wrote that because of these quarrels, "the gates of Eden were closed to the princess [Dashkova], i.e. the empress thanked her for her work, awarded her twenty-five thousand rubles, and ordered that she not be allowed in at the appointed hour when they discussed literary questions."[74] Dashkova's close collaboration with the empress ended, and Catherine terminated their afternoon discussions, allowing her to report only on Sundays. As

compensation, she granted her the money Derzhavin mentioned to build a dacha so that in lieu of their former meetings, she would have something to do with her afternoons. Dashkova's dream of a free and open exchange of ideas between all factions at court and among the opposition came to an end. For some time her role at the *Companion* had been to maintain peace and to bring a certain amount of civility and decorum to the heated discussions, especially when they touched upon the writings of the empress. In her "Sincere Regrets Concerning the Fate of the Editors of the *Companion*" ("*Iskrennee sozhalenie ob uchasti gospod izdatelei Sobesednika*"), she defended her journal and urged all participants and contributors, particularly Catherine, the author of "Facts and Fables," to continue publishing popularizations of historical events, as well as articles on other subjects, for the enlightenment of the people.[75] Yet Catherine would persist in voicing her displeasure and finally informed readers of her intention to withdraw from participation in the journal. Dashkova's letter, "To the Gentleman Author of 'Facts and Fables' from one of the Editors of the *Companion*" ("*K gospodinu sochiniteliu 'Bylei i nebylits' ot odnogo iz izdatelei Sobesednika*"), bestowed high praise on Catherine, describing the readers' tears now that her pieces will cease appearing.[76] Dashkova pleaded with the author not to depart from St. Petersburg and deprive the reader of her sophisticated, lighthearted, profound, and highly moral compositions. But Catherine was put off by Dashkova's effusive compliments, perhaps suspecting insincerity and crocodile tears, and in her "A Briefly Lengthy Reply" ("*Kratkodlinnyi otvet*") ordered Dashkova to tone down her rhetoric.[77]

Nevertheless, much harsher criticism of Catherine's work was to follow in S. P. Rumiantsev's article on Peter the Great, in which he extolled the glorious reign of Peter the Great and minimized, or at least remained indifferent to, the accomplishments of Catherine.[78] Catherine bristled up and in the same issue wrote a harsh reply accusing Rumiantsev of posturing solely to gain notoriety.[79] Although the editors defended the empress in the next issue of the *Companion*, Catherine was not satisfied. Later, Rumiantsev would write in his autobiography that she had been so displeased with his article on Peter the Great that she ordered Dashkova to submit it to a rigorous review and to write a rebuttal.[80] Dashkova obliged and presented her attack on Rumiantsev entitled "Short Notes of a Peddler" ("*Kratkie zapiski raznoschika*") to the empress, who was delighted and approved of its sharp, but as she saw it, completely justified criticism.

> In reading over the piece of the "Peddler," I could have sworn it was from my own pen, so close an imitation does it appear to me. With regard to its

criticism, it is not less true than severe; but beware of the answer. In order to make you quite easy, I intend in the future to lay an embargo on all the sheets, which fall into my hands, as marking with the stamp of secrecy those, which are already printed, is not quite so easy a matter.[81]

Dashkova must have felt intimidated as she read Catherine's threats. The empress warned that in the future, she would scrutinize more closely the content of materials submitted to the journal, for she would hate to take action against works already published. Unfortunately, the worst was yet to come when Catherine did in fact take action against Radischev's *A Journey from St. Petersburg to Moscow* and Dashkova's publication of Kniazhnin's play *Vadim of Novgorod*.

Dashkova's piece, in which she took Rumiantsev to task, appeared in the next issue of the *Companion*.[82] Disguised as a peddler's account of an overheard conversation, her work assails Rumiantsev for not knowing Russian and in his written work simply translating French words and constructions into Russian. Rather than aspire to profundity and pursue a career in writing, Dashkova recommends that it would be better for him to learn Russian. Dashkova was the only person to respond critically to Rumiantsev's article.[83] She would continue her polemic with him to the end, and in her *Memoirs*, only a few years before her death, she would present her negative views on Peter the Great during a conversation with Chancellor Kaunitz in Vienna.

Additionally, she defended the empress and voiced her approbation of Catherine's influence at every opportunity. For example, in the story "The Evening Party" ("*Vecherinka*"), Dashkova describes a soirée where Russian literature is the topic of conversation.[84] When the hero arrives he finds the hostess to be bored, and therefore decides to introduce her to Catherine's "Facts and Fables" from the pages of the *Companion*. Suddenly, the atmosphere brightens and first, the hostess smiles, then she laughs, and then the ice is broken. Discussions on literary topics animate the evening. Catherine's work introduces the reader to the traditions of Russia and the need to aspire to the heights established in the poetic works of the immortal Lomonosov. As an illustration, Dashkova cites a passage from Lomonosov's free translation of Horace in the "Preface on the Utility of Ecclesiastical Books in the Russian Language."[85] She also has only high praise for Bogdanovich, especially his poem *Dushenka*, in which he adroitly brings together the comic and heroic, Russian folklore and Greek myth. Dashkova promoted and nurtured Bogdanovich's career and encouraged

his participation in the *Companion*, where he published a number of poems and articles, some of them eulogizing his patron, Dashkova.

The contentious, antagonistic atmosphere at the journal and the Academies took its toll on Dashkova. Her efforts were in the end to no avail as personal animosity and political quarrels between Catherine, Naryshikin, Fonvizin, Rumiantsev, and others led directly to the empress's withdrawal from participation in the *Companion* and to the journal's demise. On April 17, 1784, Aleksandr wrote Simon that Dashkova was preparing to leave St. Petersburg and to spend the summer in Troitskoe. She would be departing at the beginning of May.[86] Dashkova would not return to her work as editor of the journal. During the last six months of the *Companion*'s existence it appeared irregularly and, with its sixteenth issue, folded in September 1784. It had existed for less than a year and a half. Catherine found that she could not impose her will in such an open forum, felt that the attacks were far too personal, and grew tired of the barbs directed at her royal person. According to her *Memoirs*, Dashkova had predicted the problems she would encounter when she assumed her post at the Academy and suspected that the appointment would inevitably bring her into direct conflict with the empress.

PART IV

Exile
1794–1810

Chapter Ten

Estrangement

GRIEF, ANGER, LOSS, AND ENDLESS DISPUTES at home and at court characterized the years of Dashkova's administration of the two academies as she carried out her duties and attended the empress. She was greatly saddened when she learned of Diderot's death in 1784. "His death was a great grief to me and I shall always regret him so long as there is a spark of life in my body. This extraordinary man was but little understood. Virtue and truth were the well-spring of every one of his actions and the general good was his ruling passion and constant pursuit" (126). Dashkova considered Diderot very highly, even above Voltaire, who was on a pedestal in Russia. Diderot was always much more accessible to her and she thought of him as a close friend. According to V. A. Bil'basov, "among Russian contemporaries of Diderot, only two held him in high enough esteem — two women: the empress Catherine II and E. R. Dashkova."[1] Dashkova would find little consolation from her children and other family members. In 1785, commenting on Dashkova's letter of condolence shortly after his wife's death in Venice, Simon wrote Aleksandr about his sister's bad temper, intolerable conceit, and expressed the wish that she would finally leave him alone.[2] A year later, he criticized the preposterous and exaggerated manner in which she educated her children, adding that, for example, she had inculcated her son's easy nature with the seeds of ambition.[3]

Dashkova appealed to the empress in 1785 for the division of the family property so that she could keep ownership of her beloved Troitskoe, since it had belonged to her husband, and the two additional villages of Ptitsyno (now Dashkovo in the Orlov province) and Murikovo (Volokolamsk region). Her son would receive eleven villages, and according to the law

of the time, Dashkova could acquire only a seventh part of her husband's estate.[4] Dashkova argued her claim to a greater share of the property, not only as her son's guardian, but also on the basis that she had contributed a dowry of nearly thirteen thousand rubles, had paid off her husband's many debts, including accumulated interest, had herself acquired additional land, and had assured the education of her children. The senate eventually decided in her favor and she continued her efficient and businesslike management of the Dashkov estates. Her legal victory, however, only served to exacerbate her already strained relationship with her children and led to further litigation.

At court on one occasion, Catherine pressed Dashkova to write a play in Russian for the Hermitage Theater. In 1781, the empress had charged Giacomo Quarenghi with the design and construction of her neoclassical temple of the arts, with its covered bridge over the Winter Canal connecting the magnificent chamber theater to the building of the Old Hermitage. Quarenghi modeled the interior after an ancient amphitheater, with circular rows of seats rising to the rose and yellow-colored marble walls lined in Corinthian columns. Statues and busts of Apollo, the nine muses, and ancient Greek authors occupied the niches between the columns of the intimate theater that seated some four hundred persons for dramatic presentations and concerts of chamber music. The first performance at the Hermitage, which was completed in 1787, took place as early as 1785, and Catherine personally patronized the court theater, staging Molière and Sheridan, among many others, as well as contemporary European authors. By 1786, Catherine was commissioning plays for her theater, requesting contributions from her courtiers, and writing and staging her three anti-Masonic comedies, *The Deceiver, The Seduced,* and *The Siberian Shaman.*

Although Dashkova protested that she did not possess an ounce of talent, the empress's request pleased her, and she quickly composed a two-act play entitled *Toisiokov or a Weak-Willed Person* (*Toisiokov ili Chelovek bezkharakternyi,* 1786). When she showed it to Catherine, the empress was dissatisfied, demanding something more substantial and insisting on five acts. Reluctantly, Dashkova expanded the play with what she considered unnecessary padding. When it was finally completed, Catherine had it performed at the Hermitage Theater in August 1786, and Dashkova then published it in *Russian Theater,* the journal she edited.[5] *Toisiokov* is a smiling, gentle Horatian satire on Russia's infatuation with everything French, in the style of Fonvizin's *Brigadier* (1768-69). The title of the play is modeled on two satires that appeared in 1769: *And This and That* (*I to i se*) and *Neither This nor That* (*Ni to ni se*). A. N. Afanas'ev, in his article "The Literary Works

of Princess E. R. Dashkova," argued, "This comedy was written on the French model, it is completely lacking in Russian reality."[6] Actually, it is a typical Russian play of the Enlightenment written on the European model of French classicism; its plot is representative of Dashkova's place and time. The play owes as much to Fonvizin as it does to Boileau and consists of a simple and implausible plot unfolding as a consequence of the main character's single personality trait of indecisiveness. Toisiokov complicates and tangles his affairs through constant hesitancy and uncertainty, while his aunt untangles them through positive action and boundless energy.

The comedy, in which names reflect the dominant traits of characters, condemns and ridicules fashionable Francomania, inactivity, laziness, stupidity, and corruption. It relates the trials of the main character, Toisiokov (Mr. Thisandthatov), a weak-willed, endlessly vacillating landowner, who in many ways anticipates Goncharov's immensely indolent Oblomov. Dashkova pits the inert Toisiokov against his aunt, the purposeful and resolute Reshimova (Mrs. Resolutova), an old-fashioned widow dressed in black who bears a striking resemblance to Dashkova herself, almost to the point of self-parody. He is a useless rag of a man incapable of action, while she is a strong, straightforward woman, who never delays but acts without ado. Weighed down by insecurity, contradictions, internal conflicts, and uncertainty, he cannot decide between this and that or anything else, and as a result cannot bring himself to do anything at all. Ignorance, illiteracy, equivocation, and weakness of will are his downfall, as he foolishly spends money, needlessly sells and repurchases the same property, constantly rebuilds his house, or initiates building projects that go on forever without nearing completion. The loosely structured plot, based on eavesdropping and other time-honored devices, revolves around his valet, the Frenchman Lafleur, who along with the butler swindles Toisiokov, bringing him to the brink of economic ruin. But the indomitable Reshimova intercedes, rescues her hapless nephew, and taking advantage of the situation, lectures and admonishes him at length.

In the end, Reshimova, with the assistance of her stableman Prolaz, succeeds in foiling the villains, recovering the money, and marrying off the young lovers. They are dull, conventional, and of little consequence, as are most of the secondary characters, while Zdravomyslov, a positive voice for reason in the play, is unremarkable and bears a striking resemblance to Fonvizin's Dobroliubov and Starodum. Reshimova emerges as the most interesting character: a model of positive action extricating her unlucky nephew from a complex web of deceit. Taking center stage, she chastises him repeatedly and at the conclusion holds forth on the subject of mar-

riage. Dashkova based Reshimova's monologue on her former life with her husband as she relates how initially as newly weds they pursued their selfish interests, mostly estranged from each other. Later, the young couple lived together in isolation far from the distractions of society but grew bored of each other, and at last, found it necessary to come to a compromise concerning their marriage, which resulted in thirty years of conjugal bliss. Sadly, the early death of Dashkova's husband denied her such happiness, and she could only imagine it on stage. Thus, the play ends traditionally with an instructive and morally uplifting sermon delivered for the benefit of Toisiokov and the audience alike.

At court, there was some speculation concerning the prototype for the main character Toisiokov, with Ivan Shuvalov and Dashkova's enemy Lev Naryshkin put forward as the main candidates. Dashkova denied any such connections between her character and an actual person: "I did not want people to fancy that I had in mind any particular individual living in Petersburg, and chose the most universal type of all—a man of weak character—unfortunately so common in society" (235). In drawing her hero Toisiokov for the stage, Dashkova relied on her enduring love of the dramatic arts and a lifelong involvement in theatricality, which was to play such a central role in the writing of her *Memoirs*. M. N. Makarov related that while consulting Dashkova on an article he was writing about Catherine's plays, Dashkova told him that she, not Catherine, was the author of the comedy *Mrs. Vestinikova and her Family*. However, he does not support her statement with any evidence of Dashkova's authorship.[7] According to some sources, she was also the author of *Country Celebration* (*Narodnoe igrishche*), a parody of fashionable "tearful comedies" that in 1774 Novikov published in his journal *Koshelek* (*The Purse*).[8] The play *Fabian's Wedding or the Desire for Riches Punished* (*Svad'ba Fabiana ili Alchnost' bogatstvu nakazana*, 1799) has been lost. It was Dashkova's dramatic response to August Kotzebue's *Poverty and Nobility of the Soul* and a result of her deeply felt reaction to the character Tsederstreim.[9] Written in less than three hours, it represented a passionate expression of Dashkova's dissatisfaction with the playwright's unwillingness to punish greed sufficiently. Kotzebue was a sentimental writer who lived in Russia off and on from 1781–1801. His plays started appearing at the end of the 1790s and were to influence Russian drama, loosening the hold of French classicism. A. F. Malinovskii translated the play, and Dashkova saw it at Aleksandr's estate theater.[10]

From childhood, theater was a passion Dashkova shared with her brother. Their father's well-known Theater on the Znamenka opened in 1769 in his two-story stone house in Moscow at 12/2 Znamenka. Aleksandr

continued his father's legacy and maintained at Andreevskoe one of the best estate theaters in Russia. Its success was largely due to the professional directorship of Aleksandr's companion, François Germain Lafermière, a poet, librettist, and influential figure in the theater world. He was born on February 11, 1737, in Strasbourg and studied at Strasbourg University. At the university, he met Heinrich-Ludwig von Nicolai, who was to be his friend for over forty years. Nicolai served as secretary to D. M. Golitsyn, the Russian Ambassador in Vienna and later succeeded Dashkova as Director of the Academy of Sciences. When Lafermière arrived in Russia, thanks to the sponsorship of Mikhail Vorontsov, he gained an appointment as librarian to Grand Duke Paul and then became secretary to Paul's first and second wives. He accompanied Grand Duke Paul and his wife Maria Fedorovna during their travel abroad in 1781-1782, and as a close friend of the family, he must have met with Dashkova in Rome. It was at Paul's court that he became involved in the musical theater and worked with the composer D. S. Bortnianskii, whose musical activities after 1780 were also primarily associated with Paul's "lesser" court in Pavlovsk, since he was the musical instructor to the Grand Duchess Maria Fedorovna. Lafermière collaborated with Bortnianskii on, for example, the opera *Le fils rival ou la Moderne Stratonice*, and on a collection of romances and songs.

Dashkova, however, had fallen into disfavor with Paul and rarely visited his court. In 1793, Lafermière too fell into disfavor at Catherine's court and retired with Aleksandr Vorontsov to Andreevskoe. A great admirer of Nikolai Sheremetev's estate theater, which he had visited, he attempted to create something similar at Andreevskoe, where he regularly organized productions of foreign and Russian dramatists such as Sumarokov, Krylov, Kniazhnin, and Verevkin. Normally, he staged one performance weekly, but when Dashkova was visiting he scheduled additional nights to indulge her great love for opera and theater. For 1794, the repertoire consisted of the opera *The Barber of Seville* by D. Paisiello, the comedies *Poverty and Nobility of the Soul* by A. Kotzebue, *The Brigadier* and *The Minor* by D. Fonvizin, and the one-act plays *The Enamored Blind Man* and *The Imaginary Treasure* by I. Sokolov. In addition, the repertoire included *That's How it is to Have a Basket Full of Laundry* by Catherine II, the tragedy *Dmitrii the Pretender* by A. Sumarokov, and many others. Dashkova saw many of these productions at her brother's theater, and she modeled her own theater at Troitskoe on Lafermière's work at Andreevskoe.

Theater and musical theater played an important role in Dashkova's life, absorbed as she was in the musical and cultural life of St. Petersburg. Among other productions, Dashkova saw her protégé Nikolai Nikolev's

four-act musical "drama with voices" *Rosana and Liubim* and Ia. B. Kniazhnin's *Misfortune from a Carriage* and *The Miser*, with music by the Russian composer V. Paskevich. Dashkova brought up and nurtured the talents of the writer Nikolai Nikolev, who came to live with her when he was five. He would dedicate to her his first comedy, *Nothing Ventured, Nothing Gained* (1774) and later published in the *New Monthly Essays* his "Lyrical Missive to E. R. Dashkova," a statement of his classicist ideas based on a reading of Boileau. Performed with great success in Moscow in February 1785, the play *Sorena and Zamir* was considered to be politically daring for its time with it emphasis on human rights. The Moscow authorities objected to some lines critical of absolute monarchy, but Catherine refused to ban it.[11] It was published the following year in Dashkova's *Russian Theater*, where Dashkova also published Nikolev's other plays, and in 1792, Nikolev became a member of the Russian Academy.

Dashkova often attended concerts and stage productions at the Hermitage Theater, where over the years many of the leading European performers appeared, and was present at special evening concerts in the empress's inner apartments. Catherine's musical tastes favored the light, comic operas of her Italian kappelmeisters Domenico Cimarosa and Giuseppe Sarti. Of the three surviving manuscripts with musical notation in Dashkova's album, one is of Guiseppe Sarti's opera entitled *Idalida*, dated 1785.[12] Also popular at court were the native-born Vasilii Paskevich and Mikhail Sokolovskii, among others. Giovanni Paisiello, in attendance at Catherine's court from 1776–1784, entertained the court with such compositions as *Le philosophe ridicule*. He conducted the orchestra, while the violinists Giovanni Battista Viotti and Jacques Pierre Joseph Rode performed or accompanied the diva, Catarina Gabrieli. When Cimarosa balked at Gabrieli's exorbitant demand of twelve thousand rubles annually plus expenses, explaining that such compensation exceeded that of field marshals in Russia, she retorted that field marshals were commonplace, but there was only one Gabrieli.

Regrettably, since Dashkova's presence at court and proximity to the empress did not please many of the courtiers, her humiliation there saw no end, as she continued to be the butt of the courtiers' humor and ridicule. Every rashly taken action, to which she was prone, was the focus of attention. One such incident caused Dashkova great pain and embarrassment as her problems with the Naryshkin family continued. It represented the culmination of a long-standing dispute concerning a small parcel of land, but in matters dealing with her financial interests at the academies and in

her personal life Dashkova was unshakable and unsparing of those who sought to take advantage of her.

The clash over real estate was but one instance in a long line of Dashkova's grievances toward Aleksandr Naryshkin, her neighbor and enemy at court. As opposed to his brother Lev, Aleksandr Naryshkin did not enjoy Catherine's favor and she considered him an unpleasant man. In 1787, Dashkova's animosity erupted into an epic confrontation when Naryshkin's pigs wandered onto her property and trampled six of her favorite potted plants worth six rubles or so. Dashkova was already out of sorts, since she had recently been obliged to cover her son's gambling debts. Always preferring direct action, she straightaway had Naryshkin's pigs slaughtered. After a short hearing, the local court ruled against Dashkova, assessed a fine of eighty rubles, and requested that heretofore she desist from any such actions.[13] The unrepentant Dashkova swore that she would not hesitate in the future to butcher Naryshkin's pigs once again if they ventured anywhere near her plants.

Having gotten wind of this silly incident, Catherine and her circle did everything they could to exacerbate the situation. At state functions, the empress would seat Dashkova next to her enemy, even though there was some fear that the dispute might turn violent. At the table, the combatants would sit on the edges of their chairs with their backs turned to each other, prompting court wits to comment on their resemblance to the great double-headed eagle of Russia. Khrapovitskii wrote that at that time Catherine spoke ill of Dashkova and had grown weary of hearing endless accounts of her European tours. Catherine was fond of Anna, Aleksandr Naryshkin's wife, and made it clear that she favored her over Dashkova. Khrapovitskii recorded in his diary on May 19, 1788, that when the court was moving to Tsarskoe Selo Catherine ordered that "rooms be prepared for Anna Nikitishna Naryshkina . . . but not for Dashkova. 'I want to pass some time with one and not with the other. They [Dashkova and the Naryshkins] are fighting over a shred of land.'"[14] Catherine preferred to keep Dashkova at a distance, but the quarrel amused her to such an extent that she poked fun at it in her unpublished and never performed play *Swatting a Fly with an Ax* (*Za mukhoi s obukhom*). It satirized the squabble between Naryshkin and Dashkova in the characters of the foolish Durindin (Dimwit) and the tiresome Postrelova (Rascal), endlessly bragging about her travels abroad.[15]

The incident with Naryshkin's pigs was but one of the stories that were to enhance further Dashkova's reputation for cantankerousness, fueling outlandish rumors and anecdotes. According to P. A. Stroganov's French

tutor, it was said at court that when guests arrived at Troitskoe, Dashkova ordered their servants and horses to work in the fields. She provided her visitors with work aprons and did not seat them at the table until they carried several bricks to the construction site of the church she was building. "Nevertheless, the guests kept coming and she was greeted everywhere with honor."[16] But Dashkova could not close her eyes to the derision and raillery directed at her, nor could she ignore the maneuverings and schemes at court of enemies such as the Orlovs, Domashev, and Zavadovskii, whom she called Monsieur Sans Tête. Demeaned and offended by the animosity and mockery she felt from many of her colleagues, she wanted to resign her positions at the Academies and to quit Russia entirely. She remembered stories about the manner in which Empress Anne had mortified her mother and made other courtiers feel small. Now it was her turn, even though Dashkova understood that she was overly sensitive and that she should not take everything to heart, it was tiresome and contrary to her nature to mask her true feelings continually. "Why don't they leave me alone?" Dashkova wrote in a letter,

> I ask for little, only that I be allowed to work without humiliation, and if this is not possible, I will quit and leave my native land. I would not remain in this country even fourteen months after quitting the Academy. This is why everything that is occurring now upsets me so and tears at my soul. . . . I cannot sit still and endure new insults and fault-finding — I have in no way earned them.[17]

In 1788, war broke out with Sweden and Dashkova recounted "a curious episode" that occurred during the war and lifted her spirits, if only temporarily. Her old acquaintance the Duke of Sudermania, who commanded the Swedish fleet, sent a flag of truce to Kronstadt accompanied by a packet and a letter to Samuel Greig, Scottish naval officer and admiral of the Russian fleet. On board his flagship Gustavus the Third, the Duke wrote, "A packet addressed to your highness, coming from Philadelphia, and having fallen into my hands, I could not for a moment delay the gratification of forwarding it to you."[18] As it turned out, the Swedes had seized a ship and on it found a packet addressed to Dashkova, whose name the Duke recognized immediately. Having received it from the Duke, Admiral Greig sent it directly to the Council of State in St. Petersburg, headed by Catherine, who in turn forwarded it, purportedly unopened, to Dashkova at Kirianovo. Dashkova was thrilled to receive the letter. Posted May 15, 1789, it arrived only on August 18/29, 1791, "signed in person by the fa-

mous Dr. Franklin" in recognition and "testimony of the high appreciation of the literary work of the princess on the part of most distant societies."[19]

> The packet was from the famous [Benjamin] Franklin, whose feelings of friendship and esteem for me prompted him to propose my membership of the highly respected and celebrated Philosophical Society of Philadelphia [American Philosophical Society]. I was unanimously elected and received a Member's Diploma, and from that time on the Society never missed an opportunity of sending me works it had published. The packet contained several of these, as well as a letter from the Secretary. It flattered me far more to receive Franklin's letter than the Duke's . . . [and] I wrote to Franklin and the Secretary of the Philosophical Society thanking them most sincerely for the works they had sent me (228).

When Dashkova revealed the contents of the packet to Catherine, the empress was not pleased with Dashkova's close ties to the commander of an enemy fleet or with her friendship with Franklin. She requested that Dashkova terminate her correspondence with the Duke. Nor was Catherine's attitude toward Franklin a positive one at this time, and when shown his portrait, she remarked, "*Je ne l'aime pas.*"[20] The empress, who was trying to hold the far-flung lands and people of Russia together, did not look with favor on the struggle of the North American colonies for independence. In connection with the publication of Radishchev's *Journey from St. Petersburg to Moscow*, Catherine supposedly stated angrily that he is "worse than Pugachev . . . he praises Franklin."[21] Yet on this matter Dashkova's opinions differed greatly from the empress's and she was a great admirer of Benjamin Franklin.

As ill luck would have it, personal tragedies always seemed to offset Dashkova's greatest professional achievements. As she was leaving the empress's bedroom, Dashkova noticed Vasilii Rähbiner, equerry to Catherine, alone in the antechamber. He came up to her, paid his respects, and told her about a letter he had recently received from Kiev informing him of Pavel Dashkov's marriage. Dashkova was stunned—about to faint, she requested a glass of water to regain her composure. That evening at home she was "overwhelmed by mental anguish and distress" as she "succumbed to a nervous fever and for days could do nothing but weep" (230). She had sacrificed everything for her children and had devoted herself solely to the education of her son—she deserved her children's friendship and respect! Just recently, she had made good yet again on another of her son's obligations and covered a gambling debt of twelve hundred rubles he had

incurred in Kiev. She was displeased with her son's profligate lifestyle, although he had asked forgiveness and promised to reform. It was a promise he failed to keep, and Catherine would characterize him as a "simpleton and an alcoholic."[22] Two months passed before Pavel finally wrote her requesting permission to wed, but by then Dashkova already knew that her son had married Anna Alferova, the daughter of Simon Alferov, a merchant. Dashkova felt betrayed: Pavel had kept the affair a secret from her and in so doing had acted deceptively, demonstrating his distrust, apprehension, and even fear of his mother.

Although Pavel and his wife would have no children, Dashkova's sources informed her that at the time of their marriage Anna was pregnant. According to Pavel's contemporary, F. F. Vigel', "without much thought, Dashkov just got married, although he was not truly in love."[23] Dashkova wrote back curtly, hardly containing her outrage, that when his father had wished to marry her, he rushed to Moscow to request his mother's consent, since it was required that a suitor seek the approval of the parents before officially proposing to a marriageable young woman. Dashkova expected the same obedience and consideration from her son. Yet, the clandestine nature of the union did not bother her most. Pavel had married far below his station and this "inconceivable and ridiculous" misalliance would neither advance his career nor provide him with a large dowry. In fact, it might retard the brilliant future she had planned for him and could possibly jeopardize all of her efforts over the years. Moreover, she felt it was an affront to her, since her enemies at the court knew of this marriage and were making light of it, while she had remained in the dark. More concerned with dynastic and financial questions, Dashkova had forgotten that she had married freely and impulsively.

Pavel, who desperately sought to free himself of his mother's despotic authority, would go on to serve in Poland, Moldavia, and Bessarabia, and Dashkova would not see him for four years. The years after her son's marriage were some of the most difficult for Dashkova. Weighed down by dark thoughts, she suffered greatly from loneliness and disappointment.

> I spent the summer in a mood so despondent that but for the grace of God, I should have triumphed over the thoughts of gloom and despair that had taken possession of my mind. For as soon as I fancied myself forsaken by my children, life became a burden which I should have surrendered readily—indeed, gladly—to anyone who came to destroy it (231).

In his work "On the Death of Countess Rumiantseva," Derzhavin alludes to Dashkova's anguish in the presentation of Rumiantseva's courageous response to suffering. He also makes the association with Dashkova when he wryly refers to her floors covered with English rugs.[24]

Slowly, as she regained her strength and recovered from depression, Dashkova again immersed herself into her work at the Academies, which, for a time, took her mind off the sad thoughts that plagued her. But the conduct of Dashkova's children, who continually sought to break away from their mother's suffocating control, would not give her respite. Catherine remarked that "Even with the mother's much-vaunted education both the daughter and son turned out to be scoundrels: the son could not even earn a single decoration."[25] Then her daughter disappeared and stubbornly refused to answer her letters, and a year after her son's marriage Dashkova learned that creditors were pursuing Anastasia.[26] They had obtained an injunction forbidding her to leave St. Petersburg, and she had come under the surveillance of the police, who were monitoring her every action. The next day she sought out her daughter and found her ill and breathing with difficulty. She noted cruelly that Anastasia seemed older now and even less attractive than in the past. But Dashkova came to her aid, writing on her behalf and vouching for her. She forgave Anastasia, promised to settle her debts, and arranged for her to take the waters in Aachen. Dashkova's doting attitude always carried with it a dictatorial element, and once again, her daughter revolted. Catherine commented that "nobody likes her [Dashkova] . . . even her daughter refuses to live with her mother."[27] In March 1793, Dashkova, to her dismay and disbelief, learned that her daughter was ill in Vienna and needed money. Anastasia, after completing her course of treatment, did not come home but resumed her life of extravagance, dissipation, debt, and scandal. She headed directly to Vienna and later Warsaw, where she squandered fourteen thousand rubles.

With her lavishness and indebtedness, Anastasia had found a way to sadden and hurt her mother. Her debt represented an unthinkable sum for the financially cautious Dashkova, who some twenty years earlier had purchased a large house in St. Petersburg for exactly the same amount of money. On this occasion, however, she was unmoved and unbending, certain that Anastasia's illness was a fantasy, or worse, a ruse covering up her disgraceful and profligate behavior. If Anastasia wanted Dashkova to arrange her ruined financial situation, she must return to her mother. In the end, it was a matter of honor; the frugal and pennywise Dashkova felt

she had to pay up. According to some sources, over her lifetime Dashkova would assume the staggering total of 250,000 rubles of her daughter's debts.[28] Earlier, Catherine had written that everybody now shuns Anastasia and that even her mother will not hear of her because her actions have been so despicable.[29] Dashkova had lost her children and never had she felt so alone. She knew that her children were now gone from her forever. The daughter's behavior was so outlandish and Dashkova so distressed that the empress wrote her: "Be assured of my sympathy in all your suffering, both of body and spirit."[30] It seemed that there was no escape from the darkness and despair shrouding her life.

> Everything—the past, the future—seemed black to me. I had fallen prey to dark and horrible thoughts. I shudder now to confess that the idea of suicide came to my perplexed mind, and but for religion—the failing soul's support, the unfortunate's shield and protection against despair—I do not know what excess I might have committed. Neither the thought that self-immolation was always a coward's way out, nor any other reasoning would have sufficed to save me from myself. I was too unhappy to obey the voice of reason, or ambition, or any other human feeling. I longed ardently for death (233).

Dashkova's professional activities in the areas of literature, education, and publishing were a welcome diversion from the psychological and emotional turmoil of her family life. Unfortunately, they continued to lead her on a path of direct confrontation with the empress. While Russia was enjoying the victories of the Second Turkish War, with the siege and capture of the Turkish fortress at Ochakov and further territory around the Black Sea, France was experiencing a time of social change and political upheaval. The excesses of the French Revolution horrified Catherine; the enlightened monarch who had once admired the liberal ideas of the *philosophes* would launch a period of political reaction, censorship, and greater governmental controls in Russia. Once, Dashkova inadvertently mentioned Rousseau to the empress and then had to agree with Catherine's assessment that he was a dangerous author. For Dashkova, Catherine's negative comments concerning Rousseau and Franklin signaled that governmental policies were taking an ever more conservative path. Not only Radishchev, Kniazhnin, and Novikov, but also Dashkova herself, with her liberal, enlightened views, and stubborn often-inflexible personality, were coming under suspicion.

Dashkova's relationship with the empress, already strained, took a turn for the worse. John Parkinson, the Oxford don traveling in Russia in the early 1790s, met Dashkova a number of times, and she expressed to him her "disaffection to the empress."[31] The growing rift was mostly due to Catherine's suspicion of Dashkova's involvement in seditious activity. As early as 1786 Derzhavin wrote the poet and playwright V. V. Kapnist, "Please find, my friend, your poems, copies of which I gave Princess Dashkova. She asked for odes on slavery, but I said that you did not leave them with me, since you could not locate them among your papers."[32] He goes on to explain that he advised Dashkova against publication because it would not be in the best interest of Dashkova or Kapnist. In the 1790s, Catherine also believed that Dashkova participated in the publication of A. N. Radischev's allegedly revolutionary *Journey from Petersburg to Moscow*, that with its unequivocal condemnation of serfdom predicted the complete break between the government and the opposition of the intelligentsia. During these years, Dashkova's brother Aleksandr was her closest ally and confidant, and his circle of friends included L'vov, Derzhavin, and Radishchev. Participating fully in the literary and artistic life of St. Petersburg at the close of the eighteenth century, Dashkova was well acquainted with Nikolai L'vov, an architect, artist, and musician. L'vov headed a group of artists that included some of the leading cultural figures of the time: the writers G. R. Derzhavin, V. V. Kapnist, Ia. B. Kniazhnin, I. I. Khemnitser, and I. I. Dmitriev; the artists V. L. Borovikovskii, and D. G. Levitsky; and the musicians E. I. Fomin, V. A. Paskevich, and I. Prach, among others.

Beginning in January 1778, A. N. Radishchev, the reform-minded writer and liberal thinker, worked in the Commerce Collegium that Aleksandr Vorontsov headed. He was Aleksandr's protégé and fellow Mason, and in 1789 published anonymously the essay "The Life of Ushakov" ("*Zhitie Ushakova*"). This was an intellectual biography of a fellow student, F. V. Ushakov, with whom he studied philosophy at Leipzig University, in which Radishchev confronted issues of despotism, corruption, and war. The materialistic philosophy of Helvétius in *De l'Esprit* had influenced him to a great extent, and although she too had fallen under Helvétius's spell in her youth, Dashkova did not like Radishchev's essay. Derzhavin recommended it to her and after reading the work, she immediately wrote a letter warning her brother. She explained that when she and Derzhavin were at the Russian Academy he told her that many contemporary writers did not know Russian well and by way of an example alluded to a "stupid"

work by Radishchev on the death of his friend Ushakov. She replied that she was not familiar with it but did not believe that it was so, since the author was not stupid. When she eventually read the book, she found that the author was imitating Stern's *Sentimental Journey* and that he had read Klopstock and other German writers, but had not understood them fully.[33] Written in an archaic and awkward Russian, she agreed with Derzhavin that the essay was "proof that we had many writers who did not know their own language" (236). More importantly, according to her *Memoirs*, she prophetically cautioned her brother that his protégé's thoughts and ideas "were dangerous in the times in which we lived" (236).

Dashkova therefore was not surprised when she received a letter from her brother informing her that Radishchev had published his *Journey from Petersburg to Moscow* (1790), a "tocsin to revolution," as she referred to it (237). Written in the form of a travelogue, it was a thinly disguised condemnation of serfdom, tyranny, and other government abuses. The *Journey* reflected his reading of Dashkova's friend and one time traveling companion, the Abbé Raynal, whose *Histoire des deux Indes* and other writings were highly critical of slavery and despotism. Seemingly, Dashkova had not read Radishchev's *Journey from Petersburg to Moscow*, but Catherine had, and its "revolutionary" content outraged her. According to Khrapovitskii, Catherine accused Radishchev of being a Martinist and a rabble-rouser.[34] She had Radishchev apprehended, interrogated, and exiled. Radischev's arrest distressed Dashkova, and even more, she feared for her brother's safety. Since Aleksandr defended his ally to the end, he could potentially be arrested and exiled. In protest, Aleksandr absented himself from the senate and the state council, stopped appearing at court, and spent that summer and fall at his country house on the Gulf of Finland. His remonstration was in great measure responsible for the easement of Radishchev's sentence. Indeed, her brother, many of whose ideas she shared, came out in opposition to Catherine and pointed to the corruption of her court: "The extravagance and indulgence in all forms of abuse, a greed driven desire for enrichment and the rewarding of those who participated in all these abuses."[35] Officially, Aleksandr requested a leave of absence, and in 1792, Catherine approved it. Actually, Aleksandr was forced into retirement and he subsequently resigned his governmental post. He continued to support Radishchev and his family financially during their exile in Siberia, supplying them with money and other necessities. From St. Petersburg he moved to Moscow, where he lived in his house in the Nemetskaia Sloboda and on his estate Andreevskoe. In November 1793, Dashkova wrote her brother

that Catherine still suspected them of participating in the publication of Radishchev's book.[36]

Like her brother, Dashkova was not immune from Catherine's intolerance and her persecution of writers, artists, and intellectuals as the political climate in Russia grew increasingly more repressive. The spark that ignited and fueled Catherine's anger, resulting in threats of book burning, was Dashkova's publication at the Academy in 1793 of Iakov Kniazhnin's tragedy *Vadim of Novgorod* (*Vadim Novgorodskii*). The play, criticizing autocracy and proclaiming political freedom, appeared in Dashkova's journal *Russian Theater*. Kniazhnin's widow requested that Dashkova publish her husband's last tragedy, *Vadim of Novgorod,* with profits from its sale going to the financial support of the dramatist's surviving children. Kniazhnin himself had withdrawn his work from production, fearing that after the fall of the Bastille, Catherine would interpret it as a subtle attack on the corrupting influence of absolute power, or perhaps even a call to revolution. Dashkova described her problems with Catherine over the publication of *Vadim* in a long letter to her brother. Written in Russian and French during the first half of November 1793 in St. Petersburg, she never posted the letter.[37]

In the letter Dashkova explained that in June the bookseller I. P. Glazunov had requested permission to publish the tragedy *Vadim of Novgorod,* which he had purchased from the family of the recently deceased Kniazhnin, who was Dashkova's friend, associate, and colleague at the Russian Academy. When Glazunov submitted it for publication to the Academy publishing house, Dashkova immediately authorized its publication. She never had its contents evaluated nor did she suspect that it might contain anything of a compromising nature. She related that her assistant, Osip Kozodavlev, read the manuscript and "found nothing in it to which censorship could take exception."[38] Dashkova, however, admitted to her brother that she did not think to submit the play to the censor before publishing it.[39] The uproar over its appearance, as it seemed to her, was a consequence of court intrigue when someone informed Platon Zubov, Catherine's current youthful lover, that the play contained dangerous allusions and implications. Nikolai Novosil'tsev notified her that Ivan Saltykov, who according to Dashkova never read anything, also denounced the book to her Majesty. Thus, her enemies at court, who hated her and saw this affair as an opportunity to move against her, were keeping it alive and exaggerating the seditious nature of the play's content.

Earlier, Dashkova writes, Catherine sent her an ominous and threat-

ening note informing her that she was in possession of Knaizhnin's drama.

> There has just appeared a Russian tragedy, called *Vadim of Novgorod*, printed at the press of the Academy, according to its title page. It is said to be not a little severe and bitter against sovereign authority. You would do well to stop the sale of it till I have time to look at it. Good night. Have you read it?[40]

Subsequently, Catherine and her henchmen subjected Dashkova to repeated threats and intimidation. On Wednesday, the state-secretary Vasilii Popov informed her that in the future, she should pay closer attention to the works she published, and in due course, Nikita Ryleev, chief of police and later governor of St. Petersburg, whose duties included overseeing the censorship of published materials, visited her. He politely requested her to sign orders allowing him access to the Academy's storeroom so that he could round up all copies of the tragedy and remove them from circulation. Catherine had in fact ordered the impossible task of confiscating all existing copies. While he was obtaining her signature, Dashkova informed him that he would not find any copies there, but that the work had also been published in the latest issue of her journal *Russian Theater*. He would therefore have to tear it out of the journal and thereby ruin the entire volume. Nonetheless, Dashkova, who had obviously taken fright, granted the chief of police permission to excise the offending pages from the volume in question. On Friday morning, Dashkova learned that the police had searched the academic bookstore and found nothing.

The empress's close scrutiny of Kniazhnin's work worried Dashkova and immediately, she sent off a letter to Catherine, along with corroborating documentation, confessing that in June she had authorized the publication of *Vadim of Novgorod* without reading it in advance and that it was not yet available at the bookstore. Her letter did not forestall Catherine from dispatching her newly appointed procurator-general, Aleksandr Samoilov, who in September 1973 had succeeded the deceased Viazemskii, to visit Dashkova for a stern and earnest conversation. Dashkova understood that Catherine was making every effort to bully and unnerve her, but firmly believing that she had done nothing wrong, she promised herself to remain calm and unflappable. Samoilov accused Dashkova of the dissemination of materials prejudicial to the interests of Her Majesty, already angered by the publication of Radischev's book. He recommended that Dashkova explain to the empress her certainty at the time

that the play was nothing more than a historical romance full of love, intrigue, and adventure. When the unyielding and now angry Dashkova refused to do so and countered that it was indeed difficult to explain oneself to a monarch, Samoilov's threats grew more menacing. He assured Dashkova that this was a serious matter, that Dashkova did not suspect its full gravity, and even worse, that the empress suspected her and her brother Aleksandr of supporting the publication of Radishchev's seditious work. But Dashkova was prepared for the accusation, since earlier Bogdanovich had warned her that Derzhavin, frightened by the Radishchev scandal, had been spreading malicious rumors about her.

Dashkova hoped that the affair had been blown out of proportion and would come to an end, since prolonging it would only fuel the scandal and whet the reading public's curiosity. The next day, Dashkova made her customary visit to the palace and noticed immediately that the empress, who invited her into the Diamond Room, was displeased. She was surprised and disappointed when Catherine approached her angrily. Catherine told Dashkova directly that she could not allow this situation to degenerate into something resembling the atrocities of the Reign of Terror then devastating France. The empress continued that two treasonous works, Radishchev's and Kniazhnin's, have now been published—what would the third one bring? It was a severe and dangerous rebuke, as Catherine accused Dashkova of treachery. Dashkova confessed to reading Radishchev and implicated Derzhavin, although in the *Memoirs* she wrote that the conversation concerning "The Life of Ushakov" took place a year earlier with her brother. Catherine threatened to burn Kniazhnin's awful and insulting tragedy and demanded to know what she had done to deserve such ill treatment. Dashkova seemed to have shown remarkable restraint at this meeting, for in fact Catherine had done a great deal to invite Dashkova's disapproval and anger. Even so, her sharp tongue did not serve her well and she replied that if the empress chose to burn the play, then it would not be she blushing for such actions.[41]

Writing in her *Memoirs* Dashkova cited Samoilov's words to her that Catherine did not seem to "harbor any resentment" against her. She went on to dramatize the moment of reconciliation.

> In any case, I was so pleased that the empress had not forced me into a complete breach with her that scarcely had I crossed the threshold of her room than, holding out my hand, I asked her to give me hers to kiss and to forget all that had lately passed between us.
> "But, indeed Princess...."

But I did not let her continue, and quoted a common Russian proverb: "A grey cat has jumped between us and we must not call it back."

The empress had the goodness to adopt the same attitude as I did. She chuckled good-naturedly and changed the subject. I felt gay and cheerful, and made Her Majesty laugh heartily at dinner (240).

Petr Zavadovskii, however, wrote to Aleksandr that "Dashkova's cheerful and unconcerned demeanor, without a trace of repentance for her misdeeds" upset Catherine.[42] He explained that although Dashkova had assured the empress that she had not read the play and apologized for its publication, Catherine remained angry. She felt that Dashkova had not demonstrated the necessary remorse and was not penitent enough.[43] Dashkova had defended herself by asserting that Kniazhnin's work did not differ from countless other plays acted in scores of public theaters in the capital, including Catherine's Hermitage Theater. But Dashkova failed to mention that such revolutionary works as Voltaire's *Brutus* and *La Mort de César*, and possibly Joseph Saurin's *Spartacus*, influenced greatly the tone and many of the sentiments expressed in Kniazhnin's play. Additionally, the play's republican sentiments infuriated Catherine, since its appearance coincided with the executions of Louis XVI on January 23, 1793, and Marie Antoinette on October 16, 1793. Nor was Dashkova's contention that she did not read the play convincing. According to Kniazhnin's son, Dashkova knew that the contents of the play would incur Catherine's wrath.[44] Its appearance in 1793 was almost certainly a response to the empress's actions directed against intellectual freedom generally, her brother's banishment specifically, and possibly Catherine's campaign against the Freemasons.

The last period of Catherine's reign after the French Revolution of 1789 was a time of reaction and the persecution of the liberal intelligentsia. The growing intellectual repression, directed at authors, publishers, printers, and booksellers, led to the institution of a formal system of censorship in September 1796. Moreover, a feature of Catherine's assault on liberal and progressive ideas was the persecution of Freemasonry, the closing of lodges, and the exile of Masonic leaders to their estates. A notable example was the arrest in 1792 of the writer, editor of satirical journals, and publisher Nikolai Novikov, who was held without formal trial and imprisonment in the Schlüsselburg Fortress. He was one of the major figures of the Enlightenment with whom Dashkova had worked and collaborated extensively. The police had detained him, searched his house, and discovered banned Masonic literature, which the censorship authorities sealed.

In a letter dated July 1792, Dashkova went to the defense of Novikov and appealed to the commander-in-chief of Moscow, A. A. Prozorovskii.[45]

In eighteenth-century Russia, Masonry was an important center of progressive thought. Its goal was the inner self-perfection of the individual and the creation of a just society. In practice, it focused on the limitation of absolutism by enlightened people, an idea central to Dashkova also. As a woman, she could not be a Mason, but she was close to many individuals who were. N. I. Panin was a highly placed member of the Nemesis Lodge. Virtually all of the male members of Dashkova's family were Masons, and her father was Worshipful Master of the Lodge of Silence in St. Petersburg. It was the first Russian lodge consecrated with a name, and its other members included her husband, Prince Dashkov, the writer Sumarokov, and the historian Shcherbatov. Roman Vorontsov headed a number of other lodges such as Muse and Urania, and with his son Simon, he was a member of I. P. Elagin's grand lodge. Aleksandr was also a Mason, belonged to the same lodge as Radishchev, and his resignation was at least partially a response to Catherine's actions against the Masons. Dashkova felt that she could no longer continue in such an atmosphere of persecution and coercion. Work at the academies, her turbulent family life, and court politics weighed heavily on her; her sister Elizaveta, after seeing her at this time, was alarmed and wrote, "She is sick, sad, and much changed."[46] In the end, Dashkova bore the full brunt of Catherine's anger and the Kniazhnin incident would lead directly to her retirement from the two academies.

Chapter Eleven

Troitskoe and Korotovo

A GENERAL SENSE OF SEPARATION and the immediacy of exile to the north of Russia marked the final period of Dashkova's life from 1794 to her death in 1810. On July 28, 1794, Zavadovskii wrote Simon that Dashkova was planning to leave the capital. "She is unhappy. You know yourself her personality and how difficult it is for her to remain calm both in her actions and demands."[1] Unwilling to work in an atmosphere of fear and succumb to the empress's campaign of censorship and oppression, on August 5, 1794, Dashkova submitted her resignation from the administration of the academies and requested a two-year leave of absence from her duties as lady-in-waiting "in order to restore my failing health and put my affairs in order" (243).[2] To the letter of resignation, in which she wrote Catherine about her selfless service to the Academy, Dashkova attached her "Report on the Economic Situation at the Academy of Sciences for 1783–1794." In it she summed up her eleven-year administration of Russia's main institution of research and higher learning, providing an accounting for the bookstore, publishing office, academic gymnasium, construction projects, and any profits she was "fortunate enough to realize."[3] According to her calculations, she was able to add 526,188 rubles to the budget. She sent all of the documentation to the state-secretary Dmitrii Troshchinskii, along with a letter to him expressing the great pride she took in the completion of the Academic Dictionary and her willingness to continue as president of the Russian Academy, even though she had not received any compensation for her work there. On a piece of paper accompanying Dashkova's letters Troshchinskii noted, "In accordance with the decree of August 12, 1794, Princess Dashkova is granted a two-year leave of absence."[4] Dashkova was no longer required to appear at court.

Catherine allowed Dashkova to retain her annual salary of three thousand rubles as Director of the Academy of Sciences and named Pavel Bakunin (Dashkova's second cousin and first cousin of the anarchist Mikhail Bakunin) as her replacement.[5] In reality, the leave of absence with pay constituted Dashkova's early retirement from all duties at the Academy. Her inevitable separation from Catherine greatly saddened her, and she could never quite shake the memory of their early days together. She was young then, idealistic, and her devotion was steadfast:

> I had been passionately fond of her at a time when she was not sovereign yet, and I was in the position to be of far greater service to her than she was to me. And though in her treatment of me she did not always obey the dictates of her heart and mind, I continued to love her, admired her whenever she gave me occasion to do so, and considered her far superior to any of the most famous sovereigns that had ever sat on the Russian throne (243).

On Monday, August 14, 1794, Dashkova came to the Academy for the last time. She entered the conference chamber, took her place at the head of the table, and spoke to the thirteen academicians and adjutants assembled there. She told them how proud she was to have served the Academy for nearly twelve years, thanked them for their support, and distributed copies of her official petition for leave of absence. Then, she embraced individually all the academicians and assistants present, who as a group escorted her to the door of her carriage. They expressed their warm wishes for her return to the Academy in the near future, but Dashkova departed for good.[6] She signed the minutes of her last meeting almost two years later, on May 3, 1796.[7]

Never had Dashkova felt as alone in St. Petersburg as when she busied herself with preparations to depart for Moscow and Troitskoe. She longed to see her brother, now living in Moscow and on his estate, but before she could "withdraw entirely from public service as well as from the turmoil and tumult of a life at court," there were countless financial and legal matters requiring her attention. She was resolved to break completely with her former hectic existence in the capital and to "live in peace and devote myself entirely to rural pursuits" (241). To this purpose, she sold her house for fifty thousand rubles, writing her brother that she lost five or six thousand rubles on the transaction. She settled her daughter's debts and the thirty-two thousand rubles still owed the bank, which she had borrowed for her son's education and travel abroad. Promising to vacate her prop-

erty as soon as possible and with no place of her own, she rented for a time the house of V. I. Levashev while awaiting permission from her brother to move into their father's former house, which Aleksandr had inherited.[8] The mansion Roman Vorontsov had built in 1754 was vast and seemed unreal. It reminded her of her father over a decade after his death, and the memory of his rejection and coldness to her only increased her loneliness and sorrow: "I had the impression of being an unhappy princess over whom a wicked wizard had cast an age-long spell" (242).

A lengthy lawsuit with Anastasia's in-laws, the Shcherbinin family, requiring her full attention, would not allow her to escape to a storybook land of wizards, spells, and princesses. Nor was she certain of her daughter's whereabouts. On May 23, 1793, writing from Kirianovo, she confessed to Aleksandr that she knew nothing of Anastasia's situation and again in 1794 she worried about her daughter in Warsaw, from whom she had not heard a word.[9] At times Dashkova felt publicly humiliated by her daughter's actions as, for example, when she received a letter from the empress's secretary concerning the tailor F. Meyer's submission of a complaint against Anastasia for nonpayment of her bills. In an attempt to clear up the matter and while sorting through her daughter's tangled financial dealings, Dashkova discovered that some of Anastasia's debts had in reality been incurred by her husband, Andrei Shcherbinin, and that he had at one time signed over to her a piece of country property.[10] To complicate matters, his mother and sisters, who had taken over the administration of his estate as legal trustees, disputed Dashkova's claims.

Dashkova submitted her petition to the senate adding a proviso requesting, in view of Anastasia's record of fiscal irresponsibility, trusteeship of the bulk of her daughter's property with full rights to its administration. The case dragged on endlessly in the senate to Dashkova's consternation, since she could not properly attend to Anastasia's financial problems without legal authorization from the senate.[11] Writing letter after letter to Catherine, she pleaded for a speedy resolution, and on January 14, 1794, she petitioned the empress for a timely settlement of the Shcherbinin affair. Again, on July 9, 1794, she described the legal issues of her trusteeship and urged that the senate appoint her trustee of an estate belonging to her daughter, so that she could cover her enormous debts. Dashkova wrote that Anastasia fled to Warsaw and left her with an obligation of over thirty thousand rubles, and now she received a bill of an additional twelve thousand rubles due in fifteen days.[12] Eventually, the senate ruled in Dashkova's favor. She would now improve her daughter's financial situation only to worsen their relationship, for Anastasia felt with some justification that her mother had

taken possession of her property and stolen from her almost everything she owned.

On the eve of her departure from St. Petersburg, Dashkova went to the Tauride Palace to spend the evening with Catherine and to take her leave officially. But Catherine received her coldly and formally, and there were no scenes of warm farewell. At last, Dashkova left St. Petersburg for good, in the future returning only for brief stays. Her return home was roundabout and methodical as she inspected her estate in Krugloe, stayed at Troitskoe for only a week, spent several days in Moscow winterizing her house before the frosts set in, and visited her brother in Andreevskoe, where she initiated some landscaping projects. Dashkova kept an apartment at her brother's estate, visited him often, and enjoyed working in the garden carefully arranging trees and grass, bushes and moss. Lafermière had only high praise for the quality and beauty of her landscaping skills. On October 1, 1794, he wrote,

> Last week we were visited by Princess Dashkova, who is unchanged and remains active, energetic, and spirited as ever. . . . During the five or six days she stayed with us, she devoted herself to the organization and improvement of work conducted on land attached to the garden next to the house. It must be said that she is more competent in this area than our steward who is responsible for such work. She began with four or five workers, but in the end she got everybody involved. She spearheaded the effort and could not abide idlers.[13]

Dashkova mentioned in her *Memoirs* that she was a landscapist and architect by inclination, a farmer by necessity, and that there was never an end to the work on her estate. Tree planting became a passion, and the creation of the estate was her escape from the hubbub and confusion of the capital. Troitskoe was her area of Russia that she could transform into an orderly, rationally planned, personal paradise — a sylvan Eden in provincial Russia. At that time, the estate consisted of the manor house and several buildings that created a single architectural ensemble with the Church of the Holy Trinity at its center. Dashkova worked diligently on its reconstruction, which had begun in 1767. Built in a variation of the Moscow baroque style, with later classical elements, the church was made of local brick, manufactured not far from the estate, with a thin overlay of stucco painted red with white trim. According to some sources, it was the creation of the well-known architect K. I. Blank, who had done work for Dashkova's uncle Ivan Vorontsov.

Dashkova spent the years 1794-1796 mostly in Troitskoe, often writing her brother, who after 1793 regularly lived in Andreevskoe. Dashkova requested that he supply her with needed medicines, and they sent each other pineapples, fruits and vegetables, bushes, and seeds for planting. Every year, he would remember her name day on the feast of St. Catherine the Great Martyr of Alexandria. In 1795, Dashkova and Aleksandr exchanged visits, with her brother coming for a brief stay to Troitskoe, where he was impressed with her renovations and work on the garden and various buildings of her estate. On her next visit to Andreevskoe he gave her full permission to resume laying out a garden and tracing out the plantings and walkways. She would continue working in his garden for a number of years, and in a letter written in 1800, she described the completion of her work on Aleksandr's garden, leaving him detailed recommendations and instructions on its proper maintenance. The two-page document, jokingly entitled "Your English Gardner" is in fact a set of exact directions concerning the planting of ornamental and fruit trees, the growing of flowers, and the building and maintenance of foot paths.[14] Carefully groomed with a hint of romanticism in their conception and layout, the landscaping at Andreevskoe and Troitskoe were by all accounts quite remarkable.

In Troitskoe, Dashkova remained active and busied herself with work as she made every effort to grow accustomed to the slower pace and seemingly longer days of country life. In all her endeavors, Dashkova was methodical with clockwork habits. She slept poorly and always woke early. She would work the whole day through with only an hour's rest after dinner. On rainy days, she would design and sketch her architectural projects. She threw herself into the running of her estate: building, planning, restoring, expanding the grounds, and taking charge when droughts affected her crops or the river flooded in spring, hampering work at the mill.

> Every tree, every shrub had been planted either by myself or under my supervision in the exact spot where I wanted it. One is so apt to regard with affection the work of one's own hands that I have no hesitation in saying that I found Troitskoe to be altogether one of the finest country estates I had ever seen in either Russia or abroad (248).

City life in Moscow and the amusements of high society had lost their appeal to her; she described her attendance at a masquerade, which was "repugnant both to my principles and my sensibilities."[15] As soon as the weather permitted travel she would go from Moscow to Serpukhov, where she often spent the night in her house, and from there travel on until she

crossed the river Protva and arrived at Troitskoe. There she followed the linden tree-lined entrance and passed the church on the right before entering the gates to the manor house, which stood on the high banks of a bend in the river. On the grounds, there was a path leading south of the main house, through the birch grove to a low mound where Dashkova had erected a granite obelisk on four spheres in honor of Catherine and the palace revolution of 1762. Yet she could not give up hope, however unrealistic, that Catherine would be unable to get along without her and would realize that Dashkova had been the victim of jealousy and deception. A slight elevation was located not far from the monument, which she referred to as her "Parnassus." It was a forty-foot knoll at the center of the park with a spiral path leading to a gazebo at the top. There Dashkova liked to sit, read, and look out over the Protva River and down the main Kaluga road passing not far from her house. She waited for the courier who would urgently call her back to the capital. There had been rumors and letters from St. Petersburg about a possible invitation to conduct Catherine's granddaughter, Alexandra, to Sweden for marriage to King Gustav IV. But Alexandra's marriage never took place, and the courier never arrived.

In disbelief and shock, she followed closely the events in France from the bloodbath of the Terror and the Directorate, to the creation of an executive committee that ruled from 1795, to the emergence of Napoleon Bonaparte. She had hoped that the Enlightenment would bring liberal reforms, not revolution. While not abandoning the ideals of the Enlightenment she had held from her youth, the excesses and terror of the French Revolution appalled Dashkova, not only because they threatened her economic base and social position, but also because she was opposed to all forms of violence. At the end of her two-year leave of absence from the Academy, Dashkova wrote the empress on August 27, 1796, requesting an extension of a year citing her ill health as a reason.[16] It was received on September 4, 1796, and a week later Catherine responded, granting Dashkova the requested extension with full pay.[17] But in a few months "a blow fell which for Russia represented the greatest possible disaster" and which brought Dashkova "to the very brink of the grave" (248). The shock of Catherine's death on November 6, 1796, brought on a nervous reaction and insomnia so severe that she decided to go directly to Moscow. There she sought the advice of doctors, in whom she had no trust, and had leeches applied to "calm the blood and give it a more regular and a healthier circulation" (250). For Dashkova, Paul's ascension to the throne initiated a time when "terror and anxiety soon became the constant feelings of every man and woman. Every family had victims to mourn. Husband, father, uncle suspected in his wife,

his son, his heir an informer who might send him to perish in a dungeon or in the depths of Siberia" (249). Paul had waited so long to assume power; now forty-two, he took revenge on his enemies, those individuals who had been his mother's allies.

With the exception of Dashkova, Paul was kind to the Vorontsov family; they had supported his father. The emperor looked upon Simon, who from 1785 had been living in England, with great favor because of his actions in 1762. He offered him the vice-chancellorship, but Simon declined. Nevertheless, in 1799, Paul, who was Grand Master of the Knights of Malta, awarded the Grand Cross to Simon. That same year, with the death of A. A. Bezborodko, Paul offered Simon the chancellorship of Russia, the highest governmental position in the country. Simon gathered up all his diplomatic skills and once again declined the invitation to return to service in Russia. By now, the emperor was angry, and on May 22, 1800, he relieved Simon of all administrative duties. Subsequently, he gave orders to confiscate his property in Russia, but all actions against Simon came to an abrupt stop with the end of Paul's reign.

Dashkova's persecution began almost immediately with the receipt of a senatorial decree of November 12, 1796, by which the emperor dismissed her from "the execution of all of her appointed duties" and ratified the appointment of Pavel Bakunin, who was then twenty, as director of the Academy of Sciences.[18] So ended Dashkova's administration; during her term of office, she had been one of the most devoted and energetic supporters and organizers of Russian science, letters, and education. The academician Ia. K. Grot concluded that "despite her somewhat uneven temperament, her excessive ambitiousness and vanity, she pursued her life's work honestly, fulfilling conscientiously and successfully a unique task for a woman and acquiring the indubitable right to take her rightful place among those who rendered a great service to Russian education."[19] In less than two years, the academicians revolted against the arbitrariness of Bakunin's administration; he stepped down, and the position of director was eliminated. In the same year, G. L. Nicolai became president of the Academy of Sciences, but he declined to take on the presidency of the Russian Academy, since he was not fluent in Russian. For a time the Russian Academy remained without an administrative head.

Dashkova arrived in Moscow on the morning of December 4, 1796, and Aleksandr, who worried about her health and welfare during Paul's reign, soon joined her. In fact, Paul was preparing to travel to Moscow for his coronation, and he decided to order Dashkova out of the city and confine her to Troitskoe. On December 1, less than a month after Cathe-

rine's death, Paul had written Mikhail Izmailov, the commander-in-chief of Moscow, instructing him to remind Dashkova of the coup of 1762 and to order her into exile. "Make sure that she leaves immediately," Paul demanded.[20] Dashkova had just settled into her Moscow house when Izmailov called on her and informed her that by order of his majesty the emperor she was to return without delay to Troitskoe and there "reflect to the events of the year 1762"—in other words her actions that brought down his father and led to his assassination.[21] According to A. T. Bolotov's anecdotal account, Izmailov ordered Dashkova to depart in twenty-four hours, and she replied that she would be ready to go in twenty-four minutes and left Moscow while he was still present.[22] Actually, on December 4, 1796, Izmailov wrote Paul that he had communicated to Dashkova the emperor's order to leave Moscow immediately. Dashkova replied that she would leave within three days, and subsequently Izmailov confirmed her departure from Moscow in the middle of the night of December 6, sometime after 1:00 a.m.[23]

Aleksandr tried to calm his distraught sister, assuring her that a sense of obligation toward his father's memory dictated Paul's behavior and that after his coronation he would soften his attitude toward her. His assessment was partially accurate with respect to most of the other conspirators of 1762 who had brought Catherine to the throne and who were still alive, but it missed the mark when it came to Dashkova. Even Aleksei Orlov, who was directly involved in the death of Peter III, did not incur the full weight of the emperor's wrath. Paul had him swear allegiance, attend the ceremonial reburial of Peter III, and then sent him into benign banishment abroad. Dashkova, however, was well aware of the enmity Paul had demonstrated to her after his return from Italy. She knew that his attitude toward her would not change, and that feelings of betrayal after their Rome meeting in 1782 would fuel his anger. The punishment Paul meted out to Dashkova was most severe, for he could not forgive her the abandonment of his cause and the acceptance of a position of power from Catherine when she was appointed to head the two academies. With a sense of resignation she wrote her brother, "Once a tyrant begins to strike he continues to strike until the victim is totally destroyed. I am expecting persecution to continue unabated, and I resign myself to it in the full submission of a creature to its Creator" (251).

The next blow came soon enough when a few days later her maidservant woke her at three in the morning. Vasilii Laptev, her distant relative, had arrived at Troitskoe with a letter ordering her instant departure to the northern regions of the Novgorod Province. Until further notice, she was

to reside there in exile on her son's property in the village Korotovo in the area of Cherepovets. The news of her impending exile threw the whole house into turmoil, while Dashkova, for her part, felt anger and indignation at what she thought to be the madness of Paul's actions. She described her ill-treatment as being symptomatic of Paul's policy of undoing everything his mother had created during her reign: "From the moment he ascended the throne Paul gave expression to his hatred and contempt for his mother. He hastened to break, or rather destroy, all she had done" (252). By Dashkova's account, the women in her household met Paul's assault on their secure and mostly harmonious world with strength, resolution, and camaraderie. Even Vasilii Laptev, the bearer of ill tidings himself, was so overcome with emotions that he vowed never to abandon Dashkova.

Anastasia, who had returned home, was beside herself, but dutifully agreed to follow and support her mother. Miss Bates, an English friend living with Dashkova, was also firmly committed to following Dashkova into the cold and frozen reaches of northern Russia. Another relative, Elizaveta Dolgorukaia, the granddaughter of Praskoviia Vorontsova, Dashkova's aunt, arrived at Troitskoe to lend her support. She oversaw most of the planning in preparation for Dashkova's departure and tried to foresee everything Dashkova would require to survive her exile. Her care and attention deeply touched Dashkova; she would remember her fondly, for she would see her only once more. Elizaveta died two years later at the age of twenty-five, "cut off in the prime of life," leaving Dashkova "forever disconsolate at the loss of a dear and faithful friend" (256). There were also other young women, Dashkova's wards, whom she would send home to their parents: Ekaterina Kochetova, Dashkova's niece, and Anna Islen'eva, the granddaughter of Dashkova's cousin, Daria Vorontsova. Anna Islen'eva would eventually live a total of ten years with Dashkova and was in charge of her business correspondence. After her return from exile, Dashkova was especially close to Islen'eva, who received from her seventeen thousand rubles and inherited an additional four thousand.[24] In later life, the Wilmot sisters, along with Islen'eva, helped Dashkova get through the difficult years still awaiting her. After her marriage to the historian Aleksei Malinovskii, she would stand proxy for Nataliia Goncharova's mother at A. S. Pushkin's wedding.

Dashkova wrote her son on December 25, 1796, urging him to remain in the service of Paul, despite the treatment she was receiving at his hands. She also instructed Aleksandr on the management of her affairs in her absence. Having completed all the necessary preparations, the weak and ailing Dashkova was ready to leave her home. She was fifty-three, no lon-

ger a young woman, and a number of ailments afflicted her: She suffered acutely from hemorrhoids, sciatic nerve pain in her right leg, and swelling of the feet. Confined to her bed or stretched out on a sofa, she was unable to stand or walk on her own. On the next day, December 26, her peasants carried her to a church service for a blessing, as is customary in Russia before a trip, and from there straight to the coach waiting for her. The authorities assumed incorrectly that Dashkova had traveled only in carriages and that the requirement to take a trip in the smaller and cruder *kibitka* would be a form of punishment. Dashkova proudly proclaimed that she was no stranger to travel in *kibitkas*, although every turn, every bump in the road must have been torment for her. Neither medication nor pomades could remedy her condition and a long coach journey only aggravated it. Even though she was traveling in winter on runners, the pain was intolerable and the trip agonizing. On the way to her place of exile, she stopped to dine with the Goncharov family. She was at that time, according to one observer, "an unattractive old woman in a long, cloth great-coat with a large Order of St. Catherine on her chest, and an enormous nightcap on her head."[25]

It was rough, slow going as they traveled in the dead of winter to the north of Russia. The roads were bad and the accommodations unsanitary and infested with cockroaches. Soon, Dashkova became seriously ill with stomach cramps and diarrhea, while Miss Bates, her companion, came down with a fever. Eventually, Dashkova regained her strength despite a diet consisting primarily of cabbage soup frozen into solid chunks and boiled into liquid form along the way. Far more troubling were the inaccurate rumors that she was being taken not to Korotovo but to some distant and lonely convent and the actual presence of an obscure stranger making inquiries and jotting down everything he saw and heard of Dashkova's movements and conversations. An agent of the secret police was keeping Dashkova under the strictest surveillance and reporting to Ivan Arkharov, the pitiless military governor of Moscow and younger brother of perhaps Russia's most celebrated sleuth, Nikolai Arkharov.[26] Dashkova wrote that Ivan Arkharov "had been vested by the emperor with powers and duties of an inquisitor, an employment by no means repugnant to his coarse and brutal nature." Every evening Dashkova would check under the trap doors and other hiding places of the peasant huts where she was staying "to see that Arkharov's commissioner was not hiding there," trying to listen to her conversation (258, 259).

As the party proceeded on to Tver the journey became more difficult and dangerous. Miserable weather slowed their progress. Caught in a vio-

lent snowstorm, which obliterated all traces of the road, they wandered around helplessly in the blinding snow for hours unable to locate a single dwelling where they could take refuge. The snow lay deep on the grey and white horizon with drifts banking higher and higher around them. Only the occasional silhouettes of bare trees were visible outside. In desperation, they stopped and waited for the wind to die down, and soon spotted a light in the distance. With their horses "barely dragging," the lost and frightened party, close to a "slow and terrible death," reached a small hamlet consisting of five huts (258). They had gone no more than five miles in the past twenty hours, had almost perished in the snow, and were now far from their intended route. At last, physically exhausted from their wanderings, they arrived in Tver, where they were agreeably surprised that Alexander Polikarpov, governor of Tver, accorded them a warm welcome. He had prepared excellent accommodations and had made provisions for Dashkova and her party by making available for them proper lodging along the entire route to Korotovo. He also recommended she write Nikolai Repnin about her plight and generally disregarded the possible consequences he would suffer at the hands of the "vindictive character of the monarch." In fact, Paul dismissed Polikarpov for his "good treatment of an outlaw [Dashkova]," but shortly after reinstated him (258).

The next morning, after a light breakfast, they continued on their way, but advanced gradually and uncertainly at a rate of less than forty miles a day, since stationmasters were under orders not to change their worn out horses for fresh ones. In the towns along the way, such as Krasnyi Kholm, they were treated kindly and often supplied with provisions, and in Vesiegonsk, Anastasia and Miss Bates attended a fair, reputedly one of the best in Russia. Dashkova did not go; she was too concerned about her son and the persecution he might suffer because of her banishment. Thoughts of his arrest and visions of Pavel being dragged off to Siberia tormented her, and she wrote repeatedly to her brother and others requesting news of her son. Actually, Pavel Dashkov's career did not suffer. Paul treated his godson kindly, and Pavel attempted to intercede on his mother's behalf, but with little success.

Leaving Vesiegonsk, Dashkova's party continued farther north through Danilovskoe, near Ustiuzhna, and then passed the ancestral home of the poet Konstantin Batiushkov, where his father, Nikolai, was then living. After a journey of close to two weeks, late at night in January, they finally arrived in Korotovo in four troikas, bringing some furniture and books with them. Dashkova did not expect to see the extensive marshes and dark forests surrounding the remote village. She had never been there, since it

was property she had turned over to her son. They settled in three peasant huts with Dashkova occupying one, Anastasia a second, at a distance from her mother, and the third was set aside as a common dining area. In her hut, Dashkova divided the living area with a large green curtain to separate herself from the servants' quarters. One of the first orders of business was to call in the village priest to sing a Te Deum and to bless their new residences. She then went to church in the neighboring village of Grishkino and took communion from Father Grigorii. The living conditions in the village were harsh but the people treated Dashkova with kindness and extraordinary helpfulness. Twice a week they brought her bread, eggs, cakes, cranberries, and gingerbread from the local market, and everything she needed to survive. Otherwise, local landowners, who felt it too dangerous to visit the exiled princess, shunned her.

The strain of the journey had overwhelmed her, and in exile she suffered from migraines and insomnia. Dashkova was introduced to a life she had never before experienced and was exposed to a side of Russia she had heard about but now was to witness in all its cruel immediacy. With the freezing of the marshes a pathway opened up on the ice of the lakes and rivers, shortening significantly the distance between St. Petersburg and Siberia, so that many of the political prisoners and "unfortunate exiles" were driven past her windows (264). Once, she met one of these pathetic souls, a certain Mr. Razvarin, a relation of Dashkova's mother through his first wife. Implicated in a conspiracy against the emperor, all his limbs were dislocated when the police put him to torture prior to his banishment from the capital. His condition and her inability to help him in any way pained Dashkova, "and long afterward the vision of that young man with his dislocated limbs, and his nerves so to speak torn to shreds, haunted my terrified imagination" (265).

At first, Anastasia dined with her mother, but later Dashkova stopped inviting her.[27] Although Anastasia had voluntarily followed her mother into exile and willingly endured the harsh living conditions there, mother and daughter soon quarreled. As a result, Anastasia ceased visiting her and took meals in her own hut. In a letter to her brother, Dashkova wrote that her daughter stopped coming on her own accord and that she had not seen Anastasia for thirteen days.[28] Dashkova lived alone, isolated, depressed, and ill. The sudden and total seclusion took a heavy toll, leaving behind feelings of dejection and bitterness. She noticed that many of her former friends no longer wrote her, while few of her relations communicated with her and even fewer sympathized with her plight. Regarding her banishment, Simon wrote his brother on January 20, 1797,

> I have received a letter from our sister and was sincerely saddened by what has happened to her, and that now in her old age, she has been punished for something that the recklessness and ardor of youth drew her into more than thirty years ago. Perhaps, she should have expected it, but even so, this does not make it any easier for her.[29]

Dashkova would have felt completely alone and abandoned had it not been for the exceptional actions of Avdot'ia Vorontsova, the widow of Dashkova's cousin, and her daughter, who visited her for a week and lodged in a neighboring hut. Dashkova had brought up Avdot'ia's young son from the age of seven, and oversaw his education until he entered military service at sixteen.[30] In gratitude, Avdot'ia offered her support and companionship: She brought books and, in the absence of paper, she spent hours with Dashkova drawing sketches of scenery on a small wooden table, which they would erase and reuse.

On her way to Korotovo, Dashkova had heeded Polikarpov's advice and had written another relative through marriage, Nikolai Repnin, seeking his advice and assistance. She also cautioned him to entrust his reply to the safekeeping of a number of academicians whose integrity and sincerity were beyond reproach. She would then send somebody from Korotovo to collect any letters addressed to her. It so happened that during her exile there were a number of peasant uprisings on the Apraksin-Golitsyn estates and elsewhere. Dispatched to the Archangel and Novgorod Provinces to quell these insurrections, Repnin was passing near Dashkova's place of exile. One day, as Dashkova sat at her window, she saw a priest coming directly toward her front door. When she went out to meet him, he quickly and furtively thrust a letter into her hand and disappeared. It was from Nikolai Repnin, who had not signed the letter and who requested that she burn the letter after reading it. He advised Dashkova to write the good-tempered and compassionate Empress Maria Fedorovna to intercede on her behalf. Dashkova was loath to do so, certain that since her audience in Rome, the empress was not favorably disposed to her. Even so, Dashkova feared that soon there would be no escaping Korotovo: The snow and the ice would melt, and the river would swell, overflowing its banks and flooding the fields surrounding the village. They had arrived in the dead of winter on runners, but with the coming of spring, the *kibitkas* would be useless and they did not have boats available to them.

Dashkova decided to write the empress, soliciting her aid in influencing her husband's decision concerning her exile. She enclosed a letter to the emperor, which provides a dramatic example of the manner in which

Dashkova included significant alterations in her autobiography. Dashkova sent the letter in January 1797, a month after her arrival in Korotovo, and it reached St. Petersburg on February 10, 1797. In it, Dashkova requested that Paul ease her sentence and allow her to live closer to Moscow for medical reasons. In her *Memoirs,* she wrote that the letter was haughty rather than pleasing and that she was mostly concerned not for herself but for those who had accompanied her.

> I began by describing the state of my health which, I said, was such that were it merely the question of my physical condition, it would not be worth His Majesty's while to read my letter or mine to write it, for the time of my death was a matter of indifference to me, but neither humanity nor religion allowed me to see innocent people suffer in sharing banishment which my conscience told me was undeserved; never, I added, in the lifetime of the empress his mother had I harbored any ill feelings toward him, and I ended by asking his permission to return to my estate of Troitskoe in the Province of Kaluga, where my companions and even my servants would have better accommodations and would receive medical attention in case of illness (265–66).

The actual letter she sent did not contain a word of concern for her friends and servants and bore little resemblance to her description.

> The compassionate heart of Your Imperial Majesty will forgive a subject, oppressed by age, sickness, and, what is worse, by the sorrow of living in the shadow of Your anger, if she appeals to her Monarch's benevolent heart. Be merciful, Sire, grant me the only favor I ask of you, allow me to end my days quietly on my estate in Kaluga, where I shall at least have a roof over my head and be within easier reach of doctors' help. Should unhappiness be reserved for me alone while it is Your Majesty's desire to make the whole Empire happy and while you bestow happiness on so many? In satisfying my request You will bring back life to an unhappy woman who to her dying day will glorify the name of a kind and compassionate Sovereign.[31]

The letter went through a number of revisions and Dashkova sent a rough draft to Alexandr, stressing disingenuously and proudly that there was nothing demeaning in it.[32] It was shorter and restrained, suppressing the more rhetorical, obsequious, and ingratiating passages such as "to Her Monarch's benevolent heart," "Be merciful, Sire," "Should unhappiness

be reserved for me alone while it is Your Majesty's desire to make the whole Empire happy and while you bestow happiness on so many," and "a kind and compassionate Sovereign."[33] The difference between what she felt and what she wrote defines a context of fear and her *amour propre*. Dashkova confessed to her brother that during Paul's reign "a terror was now ruling over minds."[34] Yet she was also insincere, even though in a subsequent letter, dated April 8, 1797, she assured her brother that she would have no part of two-faced attempts to grovel before the emperor.[35] Aware that she was leaving behind contradictory historical evidence, on June 28 of the same year Dashkova asked her brother to return to her his copy of the letter, explaining that she was creating a small archive and memorial for her son.[36]

Dashkova learned that when the Empress Maria Fedorovna received the letter, she gave it to her husband, who flew into an irrational rage and would not open it. He then ordered an agent to be sent to Korotovo to deprive Dashkova of all writing materials — quills, ink, paper — and to ensure that she have no further communications with the outside world. The empress informed her friend, Catherine Nelidova, who put Dashkova's letter into the hands of the infant Nicholas, the future Emperor Nicholas I, and brought him in to see his father. When Paul took the letter from his son, he was mollified and then cajoled into writing a terse and unsympathetic note allowing Dashkova to return to Troitskoe. Dashkova received Paul's decree of February 10, 1797, three days after he signed it. When the courier arrived with the letter, the pale and trembling Miss Bates greeted him by dropping to her knees and exclaiming, "Oh, let us take courage, my dear princess, God is everywhere — even in Siberia" (267). For ten days, the Englishwoman was in a fever and delirium, but when the fever broke and she had regained her strength, Dashkova and her party departed Korotovo. In March, it was still winter in the north of Russia and they glided easily over the ice and snow, but gradually as they traveled south, sand, mud, and grass began to appear under the runners, slowing their progress home. At last, they reached the Protva River and soon were able to make out in the distance the church and bell tower of Troitskoe.

Immediately upon arrival, Dashkova attended a thanksgiving service in the church filled to capacity with well-wishers from the surrounding villages and those curious to have a look at the mistress of Troitskoe, recently returned from political exile. She was happy to be living at last on her estate, yet felt lonely and dejected even though she was in the company of her niece Ekaterina Kotchetova and her companion Miss Bates. There was much to be done and many building projects to resume. First, how-

ever, she needed to restore order, and the management of her properties provided her with the necessary distraction from heartache and depression. She learned that in her absence, the steward of Krugloe had not followed her orders, had neglected his duties, and had allowed the property to deteriorate. He told the peasants that she had cut her hair and entered a convent and then proceeded to introduce new, wasteful methods. Now he demanded his salary, but Dashkova considered him a scoundrel and refused to pay him. Rather, she planned to replace him. Never good at relegating responsibilities to her subordinates, Dashkova did not trust her stewards. Earlier, as she was leaving Korotovo, she pointed and shouted to the people gathered there, "Do not believe them [the stewards], they would sell a person for a three-kopeck piece. If you have any concerns, come to me directly."[37]

On March 6 she wrote Aleksandr, inviting him to visit her in Troitskoe in May.[38] From her brother, who was in Moscow, she learned about the eighty soldiers billeted in her house on Nikitskaia, and another hundred occupying Shchukino, a summer place she owned outside of Moscow from which she sent timber downstream for sale. Since she was responsible for upkeep and fuel, and was tired of putting up with the inconvenience and of wrangling with her unwanted guest, she decided to sell Shchukino, which she had owned for thirty years and loved primarily for its garden. Moreover, she was not at all certain that the local authorities would permit her to reside again in Moscow, nor was she eager to do so. "I knew that a system of espionage had been established in all big towns and particularly in Moscow, all the more dangerous as denunciations represented the surest means of succeeding with suspicious and apprehensive tyrants" (271).

After a lifetime of political struggle and service to the state, Dashkova was now required to follow Voltaire's dictum and cultivate her own garden, although her garden consisted of vast landholdings in Russia, tilled by scores of peasants. She threw herself fully into her work, taking great pride in the prosperity of her peasants and the improvements on her estate. She oversaw the work and general management of her estate, supervising projects and people and keeping the accounts, while pursuing her interest in current events, history, and literary questions.[39] Dashkova was in complete control of her villages, their economies, and the daily life of the people who worked for her. Among other obligations, she was personally involved with the peasant commune (*obshchina*), set the money dues (*obrok*), organized the delivery of goods, and settled questions concerning disputes, the recovery of debts, payoffs, and military recruitment.[40] Herzen concluded that "Dashkova became an excellent landowner; she built houses,

designed and laid out parks. In her garden, there was not a single tree, not a single bush, which she did not plant or for which she did not designate a location. She built four houses and proudly proclaimed that her peasants were the wealthiest in the area.[41]

Her children continued to be a source of great frustration, and Ogarkov noted, "While professing the most advanced views on education, she must have been bitterly disappointed with the results of their application to her children."[42] Her son's marriage remained a cause for conflict. In two letters to his mother, Pavel regretted that she would have nothing to do with his wife, whom she did not know. She was after all the woman of his choice and worthy of his mother's love and respect.[43] Nevertheless, Pavel, who was in Petersburg in 1798 and enjoying considerable favor and influence with the emperor, was very concerned by his mother's exile and tried, as during her trip to Korotovo, to use his influence at court and with Paul to effect her release from confinement on her estate. He petitioned the Grand Duke Alexander, as well as A. L. Nicolai, president of the Academy of Sciences, and through them the Empress Maria Federovna. At last, he was able to secure his mother's freedom and on April 13, 1798, Paul granted Dashkova permission to live in Moscow, and even visit the capital, but only in the court's absence.[44] Dashkova learned that when her son heard of her liberation, he was delighted to the point of embracing Paul, and forgetting himself, lifted the diminutive emperor high in the air. For a time, Pavel's advancement was Dashkova's only joy, as she followed his promotion to lieutenant-general and on March 14, 1798, his appointment as military governor of Kiev. In a letter to his mother, dated April 28, 1798, Pavel wrote that he was on his way to his new assignment and how disappointed he was with Paul's slowness in allowing Dashkova to visit Moscow. But at the end of the letter his true reason for writing finally emerged — he needed money.[45]

Unfortunately, Pavel had not taken after his mother. Like his father, he was sociable, a good dancer, and rarely missed a ball. F. F. Vigel', the vice governor of Bessarabia, wrote that Pavel was handsome, kind, carefree, cheerful, and a fine figure of a man, with an overriding passion for dancing, and in her letters home Martha Wilmot frequently called attention to his lively and sociable nature.[46] Petr Zavadovskii had nothing but praise for Dashkov's abilities, referring to his education and innate aptitude for military service.[47] Mostly, however, the testimony of his contemporaries was not positive: Jeremy Bentham found him to be glib and overly vain, while his uncle Simon wrote on October 29, 1801, that Pavel Dashkov, "despite his many good qualities, is conceited to a tiresome degree."[48] L. N.

Engel'gardt was especially critical, citing Dashkov's negligence of duty and lack of seriousness. He was an overly carefree military commander, and there were accusations of favoritism toward certain officers, financial impropriety, and dishonesty with regard to his troops. He lived profligately, running up huge gambling debts, and under his command, "the soldiers in his regiment experienced great hardship. He held back funds earmarked for provisions and fodder; he would do the same with their wages, although they would be paid out in time."[49] The soldiers were therefore forced to steal and pillage, and his regiment acquired a bad reputation. His family life was no better. Pavel regretted being born under an unlucky star. He felt that he would never enjoy happiness, and his family life was in disarray. He lived with his mistress, with whom he had several children, while his wife lived apart in a small house in the country.

Tragically, it was typical of Paul that his patronage was neither reliable nor long lasting, and Pavel's duties in Kiev would be short-lived. Unexpectedly, he received a curt note from the emperor dismissing him of his command, since Paul suspected him of participation in the Altesti affair. Andrei Altesti was a Greek adventurer who came to St. Petersburg and became secretary to P. Zubov and later to Catherine II. He acquired great wealth and influence, but Paul accused him of corruption and misappropriation of funds, and had him arrested. Dashkova claimed that her son's only crime was to plead Altesti's innocence, but whatever the extent of Pavel's involvement, he was now disgraced and his career finished. On October 24, 1798, he retired to his estate in the Province of Tambov, and consequently, Dashkova's prodigious efforts and single-minded devotion to the grooming of her son for a brilliant military career and a life of service to the state had come to naught. After extending so much effort on his upbringing and education, she now felt that she had failed completely. He had never demonstrated the kind of resolve and discipline that characterized his mother's career. In fact, his gambling obligations were so extensive that in July 1799, she sent her son nine thousand rubles and in October, an additional twenty-four thousand to cover his debts.[50] During the reign of Alexander I, he returned to Moscow and lived there openly with his mistress, and for a short time served as marshal of the Moscow Province nobility.

Problems with her children as well as the sudden death of Elizaveta Dolgorukaia, the young woman who had selflessly assisted Dashkova prior to her exile, brought on renewed bouts of depression. Dashkova articulated her darkest feelings when she wrote about her disgust with life and how with satisfaction she only awaited death that would release her from moral

and physical suffering.[51] Aleksandr's friendship and support were Dashkova's only consolation as she visited him on his estate where she would spend six weeks at a time, continuing her efforts as his "English gardener." During the winter of 1800–1801, she made the journey between Moscow and Andreevskoe, possibly for the last time. That winter Aleksandr had not moved to Moscow and Dashkova joined him on his estate to meet the New Year with him. It was a quiet and sad occasion as sister and brother, grandees of the now defunct age of Catherine, greeted the new millennium alone and far from the hum and tumult of political activities in the capital. Still, they discussed current events, and Dashkova had a strange and, in the end, accurate premonition that Emperor Paul would not last out the year. In this way, the epochal eighteenth century ended for them. It had been the age of revolution in America and France, of the Declaration of Independence, of Voltaire, Diderot, Benjamin Franklin, and above all for Dashkova, the age of Catherine.

Later that month, when Aleksandr reminded her of the prediction she had made while greeting the New Year, Dashkova remained convinced that Paul would not see 1802. It is also possible that she had heard rumors about an inevitable overthrow of the emperor. Indeed, a group of conspirators assassinated Paul in a palace coup on the night of March 11, 1801, and his son Alexander I succeeded him to the throne. Thereupon, Dashkova's banishment effectively ceased, and on March 19, a week after the assassination, she wrote a letter full of enthusiasm and support for the new emperor, in which she expressed her "love and devotion."[52] She now thanked Alexander and his wife, Elizabeth, who as grand duke and grand duchess had sent her in exile their portraits as an expression of their commiseration. Dashkova liked the emperor, whom she had known from childhood, but she admired his consort even more. "Her good sense, her general knowledge, her modesty, all the gracious qualities that charm bestows, tact, and discretion beyond her years, all made me fond of her" (277). Emperor Alexander urged Dashkova's brother to return to St. Petersburg and again take an active part in public life, and in the summer of 1801, Dashkova followed Aleksandr to the capital. Her nephew, Dmitrii Tatishchev, had brought her an invitation and she would stay at his house on the English Embankment in May and June. She had made the same journey between Moscow and St. Petersburg countless times before. It lasted about a week, since at her age travel was difficult and she advanced slowly in short stages, even at night when she tried to sleep in a makeshift bed in the carriage.

St. Petersburg, and particularly the court, had changed in the seven

years she was away. She no longer felt at home there, and it was with a sense of relief that she left at the end of July and returned to Moscow to attend the coronation. In order to ready herself, Dashkova borrowed forty-four thousand rubles from the bank to purchase the necessary dresses and equipages, and to cover additional expenses. According to some sources, the emperor reimbursed her for most of the money, but she set aside 19,500 to cover, once again, Pavel's letter of exchange.[53] In deference to her age, and since she was now considered one of the first ladies of the court, during the solemn entry of Their Majesties into Moscow her carriage followed those occupied by the royal family. Although it was a great honor to figure so prominently in the coronation, Dashkova's heart was no longer in it, and she was unwilling to describe it in her *Memoirs*: "As I like neither ceremonies nor etiquette nor official functions, I shall say no more about them" (278).

At this time, the liberal-minded Simon, whose ideas in many areas were close to the young emperor, was preparing to visit Russia. During Paul's reign, he had been living as a private individual in England and was now due to arrive in St. Petersburg in the summer of 1802. The new emperor had returned Simon to his duties and restored the property Paul had confiscated. Despite the ill will that existed between Dashkova and her brother, age had softened their feelings and their disputes had faded with the passage of time. In her correspondence with Simon, Dashkova had confided to him of her hardships in exile and expressed her fear that perhaps she would never see him again. She thanked him for his warm letters and was very pleased to have met his son, Mikhail, who was "a complete joy."[54] Dashkova wanted to see her younger brother for the last time and she only regretted that Simon would not bring his children to visit her in Moscow or Troitskoe. Therefore, in July 1802, she once again visited St. Petersburg to call on Simon, who with his daughter Catherine was staying with Aleksandr. Dashkova would bequeath to her niece Catherine the diamond-studded portrait of Catherine II, awarded to her as lady-in-waiting. On September 8, 1802, the young Emperor Alexander designated the aging Aleksandr Vorontsov to the chancellorship of Russia, and in the fall of the same year named him the first Russian minister of foreign affairs. But Aleksandr was out of step with the new generation in St. Petersburg. The emperor had surrounded himself with young men with new ideas, and Aleksandr did not stay long in his position; he was chancellor only two years (1802–1804). In February 1804, Aleksandr left St. Petersburg for Moscow and then continued on to his estate Andreevskoe.

Emperor Alexander's court was intentionally simple, lacking the pomp

and lavishness of his grandmother's, and Dashkova took offense when she heard Catherine II criticized and Peter I praised. Although Dashkova felt that Catherine had let her down, she would not belittle her openly: "I have passed over, it is true, or but lightly touched on, some occasions of mental anguish, arising out of the ingratitude of those whom I would justify, were it possible."[55] Dashkova knew that the position of power she had achieved in society depended on the patronage of another woman. She felt out of place in Alexander's court that, according to Dashkova, was for the most part "unanimous in disparaging the reign of Catherine II and in instilling in the young monarch the idea that a woman could never govern an empire" (279). In addition, she was taken aback by the militaristic spirit of the capital. Dashkova witnessed the Prussian "parade" army she had been opposed to during the reigns of Peter III and Paul and which Alexander had continued to develop. Dashkova's understanding of the military uniform was two-edged and often tailored to the historical moment. On one hand, it was an instrument of repression and regimentation, and on the other, it embodied the potential for liberation and transformation, as, for example, when she wore it during the coup. Now, drill sergeants dominated St. Petersburg, and she had the sense that Russia was preparing for war, little suspecting that in ten years or so Napoleon's army would be standing at the gates of Moscow.

In the fall, Dashkova left St. Petersburg forever and returned to Troitskoe. An English traveler, Rignald Herber, described her during the reign of Alexander I. She was still wearing the same coat and star as when she went to Korotovo, reflecting her enduring sense of inner exile: "She, of course, has lost her ancient beauty, but still retains her eccentricities; her usual dress is a man's great-coat and night-cap, with a star."[56] Dashkova, however, was not ready to sit back and await the end of her days. Her last decade of life would also be her most creative as she reconsidered her life in her autobiography, the crowning achievement of her literary career. Earlier, members of the Russian Academy had invited her to head the Academy once again, and its permanent secretary, the prominent academician I. I. Lepekhin, wrote her a letter of invitation. In a return letter received at the Academy on May 25, 1801, Dashkova declined the offer, citing her poor health and almost immediately, A. A. Nartov took over the post.[57] Dashkova, however, chose to affirm her own, individual voice by returning to the public arena through the agency of the *Memoirs*—her story (*Mon histoire*).

Chapter Twelve

The Final Years

During the last decade of her life, which corresponded to the first decade of the new century, Dashkova lived on her estate in the spring and summer and in Moscow in the fall and winter. The visit of the sisters Martha and Catherine Wilmot for a time rejuvenated Dashkova, distracting her from her isolation and the sense of an impending end. They were the Anglo-Irish cousins of Catherine Hamilton and the eldest daughters of Edward Wilmot of Cork, Ireland, whom Dashkova had met in England in 1776 and again in 1780. When their brother died, Catherine Hamilton urged them to visit her dear old friend Dashkova in Russia. In June 1803, despite the war between France and England, Martha left England for Russia, where she stayed for five years. Once in St. Petersburg, she lived for a time in the house of Dashkova's niece Anna Polianskaia, and immediately began to hear rumors and disparaging comments about Dashkova. Anna assured her that Dashkova was a cruel, vindictive, unbridled individual, who had ruined many lives, and who lived in a pitiful wasteland far from the society of educated people.[1] The ungrateful niece railed against her aunt, although not so long before Dashkova, ignoring family disputes, had established Anna at court, and eventually willed her three thousand rubles. Others told Martha about an eccentric old woman who led a reclusive existence and who was stingy and ill tempered. A relic of a past age, she only met with similar holdovers from Catherine's reign to play cards, even if she could not stand to lose. The stories she heard were not at all in keeping with those Catherine Hamilton had told her about a courageous young woman who had gallantly, with sword in hand, participated in the revolution of 1762. Wilmot was so frightened that she sought the help of the English envoy, G. Warren, who assured her of his protection.

At last, she arrived in Troitskoe, which to her relief was not at all a wasteland. The large brick house covered in white stucco stood prominently on the banks of the Protva River. The beautiful gardens led to a seven-mile stretch of dark forest extending as far as the eye could see. Driving up to the house, past the church with a tall, detached bell tower, she could see the outbuildings: the theater, riding school, infirmary, stables, steward's house, guesthouse, and other dependencies. A special enclosure housed an enormous English bull, and despite the harsh Russian weather, plants and tropical fruits — peaches, oranges, and pineapples — grew in the greenhouse. An energetic, older woman with an animated, intelligent face greeted Martha. Dashkova was dressed in her customary old dark brown man's greatcoat, decorated with a silver star for the occasion, a nightcap, and the silk handkerchief, worn about the neck, which Catherine Hamilton had given her. Martha felt more assured when Dashkova greeted her kindly and warmly, although communication was difficult. Martha did not know Russian and her French was almost nonexistent, while Dashkova spoke broken English with "unaccountable expressions" and when in a bind, she freely relied on words borrowed from French, German, Italian, and, as a last resort, even Russian.[2] Martha was to become the love of Dashkova's final years and filled a void her children's absence had created. Herzen wrote, "After Catherine she [Dashkova] with all the ardor of a famished heart became attached to [Catherine] Hamilton. And in old age, a friendship, motherly, endlessly gentle, warmed her heart; I am speaking about Miss Wilmot, the editor of her memoirs."[3]

Dashkova surrounded herself with portraits of Martha, which were located on her snuffbox, in her bedchamber, and one as large as life in her drawing room in Moscow. The two women grew very close and their relationship was one of the only bright spots at the end of Dashkova's life. When she became concerned about her failing health, Dashkova wrote the empress Maria Fedorovna requesting that in the possible event of her death the empress take Martha Wilmot under her wing.[4] Several years later, Dashkova would make the same request of Empress Elizabeth, who replied, "Under every circumstance, however, Miss Wilmot may rest assured that nothing shall be wanting which it may be in my power to do for her."[5] Dashkova also laid aside a sum of five thousand rubles with the guardians of the Foundling House on which Martha Wilmot could draw in case of need. Eventually, she remitted the money directly to Martha in England. For her part, Martha was to name her first daughter Catherine-Ann-Dashkova in honor of the woman she referred to as her "Russian mother." Martha's sister, Catherine Wilmot, joined them in September

1805 and remained until July 1807, so that during the last years of her life, Dashkova relied on the companionship of other women, particularly the two Wilmot sisters and Anna Islen'eva. With Catherine Wilmot's arrival Dashkova arranged all forms of entertainment and excursions for the young women. Living in Moscow, the women frequented countless concerts, musical soirées, and performances at the private theaters of the nobility or at the Bolshoi Theater. In her diary, Martha Wilmot often mentioned her attendance at the lighthearted French musical comedies she enjoyed. They sledded, participated in village festivities, listened to Russian folk and gypsy songs, and attended to spiritual matters as they traveled to the Troitse-Sergiev Monastery and Rostov the Great. In winter they rode smoothly on runners wrapped in furs and sable muffs. At other times, the ploughed up and rutted roads were sheer torture, and the miserable horses would spend twenty minutes at a time trying to pull the carriage out of cavernous potholes, while the women were tossed about along with their pillows, writing-cases, and lapdogs. They would arrive bruised, fatigued, and out of sorts.

The cultural and musical life of Russia interested the Wilmots, and their journals and letters are a rich source of information about Russian folk music, customs, and dress, as well as everyday Russian estate, village, and urban life. In their letters home they wrote about the theater at Troitskoe, where during their stay serf actors performed plays every week, and about the orchestra made up of peasant musicians whom Dashkova sent to the estate orchestras of other landowners for musical instruction. Martha took musical lessons on the guitar and gusli (psaltery). Her journal contains descriptions of the songs and dances she witnessed primarily in Troitskoe and Krugloe. She wrote down and translated the texts of original folk songs, a result of her travels and expeditions to the villages of the Kaluga and Mogilev areas, annotating them with information regarding their content, their place in village traditions and rituals, and definitions of words such as *balalaika, lapti* (bast shoes), and *gudets* (a three-string musical instrument). Dashkova guided them, since the sisters did not possess the required proficiency in Russian, and as a result, their work represented an interesting, early example of the transcription and preservation of Russian folk traditions.

Dashkova too demonstrated an interest in the indigenous folk customs of her native lands, a growing tendency in Russia from the middle of the eighteenth century when it became an object of study. Of the fifteen songs Martha collected, nine belong to the folk tradition, while in contrast, Dashkova's musical album, "*Recueil des airs composés par son altesse Madame la*

Princesse de Daschkow née Comtesse de Worontzow," which she compiled during the stay of the Wilmot sisters, primarily reflected the musical tastes of her youth. Her repertoire consisted of arrangements of Russian, Ukrainian, and Polish folk songs, along with some thirty compositions adapted for harpsichord or piano accompaniment. These included romances, arias on Italian, Russian, French, and English texts, her spiritual hymn on an English text, a number of dance pieces (contra dances and mazurkas), three andantes and one romance for piano, as well as an excerpt from Giovanni Paisiello's popular opera *"La Molinara"* (1788).[6] Dashkova's inclusion in her album of romances and spiritual hymns on English texts sets her apart from the major trends of Russian eighteenth-century musical taste, dominated as it was by the influences of the French song and musical comedy, Italian opera, musical theater, and masters of Austrian and German classical music — Bach, Hayden, Mozart, and the early Beethoven.

During the winter season there were dinners, balls, and masquerades to attend at the homes of Dashkova's circle of friends and relations: A. I. Mavrokordato, P. L. Santi, A. M. Golitsyn, A. G. Orlov, N. I. Kurakina, I. P. Saltykov, I. A. Osterman, as well as other Moscow grandees. At other times, she would organize evenings at her home for her contemporaries, the formerly influential people of Catherine's reign. These once powerful courtiers and cavaliers, now knights of the green table, would gather at her house for cards and political discussion.[7] Now retired, many of them were former enemies who had long forgotten their past animosity. In one voice, they praised Catherine, while uniformly criticizing Alexander I as being far too young and inexperienced.

In 1803, Martha and Dashkova attended a ball in the Russian style given by Dashkova's nemesis of old, Aleksei Orlov, famous in Moscow for his entertainments at his palatial residence Neskuchnoe.[8] During an intermission between the polonaise and contra dances, his daughter Anna, who in later life was to give away Orlov's vast fortune and retire to a convent, performed traditional dances such as the *kazachok* and *tsiganochka*.[9] At Dashkova's request, she sang several Russian folk songs. Catherine Wilmot described how on such occasions Dashkova would habitually arrive at the ball before the lighting of the candles. "With regard to coming early to places it is a thing which may fairly be placed amongst her oddities."[10] At last, scores of wax candles in crystal chandeliers and brass candleholders illuminated the main hall. Around the hall and in an adjoining room tables were set up with sealed decks of cards on them. When enough guests had gathered, the musicians struck up a polonaise. The older, more prominent guests danced the first few numbers and then retired to the card tables to

play whist and other games. The young people continued to dance the English promenade, mazurka, cotillion, and the minuet *en deux et en quatre.*

Widows did not as a rule dance, and Dashkova had little use for idle gossip, so she busied herself by observing everything with a critical eye. The new order of things put her off as the polonaise replaced the minuet, and the waltz was coming into fashion with its repetitiveness and shocking physical intimacy. Dashkova, who had learned little about the art of concealing her feelings, was blunt with many of the guests at the ball and openly critical of the new styles they wore.[11] For her taste, fashion had become too French and too republican. By the end of the eighteenth century, with the growing popularity and influence of Rousseau, a new spirit of preromanticism emerged with its emphasis on the cult of nature and the natural. The hoops and farthingales (*les paniers*), whalebone bodices, and beauty spots were disappearing. Fashion turned to a stylized naturalness based on classical models of ancient Greece and Rome or on a playful, theatrical representation of country life. In the first decades of the new century, from 1800 to 1815, the new French fashion dominated, with the French attempting to look like Romans in tunics. In reality, Dashkova must have thought, they were wearing nothing but flimsy, tight-fitting nightshirts, with waists under their underarms and shockingly revealing their ankles. Paul had required powdered wigs, but during Alexander's reign, the young men and women stopped wearing them. In Moscow, Dashkova found herself numbered among such independent and outspoken social lionesses as Anastasia Ofrosimova (Leo Tolstoy's M. D. Akhrosimova in *War and Peace*), who were not constrained or governed by accepted norms of proper behavior. Their straightforward and outspoken manner struck fear in the minds of many a socialite. Eventually Dashkova would disappear into a back room where she would play cards. She loved whist and pharaoh, which had become all the rage in fashionable society. Then, she would depart long before the concluding cotillion.

The Wilmots lived in Dashkova's Moscow house on Nikitskaia Street, which was still unfinished, but according to the sisters was warm and beautifully appointed. Mahogany furniture with morocco leather, chinoiserie, and English rugs decorated the rooms. At home, Dashkova's usual dress was a cloth or camlet housecoat, allowing her greater freedom as she ran the large household, took care of her extensive correspondence, read, played her music, and painted. Some of the paintings hanging on the walls were Dashkova's creations and there were forte-pianos in several rooms. Books were everywhere. Catherine Wilmot in her journal enumerated the titles she was reading from the immense library located in the

house. Dashkova had no doubt recommended many of the books to her, hoping to immerse the young woman in Russian history and culture. All of the books, either in the original or in translation, were in English and French. They included *L'Antidote*, Leveque's *Histoire de Russie*, Lomonosov's *L'Histoire de Russie*, Tooke's *View of the Russian Empire and the Life of Catherine II*, Scherbatov's *Histoire de Russie*, Voltaire's *Histoire de l'Empire de Russie sous Pierre le Grand*, and Karamzin's *Tales*, in, according to Catherine Wilmot, a deplorably written translation.

Often they would travel to Troitskoe, and although smaller, the manor house there was equally grand, testifying to the owner's wealth and great interest in art, history, and travel. The main reception room was ornamented with Vigilius Ericksen's portrait of Catherine dressed in an officer's uniform riding her white stallion on "the very day of her husband's destruction."[12] Further, in an act approximating religious veneration, there were portraits of Catherine adorning every room of the house. The dining room was directly opposite the hall door leading into the sitting room decorated with red morocco leather, gold leaf furniture, and a portrait gallery of those individuals who had played an important role in Dashkova's life. The place of honor Dashkova bestowed on her late husband, although Catherine hung nearby, "a commanding looking dame" with eagles embroidered on her train and wearing an ermine robe, along with her grandson Alexander I "in all his Imperial dignity."[13] There were also portraits of Frederick II, Stanislaus Poniatowski, and scores of family members — all of the Vorontsovs and Dashkovs.

Martha and Catherine Wilmot would have coffee or tea at nine, then they would go for a walk, study, read, or write. When it was warm, they sat in the latticework arbor designed in the Chinese style, surrounded by a rose garden. The spot was idyllic, if one could ignore the gnats and wasps that forced them to wear light Italian gauze on their faces. They strolled along garden paths, talking and laughing together. In the early afternoon, they played their music until the dinner bell summoned them to table at half past one or two. It was always a substantial meal combining local Russian foods with exotic, foreign dishes. Typically, dinner consisted of egg pâtés eaten with soup, often prepared from local fish, and hydromel or kvass to drink. Roasted meat served with salt cucumbers, sturgeon caviar, young pig, curdled cream, and salads came next. For dessert, they would have preserved dates and rose leaves, apple bread, honeycomb, pickled plums, or Crimean and Siberian apples. Teatime was at six and a prodigious hot supper followed at half past nine or ten.

During the day, the women often passed notes to each other. They ex-

pressed Dashkova's touching attitude toward Martha when in the morning Dashkova invited her to drink coffee together, or at night when she wrote, "With a heavy heart and little hope to sleep I go to my bed. I would rather have remained near you to watch my sweet child." Constantly worrying about Martha's health, headaches, and the effects of the medicine she had prescribed, Dashkova referred to her as my "English child" and *martyshka* (her little monkey), while Martha called her *matushka* (mother) and *maman russe*. Martha studied Russian, Italian, and French, and Dashkova called herself Martha's tutor in French (*votre maître de langue française*). She kindly chided Martha when she "made many mistakes because she was rushed," but then assured her encouragingly that with her new method of instruction she will make rapid progress. At times, depressed and overwhelmed by the consciousness of her mortality, Dashkova would write about herself, "Do not mourn her death, as life was not happiness to her."[14]

To keep her dark moods and depressions at bay Dashkova spent her days and nights working. Catherine described her extraordinary industriousness and energy, as well as,

> Her originality, her appearance, her manner of speaking, her doing every description of things, (for she helps the masons to build walls, she assists with her own hands in making the roads, she feeds the cows, she composes music, she sings & plays, she writes for the press, she shells the corn, she talks out loud in Church and corrects the Priest if he is not devout, she talks out loud in her little Theatre and puts in the Performers when they are out in their parts, she is a Doctor, and Apothecary, a Surgeon, a Farrier, a Carpenter, a Magistrate, a Lawyer).[15]

During the sisters' stay, Dashkova had an artificial pond dug on the estate grounds and she planted fruit trees: apples, pears, cherries, and plums. At night, in addition to her business correspondence, she wrote to scholars, scientists, friends, and family. Her letters were straightforward, sincere, and lacked any sense of artificiality or hypocrisy. They pointed to the great variety of her interests: politics, the military, news, books, Russian and foreign publications, science, medicine, and so on. Often they focused on her health, on the need to drink nettle juice to cure a persistent cough, on the simple details of everyday life, and on nature.

Especially revealing is a letter Dashkova wrote to Catherine Hamilton. Although it is not dated, its self-consciousness and self-analysis must have been a consequence of her work on the *Memoirs* around 1804–1805.[16] Dash-

kova defended herself against accusations that she was capricious, proud, vain, cruel, nettlesome, and greedy. She rejected outright any notion that she was a woman of genius, but did admit to living a life devoted to the mind. Nor was she a scholar, since there was never any methodology in her education and it was more a matter of her own inspiration. Her married life, the responsibility of educating her children, and the haphazard and traditional nature of her education undermined and detracted from scholarship, research, and the pursuit of letters. Thus, the traditional education of women in the eighteenth century and her confinement to the domestic sphere impeded and hampered Dashkova: "Then followed marriage, children, sicknesses, and afterwards sorrows; circumstances, it will be admitted, most unfavorable to the acquisition of those literary attainments I so much coveted."[17]

Some commentators, Dashkova continued, wrote that she is stubborn, opinionated, and self-centered, but she felt that she was in fact the voluntary slave of her husband, mother-in-law, and the children's governess Kamenskaia. Even her friends could have their way with her, if only they wanted. Regarding her alleged vanity, Dashkova never considered herself appealing, which led to feelings of insecurity. While it never constricted her thoughts and actions, she found it difficult to disguise the lack of self-worth she felt and everybody could see it expressed in her face. Therefore, in her mannerisms there was always something awkward, which some people misinterpreted as arrogance or shortness of temper. Indeed, her insecurities expressed themselves in a reticence that was socially misunderstood and created an inaccurate impression of what she was saying and doing: "I assumed the mask of insensibility and coldness, whilst my heart confessed the painful void which the lost object of its warmest affection had too sensibly occasioned."[18] Many who judged her noted that she could be unkind, restless, and selfish, but most of these evaluations refer to her actions during the palace revolution of 1762. While not denying these charges, Dashkova explained that she had been very young and inexperienced. Possibly thinking of Catherine, Dashkova wrote that she mostly gauged others according to her own standards and often naively overestimated individuals, and this overestimation would pursue her all of her life despite the repeated lessons of bitter experience. All the same, after her husband, Catherine was the primary embodiment of her ideals, while the people who surrounded the empress at court were her enemies.[19]

Concerned about her role in the historical events of eighteenth-century Russia and the manner in which historians were evaluating her place and contribution to Catherine's reign, she read and wrote about her life.

Despite her complex and often antagonistic private relationship with the empress, Dashkova's high praise and public glorification of Catherine represented a defense and justification of her own actions and personal decisions.[20] Especially in her *Memoirs*, she endeavored to present her version of the past as seen through her often less-than-objective eyes. Angrily, she read Rulhière's *Histoire ou Anecdotes sur la révolution de Russie en l'année 1762* and Castéra's *Vie de Catherine II, Impératrice de Russie*, studies that in her opinion libeled Catherine II. Based on Rulhière's *Histoire*, Castéra's work, according to Dashkova, depended on unfounded rumors and hearsay; the apocryphal letters in the first edition disturbed her the most.[21] The decision to write an autobiography was primarily a response to the inaccurate manner in which others had inscribed her life with Catherine. In the *Memoirs*, she mentioned reading two histories laudatory of Catherine, and while correcting some factual inaccuracies, she presented them as antidotes to the fallacies in French pamphlets.

> I have lately been reading two books published in Russia. One is called *Vie de Catherine la Grande* and the other, *Anecdotes du règne de Catherine II*. They express feelings that all true Russians must entertain and cherish in their hearts toward a sovereign who really was a mother to her subjects. However, I must point out an error that occurs equally in both books. It is stated that Catherine knew Greek and Latin and that of all living languages she preferred French as being the pleasantest. I think I can say definitely that she knew neither Greek nor Latin, and if she spoke French to foreigners rather than German this was because she wanted people to forget that she was born in Germany (243–244).[22]

Also, Dashkova worked on her own articles and literary works and continued publishing under various pseudonyms in the *Friend of the Enlightenment, Messenger of Europe, Russian Messenger,* and possibly in others journals. Aware that her historical legacy depended largely on Catherine's reputation, she submitted a letter to the editors of *Friend of the Enlightenment* and attached to it the "Inscription to a Portrait of the Great Catherine." The same short panegyric piece had appeared in the *Companion* in 1783, and in a subsequent issue, she published her "Representation of the Great Catherine," which she had written some twenty years earlier.[23] The need to preserve her personal legacy in a positive light extended to other activities as well. She established the E. R. Dashkova scholarship at the Moscow Institute of the Order of St. Catherine and donated money to women's shelters under

the patronage of the Dowager Empress Maria Fedorovna. Dashkova also busied herself rearranging her cabinet of natural history, which she had collected for over thirty years. An extensive, museum-quality collection of fossils, minerals, and *objets d'art* consisting of 15,430 items evaluated in excess of fifty thousand rubles, she presented it to Moscow University.[24] In 1805, the liberal thinker I. M. Born nominated Dashkova for honorary membership in the Free Society of Those Who Love Literature, Science, and Art. It was a great honor bestowed on her by the next generation of writers, since the Society was one of the major literary groups of Alexander's reign. Considered progressive and democratic, it included among its members the sons of Radishchev, and later A. S. Pushkin and D. V. Dashkov, one of the founders of the Arzamas literary group.[25]

From February 1804 to the end of 1806 Dashkova, urged on and assisted by the Wilmot sisters, wrote her *Memoirs*. At night in Troitskoe they would try to stay warm by the fireplace, listening to the wolves howl outside; when the windows frosted over, they would read their futures in the designs of ice on the glass. Dashkova mesmerized the sisters with stories and anecdotes of life at the court of Catherine, and she would read to them from her lengthy correspondence with the empress, beginning with the early years of their friendship. Every so often, as Dashkova read, Catherine Wilmot would notice a painful sort of agitation animating Dashkova's countenance, and she longed for the reading to end.[26] Fascinated, Martha persuaded a seemingly reluctant Dashkova to record her experiences in autobiographical form. Dashkova agreed, adding that "I wrote these memoirs because she [Martha] earnestly desired me to do so; she is their sole owner on one condition only—that they will not be published before my death" (280–81). Dashkova set to work immediately collecting her papers, documents, and letters. Mornings she worked in her study, and evenings she worked at the upper end of the sitting room in her favorite armchair at a small table inlaid with a chessboard. She would retire there after supper dressed in a purple silk dressing gown and her ever-present white nightcap, simple and incongruous in this sanctuary of women's lives and imperial splendor. Her little black dog Fidelle slept on a large cushion at her feet, and Anna Islen'eva busied herself with her worsted knitting while Dashkova, who was then sixty-two, composed her *Memoirs*. She read dozens of letters from Catherine, Voltaire, Diderot, Garrick, the Abbé Raynal, and many others, and rummaged through a lifetime of notebooks, heaps of documents, and bundles of old papers tied up in large parcels.

The work proceeded quickly, and Martha was evidently mistaken when she wrote that they began work in the autumn of 1804.[27] Actually, on Feb-

ruary 10, 1804, Martha noted in her journal, "The Princess has begun to write her life. Her motive for so doing is friendship to me, as she says she will give me the manuscript & liberty to publish it. It will probably be a most interesting work."[28] Hence, Dashkova wrote the initial draft in approximately twenty-one months, since on the last page of the *Memoirs* Dashkova marked the date of completion as October 27, 1805. Martha confirmed the latter timetable when she stated, "I think it [the memoir] was completed in about two years."[29] As Dashkova wrote, Martha copied the manuscript and even undertook an English translation. On March 29, 1804, she explained, "I have begun to translate into English the dear Princess's history as she writes it in French," yet by her own admission Martha's command of French was uncertain.[30] So the task of translation fell primarily to Catherine, and on April 29, 1806, Martha remarked, "I write (I should say I *copy*) the Princess's History every day, Kitty [Catherine] translates it." Again on November 9, 1806, she added, "I began yesterday to copy out Kitty's translation of the Princess's History after having finished copying the same thing in French & since that all the Empress Katherine's Letters to Princess Daschkaw."[31] It is therefore safe to assume that in addition to the two copies of the *Memoirs*, which the sisters had labored over so assiduously, Catherine Wilmot had also drafted an English language translation while still in Russia.[32]

As they worked with Dashkova, the young women were taken aback to find that the manuscript was taking shape as a polemical rather than anecdotal narrative. Dashkova wanted to present her story to posterity. Her decision to formulate and set forth a justification of her past was a strong, assertive act and represented a desire to be "correctly" included in the historical record:

> I want to disguise nothing in this narrative. I shall tell of the little differences that cropped up between Her Majesty and myself, and because I shall hide nothing, the reader will see for himself that I never fell into disgrace, as has been claimed by several writers who wanted to harm her [Catherine's] interests, and that if the Empress did not do more for me, it was because she had an intimate knowledge of me and was quite aware that every form of self-seeking was entirely alien to my nature (95).

Again, Dashkova's defense of Catherine, despite "little differences" and the claim that "the Empress did not do more for me," may be attributed to Dashkova's realization that she would not have achieved a comparable position of power and influence during any other period of Russian history.

Equally surprising for the Wilmots was Dashkova's depiction of her personal life and the manner in which she chose to emphasize her more traditional role of a devoted mother, providing guidance and tutoring for her children. "Personally," Dashkova wrote, "I had to suffer constant privations, but was perfectly indifferent to them: my life was dedicated to the love I bore my children" (148). Remarkably, Dashkova focused exclusively on her son's education, avoiding any reference to her daughter, and when she mentioned Anastasia at all in this context, it was only as the chance, unintentional beneficiary of her brother's course of instruction. Dashkova's silence and unwillingness to discuss her daughter's education in the *Memoirs* was at least partially a consequence of the strained and finally tragic relationship between mother and daughter. Yet by the time Dashkova came to write the *Memoirs*, her son too had angered and disappointed her.

It seems that Catherine Wilmot must have questioned Dashkova concerning her silence on the topic of her daughter's education. Dashkova defended herself in a letter to Catherine, written a month after the completion of the *Memoirs*, and later published in the journal *Friend of the Enlightenment*.[33] Interestingly, an important reversal occurred in the letter that ran contrary to her discussion in the *Memoirs*: She touched on her daughter's education and ignored her son's. Dashkova enlarged on Locke's ideas of physical instruction, without mentioning Rousseau, although physical training was central to the educational theories of both thinkers. But, she explained, most all-encompassing approaches to education do not properly take into account intrinsic and extrinsic factors determining an individual's development. As a case in point, in the *Memoirs*, she stressed her own and her cousin's, Anna Vorontsova's, contrasting personalities, although their upbringings were essentially identical. "Those who claim to know all about education, please note; also those who want to impose their ideas and their theories in connection with a subject so precious and so decisive for human happiness, and yet so little known, because a single brain cannot comprehend it in its entirety with all its numerous ramifications" (32). For Dashkova, the cornerstone of education was individualization, which made allowance for variables such as environment, personality, personal needs, and gender. As she succinctly put it, the tutor should always be conscious of time (when), place (where), and measure (how much). Ironically, she deprived her daughter of precisely such individual attention.

In the same piece, Dashkova wrote that long before Anastasia was able to utter even a single word, she was planning for her *une éducation parfaite* (*vospitanie sovershennoe*). "At 16 I became a mother.... My daughter could not yet utter a single word, when I resolved to give her a *perfect education*.

Reading every book published in four languages on the subject of education, I was certain that like a bee I could extract only the best ideas, and then blend them into something wonderful." In a section of the article missing from Catherine Wilmot's copy of the original letter, Dashkova sadly admits that unforeseen circumstances may bring to ruin the results of even the best upbringing.[34] It is precisely this spirit of disillusionment in previously held principles that informs Dashkova's attitude toward her daughter's education in the *Memoirs*. In spite of her proper maternal devotion and sacrifice there were unanticipated factors linked in Dashkova's mind with notions of physical training, and because of Anastasia's physical disability brought on by rickets, Dashkova did not provide her with an education comparable to her own. In the *Memoirs* she turned a blind eye to Anastasia's capabilities, which potentially may have led to a career and intellectual independence for the daughter.

It is clear that Anastasia was a very gifted woman, who had benefited greatly from her upbringing (however traditional), and indirectly from the tutoring her brother had received. But by the time Dashkova wrote her letter to Catherine Wilmot, Anastasia was a forty-five-year-old invalid suffering from "bilious complaints" who could not forgive her mother the attention heaped on her brother, and now on Martha Wilmot.[35] She displayed "avow'd enmity and jealousy" toward Martha, accusing her of hoping to marry Pavel and persuading Dashkova to effect her son's divorce.[36] Apparently, Anastasia's claims were not far-fetched. Dmitri Buturlin wrote his uncle Aleksandr Vorontsov on September 1, 1804, that Dashkova and her son were at odds, and that she would like him to marry Martha Wilmot (*son Anglaise*). A number of years later in 1810, Elizabeth Morgan stated that had Anna Dashkova died early, Dashkova certainly would have tried to arrange for Martha to become her daughter-in-law.[37]

Consequently, Dashkova's relationship with her daughter deteriorated further. The gradual disaffection of mother and daughter resulted in anger, quarrels, and scandal. Anastasia continued to incur debts that her mother now refused to honor, and the endless disputes and clashes led to the end of any contact between mother and daughter. Therefore, at the end of her life, while confident that she had done so much for her children and publicly professing the educational ideas of the Enlightenment, Dashkova failed in the *Memoirs* to address the question of whether she had properly provided for her daughter's upbringing. As a result, the life of a woman of great intellect and prominence ended in personal tragedy because, despite her own advanced and liberal education, she could not meet and come to terms with her daughter's special needs.

Other troubles and uncertainties distracted Dashkova as she worked on her *Memoirs*. There were difficulties with the management of her estates and problems with Polish officials, as well as bad roads, bad weather, and ill health. She worried about a possible tumor in her left breast.[38] With every passing year, she found that there were fewer and fewer family members to turn to for support. Her older sisters were dead, Maria in 1779 and Elizaveta in 1792. Simon continued living in England and never returned to Russia. In 1806, he retired from the diplomatic service and Kh. A. Liven replaced him. Simon died in 1832 in his house on Mansfield Street in St. John's Wood and was buried in Marylebone.[39] It seemed to Dashkova that only Aleksandr remained, yet even he had asked her not to visit him on his estate until he could regain his health. She wrote Aleksandr to request information and to verify facts in her *Memoirs,* and on October 28, 1805, a little more than a month before his death, he responded to her questions concerning the chronology of historical events during their lifetime.[40] Fearing for his mother's health, Pavel kept from her the news of her brother's death on December 3, 1805. He alone with a few close relatives attended his uncle's modest and inelaborate funeral in Andreevskoe, where Aleksandr was buried in the estate church not far from the gravesite of his friend and companion François Lafermière. Dashkova was devastated when nearly two weeks later, at her arrival in Moscow on December 15, she learned of the death of her favorite brother and closest friend.

These were years of war in Europe as reports of battles and troops on the march reached Troitskoe. An invading army from France, the country that had inspired Dashkova in her youth with the enlightened ideas of liberty, equality, and justice, was now menacingly advancing on Russia. Napoleon had routed the Russian-Prussian army at Austerlitz in 1805, and at the end of October 1806, she learned of a French victory at Jena over Prussia, Russia's ally. These events, no matter how significant historically, paled in comparison to the news that would arrive shortly. On January 9, 1807, as Dashkova was entertaining, she learned, completely unexpectedly, that her son was running a high fever and was near death. She had been on bad terms with him, and for years they had met only on rare occasions. Therefore, she did not believe what she had heard, suspecting that it was an attempt to reconcile them. Tragically, she was never to see him again. On January 17, 1807, the news came of his death at the age of 44 in his Moscow house on Tverskaia Street. Catherine Wilmot described the scenes of despair at home where Pavel's death had "turned the house into a burial vault."[41] Even the Empress Elizabeth attempted to console Dashkova. "Very sincerely participating" in her grief and alluding to the death

of her infant son, she wrote, "My health had in some degrees suffered from the shock which my heart has lately experienced."[42]

Not wishing to meet her daughter and unable to face a disagreeable confrontation with her, Dashkova did not attend the funeral. Anastasia guarded her brother's coffin, not allowing her enemies among the guests to draw near. Martha wrote that Anastasia "as chief mourner stood close by the coffin, but stood as the Daemon of Revenge, not as the agonized sister of a brother who was but too kind to her." She caught sight of Anna Islen'eva and rushed toward her. "Don't let those English monsters approach him," she demanded.[43] When she learned of her daughter's behavior, the unhappy and grieving Dashkova was incensed. She sat down and wrote a long letter to Anastasia disinheriting her. Never again would she have to endure her daughter's hysterical scenes and disgraceful scandals. She could not forgive the outrageous behavior directed at her niece Tatiana Norova and Martha Wilmot during the funeral. "Your hysterical voice shook the whole church, and everybody was aghast at this ungodly frenzy of inhumanity and viciousness and at your intent to abuse your mother within everyone's hearing; all Moscow now speaks your name with revulsion." She recalled all of the wrongs Anastasia had committed, the malicious lying, and the attempts to turn people against her mother. Dashkova permanently denied Anastasia access to her house and specified that even after her death her daughter would have to pay her respects only in church. She also wrote that she adamantly refused to allow for the adoption of her son's illegitimate children while his wife was still alive, even though Pavel was the last male representative of the Dashkov family.

> I solemnly repeat that my son did not want the impossible: i.e. to adopt illegitimate children begotten during the lifetime of his still living wife. . . . I likewise solemnly aver that he never intended to entrust them to you, and during his final illness requested that his friend take them. You boast that you'll petition the emperor to bend that law and subvert the sacrament of wedlock sanctified by the Holy Writ, and that to satisfy your whim and conceit he will permit you to adopt these illegitimate children while the wife is still alive. This is fantasy worthy of your deluded state of mind.[44]

However, in opposition to her mother's wishes, Anastasia adopted her brother's children, and, as it turned out, she was a skillful pedagogue and tutor of considerable talent. She alone brought up and educated her nephew, Mikhail Pavlovich Shcherbinin, who bore his grandfather's and

father's names and his aunt's surname. Author, senator, and statesman, at Anastasia's request, he would serve as his cousin's, Mikhail Vorontsov, secretary and would write his biography. He also wrote very warmly and highly of his aunt and would credit her with his literary education.[45] Dashkova, in contrast, made every effort to preserve the family name by offering it to Simon and his son Mikhail. They refused, but her seventeen-year-old godson and second cousin, Ivan I. Vorontsov, accepted and in 1807, by decree of Alexander I, became the first Vorontsov-Dashkov.

It was time to formalize her wishes, since she had written her first will and testament some ten years earlier on December 24, 1796, or just before her departure into exile in Korotovo. It was on record at the Moscow orphanage founded by I. I. Betskoi in 1764 and to which she had left some of her money. Now she needed to take the necessary steps to complete her daughter's dispossession. In August 1807, she wrote the executors of her will, F. I. Kiselev, A. Neledinskii-Meletskii, P. L. Santi, and A. M. Urusov, expressing her wishes concerning the location of her will, her funeral arrangements, and the disposition of her property. The first two persons mentioned in the letter were her niece Anna Islen'eva and Martha Wilmot, and Dashkova specifically requested that the executors protect Martha from the insolence of her daughter. She also made provisions for the sale of her Order of St. Catherine, with money received going to support needy young noblewomen at the Catherine Institute. In gratitude for his help, she left Kiselev her copy of Lampi's portrait of Catherine.[46]

Dashkova divided the bulk of the estate between her nephew Mikhail Vorontsov and Ivan Vorontsov-Dashkov. Mikhail inherited her Belorussian estate Krugloe and her Moscow house, while Ivan received Troitskoe and the surrounding villages in the Kaluga and Moscow Provinces and her St. Petersburg estate, Kirianovo. Additionally, she distributed money to her executors, friends and relatives, and funds for the support of weddings, new families, the poor, convicts, the board of public welfare, and the construction of a parish church. Dashkova also freed her maids, Praskovia, Nastas'ia, and Anna. To her daughter she only bequeathed a sum of three thousand rubles, an annual stipend of four thousand rubles that Mikhail Vorontsov was to administrate, and, sadly, a lifetime legacy of anger and resentment.[47] Immediately after her mother's death, Anastasia submitted a petition to the senate challenging her mother's will. An inquiry and subsequent ruling upheld the legitimacy of the will and ruled against Anastasia, citing the money and property she had received from her father's estate.[48] She continued living in Moscow, on restricted means, bringing up her brother's children, giving them lessons, and providing for their

needs. Pavel's estranged wife had lived in a small house in the country, a property Anastasia now inherited from her brother. After refusing to see her for years, Dashkova came to her daughter-in-law's defense regarding her rightful share of the inheritance. Then she took Anna into her home and subsequently purchased her a house for seventeen thousand rubles.[49] Catherine Wilmot characterized Pavel's wife as "interesting, able, and very charming" and described Dashkova's meeting with her daughter-in-law: "Tears on both sides, and scarcely a word fill'd up the five minutes which it lasted."[50] The closeness that developed between the women did not last long, and in 1809 Anna Dashkova died, a young woman of 41.

In 1807, Catherine Wilmot prepared to leave for home a year before Martha. At their departure, Dashkova showered the sisters with money, snuffboxes, jewelry, gems, medals, clothes, paintings, and souvenirs from Herculaneum. Dashkova presented Catherine with a locket of "Venus's Hair" set in diamonds and gave her companion, Eleanor Cavanaugh, a pendant watch and silk gloves.[51] She lavished Martha Wilmot with a beautiful box of *arboris d'agate* set in gold that had once belonged to her mother and scores of other gifts that included five thousand pounds sterling and the fan she had received from Catherine at their first meeting nearly five decades earlier. Despite her reputation for miserliness, Dashkova could be charitable and was willing to help and financially support those who were close to her. Her abundant generosity toward the Wilmots belies Derzhavin's unsympathetic verdict that "Dashkova, absent her own mercenary calculations . . . would not lift a finger for anybody."[52] Most importantly, Dashkova counted on the sisters to carry the manuscript of her autobiography, her letters, and other archival materials to England. It is clear that Dashkova hoped for the publication of her story abroad and made several provisions to that effect. For instance, she left a description of her participation in the events of 1762 with her friend Elizabeth Morgan. In a letter from Bath dated 1816 Elizabeth Morgan communicated to Martha that Dashkova gave her a sketch "of that one brilliant act in her life" with the injunction to publish it after her death, perhaps for the benefit of some charity. In another letter she added that when Dashkova "quitted Ireland, about the year 1781, she gave me a manuscript brochure, containing what I think may be properly titled Minutes of the Revolution."[53]

The possession of potentially treasonous materials describing the overthrow and murder of the Russian monarch was a matter of great concern to the women, so Catherine hid the documents about her person and safely arrived home. Thereby, a copy of the *Memoirs* and presumably the English language translation survived. When Martha was also planning

to depart, hostilities broke out between Russia and England, and the authorities learned that she was carrying some important secret documents. The informer may have been Fedor Rostopchin, Dashkova's trusted friend who had read the manuscript and who was hoping to curry favor with the throne.[54] Rostopchin was governor-general of Moscow during the Napoleonic War and claimed to have set fire to Moscow, although he later denied it. When the French occupied Vinkovo, his estate on the Old Kaluga Road south of Troitskoe, they found his country house in ruins, with a note written in his hand: "I have set this house on fire voluntarily, that it may not be polluted by your presence."[55] Seemingly, because of Rostopchin's treachery, Martha fell under suspicion of bringing seditious literature out of Russia. In fact, Martha had in her possession the original copy of the *Memoirs,* miscellaneous papers, and Catherine's letters to Dashkova, all of which she hoped to publish. Russian officials arrested and interrogated her for five days; believing that her language lessons and collection of musical notations were actually coded messages, they turned her baggage upside down. The intimidated young woman took fright and burned some of her papers, Dashkova's *Memoirs* among them. Allowed to leave, Martha finally reached England after surviving a shipwreck on a Swedish island. With the original destroyed, only two copies of the *Memoirs* remained, Catherine's in England and another in Russia among Dashkova's papers and documents.[56]

When the Wilmots were gone, Dashkova more than ever felt lonely and superfluous, with her life of influence now recorded in the autobiography and wholly in the past. Dashkova returned to work on her estate and to her writing. She had always been an autodidact striving to broaden and deepen her knowledge through constant study and application. Even at the end of her days, some three years before her death, she was attending the lectures of P. I. Strakhov, rector of Moscow University, on experimental physics.[57] Her Moscow salon, where she discussed literary works as well as political events, stood out for its seriousness. The Russian army's unsuccessful campaigns, its defeat at Friedland in 1807, and the expectation of an impending French invasion of Russia fueled her anti-French views. In 1808, Dashkova contributed a letter to the *The Russian Herald (Russkii vestnik),* a journal which appeared in Moscow from 1808 to 1826 under the editorship of Sergei Glinka.[58] Her letter to the editor again presented a conversation with her aunt, in which she strongly indicted French and German influence, praised the English, and called on parents to play a greater role in the education of their children. Glinka and many other commentators described Dashkova as an oddity. "Along with being a Russian woman,"

Glinka wrote, "she possessed the mind of a European." Her extreme sensitivity to his editorial changes of her manuscript amused him. "I agree to collaborate with you," she wrote, "on one condition: I am persistent and even willful in my beliefs and writings, and I therefore request that you not change a single letter, comma, or period in my contributions."[59]

Increasingly, commentators saw her as a vestige of the now vanished age of Catherine, an eccentric old woman in man's clothing. Vasilii Kluchevskii propagated the unfounded image of Dashkova as the madwoman of Troitskoe, a sorceress of sorts and an unnatural mother. In his lectures on Russian history, he presented a grotesque and outrageous picture of Dashkova ignoring her children and spending her days training rats. The death of her son, according to Kluchevskii, did not disturb her in the least, while any misfortune befalling a trained rat would drive her to distraction. Only in Catherine's Russia, he concluded, could Dashkova begin her life with Voltaire and end it with rats.[60] The only rats, so to speak, that Dashkova dealt with were some of her contemporaries who were close to the throne, and she often remarked that such was her lot in life to invite on herself the anger and ill-will of self-centered scoundrels. Nor is it fair to write that Dashkova ignored her children when in fact the opposite was true. It was her excessive, smothering concern for their well-being that in great measure led to their revolt. Page after page of her *Memoirs* are devoted to her children and stand in sharp contrast to the autobiographies of many of her contemporaries, who focused primarily on their public lives.

Although publicly successful and at the center of Russia's political, cultural, and literary events during the second half of the eighteenth century, much of Dashkova's time had been spent away from the court. Her private life was deeply tragic. She sought the friendship and companionship of other women, but Catherine bitterly disappointed her. Widowed very early, she outlived her son and quarreled with her daughter. Dashkova's old age was a return to exile and a realization of her loneliness. Starting out her life abandoned and alone, she ended it so. Dashkova wrote Martha, "How all is changed at Troitskoe! The theater is closed. I have not had a single performance. The pianoforte continues silent—the *femmes de chambre* have ceased to sing. Everything paints your absence and my sorrow."[61] She dreamed of escape from the gardens of Troitskoe that she had once considered Edenic and wrote about her possible return to England. "As to my journey to England, in case of peace, and the possibility, I must add, of an easy passage, I wish it with all my heart; but for this my strength also must not decay so rapidly as it does at present." It was not to be, and gradually she grew frail and feeble, subject to frequent colds

and coughs. As her usual energy and strength failed her, she spent more time in bed or in her favorite armchair listening to the pealing of the bells from the bell tower she had built, a distant and fading modality of names and people now gone from her: Catherine, the woman she had idolized, and Catherine, the young woman who had taken her *Memoirs* to England; Anastasia, the mother-in-law who bequeathed her nothing, and Anastasia, the daughter she had disinherited; Marfa, the mother she never knew and whose memory she revered, and Martha, the companion of her old age who would be the first to publish her life story. When Dashkova chose to say goodbye, she did not address her daughter or anybody else. Rather, she wrote Martha Wilmot:

> The winter, which seemed willing to establish itself, has disappeared these two days, though not for good, as our climate could not support such absence. But I cannot say when I shall be able to set off for Moscow; therefore I will tomorrow dispatch this letter, and Heaven grant it may find you in perfect health and tranquility. Adieu my beloved child! *God bless you.*[62]

In the beginning of the winter of 1809 Dashkova, weak and ailing, returned to Moscow. As her condition worsened, the prescribed bleedings only drained her strength further. On January 4, 1810, Dashkova died. Venedikt Malashev, the son of her former steward, a serf, and the house musician at Troitskoe, described her final days and accompanied the casket from Moscow to the interment in Troitskoe. According to his account, the wake was held in the Church of the Ascension on Nikitskaia Street across from her house. In accord with her wishes, a unit of dragoons escorted her for the last time to her estate. Petr Santi, the executor of her will, and a few friends and relatives attended the funeral; otherwise, only people from the surrounding villages and curious onlookers crowded the church.[63]

Epilogue

*I*N THE LATE 1980S, ON THE EVE of the Soviet Union's demise, I was able to realize my dream of many years and visit Troitskoe, the estate that had been so much more than just a home for Dashkova and whose memory she devotedly preserved in the *Memoirs*. Ironically, while it was a place of banishment far from her life of influence in St. Petersburg, it also represented an antidote to the physical and spiritual rootlessness of her youth. At the very heart of her inner search for meaning and self-definition, it provided her with immediacy: a physical presence to an inner sense of loss and dispossession—a paradise lost, regained, and lost again.

The War of 1812 had devastated the Vorontsovs economically and they had sold many of Dashkova's properties, but Troitskoe remained in their possession until the beginning of the twentieth century. It was lost to them during the revolution and civil war when many family members perished and some were executed as "ideologically dangerous elements." My grandmother, then pregnant with my father, was arrested with other family members and marched off to be executed. They were miraculously saved when their guards let them go, and escaped Russia forever to rebuild their lives in distant lands.[1] As Russia looked forward to the building of a new socialist society, Dashkova's memory faded into oblivion and when mentioned at all, it was mostly as an afterthought. Her family no longer lived in Russia, and Troitskoe, renamed Bolshevik, became a state collective farm. Even though she was marginalized, Dashkova did not vanish completely and could be found prominently displayed in the center of St. Petersburg on Ostrovskii Square. There, in M. O. Mikeshin's monument to Catherine the Great (1873), the empress stands high above her

courtiers and supporters: Suvorov, Rumiantsev, Orlov, Betskoi, Potemkin, Chichagov, Bezborodko, and Derzhavin. Seated among them with a book in her hands is Dashkova, the only woman.

Over sixty years after Dashkova's family left Russia, I was the first of her descendents still bearing her name to visit Troitskoe, now only a short drive south of Moscow. With a hyphenated name and the hyphenated identity of a Russian-American, I set off to recover an antecedent and a place of origin, to sort out the remains of my family's expropriated history, and to locate myself among the shadows of my ancestors. Identification and disassociation, attraction and aversion shaped my attitude toward Russia and my own "Russianness." The journey promised to became one of discovery, as I sought to return to a past ancestral home, and thereby confront and cast light on the nature of my own relationship to a lost patrimony. I was about to enter an enchanted world of my dreams and childhood stories, a charmed realm of old, fairy tale Russia and family memories of Dashkova's lost domicile — the park and gardens, the oak and birch trees, the view opening onto the Protva River. I wanted to come across a quaint, romantic corner of provincial Russia, but found myself thrust into the heart of Soviet starkness as I arrived in Kremenki, a modern town with a population of under thirteen thousand. A local delegation escorted me to the dark and abandoned dwellings I could make out in the distance beyond the river. As we approached along a dirt road lined with a few remaining linden trees the magical land of an imagined past came up against the reality of poverty, alcoholism, and despair. Gradually, I began to ferret out an understanding of place and identity from family tales, village myths, imposed Soviet ideology, and the ruins of Dashkova's former estate.

So little had survived — the countryside was devastated, the community destroyed, the landscape transformed, the people changed. Rusted farm machinery littered the appropriated land; the manor house was gone, torn down for bricks the commune needed to build new houses and barns. Only the ruins of a few outbuildings and the former mill remained, along with the crumbling and propped up main gate, standing alone and eerily disconnected in an open field. Dashkova's "Parnassus," where once she sat awaiting a courier from the empress, was hidden in a grove of trees, completely overgrown, resembling an ancient burial mound. The obelisk had survived anonymously on a barren rise, its origins and purpose forgotten. Not fifty feet away an enormous granite hammer and sickle stood prominently among the buildings of the collective farm. Locked and boarded up, the church Dashkova had built was laid to waste and abandoned. The gutted bell-tower was still standing, but with its bells torn out

and melted down, their silence evoking absence and the echoes of an inner dialogue between past dreams and present actuality, between faith and the violation of a sacred space. When the local people, many of them descendents of Dashkova's former serfs, were smashing icons and removing "cult paraphernalia" from the church, they also emptied out her grave. Nothing remained of her there and city officials did not allow me to enter the church. Yet according to village lore, a schoolteacher in town had saved Dashkova's burial plaque, hiding it for many years in her home. When it was safe to do so, she donated it to the Kaluga Regional Museum, proud of Dashkova's accomplishments and possibly identifying with her as an educator and a Russian woman.

At the banquet after the tour, there was talk of joint ventures and million-dollar restoration projects as the multitude of official toasts to the rebuilding of Troitskoe contended in my mind with the emptiness and dull silence of felled cherry orchards. My quest for repossession had been misunderstood: capital investments, property deeds, and mortgage melodramas had nothing to do with an inner need to reclaim lost memories. Whether actual or imagined, they were located somewhere in the space between dream and the devastating reality of homecoming. Nevertheless, while the pain and disillusionment of return may have been bruising, it was also an occasion for reconsideration, liberation, and continuity. Any notion of the actual recovery of Dashkova's sacred space dissolved in the face of a violated terrain where her church once stood, its destruction reinforcing the notion of a lost home, once a family shrine, that for me now depended completely on textual reconstruction.

Although much has changed in Russia over the years, I have never been back to Troitskoe. Meanwhile, Dashkova's importance and influence has grown, and there has been a revival of interest in her life and works. Women have been in the forefront of Dashkova's discovery as early as the 1970s when L. Ia. Lozinskaia published her introduction to Dashkova's life. It was followed by the appearance in Russia of two editions of Dashkova's *Memoirs*: G. N. Moiseeva's reprint of a prerevolutionary translation into Russian (1985) and G. A. Veselaia's updated rendering that included excerpts from the letters and Russian journals of the Wilmot sisters (1987). In this country, Barbara Heldt in her groundbreaking feminist study, *Terrible Perfection: Women and Russian Literature* (1987), focused on the juxtaposition of Dashkova's public versus private selves in the *Memoirs*. She stressed the need to treat the work "as an autobiographical entity, examining how Dashkova chose to define herself in all the roles she played."[2]

Over time, Dashkova's role in the coup of 1762, her involvement in

journalism and letters, her directorship of the Academy of Sciences, as well as her final exile and seclusiveness, have become the subject of a series of publications. Today, schools, institutes, and libraries in Russia bear Dashkova's name as well as a number of scholarships for women in the sciences and humanities at major institutes and universities. A number of conferences and exhibits have been organized at, for example, the Academy of Sciences and the State Historical Museum in Moscow. In 2006, the American Philosophical Society honored Dashkova, who became its first female member as a direct result of her meeting with Benjamin Franklin in Paris over two hundred years ago. One of the first learned societies in the West to recognize Dashkova's achievements, it hosted an exhibition entitled *The Princess and the Patriot: Ekaterina Dashkova, Benjamin Franklin, and the Age of Enlightenment* in its Philosophical Hall in Philadelphia. Endowed with an excellent mind and a strong will, Dashkova was an independent woman who dreamed of glory and political ambitions. Living in the eighteenth century, she demonstrated that women could do more than merely attend balls, run a household, serve their husbands, and educate their children. They could take an active role in politics and be successful in a variety of areas traditionally dominated by men. Dashkova was repeatedly obliged to demonstrate her competence for a life of active participation in the public sphere and to assert her right to such participation in the face of established, preconceived notions of proper female behavior. Self-sufficiency, self-reliance, and a sense of one's self-worth became her personal goals as well as cornerstones of her thoughts on education and the reconstitution of society for the realization of every individual's potential.

In Troitskoe, the Holy Trinity Church has been rebuilt, and in it, Dashkova's gravesite has been restored. She did not write her own epitaph and most memorials to her list only her major professional accomplishments: Lady-in-Waiting to Catherine II, Cavalier of the Order of St. Catherine, Director of the Imperial Academy of Sciences, President of the Russian Academy, member of the Royal Irish and Stockholm Academies, the Berlin Society of Naturalists, and the St. Petersburg Economic and Philadelphia (American) Philosophical Societies. But Dashkova wanted to be remembered differently, and in the final paragraph of her *Memoirs,* guardedly and with the awareness of one who has suffered, she wrote,

> In conclusion, I may truly say that I have done all the good it has been in my power to do; that I have never done any harm to anybody; that oblivion and contempt have been my only revenge for the injustice, the

intrigues, and the slander of which I have been victim; that I have done my duty as well as I have been able to perceive and understand it; that my heart was honest and my intentions pure and I was able to bear with bitter sorrows that to which, but for the comfort of my own conscience, my excessive sensibility would have made me succumb; and lastly, that I contemplate the approach of my own dissolution without fear or apprehension (281).

Notes

INTRODUCTION

1. Pennington, *Letters from Mrs. Elizabeth Carter*, 88–89.
2. See Dvoichenko-Markoff, "Benjamin Franklin," 250–57.
3. Fitzlyon, trans., *Memoirs*, 228, hereafter cited in text. Citations from Dashkova's *Memoirs* refer to the Fitzlyon edition; page numbers are noted parenthetically. Fitzlyon's translation has been compared to the French language edition, Woronzoff-Dashkoff, *Mon histoire*. Unless otherwise specified, all other translations are my own.
4. Oberg, *The Papers of Benjamin Franklin*, Vol. 34, 347.
5. Mordovtsev, *Russkie zhenshchiny*, 157.
6. Cited by Cross, "Contemporary British Responses," 46; and *By the Banks of the Thames*, 237.
7. Cited by Lentin, "Princess Dashkova," 826.
8. Masson, *Secret Memoirs*, 281.
9. Grot, *Sochineniia Derzhavina* 2nd ed., 1: 155.
10. Grot, *Sochineniia Derzhavina*, 2nd ed., 6: 654.
11. "Sei lik: I baba i muzhik." Grot, *Sochineniia Derzhavina*, 2nd ed., 3: 270–71. Both poems refer to the portrait on the frontispiece.
12. Herzen, "Kniaginia E. R. Dashkova." In *Polnoe sobranie sochinenii*, 361–62.
13. Ogarkov, *E. R. Dashkova, Biogrficheski ocherk*, 11–12.
14. Dobroliubov, "Sobesednik liubitelei rossiiskogo slova." In Bursov, *Sobranie sochinenii*, 221–22.
15. See AKV, vols. 5, 12, 21, 24, et passim.
16. Bradford, *Memoirs of the Princess Daschkaw*, 1: xxxv.
17. Heldt, *Terrible Perfection*, 64–70. For an overview of recent works see Rosslyn, "Women in Russia," in Rosslyn, ed., *Women and Gender*, 12–17.
18. Hyde, *Empress Catherine and Princess Dashkova*, 261.
19. Wilmot, *Russian Journals*, 211.
20. See Illustrations 1 and 2.
21. Ibid., 211.
22. Woronzoff-Dashkoff, "Disguise and Gender," 61–74.

CHAPTER ONE: *Education and Enlightenment*

1. AKV, 5: 159; RGADA, f. 1261, op. 1, No. 3100.
2. Limonov, *Rossiia XVIII v. glazami inostrantsev*, 329.
3. They may be a result of misunderstandings with the Wilmot sisters during the composition of her *Memoirs*. When Martha Wilmot arrived in Russia she was not yet thirty, while Dashkova had just celebrated her sixtieth birthday. The age disparity between the two woman and the psychological effects of turning sixty may have contributed to Dashkova's "forgotten" year.
4. The family genealogy ("Rodoslovie Gg. Grafov Vorontsovykh," 1808), an unpublished manuscript prepared during Dashkova's lifetime, traces the family's origins to Simon Afrikaner. The kinship with Haakon I of Norway is a later, unsubstantiated interpretation. It is possible that Simon (Simon Afrikisson or Africanus) was the son of Afreki Erikson and nephew of King Haakon (Jakun). See the Kievan Rus Database, www.unc.edu/~smyre/rus/Shimon_Afrekisson.html.
5. In the nineteenth century, P. V. Dolgorukov in his *Rossiiskaia rodoslovnaia kniga* challenged the link between the sixteenth-century Vorontsovs and those who emerged a hundred years later. The Vorontsov family charged Dolgorukov with blackmail and a French court found him guilty of libel. The genealogical issues, however, were not resolved. See Alekseev, *Grafy Vorontsovy*, 5-13.
6. Cruse and Hoogenboom, *The Memoirs of Catherine the Great*, 188, 208.
7. By way of contrast, the young Natalia Dolgorukaia, daughter of B. P. Sheremetev, followed her husband, Ivan Dolgorukii, to Siberia. After his execution, she returned, joined a convent, and wrote her spiritual autobiography, the first modern autobiography written by a Russian woman.
8. Her paternal grandmother died three years before Dashkova's birth in 1740 and her grandfather, I. G. Vorontsov, died in 1750 when she was seven.
9. In his autobiographical sketch, Aleksandr wrote that Dashkova was seven when she went to live with her uncle (AKV, 5: 11-14).
10. The palace later housed the Corps des Pages and is currently the Suvorov Military Academy, 26 Sadovaia Street.
11. Rice, *Elizabeth: Empress of Russia*, 154.
12. Raeff, *Origins of the Russian Intelligentsia*, 122.
13. AKV, 5: 10-11; Martha and Catherine Wilmot, *The Russian Journals*, 158-59; Anthony, *Memoirs of Catherine the Great*, 284.
14. Alekseev, *Grafy Vorontsovy*, 41.
15. AAE, "Russie," (Paris) 68: 47.
16. Shcherbatov, *On the Corruption of Morals*, 248, 249.
17. Alekseev, *Grafy Vorontsovy*, 54-56.
18. Cruse and Hoogenboom, *The Memoirs of Catherine the Great*, 168.
19. SPFIRI RAN, f. 36, op, 1. d. 1069, l. 22, 72. Letter, Oct. 22, 1760.
20. Rontsov (also Rantsov) was Roman's surname with the first syllable suppressed,

according to the traditional abbreviation of the time for illegitimate offspring, so that Vorontsov became Rontsov, Trubetskoi—Betskoi, and Repnin—Pnin.
21. Cruse and Hoogenboom, *Memoirs of Catherine the Great*, 82.
22. Lotman, *Poetics of Everyday Behavior*, 69-70.
23. Kamenskii, *Pod seniiu Ekateriny*, 92.
24. The chapel was transformed into a library and the crucifix removed, but the angels always remained. In recent years the chapel has been restored.
25. Likhacheva, *Materialy dlia istorii*, 1: 70.
26. Dashkova paid the sum of 222 rubles, 22 kopeks for her sister's books. Pekarskii, *Istoriia Imperatorskoi* 2: LV, note 2.
27. MDB, 118-25.
28. AKV, 16:68 and 32: 102-103.
29. Fitzlyon, *Memoirs of Princess Dashkova*, 332.
30. Maria's son Dmitri, after the early death of his mother, was brought up and educated in the house of his uncle, Aleksandr Vorontsov. A man of great learning and a well-known bibliophile, he was Director of the Imperial Hermitage.
31. Dobroliubov, "Sobesednik," 222.
32. Lotman, *Poetics of Everyday Behavior*, 75-76.
33. He was the nephew of the famous Dutch chemist Hermann Boerhaave, whose name he added to his own.
34. Fans were forms of communication at court, giving rise to an established, secret language. In deference to the empress, a closed fan represented a person's silence.
35. Kornilovich-Zubasheva, "Kniaginia E. R. Daskova," in *Sbornik statei*, 358.
36. Alexander, *Catherine the Great*, 65.
37. Maroger, *The Memoirs of Catherine the Great*, 369.
38. Ibid., 358; Pyliaev, Staryi Peterburg, 203-04.
39. Malinovskii, "Zhizneopisanie kniagini E. R. Dashovoi" in Dolgova, *Kniaginia E. R. Dashkova*, 169. Malinovskii's wife Anna Islen'eva was Dashkova's ward, and he often based his biographical sketch on her observations and conversations with Dashkova. Seemingly, because it is a product of oral history, there are many inaccuracies. Malinovsky was possibly the author of Dashkova's obituary in the *Messenger of Europe*. *Vestnik Evropy* 2 (1810): 149-51. Also, see Ia. K. Grot's unpublished manuscript, "Kniaginia Dashkova" (SPFA RAN, f. 137, op. 1, d. 13, l. 1-10).
40. See Woronzoff-Dashkoff, "E. R. Dashkova's Moscow Library," 60-71.
41. de Rulhière, *A History or Anecdotes*, 67. Translations from this volume have been compared to the original French edition and modified slightly.
42. Dashkova's copy of Helvétius, Hadrian, *De l'Esprit* is located in the Library of the Russian Academy of Sciences, St. Petersburg, 5154.f./2015.
43. A diplomat, writer, and man of learning, his son Dmitrii converted to Roman Catholicism, joined the Jesuits, and did missionary work among the Native Americans in Western Pennsylvania.

44. Longmire, "Princess Dashkova," 226.
45. Malinovskii's, "Zhizneopisanie kniagini E. R. Dashovoi" in Dolgova, *Kniaginia E. R. Dashkova*, 169.

CHAPTER TWO: *Conspiracy*

1. Herzen, "Kniaginia E. R. Dashkova," 373, 393.
2. MDB, 124.
3. Woronzoff-Dashkoff, "E. R. Dashkova's Moscow Library," 68.
4. Anthony, *Memoirs of Catherine the Great*, 284.
5. Bradford, *Memoirs of the Princess Daschkaw*, 2: 68-69.
6. Copies of Catherine's letters, written in French, are located in the BFP and were published in Woronzoff-Dashkoff, *Mon histoire*, 227-254. The English-language versions presented in this study are based on the Wilmot (Bradford) translation and have been checked against the originals.
7. Dashkova, Nadpis', 14. A French translation can be found in RIA 12 L 25. On August 21, 1762, from St. Petersburg, Mikhail Vorontsov sent Aleksandr another French translation of Dashkova's poem (AKV, 31: 183).
8. A. V. Khrapovitskii, *Pamiatnye zapiski*, 187.
9. Bradford, *Memoirs of the Princess Daschkaw*, 2: 65.
10. AKV, 5: 157-58.
11. Rulhière writes that Dashkova met her future husband and told Mikhail Vorontsov, "Uncle, Prince Dashkov is now doing me the honor to propose marriage to me." Rulhière, *History*, 68.
12. AKV, 5: 16; Suvorin, *Kniaginia Katerina Romanovna Dashkova*, 20-21; See Thomas Newlin's translation of Dashkova's dowry in Bisha, *Russian Women*, 60-63.
13. Chechulin, *Zapiski kniagini Dashkovoi*, 319; Suvorin, *Kniaginia Katerina Romanovna Dashkova*, 20.
14. SPFIRI RAN, f. 36, op. 1, No. 1069.
15. AKV, 16: 4.
16. Ibid., 16: 35, 39.
17. Currently, the settlement of Martyshkino, Dachnoe Street.
18. For more on theatricality in the *Memoirs* see Levitt, "Virtue Must Advertise" in Prince, *The Princess and the Patriot*, 39-56.
19. Castéra, *The Life of Catherine II*, 330. On most points, Dashkova disagreed with Castéra. See Kornilovich-Zubasheva, "Kniaginia E. R. Daskova za chteniem," 355-70.
20. Davidson, *Voltaire in Exile*, 7.
21. Bradford, *Memoirs of the Princess Daschkaw*, 2: 64, 79, 81.
22. Concerning the possibility of an erotic attachment between Dashkova and Catherine, as well as eighteenth-century notions of sexuality, see Gheith's introduction to Dashkova, *The Memoirs of Princess Dashkov* (1995), 8-13.
23. Smagina, *O smysle slova "Vospitanie,"* 262.
24. Anthony, *Memoirs of Catherine the Great*, 263.

25. Maroger, *Memoirs of Catherine the Great*, 342. Letter to Poniatowski dated Aug. 2, 1762.
26. Shcherbatov, *On the Corruption of Morals*, 232, 233.
27. Anthony, *Memoirs of Catherine the Great*, 274.
28. Cited by Ransel, *The Politics of Catherinian Russia*, 62.
29. Anthony, *Memoirs of Catherine the Great*, 288.
30. Ibid., 290.
31. AKV, 5: 13, 21–22.
32. Ibid., 5: 21.
33. Nikolai Trubetskoi, field-marshal and friend of the poet Antiokh Kantemir, was actually in his early sixties. His second wife, the widow Anna Kheraskova, was the mother of the poet M. M. Kheraskov.
34. Letter to Grigorii Orlov, July 11,1763, RS 11 (1874): 487.
35. Anthony, *Memoirs of Catherine the Great*, 283–84.
36. Kamenskii, *Pod seniiu Ekateriny*, 153.
37. Catherine considered Montesquieu's *De L'Esprit des Lois* (1748) to be "the prayer-book of monarchs with common sense." Although she modified many of Montesquieu's ideas, 294 of the 526 articles in Part I of Catherine's *Instruction*, were from *L'Esprit des Lois*. See de Madariaga, *Russia in the Age of Catherine the Great*, 152–55, 158–59.
38. SIRIO, 12: 202.
39. Rulhière and Casanova, who in 1765–1766 was in Russia and visited Dashkova, repeated these rumors. RS 9 (1874): 540. In his commentary, Casanova was also highly irritated by the role women were playing in Russia.
40. AKV, 34: 333–52.
41. Cross, "Contemporary British Responses," 43.
42. AKV, 31: 260, 272. Dec. 8, 1763, and Mar. 9, 1764.
43. AAE, 70: 20.

CHAPTER THREE: *The Coup*

1. What remained of Roman Vorontsov's house stood in ruins for many years and today is a church at 186a Prospekt Statchek.
2. Bradford, *Memoirs of the Princess Daschkaw*, 2: 79–80.
3. SIRIO, 12: 7. July 1/12, 1762.
4. "Iz pis'ma," 185–91. The short account provides an interesting comparison to the *Memoirs*, written some forty years later. It is possible that Dashkova referred to a copy of this letter when composing her autobiography, for with minor exceptions the two descriptions of the coup, though much more succinctly stated in the letter, are identical.
5. Rulhière also states that Dashkova had the carriage prepared and for two days kept it in constant readiness (Rulhière, *History*, 97).
6. He seemed to contradict himself later when he added that Shkurina sent the carriage. "Rasskaz N. I. Panina o votsarenii Ekateriny Velikoi: Iz zapisok bar-

ona Asseburga," RA 1 (1879): 364-65. Panin's "Mémoiree sur le detrônement de Pierre III" was preserved in the papers of Baron von Asseburg. See Suvorin, *Kniaginia Katerina Romanovna Dashkova*, 63, 161 and Bil'basov, *Istoriia Ekateriny vtoroi*, 467ff.

7. "Rasskaz N. I. Panina," RA 1 (1879): 365-66.
8. Riabinin, "Biografiia grafa Semena Romanovicha Vorontsova," 64.
9. In 1727, possibly as a joke, Aleksandr Menshikov became the only man to receive the order.
10. "Ish babe vsdumalos' nariadit'sia shutixoi, da davai ei eshcho i shliapu, a sam stoi s otkrytoi golovoi!" Buturlin, "Kniaginia E. R. Dashkova," 575.
11. See illustration 15. In the portrait, Dashkova is dressed in the colonel's uniform of her husband's Cuirassier regiment.
12. Simon's actions during the coup recall those of Pushkin's Dubrovskii. Pushkin may have had him in mind, since Dashkova too was mentioned in an earlier draft of the work.
13. His unbending attitude would lead to a duel with Count Schtakelberg, where he was wounded and almost killed his opponent. AKV, 32: 153.
14. Currently, 103 prospekt Statchek.
15. Anthony, *Memoirs of Catherine the Great*, 274.
16. Herzen, "Kniaginia E. R. Dashkova," 394.
17. Mel'gunova, *Russkii byt*, 37, 48.
18. Ibid., 54.
19. Bradford, *Memoirs of the Princess Daschkaw*, 2: 188.
20. AKV, 7: 653-55. Dashkova recorded her principal objections and commentary on Rulhière's *Histoires ou Anecdotes sur la révolution de Russie, en l'an 1762*, which she pronounced to be a worthless book. Her critical response to Rulhière's work represents an important supplement to the views she expressed in her memoirs.
21. Hyde, *Empress Catherine and Princess Dashkova*, 83.
22. Barsukov, "Kniaz' Grigorii Grigor'evich Orlov," 139.
23. For a comparison of the two manuscripts see Woronzoff-Dashkoff, "Additions and Notes," 15-21.
24. AKV, 5: 105-06.
25. Riabinin, "Biografiia grafa Semena," 65.
26. AKV, 5: 103-104; 31: 170.
27. Ibid., 5: 175-76, 177-78, 181.
28. Alekseev, *Grafy Vorontsovy*, 255-56.
29. SIRIO, 12: 23.
30. Ibid., 7: 49.
31. Karabanov, "Stats-damy i freiliny ruskogo dvora v XVIII stoletii," RS 2 (1870): 495.
32. Alekseev, *Grafy Vorontsovy*, 31.
33. Bantysh-Kamenskii, "Dashkova," 183-84.
34. AKV, 31: 191, 193, 220.

35. SIRIO, 18: 461. July 12, 1762. He was later to become Maria Antoinette's chief adviser at Versailles, even selecting her trousseau.
36. Rulhière, *History*, 155.
37. AKV, 7: 654.
38. Ibid., 5: 118.
39. Ibid., 5: 159-60. Aug. 6/17, 1762.
40. Ibid., 5: 160-62. Aug. 30/Sept. 10, 1762.
41. Ibid., 31: 191. Aug. 24, 1762.
42. Ibid., 29: 171-72. Oct. 22/Nov. 2, 1762.
43. Ibid., 5: 164. Oct. 1762.
44. Ibid., 31: 193. Dec. 2, 1762.
45. Ibid., 5: 167. Dec. 9, 1762.
46. Ibid., 5: 168-70. Mar. 13, 1763.
47. Ibid., 5: 170-73. April 17/28, 1763.
48. Ibid., 31: 220. May 22, 1763.
49. Ibid., 5: 173. Oct. 19, 1763.
50. *Sanktpeterbourgskie vodomsti*, No. 64, Friday, Aug. 9, 1762. See "Pervye posobniki Ekateriny II," RA 2 (1864): 201 and SIRIO, 7: 110.
51. Iukhta, *Ekaterina II i ee okruzhenie*, 123.
52. Safonov, "Ekaterina Malaia i ee Zapiski," 20.
53. Ransel's, *The Politics of Catherinian Russia*, 1, et passim. Ransel discusses at length the central role in eighteenth-century Russia of powerful families generally and the Panin faction specifically.
54. Ibid., 106-11.
55. Before Paul I could destroy the letter, Fedor Rostopchin had time to make a copy and send it to Simon Vorontsov. Thereby, the only remaining version was preserved in AKV, 21: 430.
56. Bradford, *Memoirs of the Princess Daschkaw*, 2: 179.

CHAPTER FOUR: *Banishment*

1. Wilmot, *Russian Journals*, 359.
2. SIRIO, 18: 461. July 13, 1762.
3. Mavor, *Grand Tours of Katherine Wilmot*, 122.
4. Sukhomlinov, "Kniaginia E. R. Dashkova," 38.
5. Gillel'son, "Pushkin i *Zapiski* Dashkovoi," 141-42.
6. Turgenev, *Rossiiskii dvor* 424; AAE, 71: 101-02. Oct. 28, 1762.
7. Ibid., 71: 78. Oct. 12, 1762.
8. Herzen, "Kniaginia E. R. Dashkova," 393.
9. AAE, 70: 352. Sept. 13, 1762.
10. Anthony, *Memoirs of Catherine the Great*, 318; Veselaia, *Put' k tronu*, 314-15.
11. Anthony, *Memoirs of Catherine the Great*, 274.
12. Bradford, *Memoirs of the Princess Daschkaw*, 2: 148-49.
13. MDB, 118-25.

14. Bradford, *Memoirs of the Princess Daschkaw*, 2: 149.
15. Ogarkov, *E. R. Dashkova*, 38.
16. Cross, "Contemporary British Responses," 42.
17. Gillel'son, "Pushkin i *Zapiski* Dashkovoi," 141.
18. Bradford, *Memoirs of the Princess Daschkaw*, 2: 78.
19. Lotman, *Besedy*, 33.
20. "Vospominania I. M. Snegireva," 537; BERD, 75.
21. Tychinina, *Velikaia Rossianka*, 117.
22. AKV, 5: 163. For more on Dashkova as lady-in-waiting, see Karabanov, "Statsdamy i freiliny," 493-95.
23. Rulhière, *History*, 79.
24. Hyde, *Empress Catherine and Princess Dashkova*, 87.
25. Turgenev, *Rossiiski dvor*, 239; Ilovaiskii, "Ekaterina Romanova Dashkova," 287.
26. SIRIO, 7: 291, 294. Shest' zapisok Ekateriny II po delu F. Khitrovo.
27. Kornilovich-Zubasheva, "Kniaginia E. R. Dashkova za chteniem," 359-60.
28. SIRIO, 22: 67. June 7/18, 1763.
29. SIRIO, 12: 113. June 28, 1763.
30. SIRIO, 22: 101. July 29/Aug. 9, 1763.
31. Niv'er, "E. R. Dashkova," 43.
32. Dashkova, trans., "Iz opyta," *Nevinnoe uprazhnenie*, 1763, Jan. 13-21; Feb. 51-56; Mar. 99-111; Apr. 143-155. See Kucherenko, "Sochinenie Gel'vetsiia *Ob Ume*," 215-27.
33. Afanas'ev, "Literaturnye trudy," 183.
34. Dashkova, trans., "Iz opyta," 55-56.
35. The Latin, French, and Russian versions are compared by Sukhomlinov, *Kniaginia E. R. Dashkova*, 23-24, n. 26, 367-69.
36. SIRIO, 12: 154. Dec. 9, 1763.
37. Currently, 40 Moika Embankment; the house became the celebrated "Demoutov traktir," frequented by Pushkin, Chaadaev, Griboedov, and many other famous guests.
38. AKV, 7: 653. Kornilovich-Zubasheva, "Kniaginia E. R. Dashkova za chteniem," 366.
39. SIRIO, 51: 183, 498, et passim.
40. Cross, "Contemporary British Responses," 43. Also, see Turgenev, *Rossiiskii dvor*, 242-43.
41. Lozinskaia, *Vo glave dvukh akademii*, 35.
42. SIRIO, 12: 200. Mar. 1/12 1765.
43. Tychinina, *Velikaia Rossianka*, 118.
44. AKV, 5: 175-78.
45. AKV, 16: 78. Petr Bartenev identified the individual as Nikita Panin.
46. MDB, 118-25.
47. Ogarkov, *E. R. Dashkova*, 43.
48. Khrapovitskii, *Pamiatnye zapiski*, 268.

49. Buturlin, "Ocherk," 376-86.
50. SIRIO, 12: 202. Mar. 18/29, 1765.
51. SIRIO, 12: 199. Mar. 1/12 1765.
52. Eliseeva, *Vel'mozhnaia Moskva*, 54-55.
53. It seems that Anastasia actually sold the house to her granddaughter's husband, Fedor Glebov (GIM OPI, f. 47, ed. khr. 257, l. 17). Also, see E. I. Firsova, "Posle ssylki: E. R. Dashkova v Moskve i Troitskom v 1797-1801 gg." in Tychinina, *E. R. Dashkova i A. S. Pushkin v istorii Rossii*, 70.
54. The house burned during the French occupation of 1812; rebuilt and later greatly expanded, little of the original structure has been preserved. Currently, it is the Moscow Conservatory at 13 Nikitskaia Street.
55. AKV, 17: 519.
56. Bradford, Memoirs of the Princess Daschkaw, 2: 183.
57. AKV, 12: 324-25. Feb. 24, 1767.
58. AKV, 32: 97-99.
59. AKV, 24: 130.
60. Pushkareva, *Chastnaia zhizn' russkoi zhenshchiny*, 191-98.
61. Wilmot, *Russian Journals*, 349.
62. SIRIO, 12: 322. Nov. 4/15, 1767.

CHAPTER FIVE: *First Journey Abroad*

1. AKV, 24: 132-33.
2. Cross, "Poezdka kniagini E. R. Dashkovoi," 224.
3. Ibid., 224; Aleksandrenko, *Russkie dipolomaticheskie agenty*, 2: 133, n. 2.
4. Cross, "Contemporary British Responses," 46.
5. Mavor, *Grand Tours of Katherine Wilmot*, 95; Cross, "High Road and the Low," 117.
6. "Puteshestvie odnoi rossiiskoi znatnoi gospozhi," Dashkova, 105-44; Cross, "Poezdka kniagini E. R. Dashkovoi," 224. See also Cross, "*By the Banks of the Thames*," 238, and Dickinson, "The Russian Tour of Europe," 15-20.
7. Their son, Sydney Herbert, was British War Secretary during the Crimean War and directed the war effort in an area of Russia developed by his uncle, Mikhail Vorontsov.
8. Anthony Cross, "'A Red Hot English Woman': Princess Dashkova's Love Affair with Britain." In Prince, *The Princess and the Patriot*, 91.
9. Cross, "*By the Banks of the Thames*," 83.
10. Ibid., 237; "Poezdka kniagini E. R. Dashkovoi," 225.
11. Dashkova, "Puteshestvie odnoi rossiiskoi znatnoi gospozhi," 106.
12. Cited by Hyde, *Empress Catherine and Princess Dashkova*, 107.
13. Mavor, *Grand Tours of Katherine Wilmot*, 146.
14. Mohrenschildt, *Russia in the Intellectual Life*, 39, 65.
15. Rulhière, *History*, 198-99.
16. Bradford, *Memoirs of the Princess Daschkaw*, 2: 183.

17. Ibid., 2: 182.
18. Ibid., 2: 186.
19. Ibid., 2: 182.
20. Ibid., 2: 177.
21. See Bartlett, "Defenses of Serfdom," 67–74 and Michelle Lamarche Marrese, "Liberty Postponed: Princess Dashkova and the Defense of Serfdom," in Prince, *The Princess and the Patriot*, 23–38.
22. Kamenskii, *Pod seniiu Ekateriny*, 261.
23. AKV, 5: 191–93.
24. Veselaia, "Poslanie kniagini E. R. Dashkovoi," 113–24.
25. Semevskii, "Kniaginia Ekaterina Romanovna Dashkova, 417–20.
26. AKV, 21: 420.
27. Marrese, *A Woman's Kingdom*, 194.
28. Maroger, *Memoirs of Catherine the Great*, 337.
29. Anthony, *Memoirs of Catherine the Great*, 292–93.
30. Tishkin, "E. R. Dashkova i uchebnaia deiatel'nost' v Peterburgskoi Akademii Nauk," 190–207.
31. Bradford, *Memoirs of the Princess Daschkaw*, 2: 163.
32. Gillel'son, "Pushkin i *Zapiski* Dashkovoi," 144.
33. Bradford, *Memoirs of the Princess Daschkaw*, 2: 193.
34. Ibid., 2: 194.
35. Reddaway, *Documents of Catherine the Great*, 108. Letter dated May 15, 1771.
36. SIRIO, 13: 122.
37. Voltaire, *Oeuvre complète*, 47: 458–59. Cited by Niv'er, "E. R. Dashkova i frantsuzskie filosofy," 50.
38. AKV, 5: 180–81.
39. Ibid., 5: 178–80.
40. RGADA, f. 285, op. 1, d. 423, l. 114.
41. RGIA, f. 1329, op. 2, d. 31, l. 106 ob.
42. AKV, 29: 203.
43. Ibid., 12: 366–67.
44. RGIA, f. 468, op. 1, d. 3886, l. 200, 202, 168 ob., 121.
45. Ransel, *The Politics of Catherinian Russia*, 242.
46. M. A. Fonvizin, *Sochineniia i pis'ma*: 2: 127–29; "Zapiski M. A. Fonvizina," 62; Lozinskaia, *Vo glave dvukh akademii*, 56–57.
47. Eliseeva, *Vel'mozhnaia Moskva*, 52–59.
48. AKV, 5: 183.
49. Bradford, *Memoirs of the Princess Daschkaw*, 2: 167, 166.
50. Chaikovskaia, "*Kak liubopytnyi skif . . .*," 63.
51. Dashkova, "Pis'mo k drugu," 78–80.
52. Ibid., 2 (1775): 105–44.
53. Ibid., 2 (1775): 106.
54. AKK, 7: 276–81. Letters dated Mar. 3 and 17, 1774.

55. Dashkova, "Obshchestvo dolzhno delat' blagopoluchie svoikh chlenov," 80-84; "O soobshchestvennom uslovii," 85-86; "Opyt o torge," 87-112.
56. Ibid., 1 (1774): 91-93.
57. Ibid., 1 (1774): 102.

CHAPTER SIX: *Second Journey Abroad*

1. Pictorial representations are inconclusive, and in Skorodumov's 1770 engraving of Dashkova and her children, Anastasia sits at the piano, partially concealed by her standing brother.
2. AKK, 7: 294. Letter dated May 5, 1774. See also A. Kurakin's and N. A. Repnin's letters, 310-11.
3. Ibid., 460.
4. The original French is clearer: Anastasia Scherbinina [the daughter] was afflicted by '*un défaut dans la construction de son corps*' — a physical problem and not, as Fitzlyon would have it, a "sexual inadequacy," 328.
5. His sister Elena was the mother of Denis Davydov, the famous hussar and poet.
6. Ilovaiskii, *E. R. Dashkova*, 354.
7. Dolgorukova, "Cherty is zhizni," 573.
8. RGADA, f. 1261, op. 3, d. 2764, l.1-2. Letter dated Jan. 26, 1777.
9. Cross, *By the Banks*, 132.
10. Cross, "Poezdka kniagini," 229 and "Contemporary British Responses," 50.
11. Summerfield and Devine, *International Dictionary*, 492.
12. Spa, Aug. 30; London, Oct. 9 and Nov. 10, 1776. National Library of Scotland, Ms. 3942, ff. 269-270, 281-282, 287. Smagina, *O smysle slova*, 228-41; Bradford, *Memoirs of the Princess Daschkaw*, 2: 117-22.
13. Bradford, *Memoirs of the Princess Daschkaw*, 2: 120-21.
14. Ibid., 121.
15. N. Vasil'kov, "Vospitanie E. R. Dashkovoi i ee vzgliad na vospitanie," *Vestnik vospitaniia* 1 (1894): 60.
16. Ilovaiski, *E. R. Dashkova*, 319.
17. Cited by Longmire, "Princess Dashkova," 64.
18. While the trip is mentioned in the St. Petersburg version of her autobiography, it is absent from the British Museum copy and has never been appended to any editions of the *Memoirs*. Originally addressed to Elizabeth Morgan, Martha Wilmot made a copy in 1804 before she left Russia. All existing copies have been lost with the exception of M. H. Hyde's typescript, which A. G. Cross published along with a Russian translation. See Cross, "Poezdka kniagini," 223-268 and Hyde, *The Empress Catherine and Princess Dashkova*, 140-47.
19. Cross, "Poezdka kniagini," 230.
20. Ibid., 244.
21. Ibid., 241.

22. Monter, "The Public and Private Lives," 12.
23. Cross, "Contemporary British Responses," 50.
24. Bradford, *Memoirs of the Princess Daschkaw*, 2: 136.
25. MDB, 102–08; Bradford, *Memoirs of the Princess Daschkaw*, 2: 122–31.
26. Bradford, *Memoirs of the Princess Daschkaw*, 2: 126.
27. Ibid., 130.
28. *Dublin Historical Record*, 17.
29. Bradford, *Memoirs of the Princess Daschkaw*, 2: 143.
30. Bradford, *Memoirs of the Princess Daschkaw*, 2: 136.
31. MDB, 113; Bradford, *Memoirs of the Princess Daschkaw*, 2: 141.
32. Cross, "Paul Sandby and the Dashkovs," 37–44.
33. Cross, "A Russian in the Gordon Riots," 29–36. According to some sources, Ivan, who was Roman Vorontsov's youngest illegitimate son, had also been a strong contender for the position of Catherine's lover. Alekseev, *Grafy Vorontsovy*, 259.
34. "Pis'ma kniagini E. R. Dashkovoi," 156.
35. John Sinclair, who visited St. Petersburg and met with Dashkova, considered her power at court to be second only to Potemkin's and repeated the rumors that Pavel Dashkov had been groomed to be Catherine's lover (*General Observations Regarding the Present State of the British Empire*. London, 1781, 34–35). Cited by Cross, "British Responses," 55–59.
36. Currently, rue des Francs-Bourgeois.
37. SIRIO, 23: 218; "Novootkrytye pis'ma Imperatritsy Ekateriny Vtoroi k baronu Grimmu 1777–1786 gody," RA 9 (1878): 70.
38. AKV, 7: 653–55. Many historians do not agree with her evaluation of the work: "Although the memoirs of C. C. Rulhière contain many inaccuracies, they bear witness to the author's great knowledge" (Kamenskii, *Pod seniiu Ekateriny*, 58).
39. "Pis'ma kniagini E. R. Dashkovoi k kniaziu A.B. Kurakinu," RA 2, no. 5 (1912): 462–63.
40. Dashkova appended her description as a footnote to the *Memoirs*, but Fitzlyon placed it in the text proper (167–69).
41. Madariaga, *Russia in the Age*, 350.
42. Bradford, *Memoirs of the Princess Daschkaw*, 2: 83.
43. Cross, "Contemporary British Responses," 53.
44. Dolgova, *Kniaginia E. R. Dashkova*, 168.
45. Alexander, *Catherine the Great*, 248.
46. Dashkova's characterization of Peter as a "brutal and benighted tyrant" in the London copy of the *Memoirs* became the paradoxical "brilliant and benighted tyrant" in the St. Petersburg version. See A. Woronzoff-Dashkoff, "Afterword" in Fitzlyon, *The Memoirs of Princess Dashkov*, 287.
47. AKV, 12: 362.
48. Dolgorukova, "Cherty iz zhizni," 575.
49. Bradford, *Memoirs of the Princess Daschkaw*, 2: 194.
50. SIRIO, 42: 216.

51. Tiebo., "Zapiski," 478.
52. Bradford, *Memoirs of the Princess Daschkaw*, 2: 195.
53. AKV, 12: 326-27.

CHAPTER SEVEN: *The Academy of Sciences*

1. During the War of 1812, when Prince Peter Bagration lost Mogilev, Dashkovo, a village near Krugloe, saw the engagement of the Russian army with the French forces. After Dashkova's death, her nephew Mikhail Vorontsov sold the estate.
2. Currently 76 Moika Embankment.
3. RGIA, f. 468, op. 1, d. 3897, l. 172. Dimitri Buturlin wrote his uncle Aleksander from Moscow on July 12, 1782, that the empress granted Dashkova 2,500 serfs in Krugloe and 30,000 rubles (AKV, 32: 213). More precisely, it seems likely that she recieved approximately 2,577 serfs and 35,000 rubles (AKV, 24: 140).
4. Currently, house 16.
5. "Na byvshago," 2032-36.
6. Veselovskii, "Bor'ba akademikov," 457-92.
7. Nevskaia, *Letopis'*, 693. Tychinina, *Velikaia Rossianka*, 131.
8. Zaitseva, "E. R. Dashkova i knizhnaia torgovlia," 112.
9. Dolgorukova, "Cherty iz zhizni," 573.
10. RIA, 12 L 34, 207.
11. RGIA, f. 1329, op. 1, d. 153, l. 128. Copy of Ukaz No. 1066, on the appointment of Dashkova as director in Nova, 4.
12. According to Michael D. Gordin, "She ran the Academy like a business, and ran it well." "Ardous and Delicate Task: Princess Dashkova, the Academy of Sciences, and the Taming of Natural Philosophy," in Prince, *The Princess and the Patriot*, 13.
13. *Protokoly*, 3: 648-49.
14. Nova, 6.
15. Ibid., 7; Protocoly, 3: 648.
16. SPFA RAN, f. 1, op, 3 d. 67, l. 64-66 ob., and f. 21, op. 3, d. 306, l. 1; Letters dated Mar. 3, 1783, and Mar. 6, 1783.
17. PSZ, No. 15646, 21: 800-01.
18. RGADA, f. 17, op.1, d. 33, l. 108-109 ob., 125 ob.
19. RIA, 12 L 31, 174.
20. ChOIDR., otd. 5, 1 (1867): 26-28, 36-37, 40.
21. Ibid., 28.
22. PSZ, No. 15729, 21: 914.
23. ChOID, otd. 5, 1 (1867): 39-40.
24. RGIA, f. 1329, op. 1, d. 153, l. 128.
25. SPFA RAN, f. 3, op 1, d. 556, l. 64.
26. Smagina, *O smysle slova "Vospitanie*," 425-426.
27. Zaitseva, "*E. R. Dashkova i knizhnaia torgovlia*," 116.

28. Semennikov, *Materialy dlia istorii*, 76. Letter to I. I. Shuvalov, November 2, 1783, concerning Novikov's debts to the Academy.
29. Ibid., 77. Letter dated Nov. 2, 1783.
30. SPFA RAN, f. 3, op. 3, d. 556, l. 165, ob. 166.
31. RGADA, f. 17, op. 1, d. 35, l. 3.
32. Khrapovitskii, *Pamiatnye zapiski*, 200-01.
33. SPFIRI RAN, f. 36, op. 1, d. 1230, l. 150.
34. Romm, "K istorii," 13-14.
35. Sukhomlinov, "Kniaginia E. R. Dashkova," 53.
36. Lozinskaia, *Vo glave dvukh akademii*, 76.
37. RGADA, f. 248, op. 80, d. 6514, l. 127-29.
38. ChOIDR, otd. 5, 1 (1867): 20-22.
39. RGADA, f. 17, d. 35, l. 142-43. "Report to Catherine II concerning pensions for the staff of the Academy of Sciences," February 1791.
40. PSZ, No. 16951, 23: 219.
41. Semenikov, *Materially dlia istorii*, 4-5.
42. Ibid., 20-21.
43. Ibid., 44-45, 52.
44. RGIA, f. 730, op. 1, d. 11, l. 1.
45. Sukhomlinov., "Kniaginia E. R. Dashkova," 37-38.
46. RGADA, f. 199, op. 421 (portfel' Millera), d. 1, l. 1, ob. 2.
47. Ibid., l. 9; Sukhomlinov, "Kniaginia E. R. Dashkova," 53.
48. RGADA, f. 199, op. 421 (portfel' Millera), d. 1, l. 1 ob.
49. Bradford, *Memoirs of the Princess Daschkaw*, 2: 196-97.
50. Dvoichenko-Markoff, "The American Philosophical Society," 558; Ozhigova, "E. R. Dashkova—direktor," 100-01.
51. Bolkhovitinov, *Beginnings of Russian-American Relations*, 117-31.
52. Smagina, *O smysle slova "Vospitanie,"* 64.
53. RGADA, f. 248, op. 80, d. 6514, l. 124-26.
54. SPFA RAN, f. 3, op. 9, d. 511, l. 4.
55. Tishkin, "'Ee Svetlost'," 90.
56. Ibid., 85.
57. Smagina, *O smysle slova "Vospitanie,"* 62.
58. Protokoly 3: 681.
59. RGIA, f. 17, op. 1, d. 35, l. 1l, 11 ob.
60. Ibid., l. 11 ob; SPFA RAN, f. 3, op. 1, d. 556, l. 215 ob.
61. Kotel'nikov, a specialist in mathematics and mechanics, had the dubious honor of becoming a prominent censor in 1797.
62. SPFA RAN, f. 3, op. 9 d. 488, l. 1 ob.
63. Ilovaiskii, *E. R. Dashkova*, 352.
64. Sukhomlinov, "Kniaginia E. R. Dashkova," 34-35.
65. SPFA RAN, f. 3, op. 1, d. 556, l. 153 ob.
66. PSZ, No. 15948, 22: 61.
67. ChOIDR, otd. 5, 1 (1867): 22-23.

68. Currently, 5 University Embankment.
69. Schubert, *Unter dem Doppeladler*, 390.
70. Bogoslovskii, *Kvarengi*, 44.
71. Ozhigova, "E. R. Dashkova—direktor," 94-102.
72. Sukhomlinov, "Kniaginia E. R. Dashkova," 35.
73. Ibid., 35; Kolominov and Fainshtein, *Khram muz slovesnykh*, 11.
74. "Raport Ekaterine II o sostoianii, v kotorom nakhodilas' Akademiia nauk, kogda ia vstupila v upravlenie eiu v 1783 g., i v kotorom ona nakhoditsia nyne v 1786 g.," AKV, 21: 389-402. See Artem'eva, *Filosofiia v Peterburgskoi Akademii*, 182.
75. "Raport Ekaterine II ob ekonomicheskom polozhenii Akademii nauk za 1783-1794 gg. 5 avgusta 1794 g.," SPFA RAN, f. 1, op. 2-1794. VIII. 14, No. 118, l. 6-7. See Ozhigova, "E. R. Dashkova—Direktor," *ERD*, 101-02.

CHAPTER EIGHT: *The Russian Academy*

1. RGADA, f. 14, op. 1, d. 255. l. 11, 11 ob.
2. Engel'gardt, *Zapiski*, 40.
3. PSZ, No.15839, 21: 1024-25.
4. Ibid., 1023-24.
5. Alexander, "Catherine the Great and the Foundation," 20-21.
6. Herzen, "Kniaginia E. R. Dashkova," 362.
7. Semennikov, *Sobranie staraiushcheesia o perevode*, 3.
8. PSZ, No. 15869, 21: 1045.
9. Kheraskov, "Ee siiatel'stvu," 19-22.
10. Kolominov and Fainshtein, *Khram muz slovesnykh*, 143-47.
11. Bradford, *Memoirs of the Princess Daschkaw*, 2: 144.
12. Ibid., 146.
13. Ibid., 147.
14. Sukhomlinov, "Kniaginia E. R. Dashkova," 49, 53.
15. Dashkova, "Rech," 87.
16. ChOIDR, otd. 5, 1 (1867): 41-42.
17. RGIA, f. 834, op. 4, d. 750, l. 55 ob. Located at 112 Fontanka Embankment.
18. PSZ, No. 15862, 21: 1041.
19. A. I. Krasovskii, *Pervyi period istorii Imperatorskoi Rossiiskoi Akademii, napisannyi v 1839 g.* (Saint Petersburg, 1849), 21. Cited by Tychinina, *Velikaia Rossianka*, 64.
20. Bogatova, "Dashkova i slovar' ee epokhi," 13.
21. Nekrasov, *Rossiiskaia Akademiia*, 5.
22. Sukhomlinov, "Kniaginia E. R. Dashkova," 43-46.
23. Ibid., 44-45.
24. AKV, 12: 366-67.
25. Dvoichenko-Markoff, "The American Philosophical Society," 559-61.
26. Pis'ma kniagini E. R. Dashkovoi k kniaziu Grigoriiu Aleksandrovichu Potemkinu, *Drevniia i novaia Rossiia* 2, no. 6 (1879): 152-59. She also includes a peti-

tion on behalf of her nephew, D. P. Buturlin, the son of her older sister. He was eventually appointed aide-de-camp to Potemkin and, as opposed to Pavel Dashkov, made a brilliant career for himself.

27. National Library of Scotland, Ms. 3942. ff. 265. Letter dated Aug. 6/17, 1786. Cited by Smagina, *O smysle slova "Vospitanie,"* 252.
28. Papmehl, *Freedom of Expression*, 86, n. 48; Christie, *Benthams in Russia*, 92.
29. "Novootkrytye pis'ma, 195 (see chapter 6, note 35).
30. Today, Kirianovo is a "Palace of Weddings" at 45 Prospekt Stachek.
31. Shubinskii, *Istoricheskie ocherki i rasskazy*, 658–59.
32. Semennikov, *Russkie satiricheskie zhurnaly*, 53.
33. Ibid., 53, 57.
34. Dobroliubov, "Sobesednik liubitelei rossiiskogo slova," 186.
35. Ibid., 244.
36. Dashkova, "Ot izdatelei," 160.
37. Papmehl, *Freedom of Expression*, 84, n. 42.
38. Semennikov, *Materialy dlia istorii*, 148.
39. "K gospodam izdateliam," *Sobesednik* 2 (1783): 11.
40. Kochetkova, "Dashkova i *Sobesednik*" 141–42.
41. Grot, *Sochineniia Derzhavina*, 2nd ed., 5: 357.
42. Ibid., 358.
43. Ibid., 364. Letter dated Nov. 25, 1783.
44. Grot, *Sochineniia Derzhavina*, 1st ed., 6: 625–26.
45. Ibid., 8: 624.

CHAPTER NINE: *A Woman of Letters*

1. Dobroliubov, "Sobesednik liubitelei rossiiskogo slova," 222–23.
2. Dashkova, "Poslanie k slovu 'tak'," 15–23.
3. Translated by Woronzoff-Dashkoff, "E. R. Dashkova (Essay, Bibliography, Translation)," 1: 35–40. Citations are noted parenthetically.
4. Dashkova, "Otvet ot slova 'tak'," 39–43, 43–45, 141–47.
5. Dashkova, "Sokrashchenie katekhizisa," 33–35.
6. "K gospodam izdateliam," *Sobesednik* 2 (1783): 8–11.
7. Kochetkova, "Dashkova i *Sobesednik*," 141.
8. Dashkova, "O smysle slova 'vospitanie'," 12–28.
9. Lotman, *Besedy*, 76–77.
10. Lotman, *Besedy*, 75–88; Nash, "Educating New Mothers: Women and the Enlightenment in Russia," *History of Education Quarterly* 21 (1981): 302.
11. RIA, 12 L 18.
12. Woronzoff-Dashkoff, "Princess E. R. Dashkova's Moscow Library," 60–71.
13. Smagina, *O smysle slova "Vospitanie,"* 219. Locke's *Some Thoughts Concerning Education* was also available to Dashkova in Russian since N. Popovskii translated it, in all likelihood at the behest of his mentor, M. V. Lomonosov: *O vopitanii detei*

g-na Lokka. Perevedeno s frants. na rossiiskii iazyk Imp. Moskovskogo un-ta professorom Nikolaem Popovskim (Moscow: Pechatano pri Imp. Moscovsk. un-te, 1759-1760).
14. Dashkova, "O smysle slova 'vospitanie,'" 21-22.
15. Smagina, *O smysle slova "Vospitanie,"* 233.
16. Novikov, *Opyt isstoricheskogo slovaria*, 5.
17. Dashkova, "Puteshestvuiushchie," 120-32.
18. "K godspodam izdateliam," *Sobesednik* 3 (1783): 8-11.
19. Ibid., 159-60.
20. Woronzoff-Dashkoff, "Disguise and Gender," 61-74.
21. Letter to Mrs. Clarke, Feb. 1685, in *The Educational Writings of John Locke: A Critical Edition*, ed. J. Axtell (Cambridge: England, 1968), 344-46.
22. Nash, "Educating Mothers," 303-05.
23. J. L. Black, "Educating Women in Eighteenth Century Russia: Myths and Realities," *Canadian Slavonic Papers* 20 (1975): 38, n. 57.
24. Korsakov, "Petr Alekseev, protoierei Moskovskogo Arkhangel'skogo sobora (1727-1801), RA 2, nos. 5-8 (1880): 175-76.
25. Dashkova, "Ob istinnom blagopoluchii," 24-34.
26. Ibid., 29.
27. Ibid., 29.
28. Ibid., 33.
29. Dashkova, "Pis'mo k izdateliam sikh sochinenii," 69.
30. Dashkova, "Kartiny moei rodni," 17-22 and 164-66.
31. Dashkova, "Moia zapisnaia knizhka," 19-41.
32. Ibid., 21-22.
33. Ibid., 36.
34. Ibid., 41.
35. Dashkova, "Otryvok zapisnoi knizhki," 12-19 and "Prodolzhenie otryvka zapisnoi knizhki," 3-6.
36. Ibid., 47 (May 1790): 17.
37. Ibid., 12.
38. Ibid., 18-19.
39. Ibid., 66 (Dec. 1791): 5.
40. Ibid., 3.
41. Ibid., 47 (May 1790): 13-14.
42. Dashkova, "Moia zapisnaia knizhka," 25-26.
43. Dashkova, "Nechto iz zapisnoi moei knizhki," 194-201.
44. Dashkova, "Zapiski tetushki," 61-80.
45. Ibid., 63.
46. "O smysle slova 'vospitanie," *Sobesednik* 2 (1783): 25; "Zapiski tetushki," *Novye ezhemesiachnye sochineniia* 1 (July 1786): 79; "Otryvok zapisnoi knizhki," *Novye ezhemesiachnye sochineniia* 47 (May 1790): 12.
47. Dashkova, "Pis'mo k izdateliam sikh sochinenii," 67-71.
48. Dashkova, "Pritcha: Otets i deti," 71-72.

49. Dashkova, "K gospodam izdateliam *Novykh ezhemesiachnykh sochinenii*," 3.
50. Ibid., 5.
51. Dashkova, "Otvet [Ioannu Priimkovu]," 21–24.
52. Dashkova, "K gosopodam izdateliam *Novykh ezhemesiachnye sochineniia*," 3–5.
53. Shein, "Pis'mo k izdateliam" *Novye ezhemesiachnykh sochinenii* 81 (March 1793): 15–16.
54. Dashkova, "K gospodam izdateliam *Ezhemesiachnykh sochinenii: Voprosyi*," 3–6.
55. Shein, "Pis'mo k izdateleiam." *Novye ezhemesiachnye sochineniia* 86 (Aug. 1793): 12–13. Afanas'ev ascribes to Dashkova two poems entitled "Thoughts of a Certain Russian Man Concerning Autocracy" ("Mnenie nekogo Rossiianina o edinonachalii," *Novye ezhemesiachnye sochineniia*, 80 [Feb. 1793]: 4–7) and "Rule of a Russian Man" ("Pravilo Rossiianina," *Novye ezhemesiachnye sochineniia* 81 [Mar. 1793]: 25–31), in which she rhetorically transforms herself from a patriotic Russian woman into a patriotic Russian man (Semennikov, *Materialy dlia istorii*, 37–38).
56. Dashkova, "Istiny," 2–7.
57. Ibid., 3.
58. Ibid., 4–5.
59. Bradford, *Memoirs of the Princess Daschkaw*, 2: 237.
60. Vers de la P. de Daschkaw sur L'Existence de Dieu (RIA 12 L 25) and "Chetyrestishie," 144. In a letter to the editors, she states that this quatrain was composed about thirty years earlier (149).
61. Bradford, *Memoirs of the Princess Daschkaw*, 238.
62. Ibid., 238–39.
63. Kochetkova, "Dashkova i *Sobesednik*," 143.
64. Grot, "O *Felitse* i *Sobesednike*," *Sovremmenik* 11 (1845). Cited by Afanas'ev, "Literaturnye trudy kniagini E. R. Dashkovoi," 196.
65. Kochetkova, "Dashkova i *Sobesednik*," 143–46.
66. Glinka, *Russkoe chtenie* 2 (1845): 36–37.
67. Kochetkova, "Dashkova i *Sobesednik*," 142.
68. Dashkova, "Iskrennee sozhalenie," 165.
69. Kochetkova, "Dashkova i *Sobesednik*," 143.
70. Glinka, *Russkoe chtenie*, 14.
71. Grot, "Kniaginia Dashkova," SPFA RAN, f. 137, op. 1, d. 13, l. 8.
72. Kochetkova, "Dashkova i *Sobesednik*," 145.
73. Bradford, *Memoirs of the Princess Daschkaw*, 2: 89.
74. Grot, *Sochineniia Derzhvina*, 1st ed., 9: 235–36.
75. Dashkova, "Iskrennee sozhalenie," 148–54.
76. Dashkova, "K gospodinu sochiniteliu," 156–61.
77. Catherine II, "Kratkodlynni otvet," 147–51.
78. Rumiantsev, "Petr Velikii," 164–77.
79. Catherine II, "Otvet," 179–80.
80. "Proshenie," 26–33; "Avtobiographiia grafa S. P. Rumiantseva," RA 5 (1869): 850. Cited by Smagina, *O smysle slova "Vospitanie,"* 392.

81. Bradford, *Memoirs of the Princess Daschkaw*, 2: 99–100.
82. Dashkova, "Kratkie zapiski," 7–16.
83. Nekrasov, *Rossiiskaia Academia*, 59–63.
84. Dashkova, "Vecherinka," 240–47.
85. M. V. Lomonosov, *Sobranie raznykh sochinenii v stikhakh i proze* (Moscow: Moskovskii universitet, 1757): 1, 3–10. Cited by Smagina, *O smysle slova "vospitanie,"* 393.
86. AKV, 31: 433.

CHAPTER TEN: *Estrangement*

1. Cited by Niv'er, "E. R. Dashkova i frantsuzskie filosofy," 53.
2. AKV, 9: 31–32.
3. Ibid., 89.
4. RGADA, f. 1261, op. 1, d. 31, l. 19 ob.
5. *Toisiokov, ili Chelovek beskharaternyi* in *Rossiiskii featr, ili Polnoe sobranie vsekh featral'nykh sochinennii* 19 (1788): 239–317. More recently, the play was performed at the Hermitage Theater in March 1993 and reprinted in Moiseeva, *Literaturnye sochineniia*, 267–312.
6. Afanas'ev "Literaturnye trudy kn. E. R. Dashkovoi," 210.
7. Veselaia, "Ekaterina Romanovna Dashkova," 84.
8. Semennikov, *Russkie satiricheskie zhurnaly*, 58. Teplova, "Dashkova, Ekaterina Romanovna," 246 and Tychinina, *Velikaia Rossiianka*, 161, also mention a libretto to the opera *Zemfira i Azor* (1783) and the novel *Novaia Evfimiia* (1788). Erogov in *Rossiiskie Utopii*, 82–84, asserts that Dashkova is the author of *Various Narratives Composed by a Certain Russian Woman* (Moscow, 1779). These claims remain unsubstantiated.
9. Gepfert, "O dramturgii E. R. Dashkovoi," 147.
10. Mitropolit Evgenii, *Slovar' russkikh svetskikh pisatelei* (Moscow, 1845), 159. Cited by Afanas'ev "Literaturnye trudy kn. E. R. Dashkovoi," 211.
11. According to some accounts, the story is apocrypha (Papmehl, *Freedom of Expression*, 106).
12. Priashnikova, *E. R. Dashkova i muzyka*, 20.
13. AKV, 21: 404–07.
14. Khrapovitskii, *Pamiatnye zapiski*, 62.
15. Dolgova, *Kniaginia E. R. Dashkova*, 199.
16. Romm, "K istorii," 14.
17. AKV, 5: 186–87.
18. Bradford, *Memoirs of the Princess Daschkaw*, 2: 195–96.
19. Bolkhovitinov, *Beginnings of Russian-American Relations*, 127.
20. Khrapovitskii, *Pamiatnye zapiski*, 3.
21. Ibid., 227.
22. Ibid., 187.
23. Vigel', *Zapiski*, 1: 53.
24. Alekseev, *Grafy Vorontsovy*, 389.

25. Khrapovitskii, *Pamiatnye zapiski*, 268.
26. AKV, 5: 190–91.
27. Khrapovitskii, *Pamiatnye zapiski*, 187.
28. RGIA, f. 1151, op. 1, d. 8, l. 5; Tychinina, *Velikaia Rossianka*, 28.
29. SIRIO, 23: 554.
30. Bradford, *Memoirs of the Princess Daschkaw*, 2: 92.
31. Cross, *Contemporary British Responses*, 56–57.
32. Grote, *Sochineniia Derzhavina*, 2nd ed., 5: 427.
33. AKV, 5: 223.
34. Khrapovitskii, *Pamiatnye zapiski*, 226, 227.
35. Lozinskaia, *Vo glave dvukh akademii*, 93.
36. AKV, 5: 223.
37. AKV, 5, 216–25.
38. See also "Iz rozysknogo dela o tragedii Kniazhnina *Vadim*," RA 5–6 (1863): 467–73.
39. "Dostopamiatnyi razgovor Ekateriny Velikoi s kniaginei Dashkovoi," RA 2 (1884): 266.
40. Bradford, *Memoirs of the Princess Daschkaw*, 2: 101.
41. For a reconstruction of these events based on Dashkova's letter to her brother Alexsandr, see "Dostopamiatnyi razgovor," 266–73.
42. AKV, 12: 95–96.
43. Ibid., 12: 96.
44. Lozinsakia, *Vo glave dvukh akademii*, 101.
45. Dolgorukova, "Cherty iz zhizni," 581–82.
46. Broitman, "Peterburgskie adresa E. R. Dashkovoi," 192.

CHAPTER ELEVEN: *Troitskoe and Korotovo*

1. AKV, 12: 122.
2. SPFA RAN, f. 1, op. 2–1794, VIII.14, No. 118, l. 2, 2 ob.
3. Ibid., l. 6–7.
4. Esipov, "K biografii kniagini E. R. Dashkovoi," 672–673.
5. SPFA RAN, f. 1, op. 2–1794, VIII.14, No. 118, l.1.
6. *Protokoly*, 4: 388–89.
7. Sukhomlinov, *Kniaginia E. R. Dashkova*, 56.
8. Currently the Higher Military School of Artillery at 110 Fontanka Embankment and 17 Moskovskii prospect.
9. AKV, 12: 329, 335.
10. RGIA, f. 938, op. 1, d. 385, l. 2 and l. 1, 1 ob., 3.
11. AKV, 5: 202–03, 206–09.
12. Esipov, "K biografii kniagini E. R. Dashkovoi," 670–72.
13. Alekseev, *Grafy Vorontsovy*, 109.
14. AKV, 21: 408–10.
15. AKV, 5: 215–16.

16. Esipov, "K biografii kniagini E. R. Dashkovoi," 673.
17. RGIA, f. 938, op. 1, d. 386, l. 5; SPFA RAN, f. 5, op. 1-D, d. 4, l. 31.
18. RGIA, f. 1329, op. 1, d. 184, l. 36.
19. SPFA RAN, f. 137, op. 1, d. 13, l. 10.
20. "Pis'ma Imperatora Pavla Petrovicha," 6-32.
21. Esipov, "K biografii kniagini E. R. Dashkovoi," 673. Dashkova refers to Izmailov as governor-general.
22. "Liubopytnye i dostopamiatnye deianiia," 621-22.
23. Esipov, "K biografii kniagini E. R. Dashkovoi," 673.
24. Shugurov, "Miss Vil'mot i kniaginia Dashkova," 169.
25. Butenev, "Vospominaniia," 21.
26. Esipov, "K biografii kniagini E. R. Dashkovoi," 674.
27. Dolgorukova, "Cherty iz zhizni," 585.
28. AKV, 5: 257-58.
29. AKV, 10: 6.
30. AKV, 5: 260. Avdot'ia Vorontsova was the wife of Andrei Gavrilovich, who descended from one of Illarion's (1674-1750) brothers, Ivan (most likely) or Il'ia. See Alekseev, *Grafy Vorontsovy*, 441.
31. RGIA, f. 938, op. 1, d. 386, l. 6, 6 ob; Esipov "K biografii kniagini E. R. Dashkovoi," 674.
32. AKV, 5: 262.
33. Ibid., 261.
34. Ibid., 254.
35. Ibid., 267-68.
36. Ibid., 269-70.
37. Dolgorukova, "Cherty iz zhizni," 585-86.
38. AKV, 5: 262-63.
39. Firsova, "Posle ssylki," 62-75.
40. Veselaia, "Poslanie kniagini E. R. Dashkovoi," 117-124.
41. Herzen, *Kniaginia E. R. Dashkova*, 408.
42. Ogarkov, *E. R. Dashkova*, 12.
43. AKV, 5: 264-66.
44. Esipov "K biografii kniagini E. R. Dashkovoi," 674-75.
45. AKV, 5: 271-73.
46. Vigel', *Zapiski*, 1: 54. For example, letter dated April 9, 1804, in Wilmot, *Russian Journals*, 93.
47. AKV, 12: 180.
48. Ibid., 17: 45; Cross, *By the Banks*, 134.
49. Engel'gardt, *Zapiski*, 62.
50. Chechulin, *Zapiski kniagini Dashkovoi*, 283-84.
51. AKV, 5: 270-71.
52. RGIA, f. 938, op. 1, d. 386, l. 7-8.
53. Ogarkov, *E. R. Dashkova*, 66.
54. AKV, 5: 282-83.

55. Bradford, *Memoirs of the Princess Daschkaw*, 1: xxxvi.
56. Cross, "Contemporary British Responses," 59.
57. SPFA RAN, f. 8, op. 5, d. 61, l. 1, 1 ob.

CHAPTER TWELVE: *The Final Years*

1. Shugurov, "Miss Vil'mot i kniaginia Dashkova," 154.
2. Wilmot, *Russian Journals*, 201.
3. Herzen, "Kniaginia E. R. Dashkova," 397.
4. MDB, 158-61; Bradford, *Memoirs of the Princess Daschkaw*, 2: 206-09; Letter dated July 13, 1806.
5. Bradford, *Memoirs of the Princess Daschkaw*, 2: 205.
6. M. P. Priashnikova, "Muzyka v zhizni E. R. Dashkovoi," 155.
7. Glinka, *Zapiski*, 233.
8. Currently, it is the Presidium of the Academy of Sciences, where a copy of Dashkova's portrait as head of the Academies now hangs.
9. Bradford, *Memoirs of the Princess Daschkaw*, 2: 232.
10. Wilmot, *Russian Journals*, 354.
11. Ibid., 360.
12. Mavor, *Grand Tours of Katherine Wilmot*, 134.
13. Ibid., 137.
14. RIA, 12 L 25.
15. Wilmot, *Russian Journals*, 201.
16. MDB, 118-125; Bradford, *Memoirs of the Princess Daschkaw*, 2: 148-56.
17. Bradford, *Memoirs of the Princess Daschkaw*, 2: 151.
18. Ibid., 154.
19. Ibid., 154-156.
20. Eliseeva, "Ekaterina II i E. R. Dashkova," 19-34.
21. Kornilovich-Zubasheva, "Kniaginia E. R. Dashkova za chteniem," 361; Griffiths, "Castéra-Tooke," 51-54.
22. Dashkova is translating the titles of Georg Freiherr von Tannenberg's, *Zhizn' Ekateriny Velikoi, Imperatritsy i Samoderzhitsy Vserossiiskiia, s eia portretom; perevod s nemetskago*, trans. Ivan Sreznevskii, Moscow, 1801, and *Podlinnye anekdoty Imperatritsy Ekateriny II*, Izd. K. D. i A. K., Moscow, 1806. Dashkova cited these titles in a later addition to *Mon histoire*, and therefore, she must have been reading the second work when she was revising the manuscript in 1806. Indeed, she may have been involved in the publication of the latter volume, since K. D. (Kniaginia Dashkova or Princess Dashkova) is a pseudonym she used previously. I would like to thank June Pachute Farris at the University of Chicago for identifying the two works.
23. Dashkova, "Pis'mo k izdateliam," 38-39, and "Izobrazhenie," 41-42.
24. BFP, 209.
25. D. V. Dashkov was not a relative and his surname was stressed on the last syllable.

26. Mavor, *Grand Tours of Katherine Wilmot*, 138.
27. Bradford, *Memoirs of the Princess Daschkaw*, 1: xxii.
28. Wilmot, *Russian Journals*, 79.
29. Bradford, *Memoirs of the Princess Daschkaw*, 2: 241.
30. Wilmot, *Russian Journals*, 88; Bradford, *Memoirs of the Princess Daschkaw*, 2: 278.
31. Wilmot, *Russian Journals*, 267, 272.
32. Interestingly, many years later in a series of letters to Lord Glenbervie describing the preparation of Dashkova's manuscript for publication, Martha did not mention translating it, but neither did she credit Catherine (RIA 12 M 18).
33. Dashkova, "Pis'mo k K. Vil'mot," 190–93.
34. RIA 12 L 25.
35. Mavor, *Grand Tours of Katherine Wilmot*, 115.
36. Wilmot, *Russian Journals*, 295.
37. AKV, 32: 411; RIA 12 L 18.
38. AKV, 12: 356.
39. Today the street where he lived bears his name, Woronzow Road.
40. She inspired her brother to begin his own unfinished autobiography (AKV, 5: 1–87).
41. RIA, 12 L 30, 146–47.
42. Bradford, *Memoirs of the Princess Daschkaw*, 2: 203, 205.
43. Mavor, *Grand Tours of Katherine Wilmot*, 162, 163.
44. Chechulin, *Zapiski*, 297–98; BERD, 66–67; Thomas Newlin's translation in Bisha, *Russian Women*, 73–75.
45. Shcherbinin, *Biografiia Generala-Fel'dmarshala, Kniazia Mikhaila Semenovicha Vorontsova* (St. Petersburg: Eduard Veimar, 1858); Shcherbinin, "Vospominania," 285; Wilmot, *Russian Journal*, 172, n. 2.
46. Chechulin, *Zapiski*, 312–317; BERD, 63–65.
47. Chechulin, 318–25; RGADA, f. 1261, op. 1, d. 30, l. 1, 1 ob, 21, 21 ob.
48. RGADA, f. 1255, op. 4, d. 221, l. 1–4.
49. RIA, 12 L 31, 45–47.
50. Mavor, *Grand Tours of Katherine Wilmot*, 164.
51. RIA, 12 L 25.
52. Cited by Tychinina, *Velikaia Rossianka*, 187.
53. RIA, 12 L 18.
54. Shugurov, "Miss Vil'mot i kniaginia Dashkova," 185.
55. His daughter became a celebrated writer and author of a series of popular French children's books known as the *Bibliothèque Rose*. His daughter-in-law was the writer E. P. Rostopchina.
56. The two copies were not identical and a conflated, French-language edition appeared only recently in 1999 in Paris (Woronzoff-Dashkoff, ed., *Mon histoire*). Dashkova's copy was a draft version that in all likelihood was not meant for publication and did not contain some of the later additions and notes (SPFIRI RAN, f. 36, op. 1, d. 749, l. 116 ob. 123, 127–129). For a discussion of extant manuscript copies and published versions of the *Memoirs* see Woronzoff, "Ad-

ditions," 15–21. After her death, the draft copy existed only in manuscript versions in Russia, and Pushkin, among others, read an unpublished copy. In time excerpts appeared in various Russian journals such as *Moskvitianin*, *Sovremennik*, and *Russkaia starina*. Dashkova's copy appeared in print only in 1881 when Petr Bartenev published it in the AKV (vol. 21), and several Russian translations were based on this version. Meanwhile, Martha Wilmot's (now Bradford) highly altered translation of the English copy of the *Memoirs* appeared only in 1840, the lateness of its publication partially due to Simon's opposition and the doubts he had raised about its authenticity. It served as the basis for Herzen's Russian-language edition (1859), and for succeeding translations back into French (1859, 1966), German (1857, 1918), and Czech (1911). Martha's daughter donated the original to the British Museum Library (BFP), which Kyril Fitzlyon edited for his 1958 English-language translation, *The Memoirs of Princess Dashkov*.

57. Snigirev, "Vospominaniia," RA 4 (1866): 745–46.
58. Dashkova, "Letter to the Editor of *The Russian Messenger*" ("Pis'mo k isdateliu,") 227–32.
59. Glinka, "Katerina Romanovna Dashkova," 9.
60. Kliuchevskii, *Sochineniia*, 5: 177.
61. Bradford *Memoirs of the Princess Daschkaw*, 2: 54–55; Mavor, *Grand Tours of Katherine Wilmot*, 175.
62. Bradford *Memoirs of the Princess Daschkaw*, 2: 57.
63. OR RGB, f. 178, No. 7557, l. 7.

EPILOGUE

1. See "Under the Wheels of the Red Terror: The Memoirs of Anna Il'inichna Vorontsova-Dashkova," *Rodina* 7 (2002): 83–87 and "On the Eve: From the *Memoirs* of A. I. Vorontsova Dashkova" *Roman-zhurnal XXI vek* 2 (2003): 60–68.
2. Heldt, *Terrible Perfection*, 70.

Selected Bibliography

BIBLIOGRAPHIES

Lelikova, N. K., and V. I. Kapusta, eds. *Ekaterina Romanovna Dashkova (1743–1810): Katalog knizhnoi vystavki*. St. Petersburg: Biblioteka Rossiiskoi Akademii Nauk, 1993.

Safonov, M. M., ed. *Vorontsovy—Dva veka v istorii Rossii: K 250-letiiu E. R. Dashkovoi*. St. Petersburg: Rossiiskaia Akademiia Nauk, 1993.

PRIMARY SOURCES

Archives

Archives des Affaires Etrangères. "Russie," 68, 70–71, Paris.
Brook Family Papers. Additional MS, No. 31, British Museum, London.
Gosudarstvennyi istoricheskii muzei. Otdel pis'mennykh istochnikov. Fond 47, Moscow.
National Library of Scotland. MS 3942, ff. 269–270, 281–282, 287, Edinburgh.
Otdel rukopisei Rossiiskaia Gos. bib. Fond 178, Moscow.
Rossiiskii gosudarstvennyi arkhiv drevnikh aktov. Fondy 14, 17, 199, 248, 285, 1255, 1261, Moscow.
Rossiiskii gosudarstvennyi istoricheskii arkhiv. Fondy 17, 468, 730, 834, 938, 1151, 1329, Moscow.
Royal Irish Academy. 12 L 18, 25, 30, 31, 34; 12 M 18, Dublin.
Sankt-Peterburgskii filial Arkhiva RAN. Fondy 1, 3, 5, 8, 21, 137, St. Petersburg.
Sankt-Peterburgskii filial Instituta rossiiskoi istorii RAN. Fond 36, St. Petersburg.

Published

Anthony, K., ed. *Memoirs of Catherine the Great*. New York: Tudor Publishing Co., 1935.
Arkhiv kn. F. A. Kurakina. Edited by V. N. Smol'ianinov. 10 vols. Saratov: S. P. Iakovlev, 1890–1902.
Arkhiv kniazia Vorontsova. Edited by Petr Bartenev. 40 vols. Moscow: V. Got'e, 1870–1897.
Bradford, M., ed. *Memoirs of the Princess Daschkaw*. 2 vols. London: Henry Colburn, 1840.

"Bumagi E. R. Dashkovoi." In *Sbornik starinykh bumag, khraniashchikhsia v Muzee P. I. Shchukina*, 60–97. Moscow: A. I. Mamontov, 1901.

Butenev, A. P. "Vospominaniia russkogo diplomata Apollinariia Petrovicha Buteneva." *RA* 3, no. 1 (1881): 5–84.

Catherine II. "Kratkodlynni otvet." *Sobesednik* 6 (1783): 147–51.

———. "Otvet." *Sobesednik* 6 (1783): 179–80.

Chechulin, N. D. *Zapiski kniagini Dashkovoi*. St. Petersburg: A. S. Suvorin, 1907.

Chtenie v Obshchestve istorii i drevnostei rossiiskikh. Moscow University, 1846–1918.

Cruse, M. and H. Hoogenboom, eds. *The Memoirs of Catherine the Great*. New York: Modern Library, 2005.

Dashkova, E. R. "Chetyrestishie." *Drug prosveshcheniia* 4, no. 11 (1805): 144, 149.

———."Iskrennee sozhalenie ob uchasti gospod izdatelei *Sobesednika*." *Sobesednik* 3 (1783): 148–54.

———. "Istiny, kotorye znat' i pomnit' nadobno, daby, sleduia onym, izbezhat' neschastii." *Novye ezhemesiachnye sochineniia* 114 (Nov. 1795): 2–7.

———, trans. "Iz opyta o epischeskom stikhotvorstve." *Nevinnoe uprazhnenie*, 1763, Jan. 13–21; Feb. 51–56; Mar. 99–111; Apr. 143–155.

———. "Izobrazhenie Velikoi Ekateriny, pisannoe v 1784 godu." *Drug prosveshcheniia* 4, no. 10 (1804): 41–42.

———. "Kartiny moei rodni, ili Proshedshie sviatki." *Sobesednik* 12 (1784): 17–22 and 14 (1782): 164–66.

———. "K gospodinu sochiniteliu 'Bylei i nebylits' ot odnogo iz izdatelei *Sobesednika*." *Sobesednik* 5 (1783): 156–61.

———. "K gospodam izdateliam *Ezhemesiachnykh sochinenii: Voprosyi*." *Novye ezhemesiachnye sochineniia* 82 (April 1793): 3–6.

———. "K gospodam izdateliam *Novykh ezhemesiachnykh sochinenii*." *Novye ezhemesiachnye sochineniia* 78 (December 1792): 3–6.

———. "Kratkie zapiski raznoschika." *Sobesednik* 9 (1783): 7–16.

———. "Moia zapisnaia knizhka." *Sobesednik* 13 (1784): 19–41.

———. "Nadpis'k portretu ee velichestva imperatritsy Ekateriny II." *Sobesednik* 1 (1782): 14.

———. "Nechto iz zapisnoi moei knizhki." *Drug prosveshcheniia* 4, no. 12 (1806): 194–201.

———, trans."Obshchestvo dolzhno delat' blagopoluchie svoikh chlenov" *Opyt trudov Vol'nogo Rossiiskogo sobraniia pri Imp. Moskovskom universitete* 1 (1774): 80–84.

———. "Ob istinnom blagopoluchii." *Sobesednik* 3 (1783): 24–34.

———, trans. "Opyt o torge" *Opyt trudov Vol'nogo Rossiiskogo sobraniia pri Imp. Moskovskom universitete* 1 (1774): 87–112.

———. "O smysle slova 'vospitanie.'" *Sobesednik* 2 (1783): 12–28.

———, trans. "O soobshchestvennom uslovii" *Opyt trudov Vol'nogo Rossiiskogo sobraniia pri Imp. Moskovskom universitete* 1 (1774): 85–86.

———. "Ot izdatelei." *Sobesednik* 1 (1783): 160.

———. "Otryvok zapisnoi knizhki." *Novye ezhemesiachnye sochineniia* 47 (May 1790): 12–19.

———. "Otvet [Ioannu Priimkovu]." *Sobesednik* 10 (1783): 21-24.
———. "Otvet ot slova 'tak.'" *Sobesednik* 3 (1783): 39-43, 43-45, 141-47.
———. "Poslanie k slovu 'tak.'" *Sobesednik* 1 (1783): 15-23.
———. "Pis'mo k drugu." *Opyt trudov Vol'nogo Rossiiskogo sobraniia pri Imp. Moskovskom universitete* 1 (1774): 78-80.
———. "Pis'mo k izdateliam." *Drug prosveshcheniia* 2, no. 4 (1804): 38-39.
———. "Pis'mo k izdateliam sikh sochinenii." *Novye ezhemesiachnye sochineniia* 5 (November 1786): 67-71.
———. "Pis'mo k isdateliu *Russkogo vestnika*." *Russkii vestnik* 1, no. 2 (1808): 227-32.
———. "Pis'mo k K. Vil'mot s razmyshleniiami o voprosakh vospitaniia, 15 noiabria 1805 g." *Drug prosveshcheniia* 4, no. 12 (1806): 190-93.
———. "Pritcha: Otets i deti." *Novye ezhemesiachnye sochineniia* 5 (November 1786): 71-72.
———. "Prodolzhenie otryvka zapisnoi knizhki." *Novye ezhemesiachnye sochineniia* 47 66 (December 1791): 3-6.
———. "Puteshestvie odnoi rossiiskoi znatnoi gospozhi po nekotorym angliiskim provintsiiam." *Opyt trudov Vol'nogo Rossiiskogo sobraniia pri Imp. Moskovskom universitete* 2 (1775): 105-44.
———. "Puteshestvuiushchie." *Sobesednik* 11 (1784): 120-32.
———. "Rech govorinnaia pri otkrytii imperatorskoi Rossiiskoi akademii." *Moskovskie vedomosti*, No. 87. (1783). Reprinted in *Drug prosveshcheniia* 1, no. 2 (1804): 144-46.
———. "Sokrashchenie katekhizisa chestnogo cheloveka." *Sobesednik* 3 (1783): 33-35.
———. "Toisiokov, ili Chelovek beskharaternyi," in *Rossiiskii featr, ili Polnoe sobranie vsekh featral'nykh sochinennii* 19 (1788): 239-317.
———. "Vecherinka." *Sobesednik* 9 (1783): 240-47.
———. "Zapiski tetushki." *Novye ezhemesiachnye sochineniia* 1 (July 1786): 61-80.
"Dostopamiatnyi razgovor Ekateriny Velikoi s kniaginei Dashkovoi." *RA* 2 (1884): 266-73.
Dublin Historical Record. Vol. IX. Dublin: The Old Dublin Society, 1946-1948.
Engel'gardt, L. N. *Zapiski*. Moscow: Novoe literaturnoe oboszrenie, 1997.
Fitzlyon, K., trans. *The Memoirs of Princess Dashkov*. London: John Calder, 1958. Reprint, Durham, NC: Duke University Press, 1995.
Fonvizin, M. A. *Sochineniia i pis'ma*. Edited by S. V. Zhitomirskaia and S. V. Mironenko, vol. 2. Irkutsk: Vostochno-Sibirskoe knizhnoe izd-vo, 1982.
Glinka, S. N. "Katerina Romanovna Dashkova: Iz zapisok S. N. Glinka." *Russkoe slovo* 4 (1861): 1-10.
———. *Zapiski*. St. Petersburg: Russkaia starina, 1895.
Grot, I. A., ed. *Sochineniia Derzhavina*. 1st ed. 9 vols. St. Petersburg: Akademiia nauk, 1864-1883.
———, ed. *Sochineniia Derzhavina*. 2nd ed. 7 vols. St. Petersburg: Akademiia nauk, 1868-1878.
Herzen, A. I. "Kniaginia E. R. Dashkova." In *Sobranie sochinenii*, vol. 12: 361-422, Moscow: Akademiia nauk, 1957.

———, ed. *Zapiski kniagini E. R. Dashkovoi*. Reprint, Moscow: Nauka, 1990.
"Iz pis'ma kniagini E. R. Dashkovoi k grafu Germanu Keizerlingu." RA 3 (1887): 185-91.
"Iz rozysknogo dela o tragedii Kniazhnina *Vadim*," RA 5-6 (1863): 467-73.
"K gospodam izdateliam *Sobesednika liubitelei rossiiskogo slova*" *Sobesednik* 2 (1783): 8-11.
"K gospodam izdateliam *Sobesednika liubitelei rossiiskogo slova*" *Sobesednik* 3 (1783): 154-59.
Kheraskov, M. M. "Ee siiatel'stvu kniagine Ekaterine Romanovne Dashkovoi." *Sobesednik* 6 (1783): 19-22.
"Liubopytnye i dostopamiatnye deianiia i anekdoty gosudaria Imperatora Pavla pervogo (Iz zapisok A. T. Bolotova)." RA 5-6 (1864): 596-622.
Locke, J. *Some thoughts on education*. London: J. Hatchard, 1836.
Lomonosov, M. V. *Izbrannye proizvedeniia v dvukh tomakh*. Edited by S. R. Mikulinskii. Moskva, Russia: Nauka, 1986.
———, ed. *Literaturnye sochineniia*. Moscow: Pravda, 1990.
———, ed. *Zapiski i vospominaniia russkikh zhenshchin XVIII—pervoi poloviny XIX veka*. Moscow: Sovremennik, 1990.
Maroger, D., ed. *The Memoirs of Catherine the Great*. London: Hamish Hamilton, 1955.
Masson, C. F. P. *Mémoires secrets sur la Russie*. Paris: Firmin Didot, 1859.
———. *Secret Memoirs of Catherine II*. London: The Grolier Society, 1904.
Materialy dlia biografii kniagini E. R. Dashkovoi. Leipzig, Germany: E. L. Kasprowicz, 1876.
Mavor, E., ed. *The Grand Tours of Katherine Wilmot: France 1801-1803 and Russia 1805-1807*. London: Weidenfeld and Nicolson, 1992.
Moiseeva, G. N., ed. *Ekaterina Dashkova. Zapiski 1743-1810*. Leningrad: Nauka, 1985.
Montesquieu, C. *De l'esprit des lois*. Paris: Garnier, 1973.
"Na byvshago v Akademii Nauk directorom gospodina Domashneva," RA 10 (1872): 2032-36.
Nova Acta Academiae Scientiarum Imperialis Petropolitanae, vol. 1. Petropoli: Typis Academiae Scientiarum, 1783.
Novikov, N. I. "O vospitanii i nastavlenii detei." In *Izbrannye sochinenia* Moscow: Gos. izd-vo khudozh. lit-ry (1951): 452-53.
Oberg, B. B., ed. *The Papers of Benjamin Franklin*, vol. 34. New Haven, CT and London: Yale University Press, 1998.
Pennington, M., ed. *Letters from Mrs. Elizabeth Carter to Mrs. Montague, between the Years 1755 and 1800, Chiefly upon Literary and Moral Subjects*. London: F. C. and J. Rivington, 1817.
"Pis'ma Imperatora Pavla Petrovicha k moskovskim glavnokomanduiushchim (1796-1801)." RA 1 (1876): 6-32.
"Pis'ma kn. E. R. Dashkovoi k kn. A. B. Kurakinu." RA 7 (1912): 461-66.

"Pis'ma kniagini E. R. Dashkovoi k kniaziu G. A. Potemkin." *Drevniia i novaia Rossiia* 2 (1879): 152–59.
"Pis'mo k izdateliam iz Zvenigoroda" *Sobesednik* 2 (1783): 8–11.
Polnoe sobranie zakonov Rossiiskoi imperii. 45 vols. St. Petersburg: Ego Velichestva Kantseliariia, 1830.
Pontremoli, P., ed. *Mémoires de la princess Daschkoff.* Paris: Mercure de France, 1966.
"Proshenie k gospodam izdateliam." *Sobesednik* 8 (1783): 26–33.
Protokoly zasedanii Konferentsii Imperatorskoi Akademii Nauk. Vols. 3–4. St. Petersburg: Akademiia Nauk, 1900–1911.
Radishchev, A. N. *Puteshestvie iz Peterburga v Moskvu.* Moscow: Gos. izd-vo khudozh. lit-ry, 1961.
"Rasskaz N. I. Panina o votsarenii Ekateriny Velikoi: Iz zapisok barona Asseburga," *RA* 1 (1879): 362–69.
Reddaway, W. F., ed. *Documents of Catherine the Great: The Correspondence with Voltaire and the Instruction of 1767 in the English Text of 1768.* London: Cambridge University Press, 1931.
Riabinin, D. D. "Biografiia grafa Semena Romanovicha Vorontsova," *RA* 1 (1879): 58–82.
Romm, Zh. "K istorii russkoi obrazovannosti novogo vremeni," *RA* 1, no. 1 (1887): 6–38.
Rossiiskii featr, ili Polnoe sobranie vsekh rossiiskikh featral'nkh sochineni. 43 vols. Saint Petersburg: Imperatorskaia akademia nauk, 1786–1794.
Rousseau, J. J. *Julie, ou, La Nouvelle Héloïse.* Paris: Gallimard, 1993.
Rulhière, C. C. *A History or Anecdotes of the Revolution in Russia, 1797.* Reprint, New York: Arno Press & The New York Times, 1970.
———. *Histoires ou Anecdotes sur la révolution de Russie, en l'an 1762, par Rulhière.* Paris: Desenne, 1797.
Rumiantsev, S. P. "Petr Velikii." *Sobesednik* 7 (1783): 164–77.
Sbornik imperatorskogo russkogo istoricheskogo obshchestva. 148 vols. St. Petersburg, 1867–1916.
Schlegelberger, G. *Die Fürsten Daschkowa.* Berlin: Junker und Dunnhaubt, 1935.
Shcherbatov, M. M. *On the Corruption of Morals.* Translated by A. Lentin. Cambridge, England: Cambridge University Press, 1969.
Shcherbinin, M. P. "Vospominaniia M. P. Shcherbinina." *RA* 3 (1876): 285–313.
Shein, A. "Pis'mo k izdateleiam." *Novye ezhemesiachnye sochineniia* 81 (March 1793): 15–16.
———. "Pis'mo k izdateleiam." *Novye ezhemesiachnye sochineniia* 86 (August 1793): 12–13.
Smagina, G. I., ed. *O smysle slova "Vospitanie": Sochineniia, pis'ma, dokumenty.* St. Petersburg: Dmitrii Bulanin, 2001.
Sochineniia i perevody izdavaemye Rossiiskoi Akademii. Vols. 1–6. St. Petersburg: Imperatorskaia. Tipografiia, 1805–1813.
Tiebo, D. "Zapiski professora-akademika Tiebo, 1765–1885," *RS* 23 (1878): 477–83.

Tychinina L. V., ed. *Slovar' Akademii Rossiiskoi.* 4 vols, 1789–1794. Reprint, Moscow: MGI, 2001.
Veselaia, G. A., ed. *Zapiski. Pis'ma sester M. i K. Vil'mot iz Rossii.* Moscow: Moskovskii universitet, 1987.
Vigel', F. F. *Zapiski.* 2 vols. Moscow: Krug, 1928.
Voltaire. *Oeuvre complète.* Paris: Garnier frère, 1877–85.
"Vospominania I. M. Snegireva." RA 4 (1866): 513–62, 537.
Wilmot, M. and C. Wilmot. *The Russian Journals of Martha and Catherine Wilmot.* Edited by The Marchioness of Londonderry and H. Montgomery Hyde. London: Macmillan and Co., 1935.
Woronzoff-Dashkoff, A., C. Legouis, and C. Woronzoff-Dashkoff, eds. *"Mon histoire": Mémoires d'une Femme de Lettres Russe à l'Epoque des Lumières.* Paris: L'Harmattan, 1999.
"Zapiski M. A. Fonvizina." RS 42 (1884): 61–63.

SECONDARY SOURCES

Afanas'ev, A. "Literaturnye trudy kniagini E. R. Dashkovoi." *Otechestvennyia zapiski* 129 (1860): 181–218.
Aleksandrenko, V. N. *Russkie dipolomaticheskie agenty v Londone XVIII v.* Vol. 2. Warsaw: Varshavskago ucheb. okruga, 1897.
Alekseev, V. V. *Grafy Vorontsovy i Vorontsovy-Dashkovy v Istorii Rossii.* Moscow: Tsentropoligraf, 2002.
Alexander, J. T. "Catherine the Great and the Foundation of the Russian Academy." *Study Group on Eighteenth-Century Russia Newsletter* 13 (1985): 16–24.
———. *Catherine the Great: Life and Legend.* New York and Oxford, England: Oxford University Press, 1989.
Amoia, A. "Princess Ekaterina (Catherine) Romanovna Vorontsova *Dashkova.*" In *Great Women Travel Writers from 1750 to the Present.* Edited by A. Amoia and B. L. Knapp, 11–26. New York: Continuum, 2005.
Artem'eva, T. V. *Filosofiia v Peterburgskoi Akademii nauk XVIII veka.* St. Petersburg: Sankt-Peterburgskii Tsentr istorii idei, 1999.
Axtell, J., ed. *The Educational Writings of John Locke: A Critical Edition.* Cambridge, England: Cambridge University Press, 1968.
Bantysh-Kamenskii, D. N. "Dashkova, kniaginia Ekaterina Romanovna." In *Slovar' dostopamiatnykh liudei Russkoi zemli.* Moscow: A. Shiriaev, 1836, 2: 183–90.
Barsukov, A. "Kniaz' Gr. Gr. Orlov," RA 2 (1873): 1–146.
Bartlett, R. "Defenses of Serfdom in Eighteenth-Century Russia." In *A Window on Russia.* Edited by M. Di Salvo and L. Hughes, 67–74. Rome: La Fenice Edizioni, 1996.
Bil'basov, V. A. *Istoriia Ekateriny vtoroi.* 2 vols. Berlin: F. Gottgeinera, 1900.
Bisha, R., J. M. Gheith, C. Holden, and W. G. Wagner, eds. *Russian Women, 1698–1917: Experience and Expression, An Anthology of Sources.* Bloomington, IN: Indiana University Press, 2002.

Black, J. L. "Educating Women in Eighteenth Century Russia: Myths and Realities." *Canadian Slavonic Papers* 20 (1975): 23-43.
Blagoi, D. *Rasskazy babushki.* Leningrad: Nauka, 1989.
Bogatova G. A., "Dashkova i slovar' ee epokhi," in Tychinina L. V., ed. *Slovar' Akademii Rossiiskoi.* Vol 1. Reprint, Moscow: MGI, 2001.
Bogoslovskii, V. A. *Kvarengi-master arkhitektury russkogo klassitsizma.* Leningrad: Gos. izdatel'stvo, 1995.
Bolkhovitinov, N. N. *The Beginnings of Russian-American Relations 1775-1815.* Trans. by E. Levin. Cambridge, MA: Harvard University Press, 1975.
Broitman, L. I. "Peterburgskie adresa E. R. Dashkovoi." In ERD. St. Petersburg: Dmitrii Bulanin, 1996, 182-96.
Buturlin, M. D. "Kniaginia E. R. Dashkova," RS 18 (1877): 575.
———. "Ocherk zhizni gr. D. P. Buturlina," RA 5 (1867): 376-86.
Castéra, J. H. *The Life of Catherine II, Empress of Russia.* 3 vols. London: T. N. Longman and J. Debrett, 1798.
Chaikovskaia, O. *"Kak liubopytnyi skif . . .": Russkii portret i memuaristika vtoroi poloviny XVIII veka.* Moscow: Kniga, 1990.
Chernova, A. *"Mémoires" und "Mon histoire" Zarin Katharina die Große und Fürstin Katharina R. Daschkowa in ihren Autobiographen.* Berlin: Frank & Timme, 2007.
Christie, I. R. *The Benthams in Russia, 1780-1791.* Oxford and Providence, CT: Berg, 1993.
Cross, A. G. *"By the Banks of the Thames": Russians in Eighteenth-Century Britain.* Newtonville, MA: Oriental Research Partners, 1980.
———. "Contemporary British Responses (1762-1810) to the Personality and Career of Princess Ekaterina Romanovna Dashkova." *Oxford Slavonic Papers* 27 (1994): 41-61.
———. "Early British Acquaintance with Russian Popular Song and Music. (The Letters and Journals of the Wilmot Sisters)." *The Slavonic and East European Review* 66, no. 1 (1988): 21-32.
———. "Dispute with a Tutor: An Episode from Princess Dashkova's Residence in Edinburgh." *Study Group on Eighteenth-Century Russia Newsletter* 19 (1991): 22-29.
———. "The High Road and the Low: Russian Students and Travellers in Eighteenth-Century Scotland." *Coexistence* 29 (1992): 113-24.
———. "Paul Sandby and the Dashkovs." *Study Group on Eighteenth-Century Russia Newsletter* 23 (1995): 37-44.
———. "Poezdka kniagini E. R. Dashkovoi v Velikobritaniiu (1770 i 1776-1780 gg.) i ee Nebol'shoe puteshestvie v Gornuiu Shotlandiiou, 1777." Translated by Iu. D. Levin. *XVIII vek* 19 (1995): 223-68.
———."A Russian in the Gordon Riots." *Study Group of Eighteenth-Century Russia Newsletter* 1 (1973): 29-36.
Davidson, I. *Voltaire in Exile: The Last Years, 1753-78.* New York: Grove Press, 2004.
Dickinson, S. "The Russian Tour of Europe before Fonvizin: Travel Writing as Literary Endeavor in Eighteenth-Century Russia." *Slavic and East European Journal* 45 (2001): 1-29.

Dobroliubov, N. A. "Sobesednik liubitelei rossiiskogo slova." In *Sobranie sochinenii*. Edited by B. I. Bursov. Moscow: Gos. izd-vo khudozh. lit-ry, 1961-1964.

Dolgorukova, E. A. "Cherty iz zhizni kn. Ekateriny Romanovny Dashkovoi." RA 5-6 (1864): 569-86.

Dolgova, S. R. *Kniaginia E. R. Dashkova i semia Malinovskikh*. Moscow: Izdatel'stvo "Drevnekhranilishche," 2002.

Dvoichenko-Markoff, E. "The American Philosophical Society and Early Russian-American Relations." *Proceedings of the American Philosophical Society* 94 (December 1950): 549-610.

———. "Benjamin Franklin, the American Philosophical Society and the Russian Academy of Sciences." *Proceedings of the American Philosophical Society* 91 (August 1947): 250-57.

Egorov, Boris F. *Rossiiskie Utopii:Istoricheskii Putevoditel'*. St. Petersburg: Isskustro-SPB, 2007.

Eliseeva, O. I., "Ekaterina II i E. R. Dashkova. Fenomen zhenskoi druzhby v epokhu Prosveshcheniia." In Tychinina, L. V., ed. *E. R. Dashkova i A. S. Pushkin v Istorii Rossii*, 19-34. Moscow: MGI, 2000.

———. *Vel'mozhnaia Moskva: iz istorii politicheskoi zhizni Rossii XVIII v.* Moscow: Bioinformservis, 1997.

Esipov, G. V. "K biografii kniagini E. R. Dashkovoi." *Istroricheskii vestnik* 9 (July 1882): 665-75.

Firsova, E. N. "Posle ssylki: E. R. Dashkova v Moskve i v Troitskom v 1797-1801 gg." In Tychinina, L. V., ed. *E. R. Dashkova i A. S. Pushkin v istorii Rossii*, 62-75. Moscow: MGI, 2000.

Gepfert, F. "O dramaturgii E. R. Dashkovoi." In ERD, 147-51. Petersburg: Dmitrii Bulanin, 1996.

Gillel'son, M. I. "Pushkin i *Zapiski* Dashkovoi." *Molodaia gvardia* 10 (1974): 132-44.

Griffiths, D. M. "Castéra-Tooke: The First Western Biographer(s) of Catherine II." *Study Group on Eighteenth-Century Russia Newsletter* 10 (1982): 50-62.

Heldt, B. *Terrible Perfection: Women and Russian Literature*. Bloomington, IN: Indiana University Press, 1987.

Herold, Kelly. "Autobiographical Literature in Fench: Recovering a Memoiristic Tradition (1770-1830)." PhD diss., University of California, Los Angeles, 1998.

Holmgren, B. *The Russian Memoir*. Evanston: Northwestern University Press, 2003.

Humphreys, L. J. "The Vorontsov Family: Russian Nobility in a Century of Change, 1725-1825." PhD diss., University of Pennsylvania, 1969.

Hyde, H. M. *The Empress Catherine and Princess Dashkova*. London: Chapman & Hall, 1935.

Ilovaiskii, D. I. "Ekaterina Romanovna Dashkova" in *Sochineniia D. I. Ilovaiskago*. Moscow: A. L. Vasil'ev, 1884.

Iukhta, A. I., ed. *Ekaterina II i ee okruzhenie*. Moscow: Pressa, 1996.

Kamenskii, A. *Pod seniiu Ekateriny: Vtoraia polovina XVIII veka*. St. Petersburg: Lenizdat, 1992.

Karabanov, P. F. "Stats-damy i freiliny russkogo dvora v XVIII stoletii." RS 2 (Nov. 1870): 493-95.
Kenney, Jr., J. J. "The Vorontsov Party in Russian Politics, 1785-1803; An Examination of the Influence of an Aristocratic Family at the Court of St. Petersburg in the Age of Revolution." PhD diss., Yale University, 1975.
Khrapovitskii, A. V. *Pamiatnye zapiski stats-sekretaria Imperatritsy Ekateriny Vtoroi*, 1862. Reprint, Moscow: V/O Soiuzteatr, 1990.
Kliuchevskii, V. O. *Sochineniia*. 8 vols. Moscow: Izdatel'stvo social'no-ekonomicheskoi literatury, 1955-59.
Kochetkova, N. D. "Dashkova i *Sobesednik liubitelei rossiiskogo slova*." In ERD, 140-46. Petersburg: Dmitrii Bulanin, 1996.
Kolominov, V. V., and M. Sh. Fainshtein. *Khram muz slovesnykh (Iz istorii Rossiiskoi Akademii)*. Leningrad: Nauka, 1986.
Kornilovich-Zubasheva, O. "Kniaginia E. R. Dashkova za chteniem Kastera." In *Sbornik statei po russkoi istorii posviashchennykh S. F. Platonovu*, 355-70, 1922. Reprint, Würzburg: Jal-Reprint, 1978.
Korsakov, A, "Petr Alekseev, protoierei Moskovskogo Arkhangel'skogo sobora (1727-1801)." RA 2, nos. 5-8 (1880): 153-210.
Kucherenko, G. S. "Sochinenie Gel'vetsiia *Ob Ume* v perevode E. R. Dashkovoi." *XVIII vek* 21 (1999): 215-27.
Labanov, Prince A. "Eshcho o Zapiskakh Kniagini Dashkovoi." RA 1 (1881): 366-79.
Lentin, A. "The Princess Dashkova." *History Today* 18-19 (1968-1969): 18-24, 823-25.
Likhacheva, E. O. *Materialy dlia istorii zhenskogo obrazovaniia v Rossii*. 2 vols. St. Petersburg: Tip. M. M. Stasiulevicha, 1890-1901.
Limonov, I. A., ed. *Rossiia XVIII v. glazami inostrantsev*. Leningrad: Lenizdat, 1989.
Longmire, R. A. "Princess Dashkova and the Intellectual Life of Eighteenth Century Russia." Master's thesis, University of London, 1955.
Lotman, I. M. *Besedy o russkoi kul'ture: byt i traditsii russkogo dvorianstva XVIII-nachalo XIX veka*. St. Petersburg: Iskusstvo-SPB, 1994.
———. *The Poetics of Everyday Behavior in Eighteenth-Century Russian Culture*. Translated by Andrea Beesing. Edited by Alexander D. Nakhimovsky and Alice Stone Nakhimovsky. Ithaca, NY: Cornell University Press, 1985.
Lozinskaia, L. I. *Vo glave dvukh akademii*. Moscow: Nauka, 1978.
Madariaga, I. de. *Russia in the Age of Catherine the Great*. New Haven, CT and London: Yale University Press, 1981.
Mailloux, L. "La princesse Daschkoff et la France." *Revue d'histoire diplomatique* 1 (1981): 5-25.
Marcum, J. W. "Semen R. Vorontsov: Minister to the Court of St. James's for Catherine II, 1785-1796." PhD diss., The University of North Carolina at Chapel Hill, 1970.
Marresse, M. L. *A Woman's Kingdom: Noblewomen and the Control of Property in Russia, 1700-1861*. Ithaca, NY and London: Cornell University Press, 2003.

Mel'gunova, P. E., K. V. Sivkov, and N. P. Sidorov, eds. *Russkii byt po vospominaniiam sovremennikov. XVIII vek.* Moscow: Zadruga, 1914.

Mikeshin, M. I. *Sotsial'naia filosofiia shotlandskogo Prosveshcheniia.* St. Petersburg: Sankt-Peterburgskii Tsentr istorii idei, 2005.

Mohrenschildt, D. S. von. *Russia in the Intellectual Life of Eighteenth-Century France.* New York: Columbia University Press, 1936.

Monter, B. H. "The Public and Private Lives or Princess Dashkova." *Study Group on Eighteenth-Century Russia Newsletter* 10 (1982), 10–12.

Mordovtsev, D. L. *Russkie zhenshchiny novogo vremeni: Zhenshchiny deviatnadtsatogo veka.* St. Petersburg: A. Cherkessov, 1874.

Nash, C. S. "Educating New Mothers: Women and the Enlightenment in Russia." *History of Education Quarterly* 21 (1981): 301–316.

Nekrasov, S. *Rossiiskaia Akademiia.* Moscow: Sovremennik, 1984.

Nevskaia, N. I., ed. *Letopis' Rossiiskoi Akademii Nauk.* Vol. 1. St. Petersburg: Akademiia Nauk, 2000.

Niv'er, A. "E. R. Dashkova i frantsuzskie filosofy." In ERD, 41–54. Petersburg: Dmitrii Bulanin, 1996.

Novikov, N. I. *Opyt isstoricheskogo slovaria o rossiiskikh pisateliakh,* 1772. Reprint, Moscow: Kniga, 1987.

Ogarkov, V. V. "E. R. Dashkova: Biograficheskii Ocherk." In Biblioteka Florentiia.

Ozhigova, E. P. "E. R. Dashkova—direktor Peterburgskoi Akademii nauk." In ERD, 94–102. St. Petersburg: Dmitrii Bulanin, 1996.

Papmehl, K. A. *Freedom of Expression in Eighteenth-Century Russia.* Hague: Martinus Nijhoff, 1971.

Pavlenkova. Edited by N. F. Boldyrev, 11–83, 1893. Reprint, St. Petersburg: Cheliabinsk "Ural," 1995.

Pekarskii, P. P. *Istoriia Imperatorskoi Akademii nauk v Peterburge.* Vols. 1–2. St. Petersburg: Otdelenie russkago iazyka i slovesnosti Imp. akademii nauk, 1870–1873.

———. "Materialy dlia istorii zhurnal'noi i literaturnoi deiatel'nosti Ekateriny II." *Zapiski imperatorskoi akademii nauk* 3 (1863): 1–90.

Priashnikova, M. P. *E. R. Dashkova i muzyka.* Moscow: MGI im. E. R. Dashkovoi, 2001.

Prince, S. A., ed. *The Princess and the Patriot: Ekaterina Dashkova, Benjamin Franklin, and the Age of Enlightenment.* Philadelphia: American Philosophical Society, 2006.

Pushkareva, N. L. *Chastnaia zhizn' russkoi zhenshchiny: nevesta, zhena, liubovnitsa (X-nachalo XIX v.).* Moscow: Ladomir, 1997.

Pyliaev, M. I. *Staraia Moskva,* 1891. Reprint, Moscow: Moskovskii rabochii, 1990.

———. *Staryi Peterburg,* 1889. Reprint, Moscow: "IKPA," 1990.

Raeff, M. *Origins of the Russian Intelligentsia: The Eighteenth-Century Nobility.* New York: Harcourt, Brace and World, 1966.

Raney, S. T. "A Worthy Friend of Tomiris: The Life of Princess Ekaterina Romanovna Dashkova." PhD diss., Oklahoma State University, 1993.

Ransel, D. L. *The Politics of Catherinian Russia: The Panin Party*. New Haven, CT and London: Yale University Press, 1975.
Rice, T. T. *Elizabeth: Empress of Russia*. New York: Praeger Publishers, 1970.
Roosevelt, P. *Life on the Russian Country Estate: A Social and Cultural History*. New Haven, CT and London: Yale University Press, 1995.
Rosslyn, W. "Women in Russia (1770-1825): Recent Research." In *Women and Gender in 18th-Century Russia*, edited by Wendy Rosslyn, 1-34. Hampshire and Burlington, England: Ashgate, 2003.
Rudnitskaia, E. L., ed. *Spravochnyi tom k zapiskam E. R. Dashkovoi, Ekateriny i I. V. Lopukhina*. Moscow: Nauka, 1992.
Safonov, M. M. "Ekaterina Malaia i ee *Zapiski*," In ERD, 13-22. St. Petersburg: Dmitrii Bulanin, 1996.
Schubert, F. von. *Unter dem Doppeladler*. Stuttgart, Germany: K. F. Koehler, 1962.
Sebag Montefiore, Simon. *Potemkin: Catherine the Great's Imperial Partner*. New York: Vintage Books, 2005.
Semennikov, V. P. *Materialy dlia istorii Russkoi literatury i dlia slovaria pisatelei epokhi Ekateriny II: Na osnovanii dokumentov Arkhiva Konferentsii Akademii nauk*. St. Petersburg: Sirius, 1914.
―――. *Russkie satiricheskie zhurnaly, 1769-1774*. St. Petersburg: Sirius, 1914.
―――. *Sobranie staraiushcheesia o perevode inostrannykh knig, uchrezhdennoe Ekaterinoi II, 1768-1783 g.g.: Istoriko-literaturnoe izsliedovanie*. St. Petersburg: Sirius, 1913.
Semevskii, V. I. "Kniaginia Ekaterina Romanovna Dashkova, 1743-1810 gg.," RS 3 (1874): 407-64.
Shepelev, L. E. *Chinovnyi mir Rossii: XVIII—nachala XX v*. St. Petersburg: Iskusstvo-SPB, 1999.
Shubinskii, S. N. *Istoricheskii ocherki i rasskazy*. Saint Petersburg: Suvorin, 1908.
Shugurov, M. F. "Miss Vil'mot i kniaginia Dashkova." *Russkii arkhiv* 3, nos. 9-10 (1880): 150-217.
―――. "Zametki ob angliiskom perevode Zapisok Kniagini Dashkovoi." *Russkii arkhiv* 2 (1881): 132-40.
Stennik, I. V. "Voprosy iazyka i stilia v zhurnale Sobesednik liubitelei rossiiskogo slova." *XVIII vek* 18 (1993): 113-30.
Sukhomlinov, M. I. "Kniaginia E. R. Dashkova." In *Istoriia Rossiiskoi Akademii*, Vol. 1, 20-57. St. Petersburg: Akademia nauk, 1874-1887.
Summerfield, C. and M. E. Devine, ed. *International Dictionary of University Histories*. Chicago: Fitzroy Dearborn Publishers, 1998.
Suvorin, A. A. *Kniaginia Katerina Romanovna Dashkova*. St. Petersburg: A. S. Suvorin, 1888.
Taigny, E. *Catherine II et la princesse Daschkoff*. Paris: Naumbourg, Chez G. Paetz, 1860.
Tartakovskii, A. G. *Russkaia memuaristika XVIII-pervoi poloviny XIX v*. Moscow: Nauka, 1994.
Teplova, V. A. *Dashkova, Ekaterina Romanovna*. Vol. 1, *Slovar' russkikh pisatelei XVIII veka*. Leningrad: Nauka, 1988.

Tishkin, G. A. " 'Ee Svetlost' Madam Direktor': E. R. Dashkova i Peterburgskii universitet v 1783-1796 gg." In ERD, 80-93. Petersburg: Dmitrii Bulanin, 1996.

———. "E. R. Dashkova i uchebnaia deiatel'nost' v Peterburgskoi Akademii nauk." In *Ocherki po istorii Leningradskogo universiteta*. Leningrad: Leningradskii universitet, 1989.

Turgenev, A. *Rossiiskii dvor v VIII veke*, 1858. Reprinted with translation, notes, and index by D. V. Solov'ev. St. Petersburg: Iskusstvo-SPb, 2005.

Tychinina, L. V. *Velikaia Rossianka*. Moscow: Nauka, 2002.

———, ed. *E. R. Dashkova i ee vremia: issledovaniia i materialy; E. R. Dashkova in A. S. Pushkin v istorii Rossii; E. R. Dashkova i rossiiskoe obshchestvo XVIII stoletiia; E. R. Dashkova i ee sovremenniki; E. R. Dashkova: Lichnost' i epokha; E. R. Dashkova: Portret v kontekste istorii*. 6 vols, *Papers of the Dashkova Conferences*. Moscow: MGI, 1999-2004.

Udovik, V. *Vorontsov*. Moscow: Molodaia Gvardia, 2004.

Veselaia, G. A. "Ekaterina Romanovna Dashkova v sele Troitskom: Materialy k biografii." *Trudy Gosudarstvennogo istoricheskogo muzeia* 58 (1984): 77-91.

———. "Poslanie kniagini E. R. Dashkovoi svoim krest'ianam v Novgorodskuiu guberniiu v derevniu Korotovo." In *E. R. Dashkova i ee vremia*, 113-24. Moscow: MGI, 1999.

———. ed. *Put' k tronu: Istoriia dvortsovogo perevorota 28 iiunia 1762*. Moscow: Slovo, 1997.

Whittaker, C. H. *Russian Monarchy: Eighteenth-Century Rulers and Writers in Political Dialogue*. DeKalb, IL: Northern Illinois University Press, 2003.

Woronzoff-Dashkoff, A. "Additions and Notes in Princess Dashkova's 'Mon histoire'." *Study Group on Eighteenth-Century Russia Newsletter* 19 (September, 1991): 15-21.

———. "Disguise and Gender in Princess Dashkova's *Memoirs*." *Canadian Slavonic Papers* 32 (March, 1991): 61-74.

———. "E. R. Dashkova (Essay, Bibliography, Translation)." In *Russian Women Writers*. Edited by C. D. Tomei. New York and London: Garland Publishers, 1999.

———. "E. R. Dashkova's Moscow Library." *Slavonic and East European Review* 72 (January 1994): 60-71.

Woronzoff-Dashkoff, A., and M. Safonov, eds. *Ekaterina Romanovna Dashkova: Issledovaniia i materialy*. St. Petersburg: Dmitrii Bulanin, 1996.

Zaitseva, A. A. "E. R. Dashkova i knizhnaia torgovlia Akademii nauk," In ERD, 110-27. St. Petersburg: Dmitrii Bulanin, 1996.

Zimmerman, J. S. "Alexander Romanovich Vorontsov, Eighteenth-Century Enlightened Russian Statesman, 1741-1805." PhD diss., City University of New York, 1975.

Index

"An Abridged Catechism of an Honest Man," 200
Academy of Arts, 92
Academy of Sciences, 175–178
 administrative reorganization, 165–168
 Dashkova's appointment to, xxiv, 159–162
 educational programs, 172–175
 prior to Dashkova's leadership, 153–159
 problems with Viazemskii, 162–165
 publication and translation, 168–172
 research and inquiry, 168
Acta Academiae, 168–169
The Advancement of Arts, Manufactures and Commerce; or, descriptions of the useful machines and models contained in the Repository of the Society for the Encouragement of Arts, Manufactures and Commerce, 102–103
Afrikaner, Simon, 4
Agriculture, 99–100
Alexander I, 259–261
Alferova, Anna, 230
All Sorts of Things, 191
American Philosophical Society, 171, 187
American War of Independence, 127
An Attempt at National Education, 202
And This and That, 222–223
Antoinette, Marie, 112, 139–140, 238
Archive of the Conference of the Academy of Sciences, 168
Archive of Prince Vorontsov, xxiv
Arkharov, Ivan, 249

Arkharov, Nikolai, 249
Ashmolean Museum, 101
"Assembly for the Translation of Foreign Books," 183

Bailey, William, 102–103
Balls, 19–20, 264. *See also* Masquerades
The Barber of Seville, 225
Bath, 101
Baudoin V, 4
Bavarian Academy of Science, 174
Bazhenov, Vasilii, 91
Bekhteev, Fedor, 12
Berlin Academy, 182
Bestuzhev, Mikhail, 5
Bestuzhev-Riumin, Aleksei, 6, 30, 67, 68, 82
Betskoi, Ivan, 66–67, 202
Bezborodko, Aleksandr, 157, 158, 164, 165, 179, 180, 183, 184, 246, 282
Blair, Hugh, 129
Blank, K. I., 243
Blue Stocking gatherings, xxi
Bodleian Library, 101
Bogdanovich, Ippolit, 84–85, 191
Bonaparte, Napoleon, 245
"A Briefly Lengthy Reply," 215
"The Brigadier," 225
Brockett, Elizabeth, 10
Buturlin, Mikhail, 54
Byers, James, 144

Card games, 38
Carter, Elizabeth, xxi
Catherine I, 3

Catherine II, 3
 appointment of Dashkova to the Academy, 158–159
 birth of son, 44
 coronation, 79–81
 Dashkova, criticisms of, 74–82, 233–239
 death, 245–246
 fear of the Vorontsov family, 30
 Jewish community and legislation, 15
 march on Peterhof, 52–55
 Orlov and, 44
 Peter III, conspiracy to overthrow, 39–48
 plans to re-marry, 82
 Russian Academy and, 179–182
 serfdom, views of, 110–111
 St. Petersburg, development of, 4
 writings in *Companion*, 200–201, 205, 213–217
Chernyshev, Field-Marshal Zakhar, 98
Clarendon Press, 101
Collection of Russian Proverbs, 169
Collot, Marie-Anne, 140
Commission on National Education, 169
Commission for the Reconstruction of Moscow and St. Petersburg, 81
Companion for the Connoisseurs of the Russian Word, 189, 191, 192–196
 Dashkova's writings in, 197, 200–201, 209, 212–213
The Contemporary, 186
"A Continuation to Excerpts from my Notebook," 208
Continuation of the Old Russian Library, 191
Country Celebration, 224
Cour des d'éducation demoiselles, 202
Cross-dressing, 20–21

d'Alembert, Jean, 16
Damer, Anne Seymour, 145
Dancing, 20
Dashkov, Mikhail (husband):
 background, 32
 death of, 88
 gambling, 33, 36, 89
 relationship with Catherine II, 78
Dashkov, Mikhail (son), 36–37
Dashkov, Pavel, 82
 death, 274–275
 education, 128–130, 132–134, 136, 140–141
 gambling, 229–230
 marriage, 229–230
 Paul I and, 256-157
 Potemkin and, 137, 154, 188
 travel, 97
Dashkova, Anastasia (daughter), 35
 education, 124–125
 debt, 231–232, 242–243
 journey abroad, first, 97
 Pavel, after death of, 275–276
 relationship with Dashkova, 91
 Russian Academy, 188–189
Dashkova, Anastasia (mother-in-law), 34–35
Dashkova, Ekaterina:
 in Berlin, 97–99, 117, 126–127
 birth, 4
 blindness, 15, 17
 in Brussels, 136–138
 Catherine II
 accusations of plots to overthrow, 83
 dissolution of friendship with Catherine, 59–60, 233–239
 celebrity status, 76
 childhood, 7–8
 children, 35–37
 in Danzig, 97
 in Dublin, 134–135
 death, 280
 depression, 18–19, 36, 88–89, 190, 231–232
 in Edinburgh, 128–130, 132–134
 education, 11–14
 of her children, 93–94
 in England, 100–102
 estate, division of her, 276–277
 etiquette training, 11
 financial difficulties, 49–50, 89–91

in France, 102-114
Free Economic Society, 9
in Hanover, 99-100
in Italy, 141-146
in Kiev, 94-95
in Korotovo, 248-260
languages, study of, 12
in London, 127, 135
loyalty to Catherine, 27-31
measles, 14, 17
Mikhail Dashkov, 32, 33-34
military service, early interest in, 17
Mishenka, death of, 79-80
in Moscow, 92-93
music, fondness for, 79
Order of St. Catherine, 63
paralysis, 83, 88
in Paris, 138-141
Peter III, conspiracy against, 39-48
 later views of, 73-74
 minimization of the roles of others, 77-78
pseudonyms, xxv, 95
ridicule of, 22
serfdom, views of, 108-112
siblings, 4, 10-11
in Spa, 100, 117, 127
in Switzerland, 114-117, 141
travel, importance of, 94-95
in Troitskoe, 241-250
writings
 educational, 201-207, 208-210
 poetry, 85, 197-201
 social, 207-213
de Beaumont, Chevalier d'Eon, 21-22
de Beaumont, Lia, 21-22
de Breteuil, Baron, 9
The Deceiver, 222
de Lafayette, Marquis, 187-188
"De L'Egalité des Conditions," 85
De l'Esprit, 23, 85, 233
De l'homme, 24
Denny, Arabella, 134-135
Derzhavin, Gavriil, xxiii, 194-196
Descartes, Rene, xxviii
de Vertot, Abbé, 127

Dictionary of the Russian Academy, production of, 185-189
Dictionary of Writers, 85
Diderot, Denis, 22, 104
 Dashkova
 criticism of, 106-107
 opinions of, 105, 106-107
 death, 221
 serfdom, views of, 110
Discours sur l'éducation des dames, 202
"Discourse on Fundamental Law," 46
"Discussion of Essential State Laws," 212
Dmitrii the Pretender, 225
Dobroliubov, Nikolai, xxiv
Dolgorukaia, Elizaveta, 21, 248, 257
Dolgorukii, Iurii, 7
Domashnev, Sergei, 157
Donep, Fraulein, 29
The Drone, 191
The Duties of Women, 202-203

Edinburgh University, 128
Education de la noblesse française, 202
Elagin, I. P., 185
Elizabeth I, 5, 6, 32, 45, 67, 87
Embroideress, 124
Emile, 202
The Enamored Blind Man, 225
Epinus, F. I. T., 173
"Epistle to the Word 'So,'" 197, 201
"Essai sur la poésie épique," 85
Eugene Onegin, 186
Euler, Johann-Albrecht, 160
Euler, Leonard, 160-161
"The Evening Party," 216
"Excerpts from my Notebook," 207-208

Fabian's Wedding or the Desire for Riches Punished, 224
"Facts and Fables," 212
Falconet, Etienne-Maurice, 140, 147
Fashion, court, 11-12
Fedorovna, Maria, 254
Ferguson, Adam, 129
Fonvizin, Denis, 84, 212-213
Foreign Affairs Collegium, 46

Franklin, Benjamin, xxi–xxii, 128, 170–171, 187, 188
Frederick II, 6, 37, 38, 43, 45, 77, 99, 148, 266
Freedom of Nobility, 9
Free Economic Society, 9, 107
Freemasonry, xxviii, 238–239
Free Russian Society, 121, 182
French Academy, 181–182
French Enlightenment, 4, 28
French Revolution, 238
Friend of the Enlightenment, 208, 269
Fundamentals of Russian Grammar, 185

Gardens. *See* Landscaping
Gentleman's Hotel, 100
Geoffrin, Marie, 104
George III, 136, 145
Georgi, Johann-Gottlieb, 168
Golitsyn, Aleksandr, 57
Golitsyn, Dmitrii, 24
Göttingen University, 173
Grand Cross of the Order of Merit, 180
Great Instruction, 92
Grecian Lady at Work, 124
Gustav III, 179–180

The Hague, 24
Hamilton, Catherine, xxviii, 28, 100, 113, 189–190
Helvétius, K. A., 23–24
Henry I, 4
Hermitage Theater, 222
Herzen, Aleksandr, xxiii
Hinchcliffe, John, 100
Histoire des deux Indes, 234
Histoire Naturelle, 169
History of the Reign of Emperor Charles V, 128
Histoire des révolution de Portugal, 127
Histoire des révolutions arrivées dans le gouvernement de la République romaine, 127
History of Revolution in Sweden, 127
Hobbes, Thomas, 122
Horseback riding, 21

Hôtel de Russie, 97, 98
Houdon, Jean-Antoine, 139
Hume, David, 123
Hume on Education, 202

Iaroslav the Wise, 4
Idalida, 226
Idle Time Put to Good Use, 84
The Imaginary Treasure, 225
Imperial Academy of Sciences, xxii
Imperial Educational Society for Noble Girls, 202
Industrious Bee, 84
Innocent Exercise, 84–85, 191, 209
Inquiry into the Nature and Causes of the Wealth of Nations, 129
"Inscription to a Portrait of Catherine II," 31
Islen'eva, Anna, 248, 263, 270, 275, 276
Institutes of Moral Philosophy, 129
"The Iron and Wooden Plough," 103
Ivan VI, 82, 87
Ivan the Terrible, 5
Izmailovskii Guards, 51

Jefferson, Thomas, 128
Jetton, Russian Academy and, 184–185
Journey of a Certain Distinguished Russian Lady through Some English Provinces, 102
Joseph II, 147, 148, 155
Journey from St. Petersburg to Moscow, 216, 229, 234

Kabak, Krasnyi, 55
Kamenskaia, Pelageia, 84, 268
Kamenskii, Mikhail, 109
Kantemir, Antioch, 104
Kauffmann, Angelica, 124
Kaunitz-Rietberg, Wenzel Anton von, 147
Keith, Robert, 50
Khitrovo, Fedor, xvi, 51, 82, 83, 120
Kheraskov, Mikhail, 84
Kluchevskii, Vasilii, 279
Khrapovitskii, A. V., 167, 183, 227, 234

Kniazhnin, Ia. B., 29
Kniazhnina, Catherine, 29
Kokoshnik, 3
Kozitskii, Grigorii, 183
Kurakin, Aleksandr, 59, 86, 122, 125, 142

L'Ecole de Chevaux légers at Versailles, 16
L'Encyclopédie ou Dictionnaire raisonné des sciences, des arts et des métiers, 22
L'vov, Nikolai, 143, 153, 183, 194, 233
Lafermiére, François Germain, 225
Lalande, Joseph, 170
Lancaster, Joseph, 111
Landscaping, 102, 244
Lanskoi, Aleksandr, 181
La Parsale de Lucain, 85
Lectures on Rhetoric, 129
Le fils rival ou la Moderne Stratonice, 225
Le Grand Dictionnaire historique, 22
Le philosophe ridicule, 226
Le système social, 122
"Letter to a Friend," 122
Letters on Various Physical and Philosophical Matters, 169
Levitskii, Dmitrii, xxviii
"The Life of Ushakov," 233, 237
Linguarum totius orbis vacabularia comparativa, 187–188
"The Literary Works of Princess E. R. Dashkova," 222–223
Locke, John, 122, 203
Locke's Education of Children, 202
Lomonosov, M. V., 25
Louis XV, 75

"The Manifesto on the Establishment of an Imperial Council and the Division of the Senate into Departments," 46
Mary Stuart, Queen of Scots, 127
Masculinity, xxii–xxiii
Masquerades, 11, 20. *See also* Balls
Masson, Charles-François, xxiii
Memoirs, xxv–xxix
Messenger of Europe, 269
The Minor, 225

Mirovich, Vasilii, 86–87
The Miser, 226
Misfortune from a Carriage, 226
Montagu, Elizabeth, xxi
Montesquieu, Charles, 17, 28, 46, 107
Monthly Essays, 85, 192
Morgan, Elizabeth, 100, 101
Moscow Gazette, 184
Moscow University, 121, 173
Mrs. Vestinikova and her Family, 224
Music, 13
 amateur concerts, 78–79
Musin-Pushkin, Aleksei, 100
"My Aunt's Notes," 208–209
"My Notebook," 207

Naryshkin, Aleksandr, 227
Naryshkin, Lev, 79
Necker, Jacques, 100
Necker, Suzanne, 100
Neither This nor That, 222–223
"New Map of the Russian Empire," 165
New Monthly Essays, 191–192, 209, 226
Nikolev, Nikolai, 225–226
"Notes on Russian History," 212
Nothing Ventured, Nothing Gained, 226
Novikov, Nikolai, 85, 166, 191, 203, 238–239
Novospasskii Monastery, 88

Odart, Jean-Dominique-Joseph, 86, 87
"Ode to Felitsa," 194
Ofrosimova, Anastasia, 265
Ogarkov, V. V., xxiv
Old Masters Picture Gallery, 117
"On the Education and Instruction of Children," 203
"On the Education of Young Men and Women," 202
"On Genuine Well-Being," 206–207, 212
"On the Meaning of the Word Education," 201, 203, 204, 210
On the Nobility and Advantage of Women, 206
"On the Portrait of a Hermaphrodite," xxiii

"On Social Conditions," 122
"Opinion on Iron and Wooden Plough," 103
Order of St. Catherine, xxvix, 63
Orlov, Aleksei, 52, 264
 conspiracy against Peter III, 51
 letter of confession to Catherine, 69
Orlov, Fedor, 52
Orlov, Grigorii, 44
 Catherine II
 discovery as lover, 58–59
 plans to marry, 82
 conspiracy against Peter III, 50–51
 fall from favor, 117, 119
 opposition against Potemkin, 137
Orlov, Vladimir, 157, 183
Ottoman Empire, 4

The Painter, 191
Pallas, Peter, 175–176, 187–188
Panin, Nikita, 12, 85
 Catherine III, speculations of plot to overthrow, 87
 death, 159
 Peter III, conspiracy against, 45–48, 50–51, 57–58
 reform contributions, 81–82
Panin, Petr, 87
Panina, Anna, 89
"Parable: Father and Children," 209
Pascal, Blaise, 212
Passek, Peter, 45, 50
Paul I:
 ascension to throne, 245–246
 attacks on Dashkova, 246–249
Pennsylvania Gazette, 171
Pensées, 212
Peter the Great, 96
 foundation of the Academy, 156–157
 St. Petersburg and, 3
Peter III:
 assassination, 69
 coup d'etat, 5, 39–48, 49, 53–58
 beginnings, 49–52
 events following, 58–70
 court, disdain for his, 37–39

"Petition to the Russian Minerva from Russian Writers," 213
Philadelphia Philosophical Society, xxi–xxii
Philippe I, 4
"Plan for the Organization of Primary and Middle Schools," 173
Poniatowski, Stanislav, 86, 104, 126
Poor Richard's Almanack, 171
"Portraits of my Kin or the Past Twelve Days of Christmas," 207
"Portraiture of the Princess Dashkova," 106
Potemkin, Grigorii, 121, 180
Potemkin, Mikhail, 137, 154, 180, 188
Poverty and Nobility of the Soul, 223, 225
"Preface on the Utility of Ecclesiastical Books in the Russian Language," 216
Preobrazhenskii Regiment, 52, 53, 55
The Princess and the Patriot: Ekaterina Dashkova, Benjamin Franklin, and the Age of Enlightenment, 284
Proebrazhenskii Guards, 5
Prozorovskii, A. A., 239
The Purse, 191
Pushkin, Aleksandr, 53, 74
Pushkin, Mikhail, 53

Quarenghi, Giacomo, 222
"Questions," 212, 213

Radishchev, Aleksandr, xvii, 23, 111, 172, 229, 232, 233, 234, 235, 237, 239, 270
Rastrelli, Bartolomeo, 7
Raynal, Guillaume-Thomas-François, 139, 149, 182, 234, 270
Razumovskii, Kirill, 45, 157
 Elizabeth's dependence upon, 5
Regulations for National Schools, 202
Religion, 12
Repnin, Nikolai, 86, 119, 250, 252
"Report to the Empress Catherine II on the Founding of the Russian Academy," 181

Index

"Representation of the Great Catherine," 269
"A Response (to Ioann Priimkov)," 210
Rinaldi, A., 8
Robertson, William, 46, 128
Rosana and Liubim, 226
Roslavlev, Alexander, 45, 51
Roslavlev, Nikolai, 45, 51
Rousseau, Jean-Jacques, influence on Dashkova, 18
Royal London Society, 174
Royal Society for the Encouragement of Arts, Manufactures & Commerce, 102–103
Ruditsky, Ust, 25
Rulhière, Claude-Carloman de, xxvi, 23, 31, 33, 47, 58, 64, 81, 86, 105, 140, 269
Russian Academic Dictionary, xxiii, xxv
Russian Academy, xxiii
 Anastasia's contribution, 188–189
 Dashkova's appointment to, xxiv, 179–182
 dictionary work, 185–189
 finances, 183, 185
 influence of French Academy, 181–182
 journals, 190–195
 language studies, 182–183
Russian Atlas, 160
Russian Geographical Lexicon, 160
Russian Messenger, 269
Russian Orthodox Church, 12, 74–75, 190
Russian Theater, or the Complete Collection of all Russian Theatrical Works, 192, 226, 235
Ryder, John, 100

Saldern, Caspar von, 119
Saltykv, Fedor, 202
The Seduced, 222
Sentimental Journey, 234
Serfdom, 107–112
Seven Years War, 5, 98
Shcherbinin, Andrei, 125, 126, 189, 242, 275

Shein, Andrei, 210
Sheremetev, Nikolai, 225
"Short Draft on the Imperial Russian Academy," 181
Short Guide to Rhetoric, 169
"Short Notes of a Peddler," 215–216
Shuvalov, Andrei, 183
Shuvalov, Ivan, 213
The Siberian Shaman, 222
"Sincere Regrets Concerning the Fate of the Editors of the *Companion*," 215
Skorodumov, Gavriil, 127
Smith, Adam, 129
Smolny Institute, 66, 201, 202
"Society Must Assure the Well-Being of its Members," 122
Sokolov, P. I., 185
Some Thoughts on Education, 203
Sorena and Zamir, 226
The Spectator, 191
St. Petersburg, founding of, 3
St. Petersburg Gazette, 66, 166, 171, 174
St. Petersburg Mercury, 191
Stählin, Jacob, 161
Stählin, Peter, 98
"Statute for the Administration of the Provinces of the Russian Empire," 9
Statute on the Education of Young Noblewomen, 202
Stonehenge, 101
Stroganov, Aleksandr, 15
Studies of the Free Russian Society at the Imperial University of Moscow, 121–122
Succession, law of, 3
Sumarokov, Aleksandr, 29, 84
Surmina, Fedos'ia, 7
Swatting a Fly with an Ax, 227

The Tatler, 191
Terrible Perfection: Women and Russian Literature, 283
That's How it is to Have a Basket Full of Laundry, 225
Theater on the Znamenka, 224–225
Theatricality, 11

"This or That from my Notebook," 208
Tisdal, Philip, 100
"To the Editors of the *Companion*," 200
"To the Gentlemen Author of 'Facts and Fables' from one of the Editors of the *Companion*," 215
"To the Gentlemen Editors of the *New Monthly Essays*," 210
Toisiokov or a Weak-Willed Person, 222–224
Tonci, Salvatore, xxviii
"To the Portrait of Princess Ekaterina Romanovna Dashkova during Her Presidency," xxiii
Traité sur l'éducation des filles, 202
Transactions, 9, 171
Transportation, 80–81
"Travel of a Certain Distinguished Russian Lady through Some English Provinces," 122
"Travelers," 204
Travina, Maria, 47
"Truths that should be Known, Remembered, and Followed to Avoid Misfortune," 210–211
Tübingen University, 173
Turkish War, First, 95

University of Moscow, 182
Useful Entertainment, 84
Uspenskii Cathedral, 5

Vadim of Novgorod, 216, 235, 236
Viazemskii, Aleksandr, 162–165
Volkov, Dmitrii, 43
Voltaire, 85, 104
 correspondence with Aleksandr Vorontsov, 16
 influence on Dashkova, 18
von Fuss, Nicholas, 161
Voronetz, Fedor Vasil'evich, 4
Vorontsov, Aleksandr, 10–11
 banishment of Dashkova, reaction to, 246–247
 criticism of Dashkova, 64–65

education, 16
Vorontsov, Illarion, 10
Vorontsov, Mikhail, 5–6
 criticism of Dashkova, 60–61
 death of, 14, 92–93
 dismissal, 61
 influence on Dashkova, 6, 8–10
 loyalty to Peter III, 57
 patronage, 25
Vorontsov, Roman:
 background, 8–9
 conspiracy against Peter, reaction to, 62
 death, 159
 Freemasons and, 239
 indifference to Dashkova, 33–34
 marriage to Marfa, 7
 scholarship, 9
 unfavorable views of, 9–10
Vorontsov, Simon, 10–11
 arrest, 55
 education, 16
Vorontsova, Anna, 15
Vorontsova, Elizaveta:
 appointment as maid of honor, 153
 Catherine and, 10
 marriage to Aleksandr Polianskii, 117–118
 Peter III and, 15
 reaction to conspiracy against, 62–63
Vorontsova, Maria, 15
Vorontsova, Marfa, 6, 7
Vorontsov palace, 7–8

Walpole, Horace, xxii, 103
War of 1812, 181
Washington, George, 188
Williams, Jonathan, 170–171
Wilmot, Catherine, 74, 103
 Dashkova in exile and, 262–263, 266–268, 272–278
Wilmot, Martha, xxv, 211–212, 256
 Dashkova in exile and, 262–264, 266–267, 271–278

Women:
 education of, 11–14
 Europeanization of, 3
 journalism and, 190–191
 property laws and, 221–222
 rank and, 80
 widowhood and, 265
"Your English Gardener," 244

Zubov, Platon, 74, 175, 235, 257

www.ingramcontent.com/pod-product-compliance
Lightning Source LLC
Chambersburg PA
CBHW050739110426
42814CB00006B/305